RAILWAY PICTURE
POSTCARDS

Also by the author:

Railway Relics and Regalia (Country Life) 1975 (co-author)
Bells of Memory (BRD Publishing) 1981
Railway Tickets and Timetables (Moorland Publishing) 1986
Postcard Mail, An International Journal (BRD Publishing) 1978-80

RAILWAY
Picture Postcards

Maurice I. Bray

MPC

For Colin and Sue, not
forgetting Sir James William.

British Library Cataloguing in
Publication Data

Bray, Maurice I.
 Railway picture postcards.
 1. Postal cards 2. Railroads in art
 I. Title
 769'.49385 NC1878.R34

© Maurice I. Bray 1986

ISBN 0 86190 170 3

Published by
Moorland Publishing Co Ltd,
8 Station Street,
Ashbourne, Derbyshire,
DE6 1DF England.
Tel: (0335) 44486

Printed in Great Britain by
Butler and Tanner Ltd,
Frome, Somerset.

Contents

Acknowledgements

'Enthusiasm is the spur' was once quoted to me, to which I replied, 'Pleasure makes a better saddle'. But in producing this book I have also ridden that finest of thoroughbreds, encouragement.

I have been most fortunate, in that I have requested help from so many good friends, whose immediate and generous response has lightened my task far more than can be seen from the printed page. Their infectious encouragement, given to me unconditionally, proved the truth of the words and sentiments of one of them, the now sadly lamented Reverend Teddy Boston, MA. A friend of more than twenty-five years, he once declared to me that the hobby of railways, manifested in so many ways, was like his calling, the Church, a circle of friendship. This book is the result of his, and their practical encouragement, and is offered as my humble thanks to them all.

Of especial mention, along with Teddy, are David Pinfold, John Silvester (especially for the information on railway hotels), Ian Wright and Patrick Whitehouse. The first three allowed me unrestricted access to, and use of, their published researches on the subject, without which I should have struggled hard. Patrick most kindly wrote the Foreword, and like the others, left me to sort my way through treasured collections. That was perhaps the hardest part of all — not what to include, but what to leave out. Their valued efforts in checking my manuscript have ensured that the information is as accurate and up-to-date as recorded researches at present extend.

My other friends, without whom this book most certainly could not have been compiled, are Michael, Elke and Sonja Clarke; Gwilym Livingstone Evans; Ron Grosvenor; G. Brian Render; Val Sitch; Frank Staff; Stuart Underwood; Peter Woolway. Their loan of valuable and interesting documents, together with materials for illustrations, is much appreciated — not to mention the railway yarns we swapped in the process!

Very importantly, this list could not be complete without the name of John Robey, of Moorland Publishing who inspired me to write the book. Thanks must also be extended to John Buck, for allowing me the privilege of looking through some of the Francis Frith Collection; Frank Burridge, of Dalkeith Publishing Co, for permission to reproduce his 'Classic' postcards; Wilfrid Grubb, for his immediate assistance with some extra research material; Miss Clare Porter, Curator, Bath Postal Museum; Mr W. Shaw, Curator, Sutcliffe Gallery, Whitby; David Postle and Tony Bending.

Throughout the book, the individual sources of the illustrations are quoted at the end of the respective captions. All unacknowledged pictures are from my own collection.

But I feel that one group of people, which is seldom accorded acknowledgement, deserve the thanks of us all. They are the authors of the works listed in the bibliography. Some of them are now dead, but the legacy of the words they have left us is priceless, and also is their lasting tribute. In many instances their records are now the only documents which have preserved the evidence of the golden ages of both the railways and the picture postcard.

These authors, and other independent, dedicated collectors have set themselves the prodigious task of tracking down the elusive cards and records, and rationalising their often complex indexing systems. Prominent among these researchers are: the late A.J. (Jim) Butland, John Alsop, Drene Brennan, Jillian Collins, Ron Grosvenor (Shelron), Brian Hilton, Tonie and Valmai Holt, Joan Humphreys, Ken Lawson (Chairman, Postcard Traders Association), James L. Lowe (USA), Ron Mead (RF Postcards), Valerie Monahan, David Pinfold, Robert Scherer (USA), Reginald J. Silvester, John H.D. Smith (International Postcard Market), Frank Staff, Rosina Stevens, Ian Wright, and their many associates. The results of their researches, both published and unpublished, have been used in the compilation of this book, especially Appendix I and all postcard collectors owe them a debt of gratitude.

Finally, to you the reader. I hope that my words will give you as much pleasure in the reading as they did to me in the writing, and encourage your further contemplation of our fascinating heritage.

Maurice I. Bray
June 1986

Foreword

I am fortunate enough to have been born in an age where it was still possible to post a card before twelve noon and for it to arrive at its local destination by the 4pm delivery on the same day. This is how I came by some of my earliest picture postcards, for my grandfather would notify my grandmother if he was going to be late home from work by using this efficient postal service; our family certainly had no telephone in those days. What a thrill it was on my weekly visit to my grandparents to find that some of those cards (deliberately, of course) contained coloured pictures of trains. There were trains in red, in blue, in green, and in brown, each with its short caption on the back giving details of the scene, plus the name of the railway company concerned — a fine way of teaching a small boy that there had once been other lines than the LMS and Great Western which ran in and out of Birmingham.

Add to this the cards sought out at 2d each by fond aunts and parents' friends, and my collection began to grow. My father too, had some left over from his boyhood days, though I fear that I wrote 'LMS' in heavy pencil across the face of some rather nice LNWR Official cards. As time has passed, and even to this day, I have added to their numbers, and now, although not a serious card collector, I have a fascinating 1,000 or so reminders of the days when the going always seemed good — at least in retrospect. In fact, some of these cards are the only really good colour reproductions of the railway scene taking in the years prior to the disaster of World War I. We owe a considerable debt to the Locomotive Publishing Company in particular for those lovely painted-on photographs credited to F. Moore.

Maurice Bray has put together a titillating book, bringing the story of the railway postcard to life together with a potted history of the railways themselves where appropriate; there is also a series of appendices which relate the story of the cards and their development. We collectors, especially those of us who are fascinated but not totally dedicated, will not be just the wiser for this volume, but will gain enjoyment form it year by year, just by looking through its pages and savouring the contents.

Picture postcard collecting is now a comprehensive hobby, but fortunately it is not necessarily the most expensive, and I commend this book to those who are making a start; it has been compiled by an expert on the subject, aided by others of high integrity and esteem.

May it give pleasure to many thousands. I am sure it will.

Patrick Whitehouse
Birmingham, June 1986

FROM A RAILWAY CARRIAGE WINDOW

Faster than fairies, faster than witches,
Bridges and houses, hedges and ditches;
And charging along like troops in a battle,
All through the meadows the horses and cattle:
All of the sights of the hill and the plain
Fly as thick as driving rain;
And ever again, in the wink of an eye,
Painted stations whistle by.

* * * *

Here is a cart run away in the road
Lumping along with man and load;
And here is a mill and there is a river;
Each a glimpse and gone forever!

Robert Louis Stevenson
(1850-94)

This poem was re-published in *Through The Window*, Number One: Paddington to Penzance (Cornish Riviera Route), issued in 1924 by the Great Western Railway.

Introduction

The use by the Great Western Railway of Robert Louis Stevenson's very descriptive poem to introduce their famous series of travel handbooks is but another indication of how the magic of the railways captured the imagination of the public. The very rhythm of the words is an almost perfect mirror of the sights, sounds, and stimulation of the senses experienced in a railway journey during the 'Golden Age' of steam. For the most part, nostalgia for the days of steam is a self-indulgent fantasy we can only nowadays re-live on a few preserved lines. We can fondly imagine that the scalding dirty steam, the swirling soot-laden smoke, and the pungent hot oil are like some heady, exotic Parisian perfume.

We are presuaded into these dreams by the existence of contemporary publications and ephemera, from and before that golden age, which extolled the virtues of the railways. The companies and private publishers produced a plethora of timetables, handbooks, guides, maps, literary works, and brochures to encourage the traveller to invest his time and money in the new form of transport which replaced the stagecoach. The great commercial and industrial venture which came into force with the opening of the Stockton & Darlington Railway in 1825 also now provides some of the richest treasures sought by the collectors of transport ephemera.

Elaborately designed, steel-engraved share certificates, and charmingly handsome religious tracts give us a visual image of railways and travel in the mid-1800s. Trade cards issued by railway companies and travel agents lost no opportunity to illustrate some scenically attractive areas and interesting features to be seen on the various routes. The Midland Railway was fond of proclaiming that it had 'The Most Picturesque Route between Liverpool, London and Glasgow'. Like the London & North Western Railway, it produced illustrated time-tables and hotel tariff cards to prove the point.

The Victorians have left a priceless legacy of a social record in the form of those unique, superbly produced chromolithographed paper cut-outs. Naturally enough, railways feature very prominently on them. Manufacturers of almost every commodity from soap to chocolate, oil to meat extracts, utilised the same printing process graphically to advertise their products, and in the process portrayed the railways in some (real or imagined) appropriate manner. But the printed form which, more successfully than most, bridges the gap between today's nostalgia and yesterday's reality is the picture postcard.

In railway history there are countless legends, at least as many as the sleepers which carry the tracks. If you imagine the large number of sleepers, and then multiply that by millions, almost certainly the total will still be far short of the number of railway picture postcards ever produced. Some were issued by the railway companies as 'official' publications, or used by them for internal correspondence and to ac-knowledge letters. But by far the greatest number were produced by independent firms and private individuals.

Practically every country in the world with a railway line has produced, at some time or other, picture postcards featuring every aspect of the organisation from locomotives and rolling stock to views, from its stations to its staff and services. In this respect it is more than probably true to say that Britain has produced more railway postcards than any other country. The variety of cards produced almost defies the imagination; they have been produced in colour and black and white by chromolithography, collotype and photography.

The glamour of the railways has always centred around its locomotives, and this is reflected in railway postcards. It is only in relatively recent years that the historic import-ance of the view card, and those categorised as 'topographical' has come to be fully realised and appreciated. Of course, a scene across a lake, in

the hills or mountains, may not have changed significantly over the past eighty years. But where the view includes the railway track, bridges and tunnels, stations and other buildings, then the picture becomes important and valuable historically. In the first issue of the *Picture Postcard Magazine*, published in July 1900, a writer commented that the view card was not only of interest to the traveller, but that it also had a significance that was not yet appreciated. On so many of those view cards the station, works, and other buildings, even the companies themselves, have disappeared, and the picture postcards are quite frequently the only existing record of their former glories.

This lack of appreciation also extended to the railway companies themselves, and a writer in the same magazine, only two years later, was complaining of the lack of imagination by the companies in producing picture postcards. To a certain extent this was true. Railway travel was on the increase, picture postcard collecting was booming, indeed, both activities reached a peak, the 'golden age', coincidentally. Yet it would seem that railway companies and their printers had a mental block concerning the exploitation of the commercial advantage which lay so temptingly before them. Frequently, in magazines, books and other promotional literature, a railway company would proudly present its services and publications, these latter often available 'free upon request'; in these same publications the printer would have an advertisement describing the extent of his commercial accomplishments, enterprise, and products. Rarely would either indicate that postcards formed a large part of their respective businesses.

Although the railway companies were very publicity-conscious, especially during their 'trade wars' during the latter part of the nineteenth century, they made relatively little use of the postcard. Sir Felix J.C. Pole, General Manager of the Great Western Railway, was one of the authors of the classic work on railway organisation, *Modern Railway Administration*, published in 1927.

In a section on 'Traffic Inducement — Advertising', he wrote, 'Much of the business of a railway is created by the work of the Advertising Department. This is certainly the case with many American and Canadian railways, but British railways have only in recent years recognized the creative possibilities of advertising.' He went on to describe the railways' advertising activities around the turn of the century, which mostly consisted of typographic displays in newspaper columns, and the distribution of timetables and excursion handbills. He continued, 'Now, however, railways make extensive use of the Press, wherein to insert skilfully-constructed advertisements, and they issue pictorial posters, folders, handbills, booklets, travel and guide books, postcards.' But by the time he made his observations the golden age of the railways and the picture postcard was on the decline. With the outbreak of war in 1939 they were, to all intents and purposes, brought to an end.

With new electric systems taking over from steam on the underground railways, in 1906 the District, Piccadilly, and Northern Lines went to great lengths to promote the efficiency and cleanliness of the 'modern' transport. They commissioned famous artists like John Hassall and Dudley Hardy, among many others, to design special posters. After the grouping of the railways in 1923 this tradition was carried on, with such artists as Fred Taylor, Frank Newbould, and Tom Purvis producing really quite colourful, dramatic poster pictures for the 'Big Four', the LMS, LNER, SR, and GWR. Most of these pictures were also reproduced in 'Beautifully Illustrated Booklets, Free of Charge' from stations and offices. Very few ever became picture postcards; only a few of the original paintings seem to have survived, so it is an arguable point as to which is the more valuable. The advice of Sir Felix J.C. Pole that 'the work of an up-to-date railway advertising department should include the publication of artistic posters, well-written books, postcards and pamphlets' had little chance of being heard.

If the railway companies had been slow to take up the challenge, or could not heed advice, the commercial printers had not been so tardy. The Locomotive Publishing Company Limited issued the first of their prolific range sometime early in 1900, and four years later produced some of the very first coloured cards. These picture postcards were made from photographs coloured in oils by F. Moore; they were also reproduced by several other postcard publishers, notably the Alphalsa

Publishing Co Ltd. The LPC cards are generally reckoned to be among the best ever produced, being of good picture quality, accurately coloured, and sharply printed.

On the Continent, both in France and Germany, commercial printers produced some excellent railway postcards, especially the chromolithographic *Gruss Aus* (greetings from) cards. Relatively few of these early railway postcards were produced as official cards. The promotion of steam on picture postcards was mostly left to independent printers.

Like the modern preservation societies who have saved some of the original locomotives and carriages, these postcards, whether in colour or black and white, provide some nostalgic memories, and some priceless pieces of history. During World War II numerous 'salvage drives'

were responsible for the wholesale destruction of countless thousands, perhaps millions, of picture postcards, in their insatiable demands for scrap paper.

Just as they were when originally published, railway postcards are among the most popular with collectors. Many of the old cards are reproduced as advertisements by the preservation societies, while some of the exquisitely beautiful posters, spurned by the old railway companies as suitable for postcards, now appear in limited edition reproductions. Perhaps it is not too late for these treasures to form the nucleus of a library, not only to preserve the picture postcards themselves, but to perpetuate the magic and romance of a transport system which transformed the world.

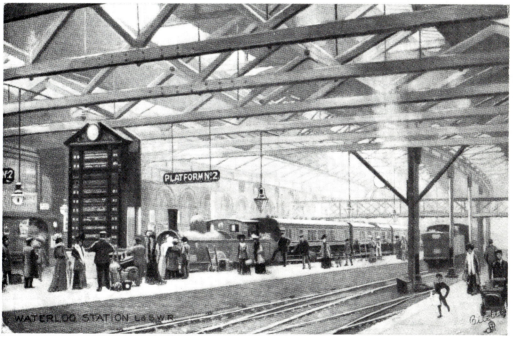

1 This Edwardian postcard shows an artist's view of the interior of Waterloo Station. Frequent trains carried passengers to the up-river resorts and to the south-west suburbs of London; long-distance expresses connected with Southampton and the south coast. (Raphael Tuck, London Railway Stations, Postcard No 9279, Oilette issued 1906; this series was reprinted in 1909 as No 8570) *(Frank Staff)*

Postcards & Railways

The Development of the Postcard

The history of the postcard, a card produced by a government agency, bearing a printed stamp, conforming to many official regulations, and issued by the Post Office, is a tedious chronicle. These earliest postcards — buff coloured without any ornamentation, measuring $4\frac{3}{4} \times 3\frac{1}{2}$in, and known as correspondence cards — have a tiresome and lengthy record. Cards bearing pictures, and now referred to as pictorial cards, which are known to have been sent through the post before official postal regulations and categories for them existed, also have a complex history.

These complexities and anomalies are thoroughly examined and authoritatively documented in three classic works on the history of the postcard. They are *Pictures in the Post* by Richard Carline; *The Picture Postcard and its Origins* by Frank Staff; and *Picture Postcards of the Golden Age* by Tonie and Valmai Holt. All of these works transform the dull chronology of bureaucracy and the determined efforts of publishers to circumvent officialdom into pleasant and very readable, illustrated stories.

To appreciate the fascinating story of the railway postcard one has to know a little of the background postal history. Not the least of this fascination is the fact that, like many other postcard collecting themes, railways spill over into other subjects.

One year after the Austrian postal authorities had implemented the suggestion of Dr Emmanuel Hermann, and issued the world's first postcards on 1 October 1869, the British postal authorities followed suit. The General Post Office issued Britain's first postcards on 1 October 1870; the buff-coloured card with its violet printed stamp was a huge success. More than half-a-million cards were recorded through the main sorting office at St Martin's Le Grand on the very first day, and it was reckoned that 76 million were in use during the next twelve months.

Bowing to complaints from the stationery trade concerned about the unfair competition of the Post Office monopoly, the authorities sanctioned the issue of privately-printed cards on 1 April 1872. Commercial undertakings seized upon this easing of postal regulations as an inexpensive method of acknowledging correspondence and orders. From the first day, firms also used the cards to carry simple pictorial advertisements of their products.

Although in America, France, and Germany, view cards had been in use since the early 1870s, it was not until May 1890, that the first radical change occurred in British postal regulations which was to lead to the picture postcard. To commemorate the Penny Post Jubilee an exhibition was held at the London Guildhall, with specially printed cards on sale at 6d each. The card featured a drawing of the London Arms and a crowned, decorated VR cipher, printed in red. It was so popular that shortly afterwards another commemorative card was produced with the Royal Coat of Arms and a portrait of Sir Rowland Hill, printed in light blue, and enclosed in an illustrated envelope.

There was now a widespread demand by both the public and commerce at large for greater freedom in the use of the postcard. Much lobbying and debate in Parliament ensued, and eventually amended regulations were brought into force on 1 September 1894, which allowed the manufacture and use of private postcards on a wider scale. But bureaucracy dies hard, and these new rules were full of muddle and inconsistencies, to the extent that Post Office officials themselves were unsure of their interpretation.

The significance of the 1894 regulations is that for the first time, privately-printed postcards bearing an adhesive stamp could be transmitted through the mails. Britain was a founder member of the Universal Postal Union but her own internal regulations did not conform with those laid down internationally. Due in no small

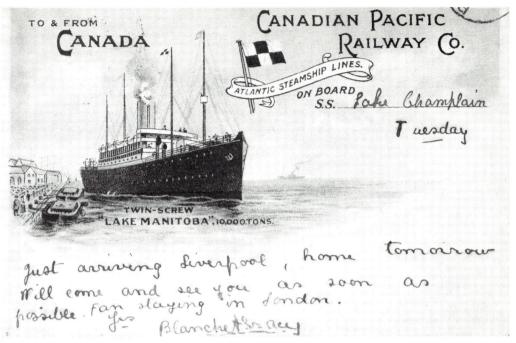

TO & FROM
CANADA

CANADIAN PACIFIC RAILWAY Co.

ATLANTIC STEAMSHIP LINES.

ON BOARD
S.S. *Lake Champlain*

Tuesday

TWIN-SCREW
"LAKE MANITOBA", 10,000.TONS.

*just arriving Liverpool, home tomorrow
will come and see you as soon as
possible. Fan staying in London.
Love*
Blanche & Tracy

2 This correspondence card is one of the earliest known cards of the Atlantic Steamship Lines of the Canadian Pacific Railway, pu Liverpool, 9 December 1903. A few months previously, the CPR flag had appeared for the first time on the Atlantic Ocean. Not wishing to wait for a fleet to be built, the CPR bought the fifteen vessels of the Elder Dempster Beaver Line. The company quickly established connections to Liverpool and London, and thence to Antwerp in 1904. (Canadian Pacific Railway Official, published 1903) *(Frank Staff)*

measure to the efforts of Mr Adolph Tuck, of Raphael Tuck and Sons, fine art publishers with a Royal Warrant, who later became more widely renowned as picture postcard manufacturers, the postal regulations were again amended on 1 November, 1899. These allowed private postcards to be manufactured to the maximum size of 5½ins × 3½ins corresponding with the recommendations of the Universal Postal Union. The floodgates were opened for the production in Britain of the picture postcard as we have come to know it.

There can be no real claimant to the issue of the first picture postcard, since pictorial cards were sent through the post before 1 October 1869, and no genuine card bearing that date has yet been found. In Britain it is generally acknowledged that two publishers can be fairly regarded as having produced the first view cards. George Stewart of Edinburgh published 'Court' sized cards (4½in × 3½in) showing views of the city, and quickly followed these with view cards of other towns in Scotland, in September 1894. The London branch manager of the firm is

reported in a 1900 issue of *The Picture Postcard* as stating, 'We have customers' invoices dated September 1894, proving that our cards were on sale during that month, and specimens would doubtless have been shown by our travellers early in September.' The report goes on to mention the various printing processes used by the firm, and those who followed, and concludes with the observation that 'there is nobody qualified to be called the first, because as soon as the new regulations came out, printers in nearly every town throughout the kingdom, began to publish picture postcards.'

The other firm was the British Photographic Publishing Company, of New Walk, Leicester. Sometime in that September, under the direction of Frederick Corkett, the firm published views of Leicester on Court cards. Both the Leicester and Edinburgh firms printed their pictures in green or brown by process blocks made from engraved or etched originals. Corkett closed down his business to become manager of Raphael Tuck's Postcard Department sometime early in 1900.

By the turn of the century Raphael Tuck and

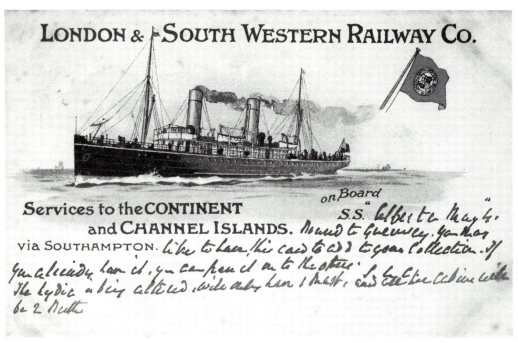

LONDON & SOUTH WESTERN RAILWAY CO.

Services to the CONTINENT
and CHANNEL ISLANDS.
via SOUTHAMPTON.

3 A correspondence card from the London & South Western Railway, which in 1910 had a fleet of twenty steamships, including two paddler steamers, and five smaller vessels, jointly owned with the London, Brighton & South Coast Railway. This coloured vignette card, pu 5 May 1904, was posted on board the SS *Alberta* and sent to a postcard collector. Information on the reverse of the card gives details of 'Holiday Tours & Services by Mail Steamers to Havre (for Paris)'. For full information and timetables passengers were advised to apply to T.M. Williams, Docks & Marine Superintendent, Southampton. The SS *Alberta* was a single funnel steamer. (London & South Western Railway Official, about 1904, printed by Andrew Reid & Co Newcastle) *(Frank Staff)*

Sons, along with many other firms whose names were to become renowned in the postcard world, went into full production. The use of postcards exceeded an annual total of 500 million, not least due to the postcard collecting craze.

The golden age of the picture postcard had begun.

The Coming of the Railways
With the practical development of the steam engine the earliest railways were commercial undertakings, laid by collieries and quarries for conveying coal and stone to the canals. None carried passengers, but an Act of Parliament in 1801 sanctioned the Surrey Iron Railway for the conveyance of public traffic. Its wagons were horse-drawn, and it eventually fell into dereliction; part of its line was later acquired by the London, Brighton and South Coast Railway.

The first public railway on which steam locomotive engines were used was the Stockton & Darlington Railway, which opened with

great rejoicings on 27 September 1825. That date marks the effective beginning of the railway age. The first train ran from Brusselton to Stockton with a mixed freight of more than ninety tons of coal and passengers. The engine, *Locomotion*, pulled six wagons of coal, one passenger carriage, twenty-one trucks fitted with seats (there were 450 passengers, including a brass band), and a further six loaded wagons (ref. original MS R.L. Stevenson.)

The Liverpool & Manchester Railway was opened in 1830, and in the five years since the Stockton and Darlington, great strides in locomotive design had been made. Although its speed of 30mph was considered exciting and wonderful, it should be remembered that stage-coaches were still running at a maximum speed of 12mph. It was in fact this railway which led the way in operating fast passenger trains.

In the previous year the historic Rainhill trials had been held, with a £500 first prize for the fastest and most reliable locomotive. The

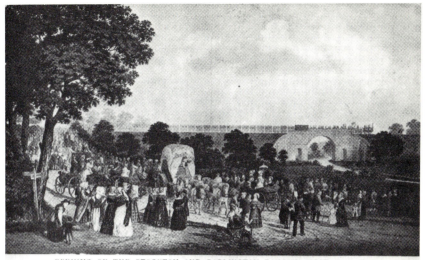

4 The opening of the Stockton & Darlington Railway inspired many artists of the day. The scene here is from a painting by John Dobbin, which at one time was hung in the Fine Art Gallery, Darlington. (Published by The Locomotive Publishing Co Ltd, date unknown) (*John Silvester*)

OPENING OF THE STOCKTON AND DARLINGTON RAILWAY, SEPT. 27TH, 1825.

high-speed era had begun, and so too had that of company liveries. Until then engines had been painted black, because it was cheap, and owners of railways considered that the locomotives were no more efficient if they were painted in gaudy colours. For the trials, the various competitors went to great trouble to present their 'iron horses' as smartly as possible. Stephenson's *Rocket* was painted yellow and black, with a white chimney; The *Sans Pareil*, entered by Timothy Hackworth, was green, yellow and black; Braithwaite and Ericsson's *Novelty*, a bright copper and blue; Burstall's engine, *Perseverance*, was reported as having bright red wheels.

The locomotive *Globe* was the first passenger engine for the Stockton & Darlington Railway,

and a contemporary drawing of it shows the ornate colouring. The chimney and boiler were painted black, with a blue and black framework containing black panels, each with decorations worked in green and yellow, the dome in yellow, and the wheels blue.

With the railways there came into being the largest commercial enterprise the world had ever seen; in more ways than one they were the foundation of business enterprise today. By the mid-1840s a large proportion of the main lines had either been constructed or received Parliamentary sanction. The railways needed money for promotion and expansion, and the whole country sought to buy into the newly floated companies; the period is known in railway history as 'railway mania'. Many people made

5 The elegant broad gauge locomotives of the Great Western Railway first appeared in 1846 in the shape of the appropriately named *Great Western*. It was rebuilt with four leading wheels instead of two, and thus the 4-2-2, eight-wheel 'singles' were born. The class was known as the *Iron Duke*, and between 1847 and 1851 twenty-two were built at Swindon, although none had numbers. The class was rebuilt in 1871-88, and *Bulkeley* was built in 1880. When she ceased work in 1892 with the scrapping of the broad gauge, she had covered 429,548 miles. (Great Western Series 6, published July 1908)

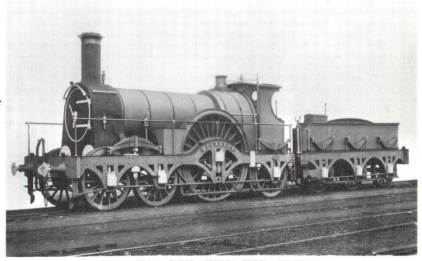

G.W.R.—OLD BROAD GAUGE "SINGLE" WHEEL "BULKELEY"

fortunes buying and selling shares which existed only on paper; many more lost fortunes during the speculation craze.

If money was lost, there was no shortage of enthusiasm for the railways, which began to compete with each other in many strange ways. Perhaps the strangest was the 'gauge war'. Almost from its beginning, the Great Western Railway had operated on tracts of 7ft gauge, while all the other companies used the 4ft 8½in gauge. After considerable wrangles, bitter and prolonged, the GWR had to yield, and in 1892 finally converted to what had originally been called 'narrow gauge' and which henceforth became 'standard'.

With all the railways in the country now operating on the same gauge tracks, none could justifiably complain of unfair advantage. The last main line to be built was virtually constructed of the metals of smaller companies, the first part of the Great Central Railway starting out in life as the Sheffield, Ashton-under-Lyne, & Manchester Railway in 1837. By the time that the new line was opened for passenger traffic in 1899 it was already meeting with fierce competition from the old-established companies.

Throughout Britain the railway companies were busy shouting the praises of their various routes as being the most scenic or picturesque the safest, the speediest, the most comfortable. For the major lines, the coveted prize was the record from London to Edinburgh. With the opening of the summer season in 1901, time-tables and advertisements were offering day services from the metropolis to the principal cities and towns of Scotland, linking up with the Highland Railway and the Caledonian Railway to the northern resorts.

'Entirely Revised and Improved Express Train Services' proclaimed the advertisements of one company, while another announced 'Three Fast Morning Expresses, Afternoon Expresses, and Three Evening Expresses'. Eager to woo the northbound tourist, each of the railway companies publicised their 'Corridor Trains with Breakfast Cars, Luncheon, Tea, and Dining Cars', and the London & North Western ran a special evening train 'for the conveyance of horses and private carriages to all parts of Scotland'.

The gauntlet was thrown down between the Midland Railway, the London and North Western Railway (who had been greatly improving their services, and had put new locomotives on their long-distance trains), and the Great Northern Railway. A contest was arranged between the three railways to seize the record in this 400-mile race. Accordingly, on 1 July 1901, the timetable details were as follows: Great Northern, depart King's Cross 10am, arrive Edinburgh 6.15pm; Midland, depart St Pancras 9.30am, arrive Edinburgh 6.5pm; L&NW, depart Euston 10am, arrive Edinburgh 6.15pm.

Although the Midland train had half-an-hour's start on her competitors, the time of arrival was fixed at ten minutes earlier; the railway got very near to her time of the first day, being one and a half minutes late. The London and North Western train arrived in Edinburgh nearly twenty minutes late. The Great Northern express came in an easy winner nearly thirteen minutes ahead of her scheduled time. Although the times were short of the GNR's 1888 record of 7hr 45min the railway travellers were the real winners.

The golden age of the railways had arrived.

This strange looking machine, *Wilberforce 23*, was designed by T. Hackworth, and constructed by Messrs R & W Hawthorn for the Stockton & Darlington Railway in 1832. It had vertical cylinders, with the connecting-rods attached to an intermediate crank. (London & North Eastern Railway, 'Railway Centenary 1825-1925', printed by The Locomotive Publishing Co Ltd) *(John Silvester)*

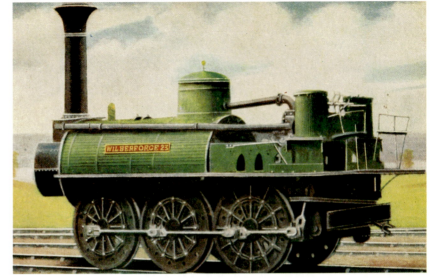

Metropolitan Railway, Baker Street to Rickmansworth train with electric locomotive and rolling stock was manufactured by the Metropolitan Carriage, Wagon and Finance Company Ltd, part of the Metro-Cammell-Laird works at Birmingham. Two Pullman coaches were run between Rickmansworth and Aylesbury. (Richard Tilling, TC62)

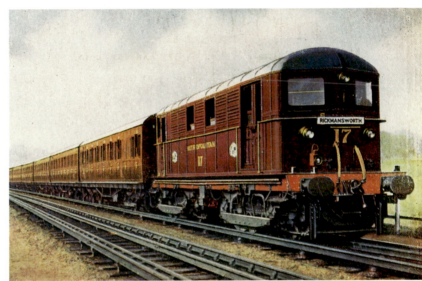

North Eastern Railway Newcastle to Liverpool Express, pictured here picking up water, was run jointly by the NER and the Lancashire & Yorkshire Railway. After leaving Newcastle at 12.30pm, the train stopped at York where the NER engine was replaced by a 4-6-0 from the L&YR. The locomotive shown is the 'Atlantic' class designed by Wilson Worsdell in 1903, and built at the company's Gateshead works; because of its relatively huge size the prototype was known as the 'Gateshead Infant.' (Raphael Tuck Oilette, Famous Expresses Series XI. Postcard No 9687, published 1912)

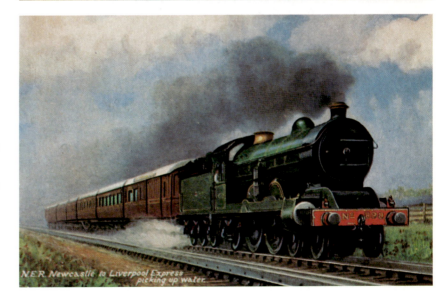

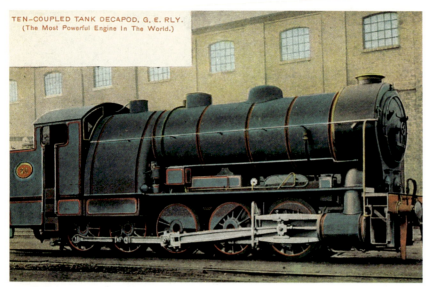

TEN-COUPLED TANK DECAPOD, G. E. RLY.
(The Most Powerful Engine In The World.)

Great Eastern Railway *Decapod* No 20 was originally designed by James Holden to cope with heavy suburban traffic from Liverpool Street Station. Weighing 80 tons, it was the first ten-coupled locomotive in Britain. It was built in 1902, and amply vindicated its power (0-30mph in 30 seconds with a heavy load), but proved to be too heavy for the track and bridges. It was converted to an 0-8-0 goods engine, its boiler length reduced to 13ft and its weight to less than 55 tons. (Knight Series No 982)

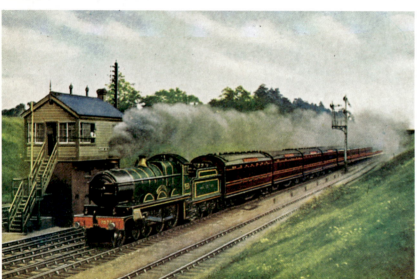

In a picture painted by 'F.Moore', a Great Western 'Saint' class 4-6-0. Designed by George Jackson Churchward, the 'Saints' owed their smooth powerful performance to the long-travel piston valves. The 'Cheltenham Flyer' made its debut behind *Saint Bartholomew* on 9 July 1923. (Locomotive Publishing Company No 63)

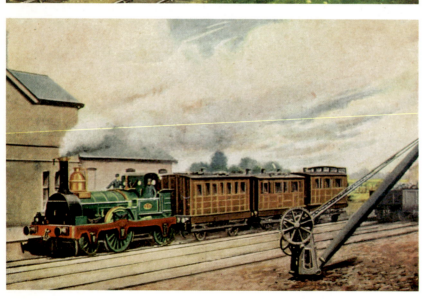

Spilsby Station, Lincolnshire, on the Great Northern Railway, about 1870, as one of the famous 'Sharpies' steams through. First built in 1847, these locomotives, originally ordered by Benjamin Cubitt, were developed by Archibald Sturrock after his appointment as locomotive superintendent from the GWR in 1850, and earned the GNR a reputation for speed. They were eventually converted to tank engines for branch line work. (London & North Eastern Railway, 'Railway Centenary 1825–1925', printed by The Locomotive Publishing Co Ltd) (*John Silvester*)

Early Officials to 1910

It is generally agreed by most authorities that the picture postcard collecting craze was given momentum world-wide by the sale of cards at the Paris Exhibition of 1889. These featured the impressive Eiffel Tower, the tallest building in the world at the time, and were inspired by the French newspaper *Le Figaro*. They could be posted at the top of the Tower, and received a special cachet. This in itself was an innovation, a fashion which has continued through to the present day; the ascent of any tall building or mountain was not worthy of the effort unless it offered a picture postcard which could be specially franked at the top.

The Welsh tourist attraction of Mount Snowdon with its Abt rack railway system was no exception. Raphael Tuck and Sons could lay very substantial claim to having published the first railway picture postcard. Sometime in 1894 they produced a Court card which depicted in vignette form the summit of Mount Snowdon and the railway. This is very curious, since the railway was not officially opened to the public until Easter Monday, 6 April 1896.

While that year is arguably the date when official postcards were first available, no railway picture postcards were placed on general sale (in Britain) prior to the summer of 1898. The possible exceptions to this were the few single cards produced for use on board railway steamers, at railway hotels, and perhaps some cards issued for the opening of the Snowdon Mountain Railway.

The very term 'official' is open to much misinterpretation since it can be applied to cards used for a company's business, or for cards sold to the public. Although both types are now available to collectors, the term is generally used to describe those cards published and sold to the public by the railway companies and their agents. The production and sale of officials effectively reached its peak just prior to the outbreak of war in 1914, when wartime restrictions curtailed existing production and put a full stop to any ideas the companies may have had for extending the range of their publicity.

Other than Tuck, another company, based in London, could claim to have issued the first Official railway postcard. Thomas Cook and Sons published in 1895 beautiful chromolithographed picture postcards of their Mount Vesuvius funicular railway. The cards could be posted from the summit station and franked with a special cachet. None are known to exist in used condition from such an early date; a card from the Snowdon Mountain Tramroad posted in 1897 has been seen.

The early cards which were issued did not depict the expected locomotives and trains, but rather views of London landmarks, or of other noteworthy places served by the railway in question. The London views were pictures of the buildings in the capital, those which visitors were expected to see, as though duty bound. There was no specific railway interest on these cards other than the particular company's title, sometimes coupled with station details, train times, or the frequency of services. The pictures were fairly predictable, but every rule has its exception. The London & South Western Railway featured Dragoons and Highlanders at Aldershot, and departures of two liners from Southampton. Frequently the pictures were embellished with decoratively designed borders or frames, with the name of the company incorporated in an Art Nouveau-esque banner.

For the supply of these picture postcards, the thirteen railway companies who made use of them relied heavily on the sale of cards from that mechanical marvel of the Victorian era, the automatic vending machine. Both John Silvester and Anthony Byatt in their books have made reference to cards being issued, ready stamped, from such machines at the major stations. These machines were rather similar in appearance and operation to the Nestlé's

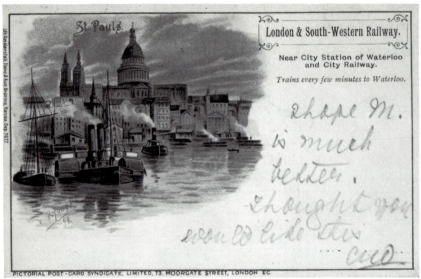

St Pauls.

London & South-Western Railway.

Near City Station of Waterloo
and City Railway.

Trains every few minutes to Waterloo.

PICTORIAL POST-CARD SYNDICATE, LIMITED, 73, MOORGATE STREET, LONDON EC.

6 One of the L & SWR's 'intermediate' cards of London views. The lighters and tugs on this Thameside scene are bathed in a roseate glow from the sunset, while Christopher Wren's masterpiece watches over all. Such skies were a favourite chromolithographer's 'licence', requiring the use of extra printing stones, which gave the picture a greater 'depth'. (London & South Western Railway, No 7677, about 1898-9 by Pictorial Post-Card Syndicate) *(Ian Wright)*

chocolate automatic vendors. Every principal station had its complement of these cast-iron devices which dispensed tickets, cigarettes, chocolate bars and picture postcards. The machines, now very rare, only a few being in private collections, were coin-operated. Although quite sturdy, they were not precision machines, and inevitably received more than a little rough handling; it was possible with some to insert a penny piece, and with a little adroit manipulation of the pull-bar or drawer, to extract more than the intended supply of the particular commodity.

The earliest of these vending-machine postcards were produced by the Pictorial Post-Card Syndicate Ltd, London; undoubtedly, the blocks used for them were of Continental origin. Some of the cards were Court sized, printed in single colours of red, black, or brown; others were of a size (124mm × 78mm) known as 'Intermediate', which carried full-colour litho illustrations. The London, Chatham & Dover Railway made exclusive use of these cards with full-colour vignettes of Kentish scenes. Their date of issue was mid-1898, a good guide to this being the styling of the railway company title.

The syndicate next produced six full-colour cards of London views, numbered 7675-80, which were used by the London & South Western, South Eastern & Chatham & Dover and the District Railways. The original artwork was signed 'R. Joust '98' and the chromolithographic printing was by the Kunstanstalt, Heinr & Aug Brüning, Hanau. Only the cards of the District and the South Western Railways

carried train information. With the confirmation of the artist's signature, the style of titling of the South Eastern & Chatham cards makes them late 1898, or 1899. The Pictorial Post-Card Syndicate produced a further series of ten London views (prominent landmarks such as Tower Bridge, Nelson's Column, etc) printed in single colours of red, black or brown. The three railways used these as well, the style of titling giving a clue to the date; cards from August 1898, are known.

Early in 1899, the name Pictorial Post-Card Syndicate disappeared from the London view cards to be replaced by The Picture Postcard Company. Whether this was a completely new company, or merely a change of name reflecting the common use of the words 'picture postcard' is unclear. Readers are referred to the extensive accounts in *Picture Postcards and their Publishers* by Anthony Byatt for further details.

The London view cards continued to be published, now with the new name, but the black printing was replaced by blue. It is an interesting coincidence, but the London & South Western Railway seems to have lost interest in the new publisher and his cards; to date, collectors have not found examples linking the railway and the publisher. However, the Great Western Railway filled the gap left by the L&SW, and between 1899 and 1901 made extensive use of the London view cards and Court card vignettes.

As mentioned earlier, the Post Office regulations of 1899 allowed the use of what is now called the 'full size' postcard. With the new regulations in force it was not long before the

Picture Postcard Co had produced a new series of thirty London views, printed in sepia half-tone. The Midland, Great Northern, London, Brighton & South Coast, London & South Western, and the South Eastern & Chatham Railways each had their terminus in the capital, and made use of the full size cards. The automatic machines were doing a roaring trade, needing regular restocking to keep pace with the sending and collecting of picture postcards. During the period 1900-01, London view cards similar to the PPC cards issued by the South Eastern & Chatham Railways, were also being sold by the Automatic General Stores.

View cards of scenes elsewhere than in London were also produced by the Picture Postcard Co for the London, Brighton & South Coast, the Lancashire & Yorkshire and the Midland Railways. Issues by the latter company were printed in a greyish half-tone. The Automatic General Stores Limited, and later still, the British and Colonial Auto Trading Co also produced postcards for the Midland Railway. It would appear that these cards belong to the 1902-03 period, and that machine issue cards were still to be found on sale up to 1904-05.

Of the earliest postcards produced by the Picture Postcard Co, by far the most numerous were intermediate-sized cards of resort views, printed in half-tone with single coloured Art Nouveau-esque borders or backgounds. That they were a popular design is evidenced by their use by eight different railway companies; they appear to have been issued from 1899 until about 1903. From the London & South Western Railway alone, over 250 different resort views, being of two designs, are known to collectors. The Great Western, Great Northern, Cambrian, South Eastern & Chatham & Dover and Joint South Western & Brighton Railways used these cards, as did the London & South Western Railway, who issued them in two colours and two designs.

In this group of eight companies, two of the minor English railways were not to be outdone by the mighty and prestigious lines in the issue of officials; like some other small companies, they beat the bigger lines with earlier issues. The Newport, Godshill & St Lawrence Railway, on the Isle of Wight, originally authorised in 1885, and given a change of name in 1889, issued cards

published by the Picture Postcard Company. So too, did the Isle of Wight Railway, which was opened in 1864.

Initially, with the change to the larger-sized cards there came a problem which the manufacturers circumvented quite simply. Their existing designs were proportional to, or filled the smaller cards, but were now printed on to the larger size card which had the effect of presenting the picture with a white border; the style is used nowadays as a matter of course rather than convenience. Also using this larger card were the Isle of Wight Central Railway, which was amalgamated in 1887, and the Freshwater, Yarmouth & Newport Railway, which was opened for passenger traffic on 20 July 1889. It is interesting to note that all these companies which formed a tight network of railways over the relatively small island were eventually amalgamated into the Southern Railway as part of the 1923 grouping.

When the Great Central Railway issued its full-sized cards printed by the Picture Postcard Company, they were not 'cards of convenience' but were specifically designed to the new size. John Silvester makes an interesting observation about another problem which arose with the new-sized cards. 'Some are found from time to time which have obviously been trimmed back to the smaller size, with which most people were accustomed. Was it that collectors did not know what to do with the larger white-edged cards, or perhaps those who filled the vending machines, which would not take the bigger cards, trimmed them?'

Picture postcards were issued, about 1899-1901, by the Great Eastern Railway, and these are worthy of mention for two innovative features. They are among the earliest picture postcards, perhaps the first, which acknowledge the holidaymaker's wish to send cards home, by the printing of the legends 'Greetings from Parkeston' and 'Greetings from Harwich'. They are also remarkable in that they depict scenes of railway interest, albeit shipping and hotel. The Company had steamers operating passenger and Royal Mail services from Harwich to the Continent, and many varieties of these cards, printed on blue or off-white card, show scenes of the quay, pier, hotel, as well as the various steamers. On the Parkeston cards, printed by

Engar Schmidt, of Dresden, the vignettes are framed within Art Nouveau scrolls and flowers. The Harwich Cards, which are known from mid-April 1901, carry advertisements for 'Summer Outings. And don't forget that the Company's arrangments for Excursions are still in force and are growing more popular year by year.' The GER actually claimed in a 1904 issue of the *Railway Magazine* that it had been the first British railway to issue picture postcards.

The year 1902 marks another significant change in British postal regulations which was to have a profound effect upon the style of railway postcards, and the boom in collecting. A German printer, Frederick Hartmann, who had set up a postcard publishing business in London, submitted proposals to the Postmaster General for a change in design of the address side of the card. His idea was simple enough, a line dividing the address from the correspondence, and in January 1902, Post Office regulations allowed the message to be written on the left-hand portion alongside the address. This enabled a picture to be printed on the complete face of the card, instead of the vignettes previously used. The railway companies were quick to take advantage of this easing of the regulations, and the issuing by more than seventy companies of the new-style cards gave extra impetus to the collecting boom.

The Great Central Railway is known to have issued postcards printed by the Picture Postcard Company, but the number is few, and only just over a dozen of these view cards are known to collectors. These issues, making use of the full-sized variety of the PPC cards, set their date at about 1900. Considering the Great Central's early advantage in the postcard field, it is strange that they did not pursue the idea further. The issue by this company of special dining car and correspondence cards highlights just one of the many complex considerations which have to be judged when attempting to determine who or what came first.

On 1 May 1900, anxious to emulate its competitors who were advertising established corridor coach and dining car services, the Great Central Railway inaugurated a dining car service between London and Bradford. At the beginning of 1902 Sam Fay succeeded Sir William Pollitt as general manager of the company; he brought wide experience to the post, having been superintendent of the line on the London & South Western Railway, and previously been instrumental in restoring the Midland & South Western Junction Railway to prosperity. One of his first priorities with the Great Central was to establish what was virtually the first railway publicity department. Under its manager, W.J. Stuart, an author and artist, the department quickly proved its worth.

An attractive, coloured 'write away' type of card was designed for use in the dining cars. In a decorated vignette a view of the plush interior was surmounted by a ribbon banner bearing the title 'Great Central Railway Corridor Car Express'. To help start the message was printed the phrase 'En Route to' The card had an undivided back, and no printer's name was shown, but these are generally reckoned to have been produced in Germany. In the manner of hotels providing stationery for their guests these correspondence cards were provided free of charge to passengers, although they may well have been on sale at some principal stations. Three years later a variation on this original design was produced, which featured a similar view of the dining car, but also included another picture purporting to show the corridor express at speed. These later cards, now with a divided back, and with the words 'Corridor Car Express En Route to' on the address side, were printed in green coloured half-tone.

During the same period the Great Western Railway also issued dining car cards, which were handed to an attendant when completed, for posting at the next stop en route. They had a different format to the Great Central cards in that the picture side carried a vignetted view (one actually shows a GWR express train photographed at speed) with the name of the company across the top of the 'write away' card. The address side carried two pictures of interiors of a smoking saloon and a luncheon and dining car. Printing of the vignetted views was in half-tone reddish sepia, with neither company crest nor name of the printer; the card had an undivided back.

From the turn of the century, eight French railways had issued picture postcards taken from their fabulous chromolithographed posters, and reproduced by the same process. That in itself makes such cards works of art in their own right,

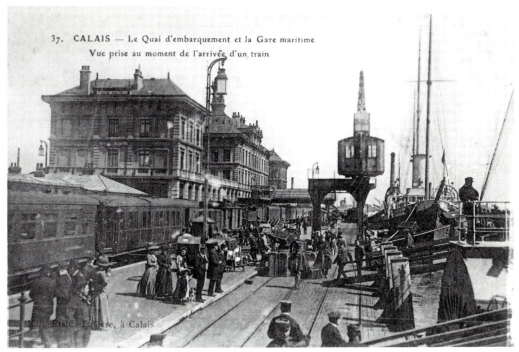

37. CALAIS — Le Quai d'embarquement et la Gare maritime
Vue prise au moment de l'arrivée d'un train

7 An early French postcard showing the Calais maritime station. The picture shows a train just having arrived, its passengers only needing to walk a few paces to board the cross-Channel ferry for a connection through to London via the South Eastern and Chatham & Dover Railway. The South Eastern operated a fleet of eight fast passenger boats, of which five were turbines. (French publication, Lefevre of Calais, No 37) *(Frank Staff)*

and when it is realised that the original pictures were by such masters as Jules Chéret (the father of the lithographed pictorial poster as an art form), Hugo d'Alési, Paul Berthon, and Georges Meunier, their worth cannot be overstated.

Sometime around 1902 the Chemins de Fer de L'Est (Eastern Railway Company) reproduced as a postcard one of their posters, originally printed by lithography in 1890 by Hugo d'Alési, entitled 'Venise'. The picture, advertising a through route from Paris to Venice via the St Gothard line, is a delightful evening study of the Grand Canal, with the Doge's Palace in the background. In the foreground, a gondola floats alongside an ornate harbour lantern while two pretty girls arrange pink flowers around the standard.

The Chemins de Fer PLM (Paris-Lyons-Méditerranée Railway) featured a picture by Jules Chéret, which he had first produced in 1892. Advertising the company's service to Auvergne, with 'detailed prospectus available in the network's major stations', the picture includes a young woman and two children in the artist's

distinctive style. He never drew from life for his pictures, his lively, laughing girls being composites taken from studies of the many models who posed for him in his Paris studio.

In 1908 the Chemins de Fer de L'Ouest issued several sets of poster cards in booklet form, with one of the cards reproduced on the cover. One of the first series issued was taken from posters produced in 1899 by J.A. Grün, and also advertises the link-up service with the London, Brighton & South Coast Railway. The picture shows an attractive visitor from France, guide book in hand, blushingly enquiring directions from a policeman, and in the background are three red-coated ensigns. It has always been a popular picture, and in recent years has been reproduced in several books on the history of the poster, and also copied in both Britain and France as a 'modern' postcard.

Many of these early French postcards were issued in booklet form and also in conjunction with various English railway companies. The Chemins de Fer du Nord (Northern Railway Company), sometime in 1908, issued a picture

card of the Boulogne-sur-Mer Plage with carica-
tures of the French President and King Edward
VII, to signify the *Entente Cordiale*; it was a
combined issue with the South Eastern &
Chatham Joint Railway. Another English
company which issued its picture postcards with
the French and Belgian market in mind was the
Lancashire & Yorkshire Railway. Many of its
officials had French text overprints specially
prepared for the 1910 Brussels Exhibition and
the 1913 Ghent Exhibition. Many of these early
sets of cards were produced between 1905 and
1910, and apart from the obvious choice of
pictures featuring places of interest on the
company's routes, they also included some fine
coloured cards showing locomotives and steamers.

The Chemins de Fer de l'Ouest (Western
Railway Company) seems to have been the most
prolific in their issues of postcards, with probably
at least six series produced between 1908 and
1913. The pictures show several typically English
scenes, particularly views of the Houses of
Parliament, Tower Bridge, and Windsor Castle.
Several other series are known, which were joint
issues with the Chemins de Fer de l'État and the
London, Brighton & South Coast Railway.
Most however, are post-1923, the final issues
appearing sometime in the late 1920s, by which
time the LBSC had been incorporated into the
Southern Railway. The quality of these later
issues is considerably inferior.

An ingenious production was issued by the
Chemins de Fer d'Orleans in 1911. The picture
postcards were artist-drawn (notably by d'Alési,
Lessieux and Duval), arranged in sets of four
cards, divided by perforations, folded concer-
tina-style, and fixed in a simple letter card
envelope. One of the most popular artists whose
works are featured on these French poster cards
was Hugo d'Alési, who seems to have been very
much in demand by the PLM. This company
also made use of the talents of the English artist
Dudley Hardy for a picture of a night scene
entitled, 'Winter on the Riviera'.

Around the turn of the century, the Midland
Railway issued fifty-four known cards with grey-
printed vignettes from the Picture Postcard
Company's library. The same pictures were used
by two other publishers, the Automatic General
Stores and the British and Colonial Automatic
Trading Company. These latter companies do

not appear to have been postcard publishers as
such; automatic vending from slot machines was
their business. There is much evidence to suggest
that the picture postcards from these three
'publishers' were sold from vending machines.
Which leaves us with an unanswered question:
who actually printed those cards, and where?

The Midland Railway is sometimes credited
with the issue of the first full-size cards as
authorised in the 1899 Post Office regulations;
but this is incorrect. Although the MR used
cards suppled by the Picture Postcard Co from
the end of 1899, so too did four other railways;
these cards were not full-sized.

The earliest full-sized postcards issued by the
MR date from late 1901 or early 1902. They are
as follows; 1901, a vignette picture of the
Midland Grand Hotel, London NW, with a list
of other hotels in the Art Nouveau cartouche.
The card was undivided (UB) and with 'Post
Office Post Card' and a green-printed Victoria
stamp; early 1902, 'The Most Interesting Route
to Scotland', with a chromolithographed picture
of an express train and the company crest; late
1902, 'The Most Interesting Route Between
England & Scotland' with a chromolithograhped
picture of the Valley of Eden and the Scotch
Express passing through; Spring to mid-1902,
'Midland Railway Hotels, William Towle,
Manager. Travel And Entertainment'. These
words and a picture of two characters representing
travel and entertainment standing on a globe,
are printed down the left-hand side of the card.
Across the top is a vignette of the hotel and its
name. Cards are known in this style for both the
Midland Grand Hotel, St Pancras Station,
London and the Midland Hotel, Derby.

The card showing the Scotch Express in the
Eden Valley carried advertising material on the
address side, which suggests that it was issued
after Post Office regulations allowed the divided
back card. Although it has no dividing line as
such, it is printed in that format, so is probably
late 1902. The early 1902 card with the express
and the crest is confirmed in its date by its
undivided back and no advertising. Both of the
chromolithographed cards were by Andrew
Reid and Co Ltd, Newcastle-upon-Tyne.

None of the cards referred to were used for
correspondence purposes except the express and
crest card, but that was not until 1904-05. The

first MR issue of correspondence cards was in 1904, some twenty-four in number. The picture covered quite a wide range from picturesque beauty spots to twin-screw steamers, dining car, St Pancras station and a Midland train. Fourteen of these cards were map cards of the Midland Railway system with the MR lines thinly drawn, and Ireland shown the same colour as the rest of the British Isles; the vignette view was printed plain half-tone. By 1905, the cards in four sets of six cards were on sale; the map shows the railway lines drawn thicker, Ireland coloured green, and the vignette in colour.

The above cards did not carry information relating to the nearest station, such cards are something different, probably printed abroad by Photochrom (1903?) — authorities are not sure of this. One such card in John Silvester's collection features a fully coloured picture of Hardwick New Hall. Beneath the title on the face is the information 'Nearest Station, Rowthorn & Hardwick, Mid. Ry,'. Hardwick Hall, 'more glass than wall', was built between 1591 and 1597 by the redoubtable Bess of Hardwick, Countess of Shrewsbury, only 100yd away from the Old Hall, her family home.

Some quite ordinary cards, produced by Photochrom for the Midland Railway, were issued as souvenirs at the Scottish National Exhibition of 1908, and the Franco-British Exhibition of the same year.

As well as the major companies, several of the smaller and narrow gauge railways issued picture postcards. Whether or not these cards were actually on sale to the public is open to question. The Barry Railway Company published several cards, from a view across the company's docks at Barry, to pictures of steamers operating with the Barry & Bristol Channel Steamship Company to the Red Funnel Line. The last of these cards, which were most probably used for internal correspondence, would seem to have been issued around 1908-10. It is of course possible that some of the steamer cards could have been sold on board the ships, which were the popular 'paddlers'.

The Corris Railway, which started life as a slate quarry line, and joined the Festiniog Railway in being referred to as a 'Toy Railway', issued four different series of photographic postcards. There were four publishers: the

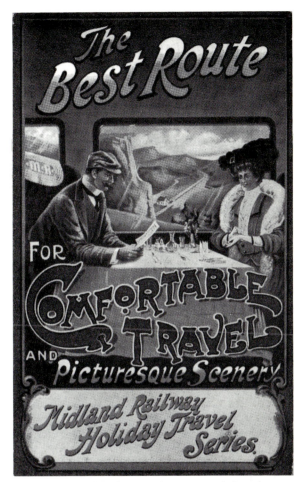

8 The Midland Railway used many sets of picture postcards as correspondence cards, both for internal and external business purposes, before they were offered to the public in the summer of 1905. This artist's picture compares favourably with contemporary photographs of similar carriage interiors. Note the glass, napery, and posy of flowers. (Midland Railway correspondence card, Set No 9, issued about 1906) *(Ian Wright)*

railway itself, W.H. Smith, George & Son, and Renaud. Of these four series, most likely the only ones to be truly official were those titled 'Corris Railway Series'; the others would undoubtedly have been used for advertising purposes, for internal correspondence, as well as being available from Smith's bookstalls on nearby main lines.

For such a relatively small line which had commenced life as a mineral tramroad, the Furness Railway issued quite an astonishing range of postcards. Their first issue was in July 1902, of a series of vignette picture cards printed by George McCorquodale, which appeared in

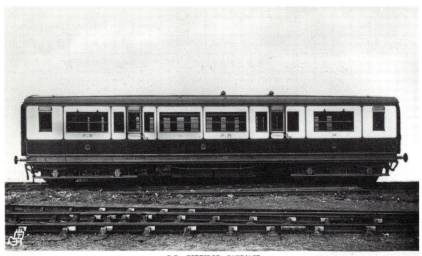

9 Although the Furness Railway had been described as 'a local line unconnected with the main railway system' this picture of an FR corridor carriage shows that the company kept abreast of main line practice. The design was based upon the LNWR Pullman coaches of the 1880s. (Furness Railway Series No 19, published about 1912, printed by Raphael Tuck and Sons Ltd) *(Ian Wright)*

F.R. CORRIDOR CARRIAGE.

four editions, including Lancashire & Yorkshire and London & North Western overprints. In 1904 McCorquodale produced another set, one edition of which was used as a correspondence card, and which included pictures of several stations, the paddle steamer *Lady Margaret*, as well as the conventional views of the lakes. During 1906 and 1907 a total of eight series (the word 'series' is included on the card) of cards, some with the previously-mentioned overprints, were issued. They were printed by Raphael Tuck and Sons from pictures by A. Heaton Cooper, many of which appear in the book, *The English Lakes*, published by A. & C. Black; his pictures only appear on these eight series. Between 1909 and 1912 a further twelve series of postcards were put on sale, but these were all photographic cards. In later years, O.S.Nock, the railway engineer and historian, and an inveterate collector of postcards, wrote in his book, *The Golden Age of Steam*, 'There were none of these to be seen on the bookstalls of Furness Railway stations, or at the reception desk of the Furness Abbey Hotel.' He went on to state that 'Many of the British railways of pre-grouping days published their own ranges of picture postcards, depicting locomotives, carriages, stations, and scenes on the line. The majority of these were in monochrome, some in photogravure, and it was only a few, like the South Eastern and Chatham that blossomed out in colour.' His observations, while undoubtedly true from his personal collecting experience, were obviously not the result of an in-depth study of the subject. Along with most other railway

companies, the Furness Railway issued souvenir postcards to coincide with several international exhibitions which were held in London towards the end of the first decade of the twentieth century. With no indication of a printer, a card was produced to commemorate the Franco-British Exhibition of 1908. Raphael Tuck and Sons produced the Furness Railway postcards issued for the Imperial International Exhibition of 1909, and the Japan-British Exhibition of 1910. The commercial view was that of the many millions of visitors expected at these events, at least a few thousand might be persuaded to visit the English Lake District and travel on the Furness Railway in the process.

Another minor English railway to issue official picture postcards was in Somerset. Beginning its life as the Weston-super-Mare, Clevedon & Portishead (Steam) Tramway in 1885, its $8\frac{1}{2}$ miles of track were opened on 1 December 1897. Two years later, it changed its name to Weston, Clevedon & Portishead Light Railway. A picture postcard is known to have been issued by this company, with its name indicated on the card as 'The Weston and Clevedon Light Railway'. Since the extension of the original line to Portishead did not take place until August 1907, it would seem reasonable to suppose that the postcard, picturing a train, was issued before then. On the reverse of the card was again printed the name of the company, with the information that it operated a 'popular and most direct route', and 'Along the whole route charming views present themselves in quick succession to the tourist.' The company was the

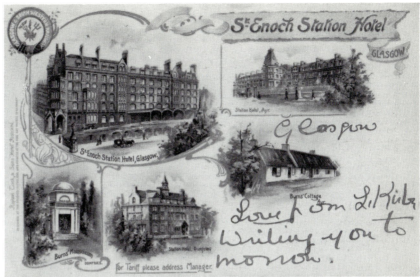

10 This chromolithographed multi-view of the St Enoch hotel, Glasgow, while colourfully attractive, did not leave the writer much room for a message. Guests at the hotel were given a handsome 108-page gilt-edged illustrated guide to Glasgow and the Clyde. The guide included a four-page list of cab fares to and from the hotel, indicating every street and important building within the city of Glasgow, (Glasgow and South Western Railway, about 1900, printed by Raphael Tuck and Sons) *(Ron Grosvenor)*

subject of much ribaldry because of the initials WC&P which appeared on its tickets.

Around 1904 an impressive selection of post-cards was published, featuring the Mersey Railway (its full name after incorporation in 1866 was the Mersey Pneumatic Railway Company). The cards, depicting station views, trains, and interior carriage pictures, were printed and numbered in the manner of the standard Wrench Series in four editions. Although some may have been issued as officials, this has yet to be proven. A similar situation exists with the famous Lynton & Barnstaple Railway. In July 1905, an advertisement in the *Railway Magazine* announced '10 cards to set', which was followed by two more. They were issued bearing the Peacock Series trademark of the Pictorial Stationery Company, and with the series numbering 2572-81.

In 1888 the Liverpool Overhead Railway took over the Mersey Dock and Harbour Overhead Railway. Although it was renowned for its very dramatic pictorial posters, the company produced only one picture postcard (so far known), for use as a correspondence card. In a view taken from the overhead line, the picture shows a large steamer entering the Gladstone Dock.

Scotland's railways are well represented in picture postcard history with the Highland Railway and the Glasgow & South Western Railway being among the first to issue officials. The G&SWR issued three sets of undivided back cards in 1902; twelve of these cards were by McCorquodale, five by Maclure Macdonald, and one by Andrew Reid of Newcastle. These

were followed in 1904 by three sets of Tuck 'Oilettes', and five or six sets of hotel cards produced variously by Tuck and McCorquodale. Hotel cards are among the most difficult picture postcards to document with absolute authority, as not all establishments with the company name, or Railway Hotel (the most common), actually belonged to or were under the management of the railway company. This subject is dealt with in a separate chapter.

The Great North of Scotland Railway issued several sets of cards in 1903, printed in half-tone by Porter of Aberdeen. Most of these were standard type view cards, but the company's issue also included the impressive 'Palace Hotel Series'. It is reasonable to assume that these cards were officials and the titling on the reverse of the cards, 'The Great North of Scotland Railway Palace Hotel Series' would appear to substantiate the theory. Of especial note is a series of golfing cards in the same style as the Palace Hotel cards. They are of scenes during the Cruden Bay Golf Tournament of 1909, and feature various players during the semi-final and final matches.

The earliest postcard to be issued by the Caledonian Railway was for the company's Central Station Hotel, Glasgow, and was printed by McCorquodale. It was a Court card, and carried the printed date-line, 189. . . , thus suggesting that at the very latest the issue had been before the introduction of the November 1899, Postal regulations. Another version was printed at the turn of the century with the date-line 190. . . .

As a full-scale venture into the postcard world,

the Caledonian's early attempts in 1903 were somewhat faltering and most unimaginative. Some conventional pictures of scenes and buildings in various towns on the company's route were produced in a decorative green frame; to make a different edition the same picture was enclosed in a brown frame, and the same picture was used, printed with an American-style back, for use by the company's agents on exhibition trade stands. Researchers have now listed twenty-one pictures for the three editions, the monotony of which was slightly relieved by the inclusion of a locomotive on a multi-view card, and a Loch Lomond steamer on another. In the same year a map card, which may have been a reproduction of a poster, was probably issued as an official.

By July 1905, the Caledonian Railway had published two very imaginative and colourful sets, the first being produced in two editions. This first series included a picture of the CR locomotive in Aberdeen station, being examined by the driver, John Souter, after the record-breaking run on 23 August 1895. The card is certainly one of the earliest, if not the first, official to feature a named company employee. The second series, and another produced in 1906, showed trains in motion, and with some carriage interiors. One of the 1905 issues could very well have been a joint issue by the *Glasgow Evening News* and the Caledonian Railway, who delivered their newspapers. Sometime around June 1902, the company produced a card with three coloured vignettes of Whiting Bay and Goatfell on the Isle of Arran and Gourock Pier; there was also a plain picture on the address side.

At about the same time two sets of correspondence cards were issued jointly with the LNWR. One set, intended for use in Scotland, was printed in LNWR style and titled in the stamp rectangle, 'Travel to England by the West Coast Royal Mail Route via Carlisle'; the other, printed in Caledonian style, and intended for use in England, carried the same legend with the word 'England' altered to 'Scotland'. There is an intriguing difference in the cartouche on the address side of the two sets. Each carries the rampant Scottish lion and right at the bottom is a scroll, within which, on the LNWR type card, are the words, 'West Coast Royal Mail Route'; the Caledonian style card reads, 'West Coast

Joint Stock'. Printed by William Ritchie & Sons, Edinburgh, under their trade-name 'Reliable Series', in 1906, the Caledonian Railway issued a series of cards illustrating the very fine Caledonian Steamers. The cards are numbered 85348-77 in the stamp rectangle, but 2553-82 on the picture.

Two printer-publishers, Valentines of Dundee and John Menzies & Company of Edinburgh, produced between them more than a dozen sets of view cards, in four variations, during 1903, for the North British Railway. Several of these sets, one of which included pictures of the company's steamers, were produced with cards from both printers in each. Probably in 1904, although the earliest card known is July 1905, several series of cards were printed in Saxony by 'M.W. & Co.' and then hand-tinted; the plain version, in sepia collotype, does date from 1904. In the same year, the West Highland Railway issued a set of six cards in the 'National Series', and overprinted in red 'On The West Highland Railway'. The 'National Series' was published by Millar & Lang of Glasgow, the name arising from the printer's attempts to discourage the import of printed postcards from Germany where the chromolithographic printing industry had reigned supreme.

Between 1905 and 1910 more than twelve sets of cards were issued, with minor variations in the printing details, and marked, sometimes on the back of the card, and sometimes as a red overprint on the picture, 'North British Railway Series'. From this same period a coloured card by the Locomotive Publishing Company is known, also bearing the legend, 'North British Railway Series', although in every other aspect as a standard LPC card. Whether this particular card, and the others similarly marked, was a true official is open to question. Other publishers had manufactured picture postcards in series about a particular theme, publicising one company in the process, but the cards were a purely private venture. In 1906, McCorquodale printed a vignette view of the North British Station Hotel, Glasgow, possibly for use as a correspondence card; probably the following year W. & A.K. Johnston of Edinburgh produced poster cards of the company's three hotels, these cards also being issued as correspondence cards.

The Highland Railway issued a vast number of cards between 1902 and 1910, principally by

11 This Great Eastern advertising card was also used as a correspondence card. The style and presentation of the picture are very similar to Tuck's Oilette series. In 1848 the Lowestoft Railway was joined by the Norfolk Railway, and worked by the Eastern Counties Railway. The profile of the track gradients between Ipswich and Lowestoft was described in 1910 as resembling 'a saw with jagged teeth.' (Great Eastern Railway correspondence/view card, probably printed by Raphael Tuck, issued 1903) *(Ian Wright)*

Valentines of Dundee, but some by Tuck in their 'Oilette' range. The cards were apparently issued in the standard six per set form, printed in collotype, but with nineteen recorded variations of titling and/or design of the address side of the cards, divided and undivided. The number of variations ranges from just one to six types, all available in a particular set.

Sometime in the summer of 1906, a series of photographic cards by Valentines, titled 'On the Highland Railway', were issued. Also by Valentines, in 1908, nearly a hundred coloured views were issued by the Highland Railway. Although no details are categorically known about these sets (which sold at 3d each for six cards), it is probable that the cards were grouped together in areas, with less than six cards for each station title. The packets indicated that the contents were six cards, but it is thought that each set probably contained cards from different station locations. There is further confusion because of eight styles of printing, with not all of the titles being of the same style in certain groups. To add an extra complication, one set contained a 'rogue' card; it was an Oilette of the Inverness to Perth passenger train, which was a Raphael Tuck production, not Valentines. From 1905, Highland Railway hotel cards were produced, mostly by McCorquodale.

In 1903, the North Eastern Railway issued ten sets of 'Panoram' view cards; the name of the printer has not been positively identified. Sold originally in 4-card sets, most of the view cards are later to be found with an overprint with maps advertising holiday contract tickets. The over-

print also enabled the card to be used for correspondence purposes.

A series of twenty-four poster cards was issued in 1908, published by Photochrom; in colour, and with titling and picture information on the reverse side, these cards were available at the Franco-British Exhibition of the same year. Also available as officials at the same time was a set of four industrial posters, similar in style to the original issue, which featured holiday resorts and beauty spots. Photochrom also published for the North Eastern Railway a coloured, three-card set of the company's Hull to Rotterdam steamers. With French text, two sepia cards were issued for the Exposition de Bruxelles, 1910. The company also issued more than two dozen hotel cards, mostly plain with some coloured, and these included an early NER card (issued in 1901) showing the Zetland Hotel at Saltburn-by-the-Sea.

The Great Eastern Railway, in March 1905, issued eight sets of cards printed in collotype in Alsace. These cards were of English and Continental views, and included a set of six locomotive pictures. In July, the company issued a further ten sets of Tuck Oilettes featuring the Norfolk Broads, seaside and coastal views, together with some fine studies of Cambridge colleges and cathedrals. Between 1902 and 1910 several non-set cards were issued, most of which were intended for use as correspondence cards. The first of these series were four chromolithographed cards from Tuck's own range, and with their individual numbering system. In 1903, Faulkners also produced a series of cathedral cards which

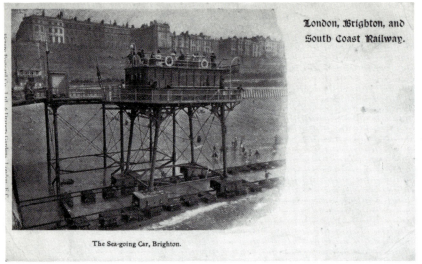

The Sea-going Car, Brighton.

12 An early London, Brighton & South Coast Railway postcard of the Sea-Going Car, Brighton, colloquially known as 'Daddy-long-legs.' It was designed for use on the Brighton and Rottingdean Seashore Electric Tramway. This was an extension of Volk's Electric Railway which ran from Paston Place Groyne to Rottingdean, and was opened for public service on 30 November 1896. The car had accommodation for 160 passengers and was required to carry a lifeboat. The stilts housed the driving shafts for the wheels which ran on rails laid on concrete blocks; at high tide the car travelled through water 15ft deep at about 6mph. (Probable official card, undivided back, about 1899.) *(Ian Wright)*

included a coloured crest of the featured cathedral in the picture. Jarrolds also produced several Yarmouth and Lowestoft views for the company in the same year. This firm was the printer for some advertisement cards issued in 1904; these were of a 'canvas' finish with East Coast travel details on the reverse of the cards. Over a period of about nine years from 1903, the Great Eastern Railway issued fifteen poster reproduction cards, most of which were coloured. A series of shipping cards, and correspondence cards featuring the company's steamers were issued sometime around 1910.

Along with several other railway companies, the London, Brighton & South Coast Railway issued picture postcards after the easing of postal regulations on 1 November 1899. These cards included both resort views and London scenes in vignettes, and were produced by the Picture Postcard Company. One resort view showed the famous Brighton & Rottingdean Seashore Electric Tramroad. This unique railway, designed by Magnus Volk, and officially opened on 28 November 1896, ran on a track of four rails with an overall gauge of eighteen feet!

It was not until 1907 that the company issued any other picture postcards. Six sets of six cards each, printed in collotype, were produced by Waterlow and Sons Limited, more renowned for their fine art engraving and bank-note printing. Apart from some expected conventional views, the sets included some good pictures of one locomotive, steam and petrol rail-motors, one of the turbine steamer *Brighton*, and some bridges. In this latter connection, of especial interest is Series 4 'Railway River Bridges', which includes pictures of the Deptford lift bridge over the Grand Surrey Canal, and the traversing bridge over the River Arun. Around 1903 the LBSC and the Chemins de Fer de l'Ouest, (Western Railway) of France jointly issued some vignette picture postcards (of which thirty-one examples have been recorded to date) with French text, concerning their services between 'London and Paris via Rouen, Dieppe and Newhaven'; most of the pictures are of French views.

With the London & South Western Railway, the London, Brighton & South Coast Railway published a joint issue of a set of six half-tone pictures in a decorative frame; the cards were of intermediate size by the Picture Postcard Company of 6 Drapers Gardens, London. The pictures were vignettes although the entire face of the cards was filled with artwork. Against a background design looking like watered silk, was set, on the right-hand side and slightly more than half the depth and width, a rectangular frame to contain the picture. To the left was an Art Nouveau cartouche for the company name, and beneath them both a scroll to contain the title. It was a basic design, on which the PPC had several variations, and was used by the eight railways mentioned previously.

The London & South Western Railway also issued about sixty intermediate-sized postcards, about 1899-1901. Of these, half were in a brown frame with an Art Nouveau-esque surround, and half in a turquoise blue frame similarly embellished; the former being oval pictures, the latter rectangular.

Postcards Go Underground

Most of the attraction of the railways for generations of enthusiasts has been concentrated on the ordinary above ground railways; sometimes quite literally so with the overhead railway systems. Those railway systems which operated, and still continue their unglamorous service under ground, have largely remained uncelebrated. For the railway companies themselves, the problems of suburban traffic in cities, created by the increasing popularity of the steam trains, were always very complex, and far from romantic.

The solution was fairly simple in theory; putting it into practice posed problems. The early city suburban lines were built underground and operated by steam trains, but not without opposition from people who declared that they would not be safe; inhabitants of houses above the railway would be poisoned by sulphurous fumes, the brick-lined tunnels would collapse, and other dire results would come from this gross interference with nature.

Probably the only 'romance' connected with the underground came as a result of the building of London's first such railway, the Metropolitan, not to be confused with the Metropolitan District Railway, which came later. To a wondering crowd on 10 January 1863, the 'Metro', with its 'cut and cover' tunnels and mixed-gauge tracks, was opened from a Great Western Railway junction at Paddington to Victoria Street (now the site of the Farringdon Underground station). As had been predicted, there were problems with the clouds of sulphurous smoke from the locomotives, despite the use of several types of condensing gear. The chief engineer, John Fowler, devised or designed his 'hot brick' locomotive, which has come down in history as 'Fowler's Ghost'. At either end of the four-mile stretch of track, fire-bricks were to be brought to white heat in specially constructed furnaces. Boiling water was also provided, ready to pump into the locomotive's boiler, the fire-bricks inserted to maintain steam pressure. The engine was given trials above ground on a stretch of the Great Western track, but it was considered unsatisfactory and was offered for sale soon afterwards. The legendary Daniel Gooch, of the Great Western Railway, designed a suitable locomotive which dishcarged its exhaust steam into special tanks, thus complying with the Parliamentary Act sanctioning the line, which said that locomotives 'must emit no smoke or vapour in the tunnels'.

But the ever-present nuisance of noise and smoke would not go away, despite many ingenious schemes to solve the problem. In the same year that the underground steam system was completed, 1884, Royal Assent was given to a scheme for operating trains on a cable system running through metal tubes more than 10ft in diameter. Undoubtedly due to the enormous success of Volk's Electric Railway, Brighton, which had opened in August 1883, (the first regular electric railway service in Britian), the promoters decided to use electric traction. Accordingly, on 4 November 1890, the Prince of Wales opened the City and Southwark Subway; it was opened to public traffic on 18 December 1890. It was the first tube railway and the first underground electric railway in the world; later that year, with permission to extend its tracks to Clapham, the company formally changed its name to City & South London Railway. Its carraiges, only two or three behind each small locomotive, had narrow slit windows in the roof, and conductors called the names of the stations to the passengers, who were unable to see out.

In 1864 Royal Assent was given to the incorporation of the Metropolitan District Railway with the Metropolitan Railway (which gave its shortened name, Metro, to underground systems the world over). Thus the original London Underground Railway was formed. It was opened in three stages between December 1868, and July 1871. The new line soon became known as the District, but while it goes down in

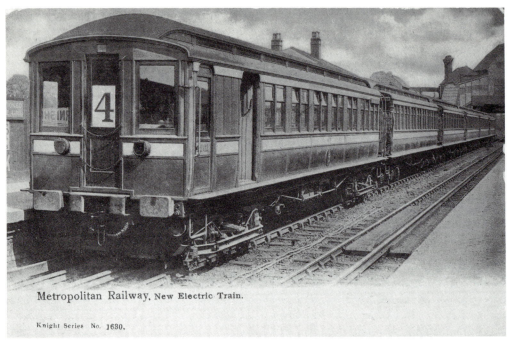

Metropolitan Railway, New Electric Train.

Knight Series No. 1630.

13 Although titled as 'New Electric Train', this type of coach which appeared on the Metropolitan Railway about 1905 was not advanced either in design or construction. The sender of the card wrote, 'Trust you will like this train although it is not made up of flounces and frou-frou stuff.' (Knight Series No 1630, pu 23 April 1906) *(Frank Staff)*

history as the first underground railway to issue picture postcards, it certainly does not receive any honours for its architecture. The few remaining red terra-cotta buildings with their graceful Art Nouveau ornamentation date from 1900 to 1910.

Sometime in the 1921-2 season, the Metropolitan Railway issued a lavishly illustrated 88-page book, price 2d: *METRO-LAND. A COMPREHENSIVE DESCRIPTION OF THE CHARMING COUNTRYSIDE SERVED BY THE Metropolitan Railway.* The book begins with a charming poem, 'My Metro-Land', by George R. Sims, its first line being, 'Realm of Romance that lies around my home'; the ten-line verse is a most unexpected and eloquent advertisement for an underground railway.

The first sentence of the Foreword shows that the company did not take fullest advantage of the picture postcard. 'Although the Metropolitan Railway — the World's Pioneer Underground System — was primarily built to provide a convenient means for rapid transit... the Company has an Extension line from Baker Street which runs out into the delightful country

situated in Middlesex, Herts and Bucks.' It continues, describing Metro-Land as 'the rural Arcadia', and there follows a guide and history of all the towns and villages (Amersham and Aylesbury to Wembley Park and Wendover) served by the railway.

Among the advertisements, which also give details of train services, the reader learns that the company was also an estate builder and developer. Kingsbury Garden Village, Neasden; Chalk Hill Estate, Wembley Park; Wembley Park; Pinner, Middlesex; The Cedars Estate, Rickmansworth, and Chorley Wood were all developments made by The Metropolitan Railway Country Estates, Ltd with prices ranging from £850 for a 3-bedroomed semi-detached villa to £4,000 for detached houses standing in 1½ acres of ground.

The next underground railway to promote its image by way of the picture postcard was the Central London Railway, opened in 1900. It was known almost from the beginning as the 'Twopenny Tube', the fare being twopence for any distance. The method of ticket collecting was unique, and it allowed many a lad to ride

round and round, dashing from train to train, until he tired of underground travelling. Entrance to the station platforms was by means of a lift, the attendant taking the tickets from passengers before they made their journeys; the tickets were not returned for booking-office checks, but immediately placed into a shredding machine. Once the uniform fare system was abandoned the nickname quickly died with it. The CLR was one of only two underground railways which had its own power station, Shepherd's Bush; the Metropolitan station was at Neasden, while all the others were fed from the big generating station 'whose four tall chimneys make Chelsea discoverable from every part of London'.

Sometime early in 1902, the Central London Railway is believed to have issued a set of six cards, among the first real photograph railway picture postcards ever published. They were produced by Giesen Brothers & Co, of Monkwell Street, London, who were associated with a Berlin photographic firm, the Rotophot Company. The name was derived, like that of the Rotary Photographic Company of West Drayton, from the use of a new rotary press for mechanically processing photographs. Its use revolutionised the picture postcard industry; by 1904 practically every major postcard publishing firm was using the system, with non-photographic postcards taking a very poor second place in popularity. The pictures on this first CLR issue included the passenger lift, the booking office at Bank Station and one of the trains.

The late A.J. (Jim) Butland, editor of *The Postcard Collectors Guide and News* (now continued by Ron Griffiths, as *The British Postcard Collector's Magazine*) was one of the pioneers of the postcard collecting hobby. His experiences in 1958 give some indication of the problems facing postcard researchers when publishers' records have been lost, destroyed or are ambiguous in their references. He visited the Rotary Photographic Company's works, examining the cabinets of glass plate negatives and examples of every card they had produced since 1901. While these were meticulously stored and indexed, the company's registers were not, and it was impossible in some cases to determine whether series numbers were sequential or numerical. These numbers, although confusing, pale into insignificance against the firm's output of 80,000 prints per day per

machine; unfortunately, there is no record of how many machines the company used. Since it also had offices and works in Paris, Berlin and New York, one can only assume that Jim Butland's very conservative estimate of production at 'the staggering figure of 780 millions' was a mere drop in the ocean.

Like the Twopenny Tube's first issue of postcards, which cannot be positively identified as officials (more than likely they were), the second issue, in October of the same year, can probably be regarded as officials in the same way. They were printed in collotype by Frederick Hartmann, who devised the divided back postcard, and were quite a popular series in their day. At least fourteen cards are known to have been issued, but there is some confusion in the numbering system which gives no indication of whether they were intended for issue in sets.

A similar sequence of cards, printed by E. Wrench Ltd, and bearing their familiar trademark of a wrench, first appeared in December 1903, and were published until November 1904. Printed in sepia half-tone set within a white frame, these cards, possibly officials, were printed in at least four editions, each differing slightly in presentation. The twelve known picture postcards range from views of some of the stations, platforms, and booking halls, to a picture of a London United Electric tram; this latter operated a service in connection with the underground railway.

The London United & County Council Tramways joined forces with the Underground Electric Railways in 1908 to promote circular routes and cheap fares for the Franco-British Exhibition. The nearest station was Shepherds Bush, and frequent services were offered via Westminster Bridge, South London, and the Thames Valley. A pictorial poster was produced — it may have been published privately as a postcard or a trade card — and from a general route map of London at the base of the picture, seven picturesque scenes within the route area are shown. They include Richmond Bridge, the west front and gardens of Hampton Court, and the ornate entrance building of the Exhibition fronting on to Uxbridge Road. This scene is of particular interest since it features an open-top trolley car.

In 1892 the Great Northern & City Railway

C. L. R.
Twopenny Tube
The Bank Station
Booking Office

*It was ever
so nice to
have your
letter. I
believe if
I had known
you were
visiting
Ilkley. I
should have
paid a
flying visit
there this
week. I
had a holiday
from the
20th to 27th*

1356.

14 Graphic illustration of why the CLR was nicknamed the 'Twopenny Tube'. Over the Booking Office window at the right is the notice 'Fare 2D To Any Station'. Access to the trains was by means of the lifts at the far end of the hall on the left. (Hartmann No 1336, possible official pu 28 February 1903) *(Frank Staff)*

15 Central London Railway, Notting Hill Gate station, a red terra-cotta building with art nouveau ornamentation. Under the London Electric Railway Facilities Act (1915), the CLR became part of the LER. By this time shops had been incorporated in the corner of the station building with beautiful art nouveau signs to announce their proprietors' names and services. Above the parapet was a vertical sign, 'TUBE Station' (Published G. Watts, Stationer, pu 8 March 1906 *(Frank Staff)*

The 'Flying Scotsman' is seen here near Hatfield; the caption on the card quotes it as travelling 'at 70 miles per hour.' The locomotive is Nigel Gresley's three cylinder 'Pacific' class No 1471, *Sir Frederick Banbury*. The class first appeared in 1922, destined to become some of the most famous express locomotives in the country. (London & North Eastern Railway, 'Railway Centenary 1825-1925', printed by The Locomotive Publishing Co Ltd) *(John Silvester)*

Another first in electric traction! There were so many claimants to the title 'first' for different systems and methods that it would take a book to describe them all. The Heysham-Morecambe & Lancaster section of the Midland Railway was opened on 13 April 1908, and was very successful. (Midland Railway, issued 1908, printer unknown) *(Ian Wright)*

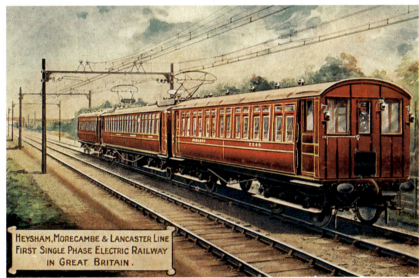

Quite clearly evolved from the stagecoach, both in its design and naming, is this early first class carriage of the Liverpool & Manchester Railway. Many of the famous stagecoaches were known by exotic names, eg *Comet, Exeter Fly, Regulator, Telegraph*. If the passenger travelled in relative comfort, the guard certainly did not; his seat was out in the open, among the luggage stowed on the carriage roof. This type of coach, used from about 1835, was quite advanced in design, having leaf spring suspension and primitive spring buffers. (London & North Western Railway, Raphael Tuck printing, Set 11, published August 1904)

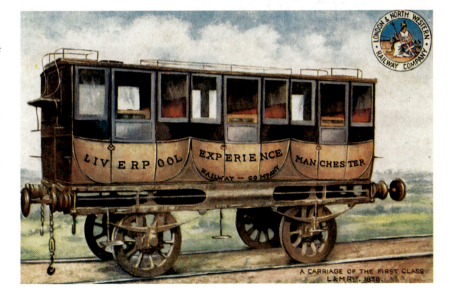

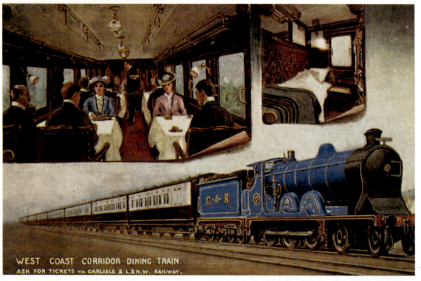

WEST COAST CORRIDOR DINING TRAIN.
ASK FOR TICKETS via CARLISLE & L. & N.W. RAILWAY.

Caledonian Railway West Coast Corridor Dining Train. The West Coast Joint Stock trains, chocolate and white carriages hauled by dapper royal blue locomotives of the Caledonian Railway, were centred at Perth General Station, the hub of the Scottish main lines. This card was sent from Partick Goods Station, 4 July 1907, to Mr Quine, GWR, Warrington, with the message, 'I am now Goods Agent at Partick Stn. Glasgow. A. Paton.' (Caledonian and London & North Western Railways, 'West Coast Royal Mail Route', Correspondence card, LNWR style, published 1905, printed by McCorquodale)

The 'Flying Hamburger', German Reichsbahn, about 1935. This unique streamlined train, comprising two articulated coaches seating 102 passengers, operated the fastest regular schedule in the world. Driven by two Maybach 410hp diesel engines, which also supplied electric power, the train travelled the 178 miles between Berlin and Hamburg at an average speed of 77mph; its maximum was 99.3mph. (J. Salmon Ltd No 4385)

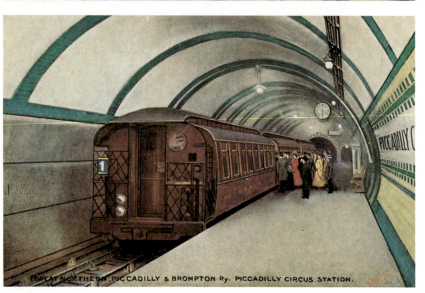

GREAT NORTHERN, PICCADILLY & BROMPTON Ry. PICCADILLY CIRCUS STATION.

The Brompton & Piccadilly Circus Railway was incorporated in 1897. The name was changed to Great Northern, Piccadilly & Brompton in 1902, and the line officially opened on 15 December 1906. From near Baron's Court Station (with access to Hammersmith over the District line) to Finsbury Park, the GNPB provided a vital link between the north and west of London. It ran through the theatre area to the West End shopping district. (Great Northern Official, drawn F Moore, printed by Locomotive Publishing Co, published December 1906)

was incorporated as an independent company and was sponsored by the Great Northern Railway. Its $3\frac{1}{2}$-mile line was officially opened for passenger traffic on 14 February 1904, trains running from beneath the GNR station at Finsbury Park to Moorgate. The line was officially purchased by the Metropolitan Railway in July 1913.

Sometime between 1904 and 1913 a set of five half-tone cards was published bearing the name 'Great Northern and City Tube'; probably in the same set was a coloured map card. All the cards carry brief information about the line, printed on the picture. No printer's name is given, and it is presumed by all authorities that these are official cards. During the same period, three cards, possibly officials, were issued, bearing the name 'Great Northern & City (Electric) Railway' above the title of the picture. The doubt about these cards being official arises because the name is an arbitrary one, probably devised by the printer; no company was officially registered with that name. The printer was Hickox & Son, Finsbury Park, and it is possible that this firm printed the five-card set and map card since there is a similarity in style. The name does not always appear on the cards; complete sets with and without the printer's name have been recorded.

Incorporation of the Brompton & Piccadilly Circus Railway was in August 1897, but its name was changed to the Great Northern, Piccadilly & Brompton Railway in 1902. By the Amalgamation Act of July 1910, the GNP&B, along with the Baker Street & Waterloo and the Charing Cross, Euston, and Hampstead Railways, became incorporated as the London Electric Railway.

In December 1906, the Great Northern, Piccadilly & Brompton Railway issued the first of two sets of coloured picture postcards. They were printed by the Locomotive Publishing Company, although no printer's name appears on the cards. The underground railway company's name followed the titles of the pictures, which included a view of the dynamos in the Chelsea Power House, the Piccadilly Circus Station, and the shield used in construction of the tunnels.

The shield was the Greathead Shield, devised by James Henry Greathead, a British engineer

who came to England from the Cape Colony in 1859, to study under William Henry Barlow, who was responsible for the building of St Pancras station. The shield method of tunnelling was a frame of the required size and shape of the tunnel, to the leading edge of which was fitted cutting machinery operated by hydraulic power. Cast iron rings of the tunnel diameter and about 6 ft wide were bolted together behind the shield as it bored its way along.

The second set of postcards, also printed by the Locomotive Publishing Company, and like the first, a six-card coloured set, was issued in February 1907. The initials 'L.P. Co., Ltd.' appeared in the stamp rectangle, with the name G.N. Piccadilly & Brompton Ry.' following the titles. The GNP&B, which was opened to passenger traffic on 15 December 1906, also published one of the first comprehensive maps of the underground system to appear on a postcard. It was included in this second set, and was entitled 'Underground Electric Railways of London'. Other pictures were of the Kings Cross station, two of the Chelsea Power House, the interior of a signal cabin, and a vertical format picture of the contruction of the Strand Extension Railway, which was opened on 30 November 1907.

Extra to these two sets of cards, one coloured picture of tube entances at Baron's Court, also printed by the Locomotive Publishing Company, has been recorded. Since it was presented in the same style as the other cards it has been reasonably assumed that it was issued as an official, but there is no record of whether it was intended to be part of a third set of cards.

Royal Assent was given to the incorporation of the Charing Cross, Euston, & Hampstead Railway in 1893, but the warrant was allowed to expire, and was revived in 1898. The eight miles of line were opened on 22 June 1907, to become part of the London Electric Railway three years later. The undertaking, along with the other constituents, was transferred to the London Passenger Transport Board in 1932, and then in 1946-7 to the British Transport Commission.

The company quickly became known as 'The Hampstead Tube', and the colloquialism was actually used on its official cards. Three six-card sets were issued, probably in 1908, the first in half-tone, the others in colour. The half-tone set

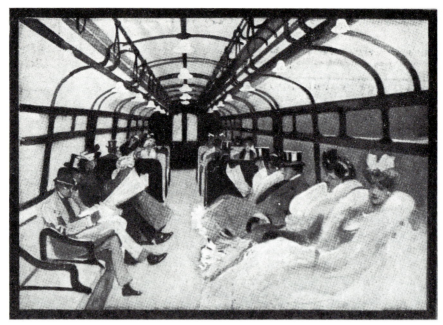

16 An artist's impression of an underground car interior. The reverse of the card, pu 17 September 1907, carries the advertisement slogan, 'Bakerloo & Piccadilly Tubes afford the maximum speed, safety, comfort & convenience in all weathers.' (Possible official published by the Underground and London Electric Railway about 1915; no printer's name, but similar to poster style cards printed by W.H. Smith.) *(Frank Staff)*

made an attempt at colour with a decorative frame, two cards each of red, light green, and blue. They were printed by Weiners of London, although their name was not on the cards, and the correspondence section had a map of the system printed in pale grey. The picture titles were all prefixed 'Places of Interest Reached By:'

The Series 2, also by Weiners, was a six-card colour set of scenic views, depicting locations which could be reached by travelling on the Hampstead Tube; the name of the nearest station followed the title of the picture. The printer's name appeared on these cards, but it is not certain whether the initials 'L.P. & A.' referred to the partners in the Acton firm or if they referred to 'Landscape, Photo & Art' publishers.

The third six-card set, in colour, was printed by the Photochrom Co Ltd London and Detroit, USA, and showed views in Highgate and Hampstead. Generally acknowledged to be one of the most prolific publishers of picture postcards, the Photochrom Company was originally founded in Switzerland sometime around 1895, and was first registered in Great Britain the

following year. They printed several series of photographic cards for other railways, including the Great Northern, the Midland, and the Cambrian Railways. A most detailed account of this firm is to be found in Anthony Byatt's reference book, *Picture Postcards and their Publishers*.

During the period up to 1910 the London underground railways' issues of postcards were mostly in sets or series, although few in number, but some single cards and non-series types have been recorded. Two of these, produced to coincide with the 1908 Franco-British Exhibition, were novelty cards, and are now both very rare and expensive should a collector be lucky enough to locate them. They were issued by the Central London Railway, one being a pull-out with pictures for each station on a concertina strip, and the other being an ingenious 'blow' card incorporating a map and an artist's impression of the exhibition site. This novelty card was folded flat to conventional postcard size for posting. To open it right out for display it was necessary to blow into it like a balloon, whereupon it extended into a rectangular box. As well as the pictures of the exhibition, the 'blow' card also

included details of train services. It is believed that the CLR also issued a similar novelty card which extended into a pillar box shape. Other single cards published were a poster type, 'This is the Best Way to Get About London', featuring a train and a map (CLR); 'Tube Entrances at Barons Court', printed by the Locomotive Publishing Company for the Great Northern, Piccadilly & Brompton Railway; a coloured poster type printed by David Allen, of London and Belfast, for the Metropolitan and District Railways, showing the Inner Circle Link, and issued in 1909; and a view card of Rockstowe House, Pinner. This was printed by Emery, of High Street, Pinner, for joint issue by the Metropolitan Railway and the Great Central Railway. There is some general doubt concerning its official issue.

The poster cards by David Allen are interesting for several reasons. Although the firm is renowned for the high quality chromolithograph postcards which it produced, they were but a small part of the printing output, Allen's specialty being posters for the theatrical world. There were works at London, Belfast, Harrow, Manchester, Glasgow and Dublin, the one at Harrow being regarded as one of the most splendid lithographic works in the world; the firm had been advertising as early as 1897 that it was capable of equalling any printing done in Bavaria and Saxony.

An autumn 1906 catalogue states, 'The List, as will be seen, embraces such a wide range and variety of subjects that suitable pictorials for almost any piece are practically certain to be found among our stock. All these posters are from designs by the best known poster artists of the day, and the work is of the most up-to-date order.' These artists included such famous names as Barribal, Hassall and Kinsella, the first of whom produced two designs (later issued as postcards) for George Edwardes' Vaudeville Theatre Company's musical, 'The Girl in the Train'. The quality of Allen's postcards can be gauged from the fact that, in many cases, the picture, measuring $5\frac{1}{2}$in \times $3\frac{1}{2}$in approximately, was reduced from a poster design whose dimensions were 160in by 90in. This represents a linear reduction ratio of 26:1 or 750:1 by area, and long before the introduction of photo techniques in the printing trade. The posters were produced

HAMBURG Hochbahn an der Börse

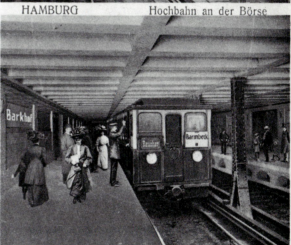

Hochbahn-Haltestelle Barkhof unter der Erde

17 The Hamburg Hochbahn (elevated railway) like some other elevated railways had several of its stations underground. The top picture shows a train on the above-ground section near the Stock Exchange. The lower picture is of the underground station at Barkhof. The total length of the station complex was more than $1\frac{1}{2}$ miles, and cost nearly 82,500m marks in about 1910. (Published Arthur Freidrich, Hamburg, pu 14 January 1913) *(Frank Staff)*

somewhat like giant jigsaws, the complete picture being assembled by the bill-poster from twenty four sheets.

The theatrical poster firm were among the leaders in the development of the 'slipping' technique, used for the stock printing of the lithographic posters. Slips were poster sheets which could be inserted into the picture where information and names needed to be changed

from time to time to suit the needs of the theatrical touring companies. They used special type (most often wooden blocks) to imitate lithography, and could be inserted in such a manner that the lettering had the appearance of having been printed with the original picture.

Before continuing with the official picture postcard story from 1910, through World War I, and into the immediate pre-grouping era, there are two railway companies whose respective stories need to be told in their entirety. They are the Great Western Railway and the London & North Western Railway.

The Great Western Railway

No British railway history, general or specialised, can be complete without an account of the Great Western Railway. This is also true when writing of railway picture postcards, although perhaps as much of the story is about the postcards the company did *not* publish as of those which it did. The GWR was probably one of the most publicity-conscious railways in Britain, but not until about the time of the 1923 grouping did that awareness really get into top gear. As well as being a railway company, the GWR was a publisher of no mean stature nor range. Books, films, jigsaws and puzzles, fine art photographs and picture postcards were part of its prolific output. Not all of these were specifically about railways.

A prospectus under the name 'Great Western Railway' was issued in 1833, and on 31 August 1835 the company received its charter of incorporation; its capital at the time was £2½ million. The Paddington terminus was publicly opened in June 1838, and by the end of 1840, more than ninety miles of track were completed. The GWR amalgamated with several lines, the most important being the Bristol & Exeter Railway (1876), the South Devon Railway (1878), as well as the minor Avon & Gloucester Tramroad. Other railways were absorbed into the GWR, notably the Oxford, Worcester & Wolverhampton Railway, known as the 'Old Worse and Worse' because of its punctuality (or lack of it) and its poor economic state.

Some of the first tracks were laid at the broad gauge of 7ft 0¼in, the company's engineer, the legendary Isambard Kingdom Brunel, deciding that such tracks, with gentle curves and gradients, would enable his engines to travel at speeds of around 60mph. They did, and more, but this state of affairs was brought to a frustrating halt where the line changed gauge. After much inter-company wrangling, Parliament intervened, and in May 1892, the broad gauge was abolished. It is interesting to note that the permanent way

gangs took just 31 hours to change 171 miles of track to the standard gauge of 4ft 8½in; quite an astonishing rate.

From its earliest days the GWR proudly advertised its services in local and London newspapers, and in several railway guide-books which appeared around the early 1860s, and its image was further enhanced by the publication of J.C. Bourne's wonderful lithographs, published in 1846, which showed off to perfection the engineering works and scenic attractiveness of the Great Western Railway. But it should be remembered that advertising in those far-off days was not the high-powered industry that it is today. The Great Western Railway had an advertising agent, but his services were dispensed with, and all advertising was handled by the general manager's office. It became the responsibility of an advertising clerk to attend to the distribution of handbills and time books.

Almost all advertising was a fairly haphazard affair 100 years ago. Since the majority of such material was for a limited period and intended for ultimate disposal, not much thought, if any, was given to its presentation. Posters, handbills and newspaper announcements were largely typographical in content, with no thought being given to design or layout. A public notice about travel arrangements was given the same consideration, if at all, as one about trespass upon company property. Advertisement copy would be given to a local printer, his only instruction probably being to print it as cheaply as possible. It was then left to the whim of the compositor as to how the information was presented. He would arrange the text in lines of type, some long, some short, the faces of different sizes and styles, all neatly centralised across the width of the paper or column available. The more he wished to show off his technical prowess the more faces would be used, bold and fine, and it was not unknown for the most mundane notices to be set out in more than a dozen

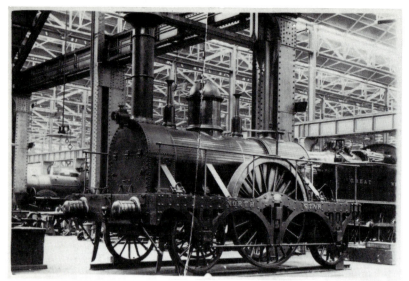

18 One of the earliest Great Western locomotives, *North Star,* is seen here at Swindon Works 30 August 1931. Designed by Daniel Gooch, soon after his appointment as locomotive superintendent in 1837, at the age of twenty-one, this engine was one of two built by R. Stephenson & Co intended for Russia. It was altered to suit the 7ft gauge of the GWR, and its driving wheels were enlarged from 6ft to 7ft diameter. In service until 1870, by which time it had travelled about 430,000 miles, *North Star* was capable of thirty-seven miles an hour. (W. Leslie Good Series) *(Ron Grosvenor)*

typefaces. This lack of real imagination in selling the railway was echoed by the other companies copying each other's ideas. The Great Western Railway, in fact, issued an official instruction in 1884 for this practice to be implemented.

Thanks to the efforts of the masters of lithographic art, such as Jules Chéret and Alphonse Mucha in Europe, and Dudley Hardy and John Hassall (famous for his 'Skegness Is So Bracing' poster, and known as 'The Poster King') in England, the pictorial poster gradually assumed a greater importance in railway advertising during the 1890s. It is not known when the Great Western first started using this advertising medium, but its earliest known poster is preserved in the GWR Museum at Swindon. A superb example, if perhaps a little too ornate, of the lithographer's art, it is dated 'June 15,16,17,18, 1897.', and advertises the Ascot Races and the company's 'Frequent Trains' and 'Four Horse Brakes'. All the Art Nouveau-esque lettering and information is scattered among the foliage around a picture of Windsor Castle and a view of coaches in the traditional Ascot Parade. What a wonderful picture postcard it would have made. It is also one of the earliest known examples of the Company's initials being used in a roundel.

The Great Western Railway went into the 'Road Motor' (omnibus) business on 17 August 1903, using the buses as feeder services to its railway services in outlying village districts. But it was not until October 1904, that the bus service was acknowledged on a sepia collotype picture postcard. The first GWR Road Motor service ran between Helston and the Lizard in Cornwall,

using 30hp Milnes-Daimler buses, carrying twenty-two passengers at a fare of 1s 6d. Between 1905 and 1907 'Advertising Motor Cars' were on the London streets. These were simply GWR buses, not for the conveyance of passengers, but covered with billboards advertising Christmas, Easter and Bank Holiday services. The posters, some pictorial, publicised the Cornish Riviera, 'England's Health Resort', and 'Excursions to Ireland by the New Route Via Fishguard'. The buses carried stocks of travel brochures and handbills for free distribution, but no picture postcards. What a golden opportunity was lost. This is especially true when it is considered that in December 1905, an advertising car travelled 1,665 miles in Scotland; hotel advertisements in the *Holiday Haunts* annual announced 'G.W.R. Motors and other Conveyances Daily'; and in 1908 a GWR bus was driven from Slough to Carlisle, and thence for a tour of Scotland in winter. GWR charabanc tours were conducted in Cardiganshire in 1908, and sightseeing tours of London by road-motor (accompanied by an official guide); between 1910 and 1914 there were also bus tours of the Midlands and the North of England. And not a picture postcard in sight on any of them!

Around 1907-8, the *Great Western Railway Magazine* published two colour supplements featuring reproductions of twelve pictorial posters. Several of these were by Alec Fraser, and were lithographed by Andrew Reid, of Newcastle. The Newquay, Cardiganshire, 'Motor Service From Llandyssil' poster is an absolute gem, featuring in three panels the Newquay beach, a

19 A pleasant example of good industrial design harmonising with nature. Because a design was functional did not mean that it had to be ugly, as can be seen from this graceful arch across the River Severn at Arley. (Great Western Railway Series 1 No 22 Sepia, issued March 1904, printed by Raphael Tuck. This series was issued in four versions.)
(Ron Grosvenor)

coastal seascape and in the centre a picture of the bus, full of passengers, and with a group of people by the roadside, a child being held up to watch the bus go by. What a splendid picture postcard that would have made.

On 12 October 1903, the GWR introduced a steam rail motor service between Stonehouse and Chalford; like the road-motors, the service was intended to provide links between the sparsely-populated branch line areas and the main line routes. Five months later, some three years after its initial enterprise with the issue of the view cards by the Picture Postcard Company, the company once more ventured into the picture postcard world with the issue of twenty-five collotype cards produced by Raphael Tuck. They were available from automatic vending machines on the principal stations, and could be purchased two for one penny unstamped, or one stamped for the same price. They appeared in four editions, which the Great Western numbered in their Postcard List, but the numbers do not appear on the cards themselves. Advance notice of the issue of these cards was given in the January 1904, issue of the *Great Western Railway Magazine,* and in the June issue five of these cards were reproduced. They were well received by the public, the machines at Paddington station needing to be refilled several times each day during the first few weeks of sale. However, the various railway magazines were much more critical of their quality of reproduction, which was considered to be below the normal high standards set by the GWR in other publications. The cards are fairly common, and show scenes,

buildings and locomotives from the early days of the GWR, including famous broad gauge engines.

The criticism of the quality of the Series 1 was perhaps a valid one, but very strange in view of the fact that the publishers were Raphael Tuck. A further set (Series 2) of twenty-five sepia collotype cards was issued in October 1904, and these also received publicity in the October issue of the magazine; nine of them were illustrated in the November issue. Like the first set, they were available from machines, priced one halfpenny each; the set of twenty-five cards could be obtained for just one shilling. Again Tucks produced the cards, which this time were received more favourably.

At about the same time that the Series 1 postcards appeared, the first of the Great Western books was published, and soon became a best-seller on the bookstalls. With the GWR monogram in gold on a white card cover around its 152 pages, it was entitled *The Cornish Riviera*. It was also the first time that the company's own description of Cornwall had appeared in print but, once again, there was not a picture postcard to be seen. Not until July 1908 did the Great Western specifically refer to that part of their territory on postcards. A set of twelve cards, price 6d, were issued, bearing the GWR twin shield coat of arms printed in green, together with the title 'G.W.R. Series 7. The Cornish Riviera'. Most of the Official postcards after this were printed, not in colour, but by photographic or photogravure processes, the most modern available at the time. The lack of colour probably resulted in a decline in sales; many of

these later sets are now quite difficult to find as a result.

Much of the production of the pictorial posters around 1905-10 was from the artwork of Alec Fraser, and from time to time, several of the original paintings were displayed in the Paddington station booking hall. Two very famous posters, which would have made splendid postcards, were produced at this time. One was, to say the least, somewhat exaggerated in its claims; the other was most original. Beneath the legend 'See Your Own Country First' is a remarkable tree, growing peaches on one side and oranges on the other! In front of it, holding maps of their respective countries, are two charming girls in national costume. The map on the left is of Cornwall ('Known To The Romans As The Western Land') complete with GWR routes. The map on the right is of Italy, reduced to the same size as Cornwall, also with its rail routes, and the comparative legend 'Known To The Greeks As The Western Land'. At the bottom of the picture is the legend 'There Is A Great Similarity Between CORNWALL AND ITALY In Shape, Climate & Natural Beauties'. Ingenious, if a trifle far-fetched. Shortly afterwards, on the same theme, the second poster also printed by Andrew Reid, appeared on the hoardings. The legend, top and bottom of the poster, read, 'Another Striking Similarity — Beautiful Britain — Beautiful Brittany' and 'The Great Western Railway Co. Will Take You To Both'. Beneath the names of the countries, two circular panels portray the resemblance between St Michael's Mount and Mont St Michel.

In March 1905 a series of twelve coloured Pictorial Poster Facsimiles was issued, all but one in vertical format, and bearing the title 'G.W. SERIES 3' in the top right-hand corner of the pictures; such picture postcards were also used for internal correspondence. Publicity for these postcards appeared in the April issue of the company magazine in which they commented upon the novelty in selecting the subject, their attractiveness and their charm: 'these postcards will doubtless be much sought by collectors.' Nine of the postcards were reproduced in the May edition of the GW Magazine; these cards are now each valued very highly indeed.

Two more sets of cards were issued in 1905, Series 4 with twenty-five cards printed in photogravure, and Series 5, another twenty-five cards, once more in colour. The Series 4, which can be identified by the words printed in the top left-hand corner of the address side, together with the GWR crest incorporating the coats of arms of London and Bristol, includes two good pictures of locomotives. The 'Cornish Riviera' Express is seen near Dawlish, and a County Class 4-6-0, *County of Devon* No 3478. The Series 5, of coloured views, sold at one shilling per set, includes just one express train, the 'Cornishman', near Box, the site of the famous tunnel.

From the mid-1890s the Great Western Railway had advertised in an annual holiday guide which listed details of hotels and general information about the resorts and beauty spots on its West Country routes. Like most contemporary publications it had a rather cumbersome title, but was successful despite that, and in 1906 the company decided to issue its own book. The title has gone down into railway lore and legend — *Holiday Haunts*. In that issue was an advertisement, 'Artistic Railway Advertising', and it was concerned with the forthcoming exhibition of 'Fine Art Engravings' in the 'Great Western Railway Passenger Carriages'. The pictures were printed on India paper, and then mounted on plate sunk paper.

The advertisement went on to say that these pictures would be 'much appreciated by lovers of fine art work', who could obtain copies ready for framing, at the nominal charge of one shilling each. An illustrated catalogue could be obtained from the General Manager's Office, Paddington, post free, 3d. The so-called 'engravings' were in fact photogravure prints, measuring approximately 8in × 6in on 16in × 12in mounts. The gravure prints were intended to replace the existing collotype and colour prints which already decorated the company's carriages. Some of these photogravure pictures may have been reproduced in the Series 4 gravure postcards of 1905, the date when the art prints were first on sale. In December 1909, a similar production of art engravings was issued. From these pictures small reproductions with details of the engravings for sale were printed on the address side of some correspondence cards; three of these have so far been recorded.

In 1908, a Welsh artist suggested what was to become a famous GWR slogan, 'The Holiday

20 A GWR poster card. The designer of the original poster was Alec Fraser, which, along with several others painted by him, was lithographed by Andrew Reid and Co, of Newcastle-upon-Tyne. The original paintings were placed on display in the Paddington booking hall. About 5,000 8-sheet posters were produced from these paintings. (Great Western Railway, GW Series No 3, 'Pictorial Poster Fac-simile', issued March 1905) *(Ian Wright)*

Line'; it was adopted, and first appeared in that year's issue of *Holiday Haunts*. In July of that year, the Series 6 — Locomotive Series was issued, with the company shield on the address side, but no indication of the publisher's name. There were twelve glossy photographs in the set, priced at one shilling. No new postcards had been issued since 1905, and this eagerly-awaited issue was of special interest to railway enthusiasts, featuring as it did locomotives old and new. Among these was the French-built de Glehn compound No 104, of a type used successfully on the French

Northern Railway, and equally successfully adapted by Churchward, the Great Western's Chief Mechanical Engineer. Also featured was the famous *Evening Star* locomotive.

The company's house journal, *Great Western Railway Magazine*, appointed a new editor in 1909, Felix J.C. Pole, and he was to continue in that capacity until 1919. Two years later, at the age of 44, he was appointed General Manager; unfortunately, his term of office only lasted eight years. By the end of the first year of his editorial appointment, Series 1-4 of the picture postcards were out of print.

Fishguard is nearer by 55 miles than Plymouth and 115 miles nearer than Liverpool from New York, a fact that was not lost upon the directors of the Booth Line and Cunard shipping companies. Soon after the harbour was ready, the great Cunarders took advantage of its quick despatch arrangements. A half-hearted attempt was made in 1908 to publicise the route with the issue of four green collotype cards. They showed one of the GWR steamers, another of the steamer at the dockside, the drawing room and the saloon. These cards were also used, with suitable overprints, as correspondence cards; they are now valued at around £6 each, as are the twenty-four cards of Series 8 which followed later.

The *Mauretania* was the first of the big ships to call at Fishguard, on 30 August 1906; several views of the mighty liner were featured in Series 8. This was a set of collotype cards issued in January 1910, titled 'Fishguard Harbour as a Port of Call'. They were part of the large-scale publicity promotion for this new route to Ireland, and the deep-water facilities of the harbour. Unlike contemporary photographs, they showed nothing of the hard rocky coast which had to be blasted away to make a route for the new tracks replacing the original South Wales Railway broad gauge system.

The Great Western Railway built four turbine ships named after saints — *Andrew, George, Patrick* and *David* — to carry goods and passengers to Rosslare, on the County Wexford coast of Ireland. The ships were not at all like ferries, but were in fact quite handsome and comfortable vessels looking more like miniature ocean liners. However well-appointed these steamers were, or how good the harbour facilities proved to be, was of little avail. The long-

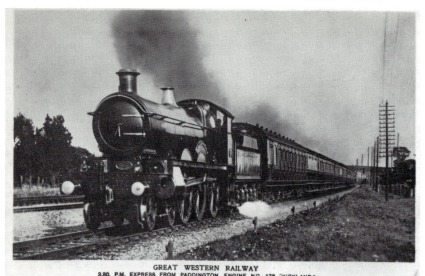

21 A postcard from the GWR locomotive series, showing an early Churchward 4-6-0 heading the 3.30 Paddington express. This type of engine was in use in 1906, and a four-cylinder version, known as the 'Star' class, appeared in 1907. Churchward was influenced in his design by the compounds of the Northern Railway of France; he was CME 1902-22. (Great Western Railway, Series No 6, published July 1908.) *(Ron Grosvenor)*

GREAT WESTERN RAILWAY
3.30. P.M. EXPRESS FROM PADDINGTON. ENGINE NO. 178 "KIRKLAND."

established 'Holyhead Route' operated by the London & North Eastern Railway was too competitive for the GWR, and the much-proclaimed 'Fishguard Route' did not live up to its expectations. The Great Western does not appear to have published any specific series featuring the Fishguard fleet, other than those mentioned. The cards which do feature the ships would most probably have been available to passengers on the Fishguard to Rosslare run.

There is reason to believe that the Series 7, originally published in July 1908, was republished in 1910. *Holiday Haunts* for that year advertised 'glossy coloured reproductions from photographs of Cornish resorts'. The twelve-card set, which was priced at 6d, is now probably the most common GWR postcard issue of all. One card is of particular interest, and features the famous Royal Albert Bridge, Saltash. It was the last bridge to be built by Brunel, and was opened in 1859, just a few months before he died. It is still in use today, carrying loads and traffic of which even he probably never dreamed. It stands as a monument to his genius.

The 1910 issue of *Holiday Haunts* was published at Easter, and announced that the company's pictorial posters which 'have been greatly admired by the public', could be purchased at a nominal charge. As a frontispiece to the annual there was a photogravure picture of locomotive No 4021 *King Edward*, and copies of this could be obtained, size 12in × 10in, printed on art paper, for 2s 6d. The offer highlights how fragmented was the Great Western's advertising. The *King Edward* picture was available through the general

manager's office at Paddington, but prints of other locomotives, rolling stock, signal boxes and other items of railway interest had to be obtained from the Chief Mechanical Engineer at Swindon.

Sometime in 1910, two photographic picture postcards, similar to the Series 6 issue, were published. One was of *The Great Bear* Pacific locomotive, the other, the picture of the *King Edward*. The picture was titled 'Great Western Railway Royal Train, Engine King Edward'. The choice of picture was perhaps a little strange, since it actually showed the funeral train of King Edward VII. Nowhere, except in the *Great Western Railway Magazine* for June 1910, was this fact mentioned. The information quoted the names of the driver and the guard, and gave details of the special decorations used on the locomotive and train.

Again probably in 1910, a further series was issued, Series 9, featuring West Country scenes. The set of twelve photographic cards, which gave no indication of the publisher, were the last picture postcard series to be issued by the Great Western Railway until 1922, the year before the Railway Grouping Act of 1921 came into operation.

Just prior to the opening of the Fishguard Route in 1906, Andrew Reid and Company, of Newcastle, had produced a poster card for the Great Western. It featured a splendid bow view of the *St Patrick* turbine steamer, 'Sea Passage Under 3 Hours'. In 1913, to publicise 'The Cornish Riviera', Reids again produced a poster card; on the border of the picture is the wording, 'Pictorial Poster Fac-simile'. This, and the 1906

42

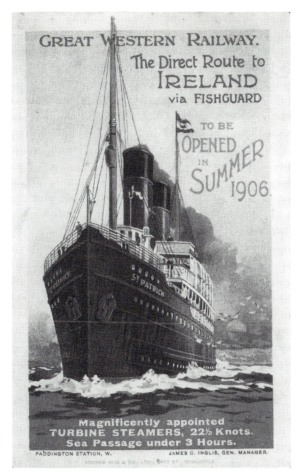

22 Another early GWR poster card. It was widely acknowledged that there were no better boats crossing the home seas than the four turbine Saints of the GWR — *Andrew, George, David* and *Patrick*. Triple-screw turbine steamers, they completed the 54 nautical miles passage in $2\frac{3}{4}$ hours. The vessels resembled small ocean liners rather than ferry boats, and were comfortable and handsome internally and externally. (Great Western Railway official, poster card, published 1905-6, printed by Andrew Reid & Co, Newcastle) *(Ian Wright)*

card, are now valued around £40. Two other poster cards, by the Acme Press, were published circa 1915, which advertised Devon and Cornwall, the latter very similar to that published by Reid. Since wartime railway travel was restricted, so far as the general public were concerned, the issue of these cards seems to have been pointless from a publicity point of view.

During 1913-15 several correspondence cards were issued, the half-tone pictures printed in three editions of green, brown and grey. There are stationery order references which help to determine the date of issue, and these are printed on the address side of the card. The only other significant wartime issue of picture postcards was during 1915-16, when five cards were issued under the general title, 'Continental Ambulance Train — 1915-1916'. The first card features the ambulance train of fifteen coaches, printed half-tone in green, with pictures of the treatment room, kitchen and two of the ward car printed in half-tone pink. Two editions of these cards were issued with appropriate year dates, and a further issue overprinted for use as correspondence cards. After 1915, announcements of picture postcard issues were no longer made in the *Holiday Haunts* annual.

The Great Western Railway produced some good slogans to promote travel, and after the war the advertising department concentrated on getting the public 'back on the rails'. In 1923 the slogan 'Go Great Western' was introduced in a triangular emblem, the words in capital letters; by 1926 the slogan appeared in the form of linked script in a rectangular frame, and was used extensively for the franking of mail. To date no postcard has been recorded with this franking.

In 1922, Series 10, consisting of eight cards of miscellaneous views, was issued. Printed in sepia gravure, and commonly known as 'etchings', the pictures are artist drawn with the wording 'Published by the Great Western Railway' printed in black down the left-hand edge of the address side; Series 11 and 12 had the additional words 'Paddington Station, London, W.2. Felix J.C. Pole, General Manager'.

A combined set of twelve Cornish views and twelve of Devon, printed in photogravure, with a white border, was issued as Series 11, 'The Cornish Riviera & Glorious Devon'. Published in the form of two books, these cards showed various scenic views and buildings to be seen in GWR territory. Each picture was duplicated, the postcard picture being perforated along its top edge, and removal of the postcard left a picture still bound into the souvenir book. The date of issue is generally reckoned to be sometime soon after the grouping in 1923.

It is very probably that Series 12 was issued in 1924 to help publicise the book *Cathedrals*, the title of the gravure set being the same. Indeed, some cards had an advertisement overprint, and were supplied to the book trade. It is not known

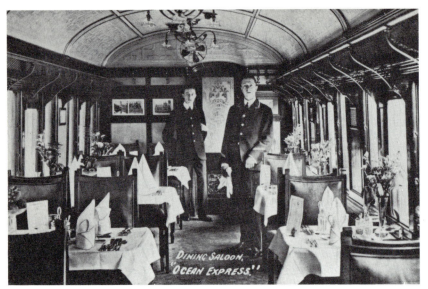

23 Great Western Railway Dining Saloon, 'Ocean Express'. Fishguard Harbour was opened by the GWR in 1906, and became a port of call for transatlantic liners. The first Cunard liner to arrive was the SS *Mauretania* on 30 August 1909, passengers entraining to Paddington on the 'Ocean Express'. A set of twenty-four sepia collotype cards, price 6d, was issued to commemorate the event. (Great Western Railway Series 8 No 2, 'Fishguard Harbour, Port of Call', published January 1910) *(Ian Wright)*

for certain how many cards were in the set, but eighteen have been recorded. A further issue of twenty-four cards (there may have been more) of cathedrals, similar in style to the Series 12, but without any numbering, as made at a later date. Authorities differ about the actual date, which is quoted as ranging from 1925 to the early 1930s. The pictures on the postcards are not the same as those which appear in the book. All but one of the 'Seventy-Four Illustrations by Photographic Reproduction' which appear in the book were photographed by the Great Western Railway Company's staff photographers.

The last issue of a specific series was made sometime between 1922 and 1924 with the 'Dock Series', twelve photographic cards with a white surround, printed by the Autotype Company, London. Although each picture is titled, the address side of the cards carry detailed descriptions, succinct but informative, in the style for which cigarette cards are renowned.

The British Empire Exhibition was staged at Wembley in 1924-5, with the Great Western Railway mounting the largest show in the Palace of Engineering. Two Castle class locomotives were put on display, one of them, 4-6-0 *Pendennis Castle* No 4079, appearing on a postcard available at the stand. Another card available showed GWR locomotives from 1838 to 1923; both cards bore company crests and the name and address of the company on the address side of the card. Apart from these two cards, no special postcards were produced for such an internationally prestigious event, a golden opportunity clearly

lost when it is considered that more than three-quarters of a million people eagerly clambered on to the footplates of these mighty engines. Similar chances were missed at the Schoolboy's Exhibition of 1931; the 1935 Brussels Exposition, the South African Exhibition held at Johannesburg in 1936, and the Empire Exhibition at Glasgow in 1938. At all of these international events the Great Western Railway was well represented. As Roger Burdett Wilson reports in his book *Go Great Western*, 'in 1937 there were no less than thirteen exhibitions at Olympia and the Royal Agricultural Hall alone, where the GWR was represented individually or jointly'. Add to this impressive list the Canadian National Exhibition of 1938, held in Toronto, and the exhibition of the British railways at the New York World's Fair in 1939, and it becomes perplexing as to why such a publicity-conscious company as the GWR did not issue any special postcards. There does not seem to be any categoric record of any of the other officials being available either, and the last advertisement of the issue of such picture postcards appeared in the 1915 *Holiday Haunts*.

Ironically, a picture postcard publicising the new issue of *Holiday Haunts* appeared in 1933. Although in modern collecting terms it is referred to as an advertising postcard (the coloured picture shows a child being carried on the shoulders of his father), the usual words 'POST CARD' were not used, 'PRINTED MATTER' appearing instead. On sale price 6d, the card carried a psuedo hand-written message giving

details about the annual; no company name or publisher's information is shown.

The last set of cards to be issued by the Great Western Railway (eight reproductions of pictures by Leonard Richmond, who also designed artwork for the Southern Railway) appeared sometime in 1938. Whether they were true officials is a little open to question, and certainly they were relegated to secondary status since they were merely to publicise a free booklet, *The Western Land*, about the Penzance area. The printer's name, W.G. Briggs & Co, and address, together with the picture title and an invitation to write for the free booklet, are the only items of information presented on the card.

Occasional picture postcards were published subsequent to the 1923 grouping: a reprint of a Locomotive Publishing Company photograph of the GWR Express 4-6-0 *Caerphilly Castle* No 4073; a restaurant car map card, about 1923; a number of poster reproduction postcards about 1923, as a supplement to Series 3; a poster card of the tropical gardens of Falmouth, produced by John Waddington; and an advertising card for GWR special football train arrangements, about 1926. Further issues included a variety of hotel cards, about 1936, of pictures by Charles H.J. Mayo, who had joined the publicity department of the GWR in 1931. He is best remembered for his dramatic perspective poster picture 'Speed To The West', which is reproduced on the cover of, and as a frontispiece to, *Go Great Western*.

A unique folded coloured postcard issued about 1928 deserves especial mention. The Great Western Railway borrowed an idea from the Great Central Railway, who, in 1904, also produced a unique picture postcard. The picture on the card was of a 4-4-0 locomotive, and could be pressed from its perforated outline; the engine could then be stood on display, the reverse carrying a London to Sheffield timetable for August 1904.

The King Class 4-6-0 locomotive No 6000 *King George V* was sent to America in 1927, taking part in the centenary celebrations of the Baltimore and Ohio Railroad; the engine was presented with an inscribed American locomotive bell which is now mounted just above the buffer beam. The following year, a book by Walter Chapman on the 'Kings' was published; it included a coloured plate of the *King George V*, the

first of the class. A folded postcard, reproducing the picture, was also issued. When folded, one side was printed in standard postcard format, with the two company shields; the other side gave details of the locomotive's American trip, its performance, and a list of the twenty locomotives in the class. Opening the card revealed the coloured picture together with the engine's technical specification.

Apart from the pictorial posters already mentioned, which would have made superb picture postcards, much more of the Great Western's output of pictorial literature of one kind or another could also have been produced commercially as postcards. The pictorial covers of several of these publications are a splendid example of what might have been. The *Camp-Coach Holidays* booklets of the mid-1930s; the *Coronation Tours* booklet of 1937; the *Railway Books For Boys Of All Ages* and the *Engine Names, Numbers, Types, Classes* books; the variety of splendid pictorial luggage labels and bookmarks issued in the 1920s and 1930s, to name but a few. The jigsaw puzzles, produced by Chad Valley Ltd, of Birmingham, were very popular. Two of the pictures, including the 'Cheltenham Flyer speeding across Maidenhead Bridge' and 'Locomotives in the Making', a view inside the Swindon Erecting Shop', are now very much collectors' items. Some of the pictures used for the puzzles were available separately, priced at one shilling but not as picture postcards.

But what is the picture postcard collector to think of the fact that the Great Western Railway, in the late 1920s and throughout the 1930s, loaned series of lantern slides to clubs and individuals. There was no charge for the loan, and as one might expect, the demand was enormous. There were more than one hundred sets made up from around 8,000 slides. And not a picture postcard from the lot! It is perhaps ironic that for these lantern lectures the Great Western also provided free souvenir postcards which carried an overprint advertisement on the back giving details of postcard series available.

It would be wrong to leave the story of the Great Western Railway without mention of an air service inaugurated by the company, of which even the genius of Isambard Kingdom Brunel could not have dreamed. Yet for such a spectacular innovation, the few picture postcards

24 An unusual picture of *King George 11* No 6005, one of the Great Western's celebrated 4-6-0 'King' Class, seen in Swindon, 30 August 1931. The strange contraption at the front of the engine is an observation platform used by engineers during test trials. These interchange trials originated in 1910 between the LNWR and the GWR; the last such trials took place in 1948 between the different types of Big Four engines then owned by the British Transport Commission. After nationalisation No 6005 was shedded at SRD Wolverhampton, Stafford Road. *(Ron Grosvenor)*

which were issued were of private origins.

The service was pioneered by the GWR in April 1931, although for some extraordinary reason it was not advertised in *Holiday Haunts* until 1935. The full-page advertisement was titled 'Railway Air Services', beneath which was a splendid photograph of a de Havilland DH86B 'Diana' Class four-engined biplane. 'If your holiday is going to be a short one . . . why not fly by Railway Air Services?'; the advertisement continued with details of the service, which also operated in LMS territory, the Lancashire coast being only two hours' flight from Croydon Aerodrome. Passengers could complete the return part of their journey by rail or steamer, and take advantage of the special 'Passengers' Luggage in Advance' facilities. 'Travel by Railway Air Services on this year's holiday and get there speedily and in comfort' was the final line.

The GWR Service was established in April 1931, after Parliamentary sanction had been given in 1929 for the 'Big Four' to operate an air service. Prior to the formal establishment of the RAS, the Great Western had undertaken the first flight in a Westland 'Wessex'; the service was operated by the Imperial Airways on a charter basis, and they also loaned the pilot and ground staff. The three-engined high-wing cabin monoplane was specially designed for charter work, and had a cruising speed of around 105mph.

Special arrangements were made for the aeroplane to be painted in the GWR livery of chocolate and cream; the interior was furnished somewhat similar to the style of a first class railway coach.

Incorporated in 1934, the Railway Air Services was formed of the Big Four railway companies and the Imperial Airways; the inaugural flight, carrying mail, starting on 20 August of that year. There were few aerodromes conveniently near to the LNER route, and contemporary records suggest that, until at least 1936, the company was 'not an active participant' in the operational flying services within the framework of the RAS; of course, it took its share of the administration. Eventually the RAS purchased its own fleet of aeroplanes, made up of de Havilland DH84 'Dragons', DH86Bs, and DH89 'Dragon Rapides'. The Railway Air Services offered too good a personal service, which was not economic, by conveying its passengers and all their luggage from aerodrome terminals to their destination for no extra charge. The RAS was eventually taken over by the nationalised British European Airways and the British Overseas Airways Corporation, both of which were combined to become the British Airways.

Unfortunately for the picture postcard collector no official cards were issued of this unique Great Western venture.

The London & North Western Railway

The capitalists' dream of 1823 had to wait ten years before the London & Birmingham Railway received the Royal Assent. On that same day, 6 May 1833, the Grand Junction Railway also received the Royal Assent. By the mid-1840s railway mania was in full spate, and on 16 July 1846, by an Act of Parliament, an amalgamation between these two railways took place. The same Act also sanctioned the take-over of the Manchester & Birmingham Railway, with all three companies incorporated as the London & North Western Railway. Thus was born the 'Premier Line'.

As an experiment, the first travelling post office was manned on 1 July 1837, on the Grand Junction Railway, between Liverpool and Birmingham. The trials were so successful that by 1847 the last mail stagecoach in England had left Newcastle-upon-Tyne for Edinburgh; it was to be another twenty-seven years before the last Scottish mail coaches were run to Thurso with London mail.

The London & North Western Railway was a most progressive company, and as early as 1858 had acquired the steamer services of the Chester & Holyhead Railway. In 1874 the company introduced a considerably improved design of sleeping carriage on the Glasgow 'Limited Mail' express. Dining cars were brought into greater use after the introduction of the corridor coach in 1883. Just after the turn of the century, the LNWR operated the first coach with a typewriting bureau saloon on the Birmingham to London trains. A single card issued sometime in 1905 shows a typist receiving dictation, but whether her secretarial duties were also part of the service is not indicated. The saloon was an extension of their long-established writing room on Euston Station. Another innovation was the introduction of the luncheon basket, first available in March 1876, at Chester. They were principally for the convenience of passengers on the Irish Mail who had to wait while the engine was changed at

Holyhead; the Admiralty Pier, built in 1873, was not strong enough to carry the weight of the express locomotive from Euston.

It was as a result of another LNWR innovation on the same trains that the English language was enriched with one more descriptive phrase — 'breaking the ice', the opening gambit in conversation between strangers. The chief engineer, Francis Webb, introduced his acetate of soda footwarmers in 1880; British railway passengers are notorious for sitting in stony-faced silence with fellow travellers they do not know, and Webb's footwarmers changed that state of affairs. Many railway friendships were formed due to the conversation provoked when porters took the cooled-down containers and shook them (like a cocktail shaker) to re-activate the soda crystals. This broke the 'ice', hence the conversation 'broke the ice' of convention.

In many ways the London & North Western kept abreast of, and sometimes ahead of innovative developments, but by the time of the 1923 grouping it had almost run out of steam. In the realm of the picture postcard however the LNWR, while not by any means the first in the field, outdistanced the others in no uncertain manner. Its first picture postcards were issued in 1904, and between then and the outbreak of World War I in 1914, it had sold nearly 12 million cards.

January 1906, saw the first issue of a set of cards featuring the company's motor vehicles. One such postcard is titled, 'Motor Omnibus Running Between Connah's Quay & Mold, Via Flint & Northop'. Following upon the success of the Great Western Railway's introduction of Road Motor feeder services, the LNWR put omnibuses into service in North Wales, starting in 1911. A London & North Western Railway timetable of motor omnibus services in North Wales, 'and regulations applicable to Road Motor Services, 1911', was discovered in Mold station. It was believed to be the first such service in the district,

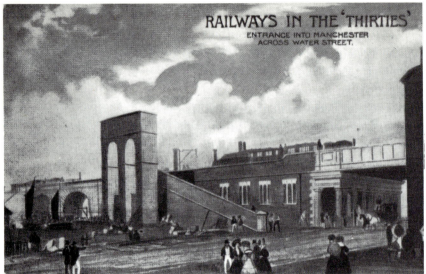

RAILWAYS IN THE 'THIRTIES'
ENTRANCE INTO MANCHESTER
ACROSS WATER STREET.

25 An early LNWR postcard showing an impressive view of the colonnaded arch support of the Water Street Bridge, Manchester. With its distinctive Georgian style, the bridge clearly shows how function was made to take second place to the fashion and style of the era. (London & North Western Railway, Set No 1 reissue, 'Railways in the Thirties', issued October 1906, printed by McCorquodale) *(Mike Clarke)*

so were the locals mistaken in their dates, or was the issue of the postcard premature?

Some of those 'regulations applicable' are worthy of comment. The timetable warns passengers that 'The Company do not undertake that the Motor Omnibuses shall start, or arrive at the Times specified in the Bills'. The conditions waived responsibility for any inconvenience due to delays, and went on to state, 'The omnibuses will stop anywhere to pick up and set down, except on steep hills'. Referring to accidents, the regulations gave quite precise instructions to the driver, 'the car must immediately be brought to a stand', and if a relief car could not be obtained quickly, a 'suitable Motor or horsed vehicles may be hired to carry on the service'.

Along with the instructions for the driver of the motor omnibus there were some for the conductor, which are curious to modern eyes. The conductor was required to clean the interior of the car polish the brass and other metalwork, and help to clean and adjust the acetylene headlamps. He also had to carry a duster and small brush in the ticket box, and clean the vehicles at frequent intervals during the day. 'During the summer months, care must be taken to keep the seats free of dust.' Drivers were required to stop the cars, 'and if necessary the engine', if horses appeared to be frightened; the conductors were warned that they had to go to the head of any restive horse 'and lead it past the car if necessary'.

Early in 1904 the London & North Western issued its first set of picture postcards, a twelve-card set of sepia collotypes, printed by Raphael

Tuck and Sons, and intended for free distribution at the St Louis Exposition of the same year. These cards can easily be identified by the title 'St. Louis Exposition 1904' down the left-hand edge of the address side, and American postage rates printed in the stamp rectangle. This first edition was evidently very popular, and continued to be so, because two further editions were issued, printed in grey or blue. It is considered by some authorities that the blue printing came first, as did the blue issues of the GWR Series 1. Three single cards were also issued, each bearing the title of the Exposition, but not all printings of these have postage rates in the stamp rectangle. The original issue had undivided backs, conforming with standard practice in America, but some cards of the original twelve and the three singles may have been issued at a later date for the British market. Two of the three singles are coloured, and show respectively, 'Old and New Passenger Trains 1837 & 1904' and 'Old and New Goods Trains 1837 & 1904'.

The demand on the British market for copies of the St Louis cards probably accounts for the different printings of them. Commenting in the *Railway Magazine* on the issue of the LNWR picture postcards which were intended to help promote tourism in Britain via the company's system, a staff writer said, 'Everyone knows that in America the railways make a study of this branch of advertising'. The same point was taken up more than twenty years later by Sir Felix J.C. Pole, General Manager of the Great Western Railway.

The London & North Western were not slow

In this picture by F. Moore of the interior of the Great Northern, Piccadilly & Brompton Railway car shed, part of the important overhaul and maintenance operation can be seen. The overhaul work was divided into five sections, and the cars were completely dismantled, the various units repaired in specialist shops, the car reassembled and taken to sidings to await return to service. (Published by GNPB, December, 1906; printed by Locomotive Publishing Co) *(Patrick B. Whitehouse)*

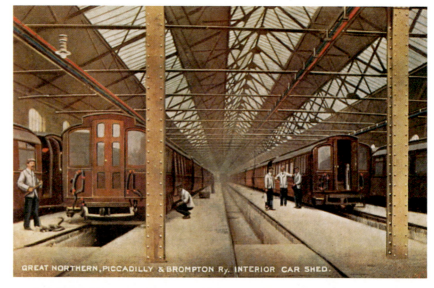

GREAT NORTHERN, PICCADILLY & BROMPTON Ry. INTERIOR CAR SHED.

An artist-drawn picture of the Moorgate Street Station on the Metropolitan Railway. Standing in Moorfields, close to the City centre, were four stations on the underground network; they were the Metropolitan, the Great Northern, the City & South London, and the Great Northern & City. At the time this card was published, the Great Northern (GNPB) had not changed over to electric traction. (Raphael Tuck, London Railway Stations Series II, Postcard 9383 Oilette, published 1907) *(Patrick B. Whitehouse)*

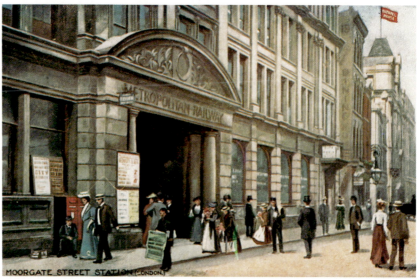

MOORGATE STREET STATION (LONDON).

The unknown artist of this picture has accurately captured the busy scene inside Waverley Station, Edinburgh. On the East Coast Route, proudly advertised as the 'Shortest and Quickest between England and Scotland', it covered an area of twenty-three acres, with nineteen platform lines handling over 600 trains every day. It took eight years to build at a cost of nearly £1½ million. *(Ian Wright)*

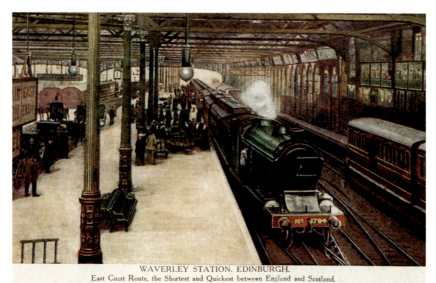

WAVERLEY STATION, EDINBURGH.
East Coast Route, the Shortest and Quickest between England and Scotland.

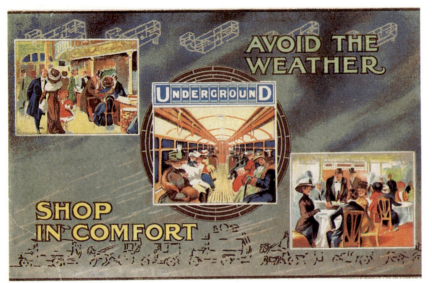

Not strictly speaking a postcard, although probably also issued as one, this colourful trade card advertised some of the many conveniences of the Underground. It has never before been recorded, although the Underground issued several poster-type cards such as this with full advertising backs. It can be fairly closely dated since the central vignette bears the word 'UNDERGROUND' in the typeface designed by Edward Johnston in 1915; the reverse of the card carries a route map of the Underground. The diagrammatic map of the system was first designed by Henry Beck in 1933; the map in use today was designed for the London Transport Executive by Paul E. Garbutt. *(Ron Grosvenor)*

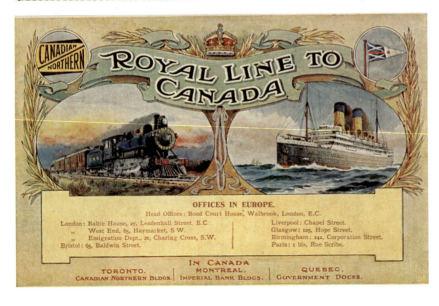

It is well known by postcard collectors that cards can be justifiably placed in several categories. At first sight, this Washington, Baltimore & Annapolis Electric Railroad Company advertisement card seems uncomplicated. However, the small print on the face shows it to be a political souvenir for the Democratic Convention of 25 June 1912. The caption on the reverse puts it in the naval category. The visitor is advised before going home to 'visit Ancient Annapolis and the Famous U.S. Naval Academy ... the greatest naval school in the world.' (WB& AERC official)

Canadian Northern Royal Line. The railway company was part of the Grand Trunk Railway, which opened various sections of track between 1853 and 1858. The train, as illustrated, was a standard 4-6-0, hauling a baggage car, several day coaches, dining, parlour, and sleeping cars on the 'International Limited' daily from Montreal to Chicago. The steamer shown was a turbine triple-screw Royal Mail ship of 12,000 tons, of which the CNRL had two, named *Royal George* and *Royal Edward*. (Canadian Northern Royal Line Official, about 1910)

off the mark in taking advantage of the popularity of the exposition cards. By August 1904, twelve six-card sets were issued, priced at 2d per set. The issue was revised in September, 1904, with the issue of two supplementary sets, 'Places of Interest' (Additional Set) No 7A, and No 10A, an additional set of locomotives to the previously issued 'Famous Locomotives'. These fourteen sets all had the famous Tuck's 'palette and easel' motif as well as that of the LNWR's 'Britannia'. A set of five cards, bearing only the Tuck motif in the stamp rectangle, is recorded by Messrs Alsop, Hilton and Wright in their *Railway Official Postcard List No 19*. The pictures appear in Sets 1-12 and the two supplementary sets, but apparently pre-date them. A postally used (3 June, 1904) edition of the 'Old and New Passenger Trains' card from the St Louis Exposition set, and sent by a senior LNWR officer, is recorded; it is thought to belong to this five-card set.

During the first three months that Sets 1-12 were on sale some 877,000 cards had been bought by collectors and others, more than 330,000 being sold in the first month. Most of these sets appear in two main versions, distinguished by the different sizes of the stamp rectangle. Other variations occur in the typefaces used for the captions, the size and position of the LNWR Britannia motif, and some brown or blue printings which have been recorded of several cards in these sets. There appears to be some doubt as to the number of such cards and the date of their issue.

Probably in October 1904, eight hotel cards were issued, printed in collotype by Tucks, and selected from twelve or thirteen similar cards produced by them. The LNWR 'Britannia' roundel has the words changed to read 'London & North Western Railway — Company's Hotels'. One of the cards in the set, for the Park Hotel, Preston, was issued jointly with the Lancashire & Yorkshire Railway, and the roundel is appropriately worded. Three variations of the Euston Hotel card are known, and have a pinkish tint, the address side being of Continental standard. It is thought that, although these cards carry the company seal, they are predominantly a Raphael Tuck & Sons production, and may well have been that firm's own issue.

A further four odd cards, not presented as a set, were issued, but for no specifically-recorded reason. The pictures are similar to those in the previously-issued sets, but in a different format. The picture of Queen Adelaide's saloon has a much smaller LNWR seal; Carlingford Lough is as that in Set 7A, but with the title printed sideways at the right-hand edge; the Riverside landing stage, Liverpool, is also as Set 7A but printed vertically; and the untitled coal wagon card is also known without a postcard back. John (Reginald) Silvester records the appearance of several Tuck's cards, different from the standard issue, and suggests, 'More likely the cards were used in the L. & N.W.R. Paris Agency at 30, Boulevard Des Italiens.' These cards originate from Series 7 and 7A, and are fairly common.

The Britannia motif or roundel was adapted from the seal of the Liverpool & Manchester Railway, and four variations, apart from the size, are recorded on the Tuck's postcards. In November, 1904, the railway company ceased to employ Raphael Tuck & Sons as printers, and turned instead to the Glasgow and London firm of printers McCorquodale and Company Ltd. Fom then on, until 1907, with the advent of the ornate crest, popularly referred to as the 'Cauliflower' crest, the design of the seal was standardised. The name of the new printer was not added to the cards until sometime between May and December 1905.

There is no recorded reason for the apparently abrupt dismissal of Tuck's services, and over the years many theories have been suggested. One of these is that the standard of printing was unsatisfactory, and this can be verified by even the most casual scrutiny of some of the sets. For fine art printers with the Royal Warrant, this is very strange, although the quality of some of their own publications is inferior. To be fair to Raphael Tuck & Sons, one has to admit that some of the McCorquodale printings leave a lot to be desired, especially some coloured view-card sets of lakes in North Wales, the Lake District, Scotland and the Emerald Isle. Probably the most generous, and certainly plausible reason is offered by John (Reginald) Silvester, that possibly 'the Tuck Company were unable to take on the work of producing the additional sets of cards the L.N.W. required'.

The new issues of cards printed by McCorquodale had the words 'L. & N.W.R. REVISED SERIES NOV. 1904' printed in the stamp rectangle. All of

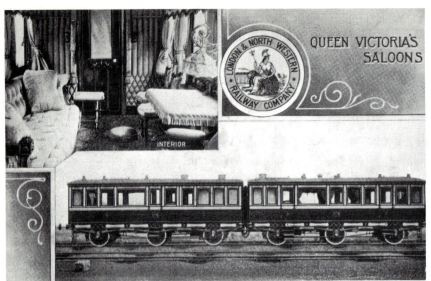

26 These views of Queen Victoria's coaches show how little the basic design had changed since the second GWR royal saloon of 1848. It was virtually two extended versions linked across a central bogie. A lookout in the locomotive tender had to watch for special dial-and-lever signals given by an officer in the saloon. (London & North Western Railway, Revised Series No 4, issued November 1904) (Peter Woolway)

the seven coloured cards by Tuck's from the original fourteen sets were kept by the company, and were available for sale along with the new issues. In the main, those first sets were reprinted by McCorquodale using updated material, and in some instances, completely new pictures. The first McCorquodale set changed only one picture, with George Stephenson shown full length against a view of Tring Cutting. A reissue of these and other sets was made sometime late in 1906 or early 1907, and the reproduction was considerably inferior to those produced by Raphael Tuck & Sons.

During November and December 1904, the LNWR issued fourteen sets by McCorquodale, with variations or replacements of the Tuck cards. Some of these changes were merely from the vertical to the horizontal or vice versa, and these sets themselves were reissued two or three times up to January 1906. Details of all the printing variations and publication dates are listed in *Official Railway Postcards of the British Isles. Part One*; similar information is contained in *Railway Official Postcard List No.19*.

Commencing in January, 1905, an additional series, sets 15 to 28, printed by McCorquodale, was issued by the LNWR, and have the words 'L. & N.W.R. ADDITIONAL SERIES JAN 1905' in the stamp rectangle. Set No 15 features six half-tone views of the famous Bourne lithographs of the London & Birmingham Railway; these pictures are similar in style to those which he drew of the Great Western Railway. There were some variations in the presentation of these sets, which ranged from locomotives and tunnels to

stations, road vehicles and old and new steamships. So popular were these cards that in the first three months $1\frac{1}{2}$ million had been sold; by the end of April that figure had risen to $2\frac{1}{4}$ million.

Set No 28, 'Old Railway Prints', saw the end of the plain or half-tone McCorquodale cards, and with a few exceptions all further issues by the LNWR were coloured cards. This last set appeared in only one edition, and the 'Additional Series' wording was no longer used. The pictures in this last set of six cards were, with one exception, reproductions of Bourne or Ackermann lithographs. With the issue in May 1905, of the first four colour sets, 29 to 32, the Glasgow printers stepped out of the shadow of Raphael Tuck & Sons.

For a while, however, that shadow remained; between January and December 1905, several McCorquodale sets (some of which included the earlier Tuck's pictures) were reprinted in response to popular demand. These reprints very conveniently quote their dates of reissue, eg 'March 1905', 'April 1905', printed in the stamp rectangle. With no end to the demand, by the end of December 1905, sales of all series had rocketed in excess of $3\frac{1}{2}$ million postcards.

Until August 1905, the London & North Western Railway issued the first four sets of McCorquodale's coloured cards, with a fifth set, No 33 'LNWR Steamships', probably issued about October of that year. This set is notable for several reasons; unlike its predecessors, the colouring was natural; the Britannia motif was accompanied by the company's red and white

27 From the very first days of railways in Britain, goods traffic was a specialised service. The advent of railways led many people to believe that the days of the horse were over, but many of the companies, by 1910, had more than 5,000 carefully chosen animals. At the time of grouping there were nearly 15,000 horse-drawn vehicles on the road, many of them being used until about 1950. (London & North Western Railway, Set No 27, issued January 1905, printed by McCorquodale)

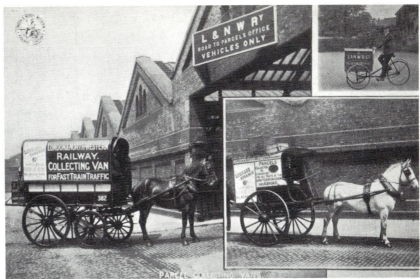

shipping pennant; the set contained the unusual number of seven cards. There were many more complex differences, which only serve to highlight the difficulties presented to John Silvester, and Messrs Alsop, Hilton and Wright in preparing the documentation of these cards for their respective publications. Many of the reissued sets appeared in up to eight editions, with the LNWR logo, printer's name, series titles and descriptions, and other information being varied and/or printed on one or both sides of the postcards seemingly at random.

In January 1906, three further sets of cards were issued, but for some unexplained reason, they were plain cards; it is generally supposed that the sets had been prepared before the coloured cards and were issued late. These three sets appeared in two editions, one printed in a green half-tone, the second in brown, at the first publication. Sometime between October, 1906 and January 1907, by which time the sales figures were nearing $5\frac{1}{2}$ million, the first thirty-six series by McCorquodale were reissued. The original set 34, Miscellaneous Views (plain), was substituted by another Set 34, Snowdon District (coloured); three of the original pictures were taken out and replaced with new views. One of the new coloured cards shows 'Snowdon Mountain Railway Train', and was a coloured version of a plain card which had appeared in the dated (Nov 1905) issue of Set 14. The coloured set of Snowdon District was issued three times, with sales figures of '$5\frac{1}{2}$ Million', '9 Million' and '10 Million' appearing in the stamp rectangle.

For the first time, in Set 35 Motor Vehicles, the LNWR advertised some of its other services. All the railway companies had been quick to seize upon the motor vehicle as an aid in the transport of passengers and goods. Pictured in this set is the steam rail motor car which operated between Prestatyn and Dyserth, North Wales. These steam railcars were an ingenious idea which never became popular with operating staff, and were eventually abandoned in favour of the more conventional steam locomotive and train. Until the 1920s their design had not changed significantly from when they were introduced nearly fifty years previously; they were an ungainly marriage between a conventional four-wheeled steam engine and a saloon carriage mounted on an extended underframe. Servicing the steam engine in the locomotive shed presented maintenance difficulties for the carriage staff.

Several types of steam lorries and buses were already successfully running on the roads, principal among these being vehicles of the Sentinel Steam Wagon Company. Cammell Laird and Company, at their Railway Carriage and Wagon Works, Nottingham, had a chief draughtsman, Hubert M. Taylor, who had been a rolling stock designer with the Societe Nationale Chemin de Fer (SNCF) of France. He had the idea of combining the vertical Sentinel boiler in a specially-designed passenger coach to provide an economical means of handling traffic on branch lines at all times, and on main lines during off-peak hours. The result was the Sentinel-Cammell steam rail coach which was first exhibited at the British Empire Exhibition at Wembley in 1924. The Sentinel-Cammell

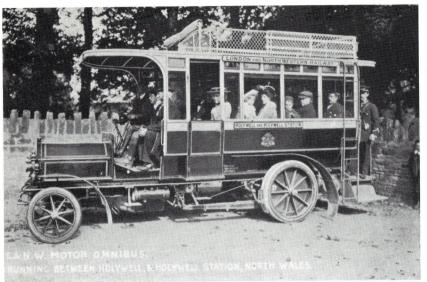

28 The London & North Western Railway were among the earliest companies to follow the lead of the GWR in using motor omnibuses as an aid to transport. Its first service started in 1904, and was quickly followed by many routes used as 'feeder' services. Immediately after 1918 there was strong competition between the railways and omnibus companies; in 1928 several Acts of Parliament empowered the Big Four to operate their own omnibuses and to hold shares in the road companies. (London & North Western Railway, Set 35 'Motor Vehicles', issued January 1906, printed by McCorquodale)

combined high efficiency with low operating costs. Tests under actual working conditions, and including drivers' wages, maintenance, and depreciation, showed that operating costs were as low as fivepence per train-mile. It was exported around the world, and by 1934 the LNER had a fleet of ninety steam railcars developed from the original. It was not popular with the other British railways, despite its obvious economies, the chief reason being that the conventional locomotive and carriage system was more flexible, each remaining separate units. Unfortunately, the Sentinel-Cammell, and steam railcars generally, did not manage to establish themselves. The LNWR Set 35 is one of the few such records of their existence.

In that same set are three cards, one of the Connah's Quay motor omnibus, one of the Holywell to Holywell Station motor omnibus, and a steam goods lorry operating in the same district. These cards are recorded as being issued as singles in November 1905, before their issue as part of the set. There is also reason to believe that they may have been reissued again in December 1905. The second issue of Set 35 carried the advertisement slogan on the reverse, 'The London & North Western Railway is noted for Punctuality, Speed, Smooth Riding, Dustless Tracks, Safety and Comfort, and is the Oldest Established Firm in the Railway Passenger Business'. Around May or June 1906, the sales of postcards had risen to $4\frac{1}{2}$ million, and a further four sets, the 'New Series', were announced.

With the issue in July 1906 of these new sets, colour was brought back again, and a standard form of wording used in the stamp rectangle. It read, 'The L.N.W.R. Series of Pictorial Postcards. 2d per set of six different cards. Over $4\frac{1}{2}$ millions sold.' Until the very end of publication, the beginning of World War I in 1914, the only change was to the sales figure.

The first of these sets, No 37, was of Stratford-on-Avon, and was issued four times, the sales figure reading $4\frac{1}{2}$, 5, 6 and 10 million on successive editions. The 10 million figure was reached in about March 1911, and the cards carried extra details of 'Cheap day Rail and Motor Car Excursions' leaving Euston for Stratford. Set 38 of Central Wales was published in four editions, the last sometime in December 1908. The Lake Windermere set, No 39, ran to five editions, the last appearing in September 1914. The fourth set, of Killarney Lakes, was published in four editions, with the 'Cauliflower' crest appearing on the last two, when the sales figures were $8\frac{1}{2}$ and 10 millions respectively.

As if suddenly remembering their earlier issue of cards showing steamships, the LNWR decided to publish four more sets designed to promote the use of the Holyhead to Dublin route and holidays in Ireland. There was a very real need for such promotion with regular long-distance non-stop runs becoming a growing feature of 1906 railway travel. As if that were not enough competition, the Great Western Railway, who headed the 'league table' of such runs (Paddington to Plymouth, $225\frac{3}{4}$ miles), announced that for the summer traffic of 1907 they were building ten new four-cylinder 4-6-0 express passenger locomotives, the class to be named after the old

broad-gauge 'Star' Class which had run in the 1840s.

As events turned out, the GWR established a record for the longest day excursion, a total distance of 958 miles. On the evening of 16 September 1907, the Great Western engine *Ophir*, specially renamed *Killarney* for the trip, ran from Paddington to Fishguard (261 miles) for a 'day excursion' to the Killarney Lakes. No speed record was made, and the LNWR had already exceeded the distance in this country with its London to Carlisle (299¼ miles) and London to Holyhead (264 miles) runs.

Although one of the constituent companies of the Great Central Railway, the Manchester, Sheffield & Lincolnshire Railway, had been the first railway company to own a steamship in (1846), the London & North Western Railway owned the largest number of ships. In 1910 the company owned fifteen screw ships with an approximate gross tonnage of 20,100. The Anglesey port of Holyhead was one of the major gateways to Great Britain, ranking second only to Dover, and owed its inception to the Chester and Holyhead Railway, which owned steamships before becoming part of the London & North Western. With American liners disembarking their passengers at Holyhead instead of the more prestigious port of Liverpool, the LNWR was anxious to publicise its port and the handling facilities for luggage, goods and the mails. This is reflected in two cards of Set 42 which show passengers embarking for Dublin, and a scene in Holyhead Station, 'Fast Transfer, Train and Steamer'.

The first of the four Irish sets seems to have been issued in three editions between October and December 1906, by which time sales had risen to six million. The second set, No 42, 'To Ireland Via Holyhead', was issued in three, possibly four editions, the last in March 1911, when ten million cards had been sold; the set carries the Cauliflower crest. Set 43, 'The Garden of Ireland' ran to four editions, while Set 44, 'Dublin and Holyhead', showing internal as well as external pictures of the steamers and a view of Holyhead Station, was issued at least three times, possibly four.

Between October and December 1906, sales of picture postcards had increased by a further half million, bringing the total at the end of the year

to 6 million, or more than 6,800 cards per day since the first Tuck's issue in August 1904. Sometime at the end of 1906, or probably in January 1907, an attempt was begun to reissue the first thirty-six sets of McCorquodale cards. Changes were made to fourteen of these sets, partly to update some of the contents in response to sales demands, and also to introduce colour into these earlier plain issues. At the same time, a further four sets were issued, the first of which was 'How Royalty Travel By Train'; it was only published once.

The last Emperor Napoleon had a sumptuous royal train which included its own wine-cellar and conservatory. It was later bought by the Czar of Russia, who increased its complement to fifteen coaches, including the Czarina's boudoir, and made it virtually a palace on wheels. Emperor Franz Josef of Austria was presented in 1891 with a magnificently-decorated eight-car train, and in India, in the trains of the many potentates, ostentation knew no bounds. In Great Britain, however, the Royal Family have never owned a private train, but the major railway companies, on their own account, built specially-designed saloons for the sovereign.

The London & North Western Railway, as well as being known as the Premier Line, was also referred to as the Royal Line; on their frequent journeys to Balmoral both Queen Victoria and King Edward VII made use of the company's coaches. A special saloon was provided in 1869, its floors heavily carpeted, and its sides and roof padded with quilted silk, to deaden noise and vibration. In 1902, the LNWR built two handsome coaches for King Edward and Queen Alexandra, adapted from the company's basic dining and sleeping carriages. The finest mahogany, ebony and rosewood were used in their construction, and they were upholstered with leather, silks and satins. Much of the interior metalwork was silver-plated, and on the exterior of the coaches, handles and rails were gilded. Externally, the coaches were painted in the London & North Western livery of chocolate and white, with the waist panels emblazoned with the Royal Arms; overall, the paintwork was given a superfine polish and a shellac finish.

The Royal Train set was, strangely, not very popular; it was followed by a six card set of the 'City of Dublin', which ran to three editions, the

last being in 1911. The set marked the end of the Irish issues. December 1906 saw the last of the four sets, Nos 45 to 48, being issued, the last being a six-card set with views of Buxton; its second edition was published in 1911.

During the next twelve months, sales steadied somewhat, rising to a total of 7 million. Whether this was due to a fall in demand, or the fact that 1907 saw only six sets issued, is debatable. An updated set of 'Locomotive Types' was issued, eventually being published in three editions, the last appearing in December 1908. It was followed by what John Silvester describes as 'one of the most interesting issued by the Company and was unique among Official cards'. The six-card set was entitled 'The Birmingham Express', and might be seen as an extension of the idea of the Great Central's 'stand-up' perforated card of 1904, and the later issue by the Great Western Railway of the folded card in 1928. It was issued sometime in December 1907, when sales had almost reached 7 million. This unique set was a composite, each of the cards a picture in its own right, but the cards were joined together con-certina fashion to present a complete side view of the 'Birmingham Express'. The cards were coloured, and each carried a plain inset picture showing the interior of the carriages or a front view of the locomotive. Each card was printed with an advertisement for the London to Birmingham Service, emphasising that the two cities were only two hours apart, and that 'Breakfast, Luncheon and Dining Cars' were available on each of the four daily trains. Only one edition was ever printed, probably around 250,000 cards, but for today's collectors a complete, unbroken set is very rare, and even single cards from the set are quite scarce.

The first card in this unique composite set was the four-coupled express passenger locomotive, *Precursor*. When, in June 1903, Francis Webb relinquished the post of Chief Mechanical Engineer at Crewe, he was succeeded by George Whale, who had been the Running Super-intendent. In less than twelve months, Whale had designed and built the first of a new class of engine; the 4-4-0 No 513 *Precursor* carried the Crewe works plate dated March 1904. In that same month two locomotives of the new class were completed, 1395 *Harbinger*, and 1419 *Tamerlane*.

There was nothing particularly unusual or new in the basic design; it was, in fact, nothing more than an improved arrangement of well-tried features. *Precursor* was described as 'a thoroughly standard North Western job', words which did less than justice to a very handsome and attractive-looking class. During trials, held on 27 March 1904, locomotive No 513 hauled a train of some 412 tons from Crewe to Rugby at an average speed of 52mph. This was later increased to 56.9mph, with a top speed of 67mph just south of Lichfield. On the return journey the average speed was raised to nearly 60mph, with a flat-out speed of 75mph coming down Whitmore Bank, near Betley.

The last three sets in the 1907 issue were of holiday resorts in Warwick, Kent and 'South Coast Watering Places'. All the cards in these sets had advertising slogans appropriate to the area, giving information about cheap day excursions and coach drives. Both the Kent and South Coast sets were issued twice, the last being around December 1908, by which time the sales figure had risen to the astonishing figure of 9 million cards.

In the early days of the railways the carriages, even for the first class passengers, were relatively crude and uncomfortable. Not until the 1870s did any significant change take place, so that all passengers, regardless of class, could enjoy some degree of comfort. Around 1874, the Midland Railway introduced the Pullman-style coaches from America, where the long transcontinental journeys made it imperative that sleeping and dining accommodation be available to the traveller. Similar facilities were required by the British traveller on the long-distance runs, but the railway companies, particularly those like the London & North Western, who dealt directly with the increasing transatlantic traffic, realised that their American passengers would expect the highest standards of comfort. Radical changes of carriage design quickly followed, matched by speedier train services between the ports and London.

The result, with the LNWR, was the American Special, a non-stop train running between Euston and the Riverside Station, Liverpool, to connect with the transatlantic liners. A similar service was operated to London to enable the disembarked American tourists to reach the

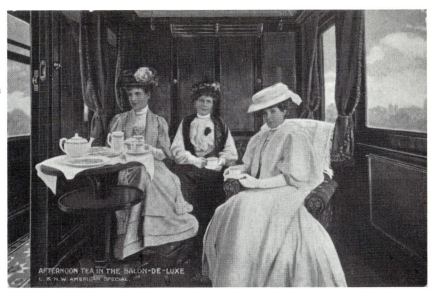

29 Afternoon tea on the LNWR 'American Special' during the closing years of the Edwardian era. The high standard of comfort demanded by the Edwardians was very evident in these salons-de-luxe. Boat-train specials ran non-stop between Euston and the Riverside Station, Liverpool (taking 5hr 15min) to connect with the Atlantic liners. (London & North Western Railway, Set 55 'The American Special', published May 1908, printed by McCorquodale)

capital as quickly as possible. Sometime between March and May 1908, a seven-card issue was made (Set 55) illustrating the company's rolling stock on this train; the compartment and dining saloon cards show the standard of comfort which the Edwardian railway traveller took for granted. The set, which was issued twice, when 8 million and 9¼ million cards had been sold, carried an advertisement promoting the 'Special' service.

The year 1909 saw the beginning of the end, with the announcement that Sets 56 to 60 would be published. No more new sets of postcards were issued thereafter. Three of these last sets were of Scottish scenes, one of the now very collectable Scotch Express, and the last, a six-card set of the Isle of Man. All five sets were issued twice, that of the express (Set 57) being issued for the second time about September 1914, by which time sales had soared to 11 million.

The Scotch Express set depicted interior carriage views on five cards, the sixth card, on the first issue, being 'The L. & N.W.R. Scotch Express at Full Speed', hauled by a locomotive often mistakenly referred to as being of the 'Prince' class. On its second issue the card was replaced by one showing a picture of the Scotch Express being hauled by the first of the new 4-6-0 'Claughton' class, *Sir Gilbert Claughton*.

On the first issue, published sometime around April 1909, (the set, No 57, may have been printed sometime between December 1908 and April 1909), the locomotive shown is in fact one of the George Whale superheated 'Experiment' class. In its non-superheated version it had first been built at Crewe in April 1905. The super-

heated series underwent extensive trials, and sixty were ordered into production in the autumn of 1908; George Whale retired at the end of the year. He was succeeded by C.J. Bowen-Cooke, who had been based at Rugby as Running Superintendent (Southern Division), and who confirmed the order for the Experiments. The first of these was locomotive No 322 *Adriatic*, built at Crewe in December 1908; the new series (to quote O.S. Nock) 'became widely appreciated as a general service passenger engine'.

There was a delay in the production of the 'Claughton' class due to some design modification concerned with the weight, and the superheated 'Experiments' probably, and conveniently, filled a gap in the LNWR development programme. The first ten engines were built according to schedule, but the remaining fifty of Whale's original order were not commenced until October 1913. The first 4-6-0 *Prince of Wales*, locomotive No 819, rolled from the Crewe works in October 1911. She was photographed in what was known as 'photographic grey'. This was a practice with all the railway companies at this time when taking the first photographs of new engines in the works' sidings, all the livery markings being painted in dark grey and white to give extra definition in reproduction as a black and white photograph.

The picture as reproduced in Set 57 is of the 2pm 'West Coast Corridor' express photographed near Denbigh Hall, Bletchley; the engine is No 1987, *Glendower*, 'the show-piece of the entire line'. To quote O.S. Nock, 'to see that engine turned out for the "Corridor" was to appreciate

the full dignity and majesty of a black engine, and just what the term "Premier Line" meant in that spacious decade.'

To give extra interest to the picture on this card of the first issue, it appears to be a photographic and artist's retouched composite! The same picture, apparently taken by an official LNWR photographer, appears in *Our Home Railways* Vol I by W.J. Gordon (Frederick Warne & Co, 1910), *The Railways of the World* by Ernest Protheroe (George Routledge & Sons Ltd, about 1911), and also *The LNWR Precursor Family* by O.S. Nock (David and Charles, 1966). Detailed examination of the four pictures show that the locomotive is the same, with all the sunlight and shadows and reflections corresponding. The fireman leans nonchalantly from the cab-side, against the background of a mountain of coal awaiting his attentions in the tender. The train passes between a 'guard of honour' of signal gantries and telegraph poles; in the foreground is a grassy bank with wild flowers, and in the distance trees complete the scene. A slight haze of steam fades the left-hand signal gantry on the 1910 and 1911 pictures, but the signal arms remain visible. On the picture reproduced in 1966 that hazy steam has obscured most of the standard and gantry, leaving only the topmost arm visible. On the card, however, all of the standard, gantry, and signal arms are clearly seen, while a blast of artist-brushed 'smoke' manages to fade away before it reaches the signal. It is on the rake of coaches where the real differences occur. The card and the two earlier pictures correspond, but the 1966 picture shows the two leading coaches as LNWR 'Radials', one being a composite luggage and passenger vehicle. These have been replaced with a later design of a twelve-wheel bogie coach, the rest of the rake being modified to suit, and the carriage roofs blended into uniformity. Clearly, the picture which is reproduced later is the one from which the picture postcard was prepared in 1909, the resultant picture being used as the illustration in the 1910 and 1911 books.

This intriguing set No 57 is very collectable, being produced in relatively small numbers, and therefore scarce. But its real attraction is the replacement card of the 'Claughton' which is very scarce. In the following series of 'Watering Places on the Clyde', with its second issue in March 1911, the picture card of Dumbarton Rock was replaced by one showing Saltcoats and Ardrossan Beach; that too, is a scarce card very much in demand. It is strange how these replacement cards seem to be the scarcest of all.

The issue of picture postcards by the London & North Western Railway between April 1904 and September 1914 produces some interesting statistics, some of which John Silvester lists in the introduction to his book. During that period the company sold more than 3,130 cards every day, at a total price of more than £6 10s at a time when the average weekly wage was well below £2. Raphael Tuck & Sons produced more than 130 cards in sets and replacements, while McCorquodale produced in excess of 870 in the same way; in addition to these, together they produced well over 100 singles, advertising, and trade cards for different ventures. All told, the LNWR issues, according to John Silvester, ran to 'about 700 different subjects and nearly 1,500 variations.' These totals are confirmed in the *Railway Official Postcard List No. 19* by Alsop, Hilton and Wright.

The difficulties experienced by these authors when originally compiling their respective works, and postcard-collecting railway enthusiasts seeking elusive cards for their collections, can be gauged from the fact that although the LNWR documented their issues well, their methods left a lot to be desired. Lists were announced in the company's own proliferation of brochures, guide books and other literature, as well as in the railway press, particularly the *Railway Magazine*. At first sight, that seems reasonable enough, but when the LNWR used their stock phrase 'now ready' it did not always mean what it said. Such announcements were often well in advance of the actual issue, and the titles quoted in these lists did not always agree with those actually used on the picture postcards themselves.

In addition to the sixty sets and the reissued thirty-six sets, McCorquodale also produced more than 100 non-set cards. These can be listed into twelve or thirteen categories, with six subsections. For reasons which cannot now be verified, these non-set cards are very difficult to find; it is perhaps also significant that after 1910 the postcard collecting craze began to decline. Nonetheless, some undocumented cards do occasionally crop up to delight the collector.

A brief description of some of the cards in these

30 The North Western Hotel, Greenore, was advertised in conjunction with the sea-fishing facilities at Carlingford Lough, a 'Unique Winter & Spring Resort.' Set in attractive mountain scenery, the hotel had an excellent 18-hole 'GOLF COURSE and STEAMER' the use of which was free to the hotel's visitors. (London & North Western Railway, about May 1909, printed by McCorquodale)

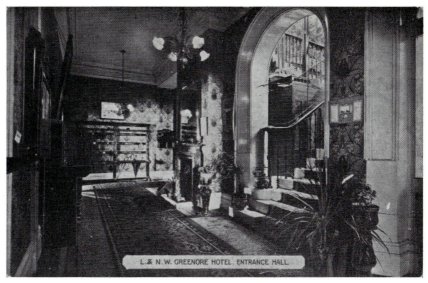

L. & N.W. GREENORE HOTEL. ENTRANCE HALL.

extra categories brings the story up to the outbreak of war in 1914. The company shared its agency office at 30 Boulevard Des Italiens, Paris, with the South Eastern & Chatham Railway. Among the three single cards in the category 'Buildings and Offices' is a half-tone card of the office. It carries an overprint giving information about trains form Euston, and details of tourist tickets. There are nine 'Exhibition' picture postcards, issued variously between early 1906 and April 1914. The Great Exhibition of 1851, designed to show the world the supremacy of the British Empire's trade and commercial enterprise, set the standards for all subsequent trade exhibitions. The London & North Western was a frequent exhibitor at these shows, often sharing a stand with another railway company where the joint display of services and engineering capabilities was of mutual benefit. One of the most interesting in the Exhibition series is of the Crewe Cottage Hospital Bazaar, held on the last two days of April and the first two days of May 1914, by which time the total number of cards sold had exceeded 10 millions. The picture shows the express locomotive *Sir Gilbert Claughton* and the *Rocket*; inset portraits show the chairman of the LNWR, Sir Gilbert Claughton, and the Chief Mechanical Engineer, C.J. Bowen-Cooke. The reverse of the postcard has the Cauliflower crest and details of the hospital, founded in 1895; it was hoped that sales at the bazaar would raise the endowment fund by £1,000.

The hotel cards were issued in both plain and coloured versions, and were intended for use at the company's nine establishments; they were issued in far greater quantity than any of the other single cards. Issues commenced sometime in May 1905, and continued, for the plain cards until May 1909; the coloured cards were first issued in July 1906, and continued right up to the outbreak of war in 1914. Three cards of the plain issue, showing Greenore Hotel and the Golf Links, were issued in three editions, with '5', '6' and '7' million' sales figures in the stamp rectangle. They were available at the 1909 Dublin Horse Show; although the LNWR had a trade stand at the show no exhibition postcards for the event have so far come to light.

Several of the postcard-issuing railway companies produced map cards, among the most note-worthy of these being the Midland Railway. The regional and national advantages of such postcards, especially with the use of local overprints, would seem to be obvious, and yet only three designs have so far been recorded. Two, apparently for use as correspondence cards, were issued sometime around 1905-6. The third, in vertical format, titled 'From the North to the Sunny South in Through Trains', appears to have been issued between April 1909 and February 1910, when sales figures had reached $9\frac{1}{4}$ millions.

Another intriguing series of non-set cards is that of menu cards — were they attached to menus or available in booklet form? So far, eighteen of these cards, perforated along one edge, have been recorded. They were un-coloured view cards, issued with the legend '10 million cards sold' in the stamp rectangle, and were probably intended for use like the dining

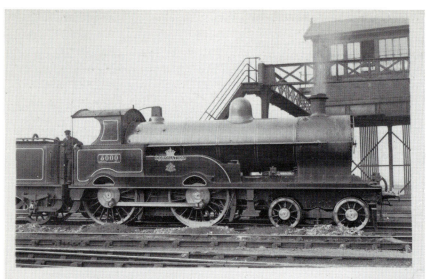

car or correspondence cards of other companies.

The London & North Western Railway apparently did not rate their many fine posters as worthy of reproduction in picture postcard form. There were only six cards (five coloured, one plain) issued variously between 1905 and 1911, showing views, locomotives, and steamships. In the category of road vehicles, only three cards were issued, each of which carried advertisements for passenger services, in November 1905.

Non-set issues of ships cards were available in coloured and non-coloured versions, and came on to the market between June 1905 and March 1911. Both varieties were probably issued in three editions, although so far only odd cards from each edition (indicated by the sales figures in the stamp rectangles) have come to light. The cards became available as new steamers were commissioned on the Dublin to Holyhead route. Some of these cards are of steamers on the Fleetwood to Belfast run and carry both LNWR and Lancashire & Yorkshire Railway crests on the address side; this is because the service was jointly owned. John Silvester leans to the reasonable theory that, although the cards were issued by the LNWR, they should more correctly be regarded as L&Y officials.

A further issue of coloured and non-coloured train cards occurred between March 1905 and September 1914; they were probably issued on the same basis as the ships cards, as new locomotives, rolling stock, and services were commissioned or brought into operation. If one acknowledges overprints and additional wording, together with advertisements, as separate editions,

then the trains cards appeared in at least five editions, the nature of the overprints depending upon the date of issue. Some of the pictures were similar to those which appeared in earlier issues; locomotive No 2053, *Greater Britain*, was like that in Set 50 'Locomotive Types', with an inset 'Experiment' engine removed and further caption information added. The *Experiment* was issued as a separate card in July 1905, soon after the locomotive had been built.

The only coloured non-set train card was issued in two versions, one as a correspondence card and the other as a trade card for free distribution among the LNWR's industrial and commercial associates, particularly with the London to Birmingham services. The card features *Coronation*, the 5,000th locomotive built at the Crewe works. On 15 May 1911, the engine left the shops on trials. hauling the Euston to Carlisle express; a 4-4-0 type, the wheels had large bosses and what were nicknamed 'half-moon' counterweights. It was intended for extensive use on Royal trains, its wheel rims and buffers being highly polished along with the brasswork, which was more in evidence than on standard LNWR locomotives. It was officially named *Prince of Wales*, and a locomotive which had formerly carried that title was renamed *Shakespeare*. Mounted on the driving wheel splashers was a brass plate (surmounted by a crown) bearing the word *Coronation*, and below this the inscription 'The 5000th engine built at Crewe Locomotive Works, June, 1911'. The locomotive was one of the first of the new locos built under the superintendence of C.J. Bowen-

Cooke, the new Chief Mechanical Engineer, almost entirely from material and components manufactured in the LNWR's own plant. Very few pictures of this splendid locomotive show it in the black, with red and white linings of the company's livery, but in the very bland 'photographic grey'.

Sometime in 1908, between May and November, when sales had reached 8½ million, a small number of view cards was issued. They fall into two distinct types: a strip picture, with most of the cards bearing an advertisment beneath the picture and an overprint on the address side. Two of the known cards of this type are recorded in a coloured edition, the others being plain halftones. The second type was basically a correspondence card, without printer's name, company crest, or stamp information in the rectangle. These correspondence cards were issued sometime between May 1908, and March 1911, printed as plain half-tone views. They had several different backs, some of which were consignment note blanks, obviously intended purely for commercial use. The address side of these cards was printed in red, with a slogan, 'PLEASE ORDER YOUR GOODS BY LONDON AND NORTH WESTERN ROUTE', and a code number, four different ones having been recorded. Of the twelve recorded correspondence/view cards two of the pictures are from previous sets; Colwyn Bay is the same as 'The Sands, Colwyn Bay', Set 36, and Llandridnod is the same picture as 'View from Alpine Bridge', Set 34.

About eight cards are known to have been issued as 'miscellaneous' between June 1905 and March 1911, and may well have been published in two editions. Three plain half-tone cards were issued under the general description of road vehicles in November 1905, and can be distinguished by the advertisements on the address sides. Strangely, the picture card of the 'Motor Omnibus, Running Between Connah's Quay & Mold' (similar to Motor Vehicles, Set 35), carries an advertisement, 'L&NW and CR Travel to Scotland and the Highlands'. The other picture of a 'Motor Omnibus, Running Between Holywell and Holywell Station, North Wales' (similar to Set 35), is known bearing two separate advertisements, one for 'The Best and Quickest Route to the English Lake District (Euston)', and the other, 'The Best Route.

Aberystwyth Barmouth Shrewsbury Chester'. Not exactly the best co-ordination of advertisement and picture, but the third picture postcard takes some beating in this respect. It shows a picture of a 'Steam Lorry, Running Between Holywell and Holywell Station', and carries on the reverse the advertisement, 'The Most Comfortable Route To Shakespeare's Country'.

Defining advertising trade cards might seem at first thought to be easy. This, however, is not the case. Trade cards come in so many different shapes, styles, sizes and guises, that it becomes impossible to fit them all into one convenient descriptive pigeonhole. When they are issued in picture postcard shape and size, and railway cards at that, then the complexity of the problem becomes evident. In the end, they have to be accepted at face value and described individually.

Broadly speaking, however, they can be acknowledged as advertising ephemera promoting some company product or service, very rarely dated, included with commercial correspondence, or as literal handouts to customers. They had a picture front, the back was completely covered with company advertising leaving no space for either address or postage stamp. A slight variation on this is when the picture card, obviously promoting one company, is given to another, a customer of the first, for their related advertisement to be printed on the back. This secondary advertising will often tell an interesting story.

Although some railway companies did issue such trade cards to their customers for secondary overprinting, the London & North Western did not; or at least, none have so far been recorded. Indeed, the company only issued five known trade cards, at least two of which had been issued as postcards for sale, and a third, similar to a Tuck's card, which had been issued not later than October 1904.

The latter card depitcted a '15 Tons Coal Wagon No. 41625' (Tuck's card; the wagon is numbered 47777) with the reverse giving information concerning the 'Economy of Large Wagons'. The information refers to a magazine article which had appeared in March 1904, and John Silvester considers that the card could be an early McCorquodale printing. Another of these trade cards shows a seven-picture multiview of

the tube stations at Euston, while a card showing 'Unloading Motor Cars at Camden Goods Station' illustrates an early form of motorail service — nowadays the cars travel on open ramps instead of closed vans.

The London & North Western Railway had a very convenient and mutually profitable joint service with the South Eastern & Chatham Railway. Transatlantic passengers disembarking at Holyhead could catch a through train to Folkestone or Dover, board the cross-Channel steamer, and then continue their journey on the Continent. The entire train journey could be made without the passenger having to change carriages. This service was advertised by way of overprints on the backs of LNWR picture postcards. Printed in light blue a typical advertisement would read:

LONDON & NORTH WESTERN RAILWAY
West Coast Mail Route —
New Through Services,
WITHOUT CHANGE OF CARRIAGES,
between the Principal Places on the
L. & N. W. System and the South Coast,
via WILLESDEN JUNCTION.

S.E. & C.Rly. —
Through Carriages between Manchester (London Road) and Tonbridge (for Tunbridge Wells), Ashford, Folkestone (Central), Dover (Harbour), Walmer, and Deal, &c.
Luncheon Cars, Stafford to Willesden,
and Willesden to Crewe.
Ask for Tickets "via NORTH WESTERN"

The District Travel Agent
[a printed insert in red, such as,
Mr. J. QUICK,
30, Broadway
Maidstone,]
will be pleased to supply any information,
and make arrangements for your
comfortable travel.
Goods and Parcels should be carefully consigned per "L. & N. W. Rly."
For Business or Pleasure travel by "NORTH WESTERN".

The picture postcard flourished because it was the cheapest and most reliable method of communication, both for commercial and industrial undertakings as well as for private

individuals. As always, in commerce, speed is of the essence, and the postcard fulfilled this condition admirably. It should be remembered that the telephone did not come into extensive use, particularly on the railways, until well into the second decade of this century, hence the widespread use of correspondence cards. With their awareness of the need for publicity, the advertising techniques available (especially the chromolithographic pictorial poster), and in particular, the popularity of the picture postcard, it is more than a little surprising that the railway companies did not take more extensive advantage of the medium. Even the most publicity-conscious companies seemed to have had a casual approach to the idea.

With the introduction of the postcard in 1870, businesses saw the new postal stationery as a means of speeding up their trade and advertising it at the same time. The method was quite simple; official Post Office cards were overprinted with their own correspondence requirements. The practice was continued by the railways with their picture cards, and for the most part, the use of advertising overprints seems to have been a means of using up old stock. Even when used on newly-issued cards, its appearance was very timid and half-hearted, most likely because the issue of postcards, ordering of stationery, and advertising promotion were all separate responsibilities within the administration of the railway company, both at regional and national levels. (There are several references to this in *Go Great Western*). More than seventy advertising overprints are listed in the separate works by John Silvester and Messrs Alsop, Hilton and Wright.

The outbreak of World War I in 1914 brought about an almost immediate decrease in picture postcard production generally, and virtually a complete halt to the issue of railway postcards. But although the railways ceased to produce postcards, they did not curtail their other activities, and responded in traditional ways to the needs of war. The first wartime use of railways had been during the American Civil War; their role had been developed during the several European and Asian wars between 1870 and 1900. In the Boer War of 1899-1902 the strategic importance of railways was realised, as can be observed from the number of battles

32 An example of one of the several ways in which official postcards were used, probably as a hand-out at the stations listed. The picture side of the card shows Conway Castle from Deganwy. (London & North Western Railway, Set 29, 'North Wales Resorts', reissued October 1906, printed by McCorquodale) *(Mike Clarke)*

which were fought around railheads. For the maintenance of supplies and the conveyance of troops, the railways proved supreme.

Even before 1914 the British Army, as also those of other countries, had been practising the speedy entraining of troops and supplies on Army manoeuvres. The capabilities and capacity of all locomotives and rolling stock was known, so that at short notice they could be brought into their most effective use. It is interesting to note that most of the general managers and chief officers of the railway companies held commissions in a unique British Army regiment. This was the Railway Engineer and Staff Corps, a regiment whose lowest rank was that of major.

Within a week of the declaration of war, the British Expeditionary Force was embarked at Southampton, with 334 trains in many liveries being commandeered. By the end of August 1914, that number had risen to no fewer than 670 trains carrying nearly 12,000 men, nearly 38,000 horses, and all the weapons and stores in proportion. Significantly, this was done with little interference to ordinary traffic.

Apart from the obvious need to transport troops and supplies to the battle-front, there was the need to carry the wounded back to base hospitals and to similar establishments here in Britain. More than twenty-five military and naval ambulance trains were used on the home railways. More than fifty sixteen-coach trains were provided for use in France, Egypt, and Greece, nineteen of these being for the use of American troops.

The naval ambulance trains were slightly

different to the standard stock in that they were fitted with berths instead of cots, naval-type washing arrangements, and clear floor space for seamen to 'squat' as was the current practice on the deck of a ship. The Great Eastern Railway was the first British company to provide an ambulance train, but within two months the London & North Western Railway had rebuilt enough main-line stock to equip four ambulance trains. The whole project occupied only ten days, and one of the trains was altered to naval specifications at the Wolverton works within a day and a half. To judge by the title on the card, 'New Naval Ambulance Train Exhibited for the benefit of the Seamans Hospital (Dreadnought) Greenwich. Built by the L. & N.W. Rly.', this was the same train. Five cards were printed in sepia half-tone, but carry no printer's name or company motif. In similar anonymity, the Great Western Railway also produced, in two editions, sometime in 1915 and 1916, a set of five cards depicting their 'Continental Ambulance Train'. With appropriate overprints these were reproduced, possibly at a later date, as correspondence cards.

Several companies rallied to the cause by building ambulance trains, but the North British Railway appears to be the only other company to have issued a card featuring the adapted rolling stock. The Midland Railway converted coach No 58, one of its 56ft 6in corridor third types, as a World War I ambulance coach on an older type underframe. It was reconverted to corridor stock in 1922, being renumbered LMS 3214. As with the LNWR standard coach (which was 6in

longer overall), the ambulance conversion stock was fitted with stout safety chains in addition to the standard coupling equipment. It is interesting to observe that for the World War II ambulance trains supplied by the LMS, conversions were made mostly from 1923 to 1929 composite coaching stock. The internal conversions incorporated the existing window and door arrangements, so that little alteration was made or needed externally. The types of LMS coaches used in these conversions were third class vestibule, third class brake and composite brake.

In their several ways, all of the railway companies helped the war effort by supplying locomotives, trains, equipment and staff of all kinds. Their endeavours were largely unsung, and in view of the fact that much of the proceeds from sales of the LNWR, GWR and NBR cards was given to soldiers' and sailors' relief and benevolent funds, it is most strange that they and the other companies did not make use of the picture postcard to publicise their noble achievements.

The war and its aftermath completely changed the structure of society. The Edwardian era, the last age of elegance (and efficiency, from a railway point of view) had succumbed, the new Georgian age not having had a real chance to carry on its traditions. Railway services, in one way or another, were concentrated on national service; staff had been depleted, men and women going off to war or being transferred to 'essential occupations'; travel by the general public was restricted, and extensive holidays of the kind glamorised in pre-war publicity were out of the question for most people. With services either being withdrawn or terminated, there was no need for railway publicity, and consequently, although picture postcards flourished in other spheres, notably military and patriotic themes in a wide diversity of representation, the railway postcard declined.

For the London & North Western Railway also, it was the end. Several circumstances had caused a lowering of standards and efficiency at home, locomotives and rolling stock had been lost or destroyed due to war action. There was an acute shortage of money, men and materials; pre-war opposition was, after much argument, laid aside, and amalgamation in the name of economy came into being. The grouping provisions of the Railways Act, 1921, came into force on 1 January 1923.

On that date 120 separate railway companies became incorporated in four big systems, the London, Midland & Scottish Railway, the London & North Eastern Railway, the Great Western Railway and the Southern Railway, collectively known as the 'Big Four'. The London & North Western Railway, the 'Premier Line', now became the premier constituent of the LMS. While it did not survive in the manner of the Great Western (the only company in the grouping not to change its name), neither did it completely die. Some hotel cards, originally printed by McCorquodale, had the name, 'L&NW Railways', and the company seal obliterated and replaced on the back with the new LMS seal and the title 'London Midland and Scottish Railway Hotels'.

The Troubled Years to Grouping, 1910–23

Following upon the affluence of the Victorians the fashionable life of the Edwardian era seemed secure. There are numerous quotations from the period which show that the Edwardians considered that the good life would continue for ever. But to the more discerning contemporaries and the later historians there were signs that the extravagances of the age were nearing their end. The social fabric was wearing very thin. Just one year before its demise, the author and philosopher, H. G. Wells, wrote: 'The hand of change rests on it all, unfelt, unseen; resting for a while before it grips and ends the thing for ever'.

On 6 May 1910, Edward VII died. With his death came the end of the last age of elegance, and social conflict shattered the composure of an unsuspecting, unprepared society. The year was to prove a watershed in many spheres of activity, and strikes almost became the order of the day. The Welsh miners' strike of 1910 was followed by the first national railway strike in 1911. Parliamentary crises, an Army mutiny at Curragh, and the increased militancy of the suffragette movement brought the country to a state of social unrest unknown for many years. The outbreak of World War I in 1914 diverted the nation's attention and redirected its endeavours.

The social unrest had its effect upon the railways, and through them the humble occupation of the picture postcard collector and his ephemeral treasures.

The Lancashire & Yorkshire Railway, which had changed its name by Act of Parliament in 1849, seemed determined not to be affected by social disturbances. Sometime in 1910 it issued the first of a new series of eleven sets of cards; view cards of Hardcastle Crags, the plain printed six-card set, with scroll title, was issued in two editions. One had no description other than the title, the other included a brief account of the picture on the back; the printer's name is unknown.

This was quickly followed by a coloured set,

'Old Passenger and Goods Trains', which appeared in three editions, two of which were issued with French overprints specially for the 1910 Brussels Exhibition. For this, and the 1913 Ghent Exhibition, a total of eighteen overprints were made, a full list of which appears in *Railway 'Official' Postcard List* No 3, by Alsop, Hilton and Wright. These overprints, eg *'Visitez les plages renommées de Blackpool, Southport, Morecambe, et l'Ile de Man, et voyagez par la route de Zeebrugge – Hull Service régulier au 3 Octobre, 1913.'* drew the attention of prospective passengers to the travel facilities which enabled them to book through from Zeebrugge to Hull, across country to Fleetwood or Liverpool, and thence to Scotland, the Lake District, Ireland, or the simple pleasures of the Lancashire seaside.

Printed by Photochrom Company Ltd, who had originated in Switzerland before establishment in Tunbridge Wells in 1897, the next two six-card sets, 'Modern Locomotives', were published in four editions, and were in colour. Also printed by Photochrom in colour, Sets 6 and 7 were of 'Lancashire & Yorkshire Railway Steamers'; the former was issued in three editions with two overprints, while the latter ran to no less than five editions, four of which carried French overprints.

The remainder of the New Series issues were view cards; for some extraordinary reason the six-card sets 9 and 10 had description changes on one card in each set. The seven cards were never issued together. The last set, No 11, was issued in 1913, although some odd cards, mostly correspondence cards, were published subsequently, printed by anonymous or unknown firms. One card, picturing the TSS *Duke of Clarence* Hull to Zeebrugge steamer, printed in the Photochrom Sepiatone Series is thought to be a probable official L&YR postcard.

The North Staffordshire Railway was incorporated by three Parliamentary Acts in 1846, all receiving the Royal Assent on 26 June. The first

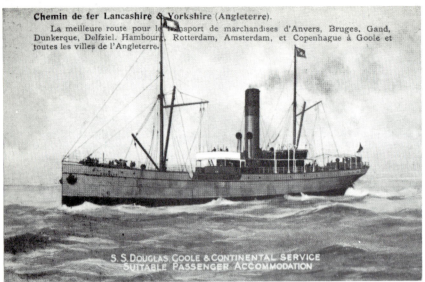

33 With its purchase in 1905 of the fleet of the Goole Steam Shipping Company, and later, the Goole boats of the Wholesale Co-operative Society, the L&Y had twenty-six steamers trading between the Humber and the Continent. This rather nicely painted picture of the SS *Douglas*, along with several other cards and sets, was overprinted in French for the Ghent Exhibition, 1913. (Lancashire & Yorkshire Railway official, Set No 6, available in three editions, printed by Photochrom Co)

was for the Churnet Valley Line, the second for the Hardcastle to Sandbach Line, and the third for connection with the Macclesfield Branch of the LNWR, and known as the 'Potteries Line'. The latter company was also given Parliamentary powers to purchase the workings of the Trent and Mersey Canal.

It is not known for certain when the NSR first commenced publishing picture postcards, but by June 1910, it had issued fifteen six-card sets of views, most in colour. They had been printed by McCorquodale, Wildt & Kray, Wood Mitchell & Co of Hanley (who produced two sets in photogravure), and an unknown firm who printed the first three sets. Wildt and Kray established their picture postcard business in 1904, and after several changes of address, continued publishing until 1939. Between June 1910 and September 1912, they printed three, possibly four, more sets of view cards for the NSR. Of the nineteen sets issued by then, two had run to two editions, and three were published in three editions.

The last four sets of cards issued by the NSR were published between September 1912 and August 1914, the outbreak of World War I curtailing any further publications. Set No 20 was printed by W & T Gaines, of Leeds; although they contain no indication of the printer, it is possible that the remaining three sets were also printed by them. Although the Leeds firm did publish their own picture postcards, they were better known as printers to the trade; their plate-sunk view cards for the NSR are some of the few postcards which can be positively

identified as their work.

Only two sets of postcards issued by the Great Central Railway after 1910 can be positively dated. The first is a set of ships, coloured views from paintings by C.E. Turner, and printed by Taylor Garnett Evans and Company, of Manchester, in 1911. The second, a series of six coloured cards of Immingham Docks, from the paintings by Fortunio Matania, issued in 1912; the artist's name is not distinct on all of the pictures. The docks were officially opened by King George V on 22 July 1912. Probably also around 1911, a three-card set of ships, featuring three of the GCR's fleet, were printed by the Hamburg firm, G.H. Schutt; whether or not these were official cards is a little open to question. The Great Central also issued some other shipping cards, but these were overprints of GCR slogans on the postcards originally published by the various shipping lines for whom the railway company operated connecting services.

The last cards which can be positively dated, to be issued by the North Eastern Railway, were two French-text sepia pictures, specially published for the Brussels Exhibition, 1910. Several hotel cards, issued both before and after World War I, were undoutedly of pre-1910 origin. They were published in five editions, two by Photochrom, two by Ben Johnson & Co, York, and one by an anonymous printer.

The Great Eastern Railway was during this time, the largest East Coast publisher of postcards, with approximately twenty small sets and odd cards being issued in the ten years up to 1920. For

The Snowdon Mountain Railway
makes the ascent of the mountain by
the easiest gradients, the steepest of
which is 1 in 5½, and its sharpest
curve 264ft radius. Sir Douglas Fox
examined the various Continental
mountain railway systems, and
recommended that the Abt rack
system was best suited to the Welsh
project. (Snowdon Mountain
Tramroad & Hotels Co Ltd,
Snowdon Series No 52, with special
'Summit of Snowdon' cachet on
reverse, about 1923, printer
unknown) *(Ian Wright)*

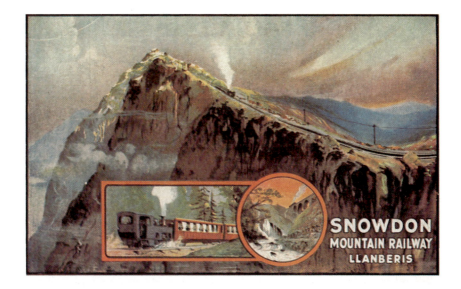

Ashwood Dale, seen here, is one of the
famous dales, in the Derbyshire Peak
District. From this picture (the view
would rival that from any Alpine
railway) it is easy to see why the
Midland railway was so fond of
advertising its routes as the most
scenic. The road is wider now, not
really suitable for strolling
pedestrians, and although the River
Wye still sparkles through the crags,
the scene is not now so tranquil.
(Midland Railway, Set 15, probable
date of issue 1906-10, printed by
Photochrom Co Ltd)

Queen Victoria's day saloon, showing
the interior of the coach. Heavily
carpeted to deaden noise, the walls
and roof were padded with quilted
silk. In 1899 the separate sleeping and
day saloons were united on one frame
running on two six-wheeled bogies.
(London & North Western Railway,
Official, Series 4 'Royal Saloons',
issued August 1904, printed by
Raphael Tuck & Sons)

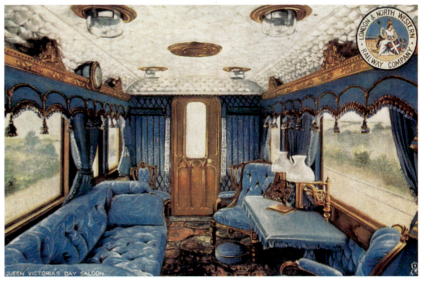

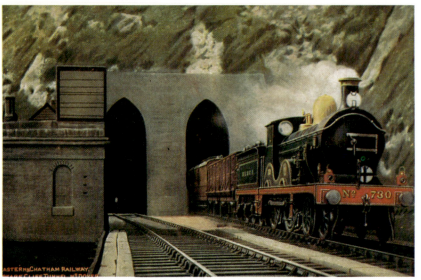

A view of the Shakespeare Cliff Tunnel, on the South Eastern & Chatham Railway, as a 4-4-0 express bursts into view. The tunnel was constructed in 1843, and involved the removal of 2 million tons of the Round Down Cliff on 26 January of that year. A total of 18000lbs of gunpowder, fired by electricity through 1,000ft of wire, was used. This was the first time that electricity had been employed for such a purpose. (Locomotive Publishing Co, about 1910)

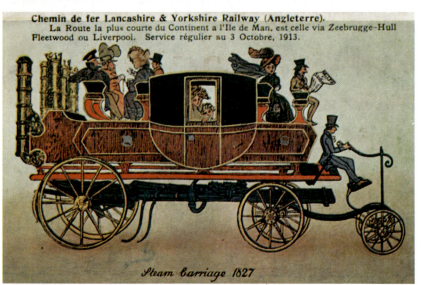

Chemin de fer Lancashire & Yorkshire Railway (Angleterre).
La Route la plus courte du Continent a l'Ile de Man, est celle via Zeebrugge-Hull Fleetwood ou Liverpool. Service régulier au 3 Octobre, 1913.

Steam carriage 1827

A six-card set of coloured cards in three editions was issued for the 1913 Ghent Exhibition; the variations were in the French language overprints. The picture is an artist's impression of Sir Goldsworthy Gurney's fourteen-seater steam coach with which he conducted experiments in 1826-7. The 28hp machine, which weighed three and a half tons unladen, received a Royal patent in 1828; two such machines operated between London and Bath. (Lancashire & Yorkshire Railway, New Series Set 2, about 1910)

Franciskaner am Stadtbahnhof Friedrichstrasse.
Gruss aus dem

On many main lines into German cities the Down and Up tracks were taken on separate viaducts into the Bahnhof. The Franciskaner (Franciscan Friar), a smart restaurant in Berlin at the turn of the century, was housed in two of these viaduct arches; the fountains and ferns were in the open-air 'courtyard' between the tracks in and out of the station. (Chromolitho by Bernhard Wertheimer & Co, Frankfurt, No 213, pu 8 April 1900) *(Mike Clarke)*

34 Artist-drawn by C.E. Turner, this Great Central Railway shipping card was used to advertise the four sister ships, the SS *Accrington*, *Bury*, *Dewsbury*, and *Stockport*. Ordinary screw-type steamers of 1,631 tons, they operated a service to Hamburg every week-day at a speed of 13½ knots. They also sailed the Royal Mail route to Antwerp and Rotterdam three times per week. (Great Central Railway official, published 1911, printed by Taylor Garnett Evans & Co Ltd)

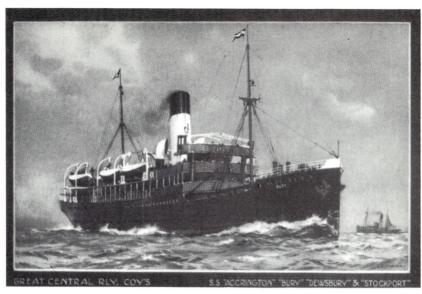

the most part, they were plain-printed or half-tone views by Jarrold and Sons, the Norwich firm who had produced some of the Great Eastern's earlier issues. The printing firm, established during the Napoleonic Wars, is generally reckoned to be one of the oldest postcard publishers, possibly having produced cards as early as 1895.

A very ordinary-looking, plain printed card was issued for the Anglo-American Exposition, 1914, held at Shepherd's Bush, London. This was followed by several hotel cards, some coloured, plain-printed, or photographic. A four-card coloured set was printed by J.J. Keliher and Co, London, whose small postcard output appears to be similar in style to those of Gale and Polden. Only one set of the hotel cards can be dated with any certainty. Four cards show views of the Felix Hotel, Felixstowe; this establishment was purchased by the Great Eastern in 1920, and although earlier cards of this hotel are known, they are not GER officials.

Sometime between 1903 and 1912, fifteen poster reproductions were issued, of which five are dated. The range of cards, which are usually to be found with correspondence backs, and mostly coloured, includes the John Hassall poster, 'Come and Join Us on the East Coast'. Several of the posters advertise British Royal Mail services between Harwich and the Hook of Holland, and one card, issued in 1904, was printed by Seghers Frères, Anvers. In 1910, two shipping sets, each in three styles, were issued. The cards feature seven steamers operating on the Hook of Holland and Antwerp services, in

coloured, plain, and plain with wireless telegraphy information editions. Five plain printed correspondence cards with different pictures of some of the continental fleet may have been issued around the same time. In 1912, the Locomotive Publishing Company produced three coloured cards for the GER, presumably from their own stock, since they bear correspondence overprints. The last postcards to be issued by the Great Eastern Railway appeared in 1916 and 1920; the former featured its poultry and small stock demonstration train, the latter its recently-acquired hotel at Felixstowe. Three years later, the company, which was formed on 7 August 1862 of an amalgamation of the Eastern Counties, the East Anglian, the Eastern Union and several other small railways, itself was grouped into the London & North Eastern Railway.

Of the minor English railway companies, only two can be said with any certainty to have issued picture postcards during the period under review. Just one card, for correspondence, was published by the Maryport & Carlisle Railway. Printed in red, blue and white, showing a map of the company's rail network, the card carries the dateline 191... The company was granted the Royal Assent in 1837 to operate a 28-mile route between the towns from which its name was taken; it remained independent until the 1923 grouping.

From 1907 to 1919 the Cheshire Lines Committee published at least sixteen half-tone views, each in editions of grey, brown and blue. The name Cheshire Lines Railway is printed in Gothic characters below the picture, and in

CHESTER CATHEDRAL.

Chesbire Lines Railway. ⒸHESTER is an ancient and venerable city, and will well repay a visit. Northgate Station is situated close to the numerous attractions of the City, as well as being in the proximity of the "North Gate," a structure built in the Grecian style.

35 One of a twelve-card set issued in three editions between 1907 and 1919. The half-tone printing was in grey, brown or blue, from an original picture by Francis Frith & Co. The backs of the cards (various views of the CLC area) were overprinted for use as internal corespondence cards. (Cheshire Lines Committee, correspondence card, about 1910) *(Ian Wright)*

similar style either Cheshire Lines or Cheshire Lines Committee appears on the reverse of the card. The Cheshire Lines Act of 1866 authorised the CLC to operate the Chester & West Junction Railway. After its incorporation in 1865, the committee was empowered to build and acquire several other lines; the CLC was one of five independently-operated railways which worked jointly with the Group Companies until its formal closure by the powers of the 1947 Transport Act.

After 1910, only two of the London Underground railways appear to have issued further cards. The Metropolitan Railway in 1913 published a six-card coloured map set, using the 'Geographical Series', printed by George Philip and Son Ltd, the well-known map makers. The set would appear to have been priced at only one penny for the six cards. W.H. Smith & Son printed a six-card colour set of poster-style cards for the London Electric Railway about 1915. The year would appear to be confirmed by the fact that one of the postcards shows 'The Link of London Lines'. In 1915 the Facilities Act allowed the City & South London Railway, the Central London & Metropolitan-District Railway, together with the London Electric Railway to form a common financial pool of their gross revenue from which could be drawn an agreed net revenue; also included in the deal was the London General Omnibus Company. On 31 January of the same year the LER opened a line from Paddington to Kilburn Park; 1 February saw the opening of further track between Kilburn Park and Queen's Park.

Probably pre-dating the poster-style cards by a couple of years, a six-card coloured set, designed and printed by The Avenue Press Ltd, of Bouverie Street, was issued by the LER. The set was known as 'London Nooks and Corners', and was derived from posters drawn by the artist S.T.C. Weeks. With the outbreak of World War I in 1914 the Avenue Press seems to have ceased trading, it is known for its production of humorous postcards, including among its artists the renowned Fred Spurgin and George Shepheard. Sometime after July 1910, a four-card set of 'Miscellaneous Posters' was issued by the LER for use as correspondence cards.

An earlier reference to the firm W.H. Smith and Son in connection with railways should come as no surprise, although it is not certain when they first printed and issued picture postcards. Indeed, it is not certain when the firm itself began. The earliest record of the existence of W.H. Smith & Son is contained in an advertisement in the Sunday magazine, *John Bull*, dated 9 December 1821, some four years before even the railways had arrived. Until the advent of the railways, stagecoaches and couriers were the only means of distributing newspapers throught the country, but not until the autumn of 1847 were special trains run for newspaper deliveries. The first newspaper express left Euston at five o'clock in the morning, arriving in Manchester five hours later. It continued to Liverpool for 10.30am, and thence to the end of the line at Beattock, where it arrived at 2.15pm. Several post horses carried the papers to Glasgow where they arrived at eight o'clock in

the evening.

One year later, when income tax was raised by the Chancellor of the Exchequer to the staggering sum of one shilling in the pound, W. H. Smith ran an even more remarkable express. On 15 February the railway was opened from Beattock to Glasgow to Edinburgh, but the newspaper train took an East Coast route. It travelled via London & North Western lines to Rugby, and thence through Leicester, Derby and Normanton to York, and so via Newcastle and Berwick to Edinburgh and Glasgow. The time for the 472½ miles was ten hours twenty-two minutes, a marvellous performance. The newspapers which had left London at 5.35am were delivered in Glasgow at 3.57pm. A quotation from the *Newcastle Journal* adds, 'two hours before the mails which left London the previous evening.'

Until March 1875, most newspaper trains were chartered by the proprietors of a particular publication, but in response to concerted demands from all the London newspapers, this was altered. Previously, most of the traffic had been carried by the London & North Western Railway, but the Midland and the Great Northern Railway decided to end this monopoly. The result was that the early hours of the morning saw more than six expresses leaving London to distribute newspapers to the furthest corners of the kingdom.

W.H. Smith had first turned their attentions to bookselling at about the time of the Great Exhibition in 1851, and brought a great moral force to bear on the 'unmitigated rubbish on the bookshelves on almost every bookstall at every railway terminus in the metropolis'. Less than ten years later, when W.H. Smith had acquired the sole right of selling books and newspapers on the London & North Western Railway, the situation changed dramatically. It was not long before the familiar green and cream bookstalls appeared on every line in England, with the single exception of the Metropolitan Railway. By 1892 there were more than 600 of these bookstalls on station platforms throughout the country, with at least as many more stations at which W.H. Smith's newspaper lads had a stand. A contemporary writer wondered why 'the railway bookstalls should be the monopoly of a single firm', and marvelled that the service seemed to improve every year. By 1910 the firm

was offering more than 6,000 different editions of picture postcards, mostly views; a large number were printed on the back in either light green or chocolate brown, with the initials WHS contained within an oval frame.

A minor Irish railway had its moment of glory during 1913-14. In 1913 the Cork, Blackrock & Passage Railway purchased the paddle steamer *Audrey* from the City of Cork Steam Packet Company. Anticipating that many passengers would want to write to their friends the company issued in that same year a plain printed correspondence card which featured the 'flagship of the fleet'. Apparently the company's dreams did not materialise, because the following year the paddle steamer was sold, and their first venture into the world of postcard publishing was also their last. The company received Parliamentary sanction in 1846, and its 6½-mile line of 5ft 3in gauge was opened on 8 June, 1850. The gauge was converted to 3ft in 1900, and the undertaking was absorbed into the Great Southern Railway of Ireland in 1924.

Another Irish company, which in 1923 had amalgamated with other subsidiary companies to form the GSR(I), had issued a correspondence card in 1911. It was a coloured card showing the Seven Churches, Glendalough and Rathdrum Station on the Dublin & South Eastern Railway Company's line. Perhaps the fact that the company changed its name three times and had absorbed two other railway companies between 1846 and 1906, deterred its passengers from corresponding. It was the only postcard ever issued by the company.

The Midland Great Western issued two postcards, about 1916, of hotels in County Mayo; they were half-tone but with no indication of the printer. By an Act of 1845, the MGW was authorised to construct a 50-mile line between Dublin and Galway, with several extensions over the following twenty years. It absorbed the Dublin & Meath, the Navan & Kingscourt, the Great Northern & Western and the Sligo & Ballaghadereen Railways before being incorporated into the Great Southern in 1924.

Halfway across the Irish Sea, virtually equidistant from the mainlands of Ireland, Scotland and England, lies the 221 square miles of the Isle of Man. The railway system extended at one time to more than eighty miles of track linking the

four principal towns of Douglas, Ramsey, Reel and Port Erin, with electric tramways radiating from Douglas. With four railway companies operating on the island it has an interesting history; steam, electric and the Douglas horse tram. Surprisingly, from a picture postcard point of view, the railways are difficult to document, especially the Manx Electric Railway.

So far as is known, no official postcards were ever issued by the Isle of Man Railway, the Manx Northern Railway or the St John's & Foxdale Railway. Other than the Manx Electric, the only company to issue officials was the Douglas Southern Electric Railway, sometimes also known with the word 'Railway' changed to 'Tramway'. It operated a $3\frac{1}{4}$-mile track between Douglas and Port Soderick.

The Isle of Man Railway was authorised in 1872, and opened for public traffic the following year. With the Manx Government Railway Act of 1878 the Manx Northern Railway was formed, establishing a circuitous link between Ramsey and Douglas which was opened in 1879. A branch line of some $2\frac{3}{4}$ miles long connected St John's and Foxdale, and was built to serve the old lead mines. A Manx Government Act of 1904 gave powers to the IOMR to purchase the Manx Northern and Foxdale Railways, and in 1916 the total length of line operated was in excess of forty-six miles.

The Manx Electric Railway operated a 3ft gauge track, but had no locomotives, being worked throughout by motor and trailer electric cars. The company was formed in 1902 and amalgamated with the Snaefell Mountain Tramway. This line, working on a 3ft 6in gauge track, operated on the 'Fell' system, a central rail securing the adhesion of locomotives on the route to the 2,034ft summit of Snaefell. The system was patented by J.B. Fell in 1863-9 for special locomotives on the Swiss Mont Cenis Pass.

Although six series of cards issued by the MER are detailed in the Definitive List by Alsop, Hilton and Wright, they acknowledge that the number of cards in a set is not known. The extent of the series is further confused by the fact that there is considerable repetition of pictures in different styles. Most of the cards were printed by Valentine and Sons Ltd, Dundee, although no date of issue is printed or can be determined with certainty. The only clue lies perhaps in the serial

numbers of many of the cards; these are Valentine numbers, but in the MER series they follow no logical order. The first two sets of cards listed are coloured view cards, seven per set, all titles beginning, 'The Manx Electric Railway'; there is no printer's name.

A strange issue is known as 'Series 1' and 'Series 2', of which there are twenty-three known cards in three styles or editions. The two series are distinguished only by their respective numbers printed on the backs along with a green seal. The third edition repeats all the pictures, but with no series number, and the green seal now printed in brown. The coloured cards carry no printer's name, but most have a Valentine's number. Series 3, only known from nine cards, was printed by Valentine, and appears in three editions which differ in their presentation. Some fifteen 'Photo Views' cards, the picture bordered in white, and a further twenty similar cards without the border, both lots produced by Valentine, have been recorded.

One odd photo card of the Tholt-E-Will Hotel, Sulby Glen, is known. It carries the name 'R.A. Series' and the number 6233; it could possibly be a production by Radermacher, Aldous and Company who printed postcards for other firms. One other odd photo card is known, titled 'Manx Electric Railway Co. Personally Conducted Tours.' When and by whom is not known.

The picture postcards issued by the Douglas Southern Electric Tramway were issued as a series of twelve views, repeated (with two picture changes, making fourteen cards in all) through no less than six styles. They were printed by Hildesheimer, who were established as fine art publishers in the mid 1870s; although they printed in several media they are most widely known for their superb chromolithography. Their establishment in Clerkenwell Road, London, was known as 'Chromo House'.

On mainland Britain, in Cumberland, the tiny Furness Railway continued to issue postcards. Sometime in 1910 they issued a most unusual series for a railway. Series 12 and 13 are photographs by James Atkinson, 'After George Romney's Pictures', and all of Series 12 feature the famous Lady Hamilton. There followed seven series of photographic cards printed by Raphael Tuck about 1912; with the exception of

36 Furness Railway Old Inspection Car, 1870. Although incorporating a vestibule, the design of the coach is basically the same as those of thirty years earlier. The idea of the inspection car was later evolved into the passenger rail-car which had a brief life in the mid-1930s. (Furness Railway Series No 18, published about 1912, printed by Raphael Tuck & Sons Ltd) *(Ian Wright)*

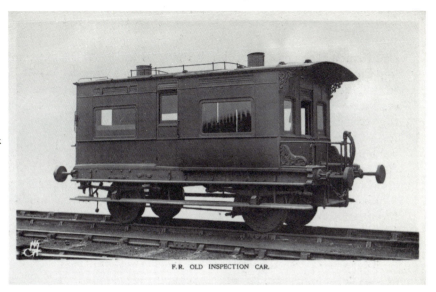

F.R. OLD INSPECTION CAR.

Series 18 'F.R. Rolling Stock (The Past with New Rail Motor)' a seven-card set, they contained six cards. The first four sets were of Furness Abbey and the Furness Abbey Hotel. Unlike the abbey, which was founded in 1127 by Benedictine monks from Normandy, the hotel only dated from 1862. Although it was owned by the Furness Railway, it was leased out, the FR only taking over the management in 1917. The establishment was closed in 1938. The 'New Real Photo Series', Nos 16 and 17, produced by Raphael Tuck before 1917, showed the Abbey Hotel interior and exterior. Each packet of cards carried the FR crest as did the cards, which, when issued from the hotel, were rubber stamped accordingly; the packets were marked '6 Photos 4d.'.

Series 20 is an interesting six-card set showing two of the paddle steamers operating on the Barrow and Fleetwood Service; this service is indicated in the titling. One of the steamers, *Lady Moyra*, was originally built as *Gwalia*, at the Clydebank shipyard of John Brown. She was intended as a sister ship to *Devonia*, operated by the Barry Railway Company, running Bristol Channel excursions from Cardiff, and was purchased in 1910 by the Furness Railway. The following year the remainder of the Barry steamers were acquired by P. & A. Campbell for their White Funnel Fleet; in 1922 they were rejoined by *Lady Moyra* who was renamed *Brighton Queen*. The panels of the *Gwalia's* paddle boxes carried a beautiful ornate bas-relief of the Barry Railway rampant lion crest with unicorn supporters; the crest was etched into the deck saloon windows.

A further printing by Tuck, a six-card FR Posters series in full colour was issued in 1914; the original posters had popularised tours in and around the Lake District. The idea of promoting such tours occurs in a nine-card photographic series, 'Tours Through Lakeland', printed by Sankey. The title of the series appears to the left of the description of the picture, with FR station details to the right. Whether or not these Sankey cards were true official cards is a little open to question. Certainly the railway company operated such tours, and the postcards may have been a joint promotion, so they are regarded as probable officials. Sankey published many photo cards of scenes taken on board the Barrow steamers, but these are not classified as being official Furness Railway issue.

There is some confusion about the Official status of some 'HHH' photographic cards, twenty-four in number, which prominently feature FR station information along with the title. Similar doubt exists for such cards for the Great Central and North Eastern Railways. Very little is known about them, although they are excellent photographs, probably by Haigh Brothers, of Barnsley. But many of the pictures can be found in the Kingsway Series, a marque of W.H. Smith and Son, and which are predominantly of railway stations, trains and ships. They are regarded as probable officials.

Further north, in Scotland, only one minor company seems to have issued cards in this period. Sometime in 1920, the Dumbarton and Balloch Joint Line Committee issued a twelve-

card set of Loch Lomond Steamers in two issues, coloured and sepia; the printer's name is unkown. Several other minor Scottish railways are known to have issued cards, some of which may have been published in this decade. In particular, the Portpatrick & Wigtownshire Joint Railway probably issued some steamer cards, featuring ships which had been acquired from the Larne and Stranraer Steamboat Company. This company had first introduced paddle steamers in the early 1870s, and two of the ships featured on the steamer cards, the *Princess Victoria* and the *Princess May* were the last paddle steamers to operate on the Belfast route. The Portpatrick & Wigtownshire Joint Railway had a rather complicated history, being formed in 1885 by the amalgamation of the Portpatrick Railway (1857) and the Wigtownshire Railway (1872). The newly-formed PWJR was itself a joint committee of the LNWR and MR, the Caledonian Railway, and the Glasgow & South Western Railway, operating about twenty miles of line.

Elsewhere in Scotland the larger companies were a bit more productive with their postcard issues, but in some cases, the details are more confused. In 1910 the North British Railway issued its 'Caledonia Series' 129, glossy coloured view cards, in four issues. There were twelve pictures in the set, with some title variations, but the views and picture numbers unchanged; however, only three editions can be positively identified. These three editions were issued in 1910, 1911, and sometime between 1912 and 1914. Each card carries a printer's number (the name is unknown) and the identification 'North British Railway Series' on the back. The printer's numbers do not change with the issues, but have no logical sequence or apparent date reference. Not all of the twelve pictures are known in each edition, and they seem to be distributed at random through the issues. There are several other 'Caledonia Series' cards known, but in different styles, un-numbered, and although carrying a printer's number there is no reference to name; all are identified with the NBR Series titling on the back.

Two exceptions to this are a 'Caledonia Series' Views, of only two known cards, featuring in colour Craigendoran Pier and the station, printed by J. Menzies; and two views, similar to the 1906 issues, of the pier and the Forth Bridge, also in colour, possibly printed in Saxony. One 'Trains' postcard is known, printed in colour by the Locomotive Publishing Company on a blue-backed card, and with 'L.P.Co. Ltd.' in the stamp rectangle. In all ways it is as a normal LPC card but with (North British Railway Series) printed on the back. The picture shows an NBR train on the Edinburgh-Glasgow-Dundee-Aberdeen service.

Another strange issue by the North British is a sepia collotype of the SS *Waverley* in the 'North British Railway Series'. The back of the card bears the initials 'J.M. & Co., E. & G.', while on the front is the title to the picture, printed by 'V. & S., D.' The first set of initials has been identified as J. A. McCullough and Co, Edinburgh. According to Wilfrid B. Grubb, whose researches are acknowledged by Anthony Byatt in his book, this firm printed several series on behalf of the North British, and apparently it was their regular practice to use the cards of several other companies. The second set of initials is of the more familiar firm of Valentine and Sons, Dundee.

The SS *Waverley* featured on the postcard was the third ship to bear the name. She was a paddle steamer, the first compound-engined steamer in the North British fleet, and was built in 1899. Famous for her races with the Clyde steamer *Jupiter*, achieving speeds of around nineteen knots, she was refitted with her promenade deck covered to the bow, and her bridge placed forward of the funnel. This affected her trim, and her racing speed of nineteen knots was thereafter far beyond her powers. A previous ship bearing her name, and built in 1885, was the first ship of the Campbell White Funnel Fleet, which operated in the Bristol Channel.

The Invergarry & Fort Augustus Railway was opened on 27 July 1903, some seven years after receiving the Royal Assent. It was worked by the Highland Railway until 1907, when the North British Railway took over its operation until closure in 1911. Two years later the Invergarry was reopened as a constituent company of the North British; it continued in this way until final closure on 31 October 1933. During its relatively short and erratic life the Invergarry Railway issued a series of at least thirty postcards in two editions. The cards were printed by Valentine's, and most carry the JV number, originally being

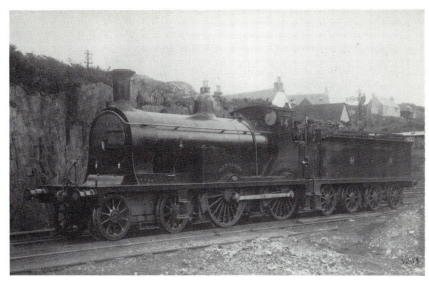

37 Highland Railway 4-4-0 *Ben Dearg* No 14. Engines of the 'Ben' class were a mixture of designs, being similar to the 'Dunalistairs' designed by J.F. McIntosh in 1897, and having cabs similar to the London & Brighton 'Gladstones'. The first HR 4-4-0 appeared in 1873, converted from a 2-4-0 outside-cylinder locomotive. (F. Moore's Railway Photographs, LPC 5203)

issued as part of 'The Highland Railway Series'. The change of ownership only required the blocking out of the original company name with a red overprint and the addition of the new name. Although there is no categorical date for their publication, these postcards are presumed to be post-1913. In both editions the cards, featuring views around Invergarry and Fort Augustus, are plain printed. Another small company which came under the aegis of the Highland Railway was the Wick & Lybster Light Railway. The provisions of the Light Railway Act of 1896 were intended to allow small local lines to be built and operated on a low budget. Although many such applications were received at the Board of Trade, a great number were submitted by the larger main-line railway companies who already had experience in the operation of light railway systems. Incorporated under the Light Railway Act, the Wick & Lybster opened 13½ miles of track in 1903. On 1 September 1906 the Highland Railway agreed to take over its operation and maintenance; the line was eventually closed to passenger traffic in 1944, and was later abandoned. In the same manner as the Invergarry Railway, the Wick & Lybster Railway also published some plain printed view cards. Only seven cards have been recorded, but it is thought that there may have been twelve cards in two sets. It is interesting to note that naval historians give praise to the Highland Railway. Its mostly single track was used only during a three-month tourist season during the summer, but despite many of its locomotives being out of action, in 1914-18 the

company maintained services vital to the navy. But not a single picture postcard to record its achievement!

An unusual picture postcard publication appeared in August 1914, being republished in February 1915 and March 1919. It was a booklet of twelve sepia printed picture cards with a counterfoil for each card bearing a miniature of the postcard and space for the addressee's name to be inserted. The left-hand edge of the cards was perforated, the pictures showing various views to be seen on the Glasgow to Oban run of the Callander and Oban section of the Caledonian Railway. The final picture in the booklet, produced by McCorquodale at their Caxton Works in Glasgow, is of the 'Interior of Observation Car'. The inside back cover advertises Pullman services, and it is thought that the booklet would have been issued in connection with the Pullman Observation Car. During the summer season this special observation car was used daily; it was named 'Maid of Morven' and was eventually taken over by the London, Midland & Scottish Railway.

Very few French poster cards appear to have been published during this period, and although a considerable number overall have been recorded, only two lots can with any certainty be dated after 1908 and before the outbreak of World War I. The Chemin de Fer d'Orleans issued two or three sets of lettercards, about 1911. Very thin postcards, in sets of four, separated by perforations along the left-hand side, were folded concertina-style into an open envelope. The cards were artist-drawn views of prominent

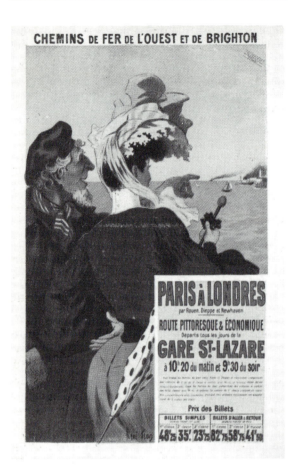

38 Originally sold in booklets of eight cards, these
poster cards were issued jointly with the London,
Brighton & South Coast Railway, about 1908. Shortly
after the issue of these cards (probably six sets), the State
Railways absorbed l'Ouest, along with several other
unprofitable lines. Under the management of M. Dautry,
the 'Etat' became one of the best run railways in Europe,
and claimed to provide the most comfortable ferry service
between the France and Britain. (Chemins de Fer de
l'Ouest, about 1908)

written, 'You enter a railway station and
everybody on the platform has a pencil in one
hand and a postcard in the other.' *Picture Postcard
Magazine*, August, 1900; (quoted in full in *Picture
Postcards of the Golden Age*, by Tonie & Valmai
Holt). The enormous flood of picture postcards
imported from Germany, and of course those
printed there by British publishers, ceased
abruptly.

After the Government's assumption of control,
railway fare structures underwent radical alter-
ations. Excursion and cheap fare facilities were
withdrawn in March 1915, and an Order in
Council of December 1916 increased ordinary
fares by as much as 50 per cent. In 1919, the
newly-established Ministry of Transport set up a
Rates Advisory Committee to investigate means
of obtaining increased revenue from the railways.
A 75 per cent increase on the pre-war rates was
recommended, operating from August 1920.
When the Government relinquished control of
the railways in 1921, the companies reduced
fares an introduced standards, but the public
were becoming disenchanged with railways.

The final nail in the coffin of the picture
postcard occurred on 3 June 1918, when new
Post Office regulations increased the postage
rate to one penny, and also attempted to limit the
number of words which could be written. The
postcard, as a cheap means of communication,
was no more. The magic had disappeared in a
strangling web of red tape.

For both the railways and the picture postcard
the golden age had come to an end.

beauty spots from Touraine to the Pyrénées.

Sometime during 1912-13 the Chemin de Fer
de l'État published fifteen poster cards in booklet
form as a joint promotion with the London,
Brighton & South Coast Railway. Probably as
earlier issues they were part of two eight-card
sets, but this has yet to be confirmed. The artists
included Toussaint, Duval and Dorival.

As early as 1871, an Act of Parliament had
decreed that in a time of emergency the
Government could take over control of any or all
of the principal railways. At midnight on 4
August 1914, the British Government exercised
that power. The demands of war brought about
restrictions in travel, and never again could it be

Grouping to 1939 and Nationalisation

From New Year's Day 1917, when the Order in Council of the previous month became effective, drastic changes took place in the structure of the railways' administration. With the curtailment of services and increased fares came the closure of stations and halts, and quickly in their wake, the closure of several branch lines; some were never to reopen.

Now, after more than 60 years, the impact on the railways, and the immediate effect upon the public of the radical Railway Act of 19 August 1921, which amalgamated nearly all the railways in Britain into four major groups is difficult to appreciate fully. Even the apparent parallel of the later nationalisation bears no real comparison. Just as the picture postcard had been a popular and cheap means of communication, so too had the railways enjoyed universal acclaim. But now the familiar order of society had changed — and people do not like change.

In the climate of social unrest which clouded much of the 1920s, public opinion, both in and out of Parliament, fluctuated considerably with regard to the railways. The new companies began to look to the experiences of the North American and Canadian railways' successes with publicity, and the 'Big Four' recognised the promotional possibilities of creative advertising. The lessons of the postcard-collecting hobby during the first decade were not entirely lost. Pictorial posters created by specially-commissioned artists began to appear, along with the brochures, guide books, picture postcards, and lantern lectures. Advertising became the science of persuasion rather than random announcement. The technical advantages of inventions and improvements in printing processes aided the development of new advertising techniques.

Following upon the delicacy and curves of the Art Nouveau era came the formalised and geometric boldness of Art Deco with its elements of Cubism and Futurism. These artistic fashions were echoed in the picture postcard world. The fresh modernity of Art Deco was for a while dominated by the Parisian couturières, prominent among whom was Paul Poiret. Contemporaries developed the theme so that it spilled over into transport and architecture. On the railway scene an influential artist was A.M. Cassandre, the initials being those of his real name, Adolphe Mouron. His dramatic graphics are best remembered from his poster 'Nord Express', created for the Chemin de Fer du Nord in 1927; also his starkly simplistic 'Étoile du Nord' for the same company. New standards were created by famous artists commissioned by the railways to present the new commercialism. Colourful realism by Norman Wilkinson for the LMS, Frank Newbold for the LNER, and Fred Taylor for the London Underground, brought beauty to the railway poster. Sadly, their work extended little into the picture postcard world until the days of the 'modern' postcard with its poster reproductions. Of the few examples known, the 'L·N·E·R Our Centenary 1825-1925' card, with its graphically dramatic 'light and shadow' illustration of *Locomotion* by Fred Taylor, and the coloured picture of the SR steamer *Invicta* leaving Dover, by Norman Wilkinson, are fine representatives.

The Snowdon Mountain Tramroad and Hotels Co was one of seventeen light railways which did not come within the scope of the grouping Act. Along with five other light railways in Wales it continued to trundle its own way without the encumbrance of political pressures. Sometime around 1923, the Snowdon company, which ran to the Summit Station 3,493ft above sea-level, issued eighty-eight postcards known as the 'Snowdon Series'. Number 1 was a vertical map card showing the railways of North Wales in black, with the Festiniog, Welsh Highland and Snowdon Railways printed in red. Numbers 2-25 were printed in brown collotype, with the title on the back; 26-50 were photographs of paintings; 51-2

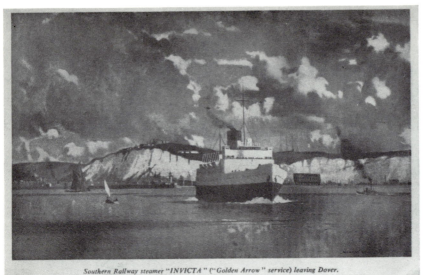

Southern Railway steamer "INVICTA" ("Golden Arrow" service) leaving Dover.

39 This plain printed postcard does rather less than justice to Norman Wilkinson's very colourful poster illustration. The steamer *Invicta*, seen here leaving Dover, was the second link in a chain which connected Southern Railway passengers with Paris, and on to the Riviera, the Orient Express, India, and the Far East. The entire train-load of passengers and luggage was transferred to the ship, and five minutes later, 1 hr 55 min after leaving London the cross-Channel journey began. (Southern Railway correspondence card, issued about 1947, pu July 1947, printer unknown) (*John Silvester*)

were coloured posters; and 53-8 were photographs by Abrahams of Keswick. There are considerable gaps in the list of known cards in this series, and it could well be that more cards were printed, possibly up to one hundred.

George Abraham was apprenticed to the famous London engravers and photographers, Elliott and Fry, in 1860, before setting up his own business in Keswick sometime in 1865. This establishes him as one of the pioneers of commercial photography, and it is more than probable that he took some of his inspiration from another photographer, Francis Frith, who went on to become a picture postcard publisher. Frith established his business in Reigate in 1860, and was the first to exploit the commercial potential of photography; within a few years, more than 2,000 shops throughout the country were selling his pictures. Abraham's eldest son, George Dixon, was a painter after the style of Elmer Keene, some of his work being featured on postcards. Possibly some of those issued by the Snowdon Tramroad, who always referred to themselves as a Mountain Railway, (card Nos 26-50, mostly of the Festiniog and the Welsh Highland Railways) could have been by him.

It was not until about 1931 that another set of cards appeared, eleven (possibly twelve) plain-printed, by Valentines. The pictures included various scenes along the track towards the summit and the hotels, some showing the train. Some similar views, and others, were on a twenty-four card set printed by Photochrom, and issued in 1936. They were printed in sepia, but at least one card is known in photographic

style, so possibly the rest could have been issued also in this style.

The other five non-grouped light railways did not issue picture postcards in this final era. The Corris Railway, which began life as the Corris, Machynlleth & River Dovey Tramroad Company in 1858, has an uncertain postcard history. Although it only issued one series of cards which can fairly safely be assumed to be officials, others have been recorded which may or may not fall into that category. Indeed, the only certainty about these cards is their uncertainty; dates cannot be categorically stated for them. This is especially true of the final set of probable officials issued in its name and bearing the Kingsway Series marque of W.H. Smith. Although it is described in a GWR publication, *Welsh Mountain Railways* (1924), the map only shows it as a jointly-operated line. Not until 1930 did the GWR formally assume control of the ungrouped line, which finally closed in 1948.

The nowadays very popular Festiniog Railway bears very little resemblance to the FR of the 1920s, and the railway of that era was vastly different to the original 1832 line. On its opening in April 1836, it became the first public narrow-gauge railway in the world. In 1924 the GWR Tourist Guide described the Blaenau Ffestiniog station by saying that 'Whichever way the tourist may take, there is the impression, on arriving, that he has now reached the Roof of the World.' Only one picture postcard is known to have been issued by the Festiniog Railway, date uncertain, a reproduction of its famous silhouette-style poster showing a train coming

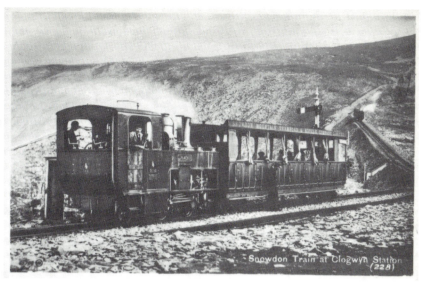

40 The locomotive *Snowdon* of the Snowdon Mountain Tramroad waits on a passing loop at Clogwyn Station. The photograph was taken much earlier, but the card (Valentines 228) was franked at the summit of Snowdon and posted in Llanberis, on 9 May 1938. The sender of the postcard observed, 'A lovily [sic] drive & scenery. Very cold up here!'

round the Moelwyn Mountain. Such a card would probably cost the collector lucky enough to find one something in the region of seventy to eighty pounds.

In 1872 the North Wales Narrow Gauge Railway received the Royal Assent, the authorisation originally being for a section of line from the Croesor & Portmadoc Railway. Its chequered career was brought to a halt in 1916, part being reopened in 1922 before becoming part of the Welsh Highland Railway. It is not known to have issued any official postcards, although a few private publications do exist.

The Portmadoc, Beddgelert & South Snowdon Railway, opened in 1904, had working agreements with the North Wales NGR, but these did not come into force until 1908. It was opened up the Glaslyn Valley to Snowdon as part of the Welsh Highland Railway, and started from the same station as the Festiniog line, just beyond the GWR Portmadoc station. The Talyllyn Railway was opened in 1865 to enable slates to be brought from the Bryn-Eglwys quarries. It was closed in 1949, reopening in 1951 under the management of the Talyllyn Railway Preservation Society. Like the Portmadoc and Snowdon line it did not issue any postcards.

The only other narrow-gauge railway to issue picture postcards during this time was the Vale of Rheidol Railway. The company had been incorporated in 1897, authorised to build a line some eleven miles or so, at the very narrow gauge of 1ft 11½in, between Aberystwyth and Devil's Bridge. The original Royal Assent had been given in 1873, but it was not until December

1902, that it was opened. It was amalgamated with the Cambrian Railway in 1913, eventually being absorbed by the Great Western Railway in 1922. A GWR guide book of 1924 stated that in August more than 5,000 passengers per week travelled through 'the majestic beauty of this valley' to Devil's Bridge. The line was closed in 1940, ten years after winter services had been withdrawn, but reopened in 1945 and is still steam operated.

The VRR only issued eight cards, the dates of which are uncertain. At least five advertising overprints have been recorded, one of which reads, 'Tomorrow (Friday, June 30th, 1905), LAST DAY 1s 6d RETURN TICKETS to DEVIL'S BRIDGE Are Issued This Season'. The railway was also advertised as 'The Prettiest, The Shortest, and the Cheapest Route to the DEVIL'S BRIDGE'. The first three cards were in the Dainty Series, a trade name of E.T.W. Dennis, of Scarborough, which appeared about 1904. The use of overprints on these and the other cards is just another example of the standard practice of the day of printers and publishers making use of old stock for new purposes.

Two coloured views of Aberystwyth, both known with various overprints were printed by LP&FAP Llandrindod Wells. The initials hid the rather cumbersome name of 'Landscape, Photographic & Fine Art Publishers' under which title Evans & Son traded. They specialised in Welsh view cards, their first postcards appearing circa 1905. The fifth card was one of the Peacock Series, No 276, a picture of the Hafod Arms Hotel, and was originally an

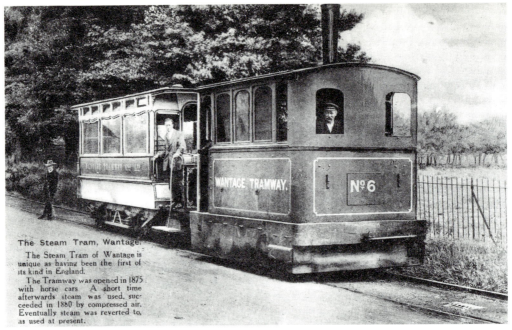

The Steam Tram, Wantage

The Steam Tram of Wantage is
unique as having been the first of
its kind in England.
The Tramway was opened in 1875
with horse cars. A short time
afterwards steam was used, suc-
ceeded in 1880 by compressed air.
Eventually steam was reverted to,
as used at present.

41 The original steam tram built by Grantham in 1872 was put into service on the Wantage Tramway in 1876. Opened in 1875 with horse-drawn trams, the company soon turned to steam power, abandoning that in 1880 in favour of compressed air. The line eventually reverted to the use of steam which provided its motive power well into the 1920s. ('Famous Series' by Tomkins and Barrett, Swindon; pu Wantage, 22 July 1925) *(Frank Staff)*

advertisement for the inn, but was occasionally overprinted with railway advertisements. The card, with the familiar green peacock trade mark, was printed by the Pictorial Stationery Company, who were one of the earliest picture postcard publishers.

Most of the early issues of the LMS were hotel cards, some being reissues of the cards originally published by its constituent companies. With the obvious exceptions of about six dated cards (some of the six-card set of the Turnberry Hotel and Golf Course have been recorded with 1922 postmarks), few of the more than eighty-five LMS hotel cards can be positively dated, except that they were published after 1923. Two in particular, are cards featuring the Welcombe Hotel, Stratford-upon-Avon, which opened on 1 July 1931, and the New Midland Hotel, Morecambe, which opened early in 1933.

A correspondence card in colour, but with no indication of the printer, shows an LMS furniture removal wagon. The card is known in two versions, one including background houses, the other having the buildings artistically touched out of the picture. One version has the information 'IV. 33' above the stamp rectangle, but some similar pictures, about 1930, have been repro-

duced in various publications.

The lack of a date affects five sets of shipping cards issued by the LMS, probably about the same time; only a few cards from each set are known. In the absence of any official record, two of these shipping cards present a bit of a puzzle; arguably, they are both railway and shipping officials. The cards were printed for the White Star Line who operated services to Ireland, France, North America and Canada from the busy port of Liverpool, to and from which the LMS ran connecting trains. There was probably some agreement that they could be overprinted with railway information. Pictured on the cards are the White Star liners *Megantic* and *Olympic*, and on the reverse is an overprint, 'Exchange Station Hotel, Liverpool'. Of the three hotels in Liverpool owned by the LMS, the Exchange (formerly belonging to the Lancashire & Yorkshire Railway) was the nearest to the White Star Line Dock.

It is more than likely that the sporadic issue of official railway cards between the 1923 grouping and 1930 owed much to the state of unrest within the Big Four companies themselves. In the third week of the first full year of amalgamation there was a strike of locomotive drivers, and closures of

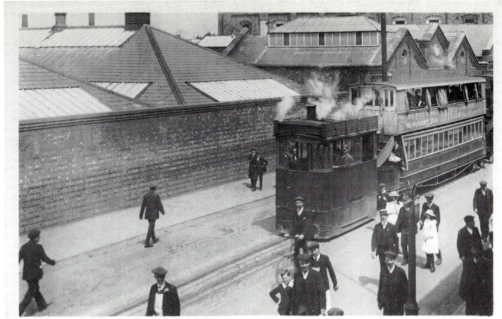

THE TRAM, WOLVERTON

42 The Wolverton and Stoney Stratford Tramway Company was incorporated in 1869 and opened in 1887. It was operated by the LNWR after reopening on 11 November 1891. Under the 1921 Grouping it became part of the LMS, and closed during the General Strike on 19 May 1926. The engine seen here is a Falcon Steam Tram built at Loughborough. The catalogue specification stated that all the brasswork was of 'ample strength and made of the best gun metal.' *(Frank Staff)*

branch lines became a common occurrence. There was an easing of the situation in 1925, the centenary year of the railways. A wide variety of publications celebrating the event was issued by the railways, but only the LNER seems to have issued any postcards to mark the occasion. In that centenary year the Wantage Tramway, which had been incorporated in 1866, was closed to passenger traffic, waiting another twenty years before final closure.

May 1926, opened with the General Strike which included railway workers, and in the third week, the LMS-operated Wolverton to Stoney Stratford Tramway, which had originally been worked by the LNWR since 1891, was closed. The same fate befell the old Ripley section of the Midland Railway. The following month saw the closures of two sections of the old Great Eastern Railway in the London area, and a section of Great Western line. Between then and September 1930, which saw the centenary of the Liverpool & Manchester Railway, no less than forty-two branch lines were closed all over the country. Small wonder that the public were disenchanted with the railways, and that the 'smart set' went motoring, inspiring some very fine Art Deco postcards by Pierre Brissaud, Rene Vincent,

George Barbier and André Marty.

Among the many publications for the 1925 Railway Centenary, perhaps the 162-page supplement to *The Locomotive* was the most remarkable. This magazine was published by The Locomotive Publishing Company who also specialised in picture postcards of railway interest. The supplement commemorated the opening of the first public railway and was also a souvenir of the Tenth International Railway Congress. It includes many monotone full-page composite plates of locomotives, bridges, and other scenes on the various sections of the Big Four described in their histories. Also featured are eight splendid appliquéd colour pictures of postcard size; only six of them have ever been recorded as postcards. Among the thirty-eight pages of advertisements, most of which would have made superb advertising cards, the LPC could only manage to advertise its predominance in the railway field with announcements of two books, *Laminated Springs* and *Train Heating and Lighting*!

The *Book & Programme of the Liverpool & Manchester Railway Centenary* was just as bland and 'blind' in its publicity approach to such a momentous occasion. In its 124 pages there were numerous illustrations from old prints depicting

scenes in the two cities; but only four were anything to do with the railway! Indeed, there were more illustrated advertisements which fulfilled that duty, the designs of which would have made splendid picture postcards. One such advertisement actually appeared as a postcard, but not until the advent of the modern poster reproduction of the 1970s; it was the dramatic picture used by The Liverpool Overhead Railway which advertised a 'Splendid View of the Docks & River'.

The LMS itself only managed to publish one picture postcard of the 1930 Centenary Celebrations. It was a photograph with a white border of the locomotive *Lion* and replica coaches. No postcards were published by the LMS to mark the 1925 celebrations. The *Lion* was a Stephenson's *Patentee* class (evolved from the *Planet* class in 1833 by the addition of two trailing wheels behind the firebox), and was specially built for the Liverpool & Manchester Railway in 1838. She was sold to the Mersey Docks and Harbour Board in 1859, and ended her working life as a stationary pumping engine; this historic locomotive survived until recent years as a working museum exhibit.

A four-card set, printed by Photochrom, was issued about 1930, and depicted the LNER high-pressure compound express locomotive No 10000, built in 1929, and known as the 'Hush-hush' because of the secrecy surrounding it. The first locomotive built in Britain with a marine water-tube boiler, No 10000 was a very advanced design, and in working trim weighed more than 103 tons.

Printed variously by Photochrom and the Locomotive Publishing Company, other cards showed *Sir Nigel Gresley*, *The Coronation*, and the *Silver Link* engines and their trains, among more than fifteen named trains; these cards can therefore be fairly closely dated.

Of especial interest is a two-card set of 'The Northern Belle in Scotland'. This was a cruising train introduced in 1933 by the LNER, and was claimed to be the most unusual luxury train in Europe. The train was as self-contained as an ocean liner, and indeed was the railway company's answer to the then current fashion of liner cruising; it was virtually a five-star hotel on wheels. Four cruises were run during June, for which passengers paid £20 for the week's holiday,

travelling over 2,000 miles. Only sixty passengers were carried on each trip, and special souvenir tickets were issued. In addition to the footplate-men of the two locomotives used to haul the train, there were a total of twenty-seven staff and a host, who were accommodated in their own coach. The cruise, which was a very fashionable social event, included motor-coach trips in the English Lake District and extensive coach and steamer tours through the Scottish Highlands.

Although the LNER were the innovators of camping coaches only four postcards of them have been recorded; they were photographic with a white border, but with no indication of the

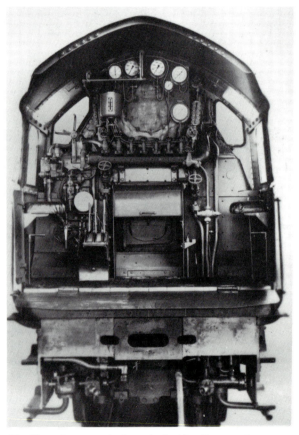

43 Few picture cards show the inside of locomotive cabs, perhaps for obvious reasons. This one is of the LNER high pressure compound express locomotive No 10,000, nicknamed the 'Hush-hush' because of the secrecy which surrounded its construction in 1929. Designed by Nigel Gresley, it was used on the non-stop run from King's Cross to Edinburgh, hauling the 'Queen of Scots' Pullman Express. Due to several unforeseen problems connected with its use of high-pressure steam, it was never a great success, and further development was discontinued. (Photochrom Co)

44 LNER Camping Coaches were situated at quiet little country stations, infrequently visited by trains. They were out of the way of what little traffic there was, not too far away from the station, and under the care of the local station-master. Equipped with every possible requisite for a camping holiday, the coaches accommodated six persons for an average rental of just £3 per week. They were very popular during the mid-1930s just prior to the outbreak of war. (London & North Eastern Railway, about 1934) *(John Silvester)*

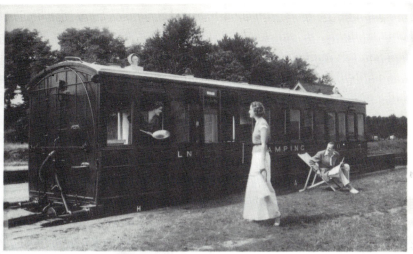

L.N.E.R. CAMPING COACH

printer. The sites for the coaches were scattererd throughout the tourist areas of the country served by the individual companies; from the heart of Dartmoor or the New Forest to Hadrian's Wall and the Lincolnshire coast, from rural Essex to the Lake District and North Scotland from Southern England to Wales. The campers could thus enjoy any and every type of scenery, with beauty spots all within easy walking distance. Designed to accommodate six to eight persons the coaches were very well supplied with equipment for the modest sum quoted earlier.

Among the other postcards published by the LNER there are two of the 'Pacific Type Express Passenger Locomotive No 4472', otherwise more familiarly known as the *Flying Scotsman*. One is by Photochrom, in photogravure, and the other by the LPC. A further set of photogravure cards by Photochrom features views 'On The Track Of The Flying Scotsman'. Both the locomotive and the train were quite remarkable in many ways. In 1911 Nigel Gresley succeeded Ivatt as Chief Engineer at the Doncaster Works; eleven years later came the pioneer 'Pacifics' which were to bring renown to Gresley. The most famous of these six-coupled engines was named *Flying Scotsman*; more than eighty were built by the mid-1930s, working all sections of the London to Aberdeen main line.

In 1934 the locomotive achieved several distance and speed records to add to an already impressive list. For several years it ran non-stop between London and Edinburgh, the longest such journey in the world. Such a performance brought into being a piece of special equipment, the like of which was found on no other railway in

the world. This was a corridor tender with a vestibule connection to the leading coach so that train crews could change over at the midway point of the journey. The train itself was quite unusual, having in its rake of eight or ten coaches (according to traffic demands and the season) a hairdressing saloon, a ladies retiring room and a cocktail bar. The restaurant car was perhaps the most remarkable, being a very luxurious three-car composite, furnished in Louis XVI style. It was articulated in familiar LNER style, with the central kitchen car sharing its coach-end bogies with the restaurant carriages at either end.

The *Flying Scotsman* caught the public's imagination, and for the occasion of the Railway Centenary the LNER produced some fine publicity material. Prominent among these items was a 130-page stiff-covered book entitled, *"The Flying Scotsman" The World's Most Famous Train*, and priced at one shilling. It was presented in similar style to the GWR publications about their expresses, and at the end of its lavishly-illustrated history there appears a list of 'interesting publications' dealing with the locomotive.

Photographs, 11in × 7in, of the locomotive as exhibited at the British Empire Exhibition (1924) were available, price 1s post free. The postcards mentioned earlier, and in colour, were listed, price one penny; through the post they cost the purchaser one halfpenny extra. A coloured plate of the *Flying Scotsman*, 25in × 11in could be obtained for the modest sum of 1s 6d post free. Cardboard scale models of locomotives (*Locomotion No 1* and *Flying Scotsman*) and carriages (*Experiment*, 1825 and the latest sleeping

cariage), each with full instructions for cutting out and assembling, were listed at 6d per set, or 8d by post. A book, *The Railway Centenary*, describing a century of railway development, was available price 3s 6d. These publications were obtainable from LNER offices and stations, or from the Advertising Manager, 26 Pancras Road, London NW1; York; or Waverley Station, Edinburgh.

But it is the last item on this list of what are now collectors items, which provides a puzzle. Boldly advertised are 'Railway Centenary Postcards — Postcard views of old and modern engines and trains, and public notices of 100 years ago. Price 1s.6d. per packet of 12 cards, post free'. They must have been produced in thousands, yet few of these remarkable picture postcards appear to have survived to be recorded and catalogued, individually or as the advertised set. What happened to them, the only official set of Railway Centenary picture postcards ever published?

Probably about 1930, the LMS published a six-card set of locomotive pictures by M. Secretan printed by the Locomotive Publishing Company. The splendid line drawings by this artist were a regular feature of the *Railway Magazine* at the time. An anonymously-printed set of eight photographic postcards, issued by the LMS, can only be approximately dated by the pictures they show. Most were of the 'Royal Scot' which toured America in 1933. Similarly, some odd cards of LMS camping coaches are from about 1934; the previous year, the LNER had introduced the idea of converted coaches located at fixed sites in tourist areas; special tickets were issued for travel to these special coaches. These temporary homes on the railway were very popular, providing the holidaymaker with one of the cheapest of all holiday apartments. The average cost was £3 per week for a coach accommodating six persons, the price including all lighting, heating and water services. Some coaches could be hired on the caravan principle, being towed to a different location every day.

Sometime in the mid-1930s the LMS issued a six-card photographic set, which bore no printer's mark, and were really more of an advertisement card. The pictures were of various scenes, popular with tourists, in North Wales. Each carried a message in handwritten style, 'On an

LMS Train. You must come to North Wales for your Holidays this Summer and get an LMS ''Runabout'' Contract Ticket the day you arrive — They only cost 10/- Third Class or 15/- First Class and you can have unlimited travel in the district for a week. It's a jolly good bargain!' The tickets were a development of the tourist and season tickets, intended to extend the limited flexibility of the special camping coach and excursion tickets.

The last issue of picture postcards by the LMS was in 1946. Printed by the Locomotive Publishing Company, they depicted in a six-card colour set, several classes of LMS locomotives. They have an extra historical interest in that they were priced '1/6 including Purchase Tax', a punitive, inconsistent tax which was eventually replaced by a more widespread imposition.

The greatest concentration of picture postcard issues by the London & North Eastern Railway was of the company's hotels throughout the country. The majority were, of course, reissues of pictures and cards of establishments formerly belonging to the constituent companies of the LNER. One thirty-seven card set ran to no less than six editions.

The only other large set of postcards was of LNER shipping which includes twenty-six cards. Most of these are of anonymous origin, but some carry the Kingsway marque of W. H. Smith and their number; all are in this style. The official cards carry informative details on the back about the ships pictured; many of these cards are known as private publications (some are pirated versions), and are without the information. In the lower right-hand corner of some of the pictures there is a number which may indicate the year of issue (probably ranging from 1931 to 1937); the pictures remain unaltered in the non-numbered versions. Issued in the same manner as the LMS White Star liner cards with overprint, and presenting the same puzzle, was the postcard picturing the RMS *Franconia* of the Cunard line. On the reverse is an overprint, 'Royal Victoria Station Hotel, Sheffield, L. & N. E. Rly.'

A single funnel, twin-screw liner carrying just over a hundred passengers (more than fifty with private cabins), the RMS *Franconia* was a sister ship to the *Laconia*. Of 19,695 gross tonnage, she normally sailed between Liverpool and New York, calling at Cobh, County Cork, en route.

On Saturday 16 December 1933, the *Franconia* departed Liverpool for provisioning in readiness for her 1934 World Cruise. She left New York at midnight on Tuesday 9 January 1934, commencing her Southern Hemisphere cruise, and returned to her New York berth at 2.00pm Thursday 31 May 1934, having spent 142 days at sea, travelling 37,555 miles, and visiting some thirty-eight ports in more than fourteen countries.

Some twenty-nine cards in five sets and three singles were published showing LNER trains and engines. Although some approximate date can be given for them, only one card, for the Railway Centenary, can be positively dated. This card, from the poster by Fred Taylor, 'L·N·E·R Our Centenary 1825-1925' showed the famous *Locomotion No 1*; this engine was the progenitor of countless 4–4–0s, although the particular wheel arrangement originated in America.

Of the Southern Railway's output of picture postcards, by far the greatest number were of their locomotives. Some hotel cards were probably issued, but only one is known with any certainty as an official. It is of the Charing Cross Hotel, in the Strand, and is a sepia reproduction from a sketch by Lambert. The card announces that the hotel has 'Recently been Re-decorated and Re-furnished.', and quotes a telephone number; but it gives no indication of either the printer or the year of issue. Relatively little is known about the SR Hotels, and Alsop, Hilton and Wright consider that there are probably only four for which officials might be found. They list eleven hotels, and advise that some were on lease to other firms; postcards issued by these leased hotels are not regarded as Southern Railway official. Perhaps there could be more waiting to be found; in the 1933 edition of *Hints for Holidays*, published by the Southern Railway, there appears an advertisement, 'The Company's well-appointed HOTELS include the following:' giving details of five names which are not shown on the Alsop list. The operative word is 'include', which hints at the possibility of others.

Two poster-style cards were issued about 1930; one card of the *Hampton Ferry*, and the other, probably as well-known as the 'Skegness Is So Bracing' poster by Hassall, features the little boy, Wilfrid Witt, and his suitcase, standing by a *King Arthur* Class locomotive. He was photo-

"Yes, I always go South for Sunshine by SOUTHERN"

45 The famous poster, reproduced on a postcard, of little Wilfrid Witt chatting with the engine driver. Printed in Britain, the card was issued in France to advertise British railways. Tickets of all categories were available from the Paris Bureau for passengers wishing to travel from the city or the French ports to London 'and all destinations in Great Britain'. (Chemins de Fer Britanniques, about 1930, printer unknown) *(John Silvester)*

graphed looking up at the engine driver, and the publicity department recognised the appeal and potential of the picture. Waterlows were commissioned to produce a poster-sized photogravure reproduction; it was the largest example of such printing that had ever been made in Britain at the time (1925). Subsequently the picture was reproduced in colour for both poster and postcard with the title, 'Yes, I always go South for Sunshine by SOUTHERN'.

A probable set, printed in half-tone, of SR ships, was issued about 1924. They were almost certainly officials, splendidly presented with descriptive details below each picture; so far John Silvester has recorded seven of these

pictures, and thinks it probable that one was produced for each ship. A further two cards show the interior of the Ladies General Lounge on the SS *Isle of Guernsey*, and the other a view of the King George V Graving Dock; both were photographic cards.

The *Isle of Guernsey* was introduced in 1932 and was one of the Southern Railway's new steamers in the Southampton to the Channel Islands service. Sailing outward from Southampton at night the steamers first called at Guernsey ($6\frac{1}{2}$ hours' journey), a further two hours to Jersey, and with motor-boat connections to Herm and Jethou. The twin-screw, oil-burning steamers were among the most comfortable and luxurious of any which crossed the Channel. To make the connection during the summer season, a supper-car express left Waterloo Station every night for Southampton. There were convenient through trains from the Midlands and the North to the port, with an alternative route via Weymouth.

The first sets of 'Trains and Engines' issued by the SR appeared sometime in 1924, probably to coincide with the British Empire Exhibition. Three sets, two of six cards and one of seven, were printed in sepia, with a white border, by the Locomotive Publishing Company. They featured quite a wide variety of engines, mixed traffic, tank engines, expresses, with Pullman and all-steel rolling-stock well illustrated. The Southern Railway was one of the main developers of the Pullman car system in Britain, and for many years ran a non-stop service between London and Brighton. One of the cards pictures the Down Southern Belle Pullman Limited Express which accomplished the journey in exactly 60 minutes. After a quarter of a century, the Southern Belle, Britain's first all-Pullman express, having carried more than four and three-quarter million passengers, was replaced by the crack electric express, the Brighton Belle.

The Photochrom Company produced some postcards of the locomotives *King Arthur* and *Lord Nelson*. Several cards featuring SR locomotives were produced by Photochrom, and in a similar style to the LPC issues, but they do not carry the wording 'Produced for the Southern Railway by' The *King Arthur* Class locomotives, which weighed 138 tons with tender, were finely-proportioned engines which were among the most efficient 4-6-0s in Britain. They regularly

hauled rakes of twelve to fourteen coaches up lengthy gradients of 1 in 80.

Between 1930 and 1935 three special sets were issued by the Southern Railway. The first featured *Lord Nelson* Class, the second *Remembrance* Class, and the third the 'Schools' Class. As discovered by Alsop, Hilton and Wright, there are several cards in these three sets, generally of a similar style, with a white border and the titling below the picture; technical details are printed on the back of most cards. The authors thought that it was possible for cards to have been produced for every engine in these classes, so they give a complete list. As with the other 'class' cards, the 'Schools' postcards were numbered; they were published in two editions, one photographic and the other photogravure, but to date not all of the cards have been recorded.

The *Lord Nelson* Class locomotive was a larger development of the *King Arthur* Class, with four cylinders instead of two. The engines were unusual in that the conventional 90° crank arrangement was altered, two opposite cranks being advanced by 45°. This gave the locomotive a distinctive exhaust sound from the eight piston impulses for each revolution of the driving wheels. Although it was a larger locomotive than the *King Arthur* it weighed only $2\frac{1}{2}$ tons more.

Named after famous public schools, the 'Schools' Class were the heaviest 4-4-0 express locomotives in Britain. Although only having three cylinders, on a power/weight ratio they were almost as powerful as the *King Arthur* Class, producing 25,130lb of tractive effort. Being both powerful and relatively lighter than other SR express locomotives, the 'Schools' were extremely useful over sections of line with weight and dimensional restrictions.

Probably between late 1938 and early 1939, the Southern Railway issued four attractive eight-card sets, printed in colour by W.G. Briggs & Co from oil paintings by Leonard Richmond. The first set, 'The Channel Ports', was of standard size and available price 8d, with the titles on the backs. Each also carried the slogan, 'Eight routes to the Continent by Southern Railway'. The other sets, 'Hampshire Views', 'Devon Views', and 'Cornish Views', also in colour by the same printer, were slightly larger cards. Although twenty-three titles have been recorded by John Silvester, it is not known in

46 A fine artistic study by Leslie Carr of the Southern Railway lightweight 'Pacific' type locomotive, 'West Country' class *Axminster*, built at Brighton in 1945. The style of the picture owes much to H.J. Mayo, of the GWR publicity department, whose famous poster 'Speed to the West' appeared in 1939. These postcards were presented to guests at the naming ceremonies, but how many of the class were thus represented is not known. Some cards are known untitled or with the appropriate town crest printed in the top right-hand corner. (Southern Railway, West Country Class, published 1945-6) *(Ian Wright)*

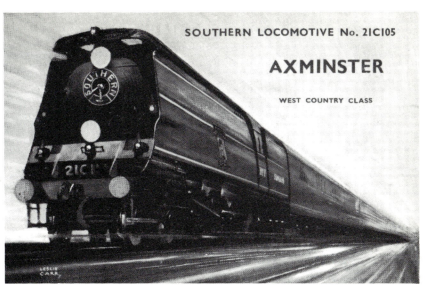

SOUTHERN LOCOMOTIVE No. 21C105

AXMINSTER

WEST COUNTRY CLASS

what order they were printed as they are not numbered. Some half-tone views issued as correspondence cards were probably used in the mid-1920s; they are very similar to late-issue correspondence cards of the London, Brighton & South Coast Railway.

Leslie Carr produced a fine picture of the SR 'West Country' Class locomotives, similar in style to Mayo's 'Speed to the West' picture (GWR, early 1930s). The series was numbered consecutively 21C101 to 21C120, but on the picture the last two figures, visible just above the buffer beam, are deliberately indistinct. The cards, issued sometime between 1945 and 1946, are known in two versions, one with the area to the top right of the picture shown blank, and the other with the space filled with the number of the engine, the name (and sometimes the crest) of the town, and the title of the class. In this latter form the number above the buffer beam does not conflict with the overprinted number for the individual engine. At least seven of the titled cards are known, and although there is no indication of the printer's name, there is a detailed description of the class on the back of each card.

A correspondence card was issued sometime in 1947, which featured the SS *Invicta* in a picture by Norman Wilkinson, previously mentioned; plain printed, the card gives no indication of the printer's name. The steamer operated on the 'Golden Arrow' Service which was inaugurated in 1926 between London and Paris. On both the Southern Railway and the Chemin de Fer du Nord sections passengers travelled by Pullman

cars, the exchange between railway and cross-channel steamer averaging about twenty minutes. The 'Golden Arrow', or the 'Flèche d'Or' as it was known in France, arrived at the Gare du Nord only six hours forty minutes after departure from London Victoria.

Before the concept of officials was abandoned there were a few more issues from French and British lines. Sometime after 1923 the Chemin de Fer de l'État issued some reprints of a previous series. Printed by Henon of Paris, the cards were of a much poorer quality than the originals issued jointly with the London, Brighton & South Coast Railway. The LBSC by this time had become part of the Southern Railway. The pictures were artist drawn, probably about 1905, by such masters as Duval and Toussaint; only eleven cards are known. A similar series of six cards, printed by Norgeu of Paris, was issued by l'État about 1926. In 1930, or thereabouts, a six-card set, also artist drawn, was issued by the Chemin de Fer d'Orléans, with the title and description in a box on the back of the cards.

The Larne and Stranraer Steamboat Company was formed in 1871, and one year later introduced paddle steamers into its fleet. It had a chequered history of ownership until it was taken over by the LMS in 1923. Sometime thereafter three coloured postcards were issued which apparently show the RMS *Princess Victoria* and the RMS *Princess May* in their new livery. The third card is of the turbine steamer RMS *Princesss Maud*. The first two ships were built in 1890 and 1892 respectively as sister ships by Denny of Dumbarton; they were the last two paddle steamers to be used

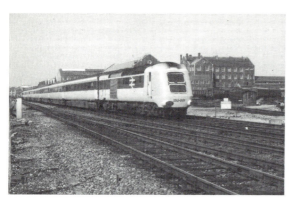

47 A prototype locomotive No 252 001 of the
experimental High Speed Train is seen passing through
Swindon in June 1975. Many of its early problems were
the same as those discovered by George Stephenson,
namely, that railway construction needed to keep abreast
of locomotive development. (OPC Collectors Series No 46)

on the Northern Channel route between the
Scottish and Irish mainlands. Being sister ships
they were identical, and the same picture is used
to show both, but which was actually which is not
really known.

The last official postcards to be issued by any of
the London Underground railways came from
the Metropolitan District Railway for the
occasion of its Diamond Jubilee Exhibition, 5-8
November 1928. White-bordered sepia photo-
graphs, the seven-card set were not individually
titled, but listed on their presentation packet.
The cards are numbered within the stamp
rectangle, with the date of the subject stamped
on to the picture. The subjects range from a
District Railway locomotive of 1868 to the 1928
all-steel carriages.

The official railway picture postcard, born in
the heyday of both postcards and railways, had
been dying gradually since the grouping days of
1923. Several brave attempts were made to
revive it in the early 1930s, but the spark of life
was virtually extinguished. It lingered through
the war years between 1939 and 1945, struggling
to survive against overwhelming odds, with
restrictions on money and materials taking their
further toll. Between 1930 and 1947, 192 branch
lines and important sections were closed, some
actually being abandoned. Small wonder then,
that little notice was taken when, on 6 August
1947, the Transport Act (1947) received its
Royal Assent. With its entry into the Statute
Book, nearly a century and a quarter of railway

history came to an end.

In agreeing that the Golden Age of railway
picture postcards passed in 1947, John Silvester,
with characteristic loyalty to the memory of the
official postcard, asserts, 'We did at least enter a
"Silver Age" under British Railways.' There
does not appear to be a complete and official
record of what was issued, how many, and
exactly when. But more than 150 cards of hotels,
steamers, trains and posters have been issued by
the nationalised British Rail(ways) between
1948 and 1985.

Their style and presentation have changed
quite distinctly in that period, from the real
photographic to three-colour photo-litho. Picture
postcards have always been a unique social
record; as a friend of mine once described them,
'fascinating fragments of other peoples' lives'.
Railway postcards are no exception to that rule,
and are a mirror of the times. Today's railway
officials are harsh, brash and aggressive, lacking
the gentler, if matter-of-fact 'documents' of
earlier days.

Three of the more modern BR cards are worth
a mention in this respect. The card for the APT
(Advanced Passenger Train) is unique. The
train's technology was so far advanced that it
could not adapt to existing conditions, and
required more than its fair share of modifications
before being ready to go into service. One of the
factors which inhibited its use was that, just as
George Stephenson had recognised 145 years
earlier, railway construction development had
not kept pace.

The second card advertises the Inter-City 125:
'It's the changing shape of rail.' Beneath the
information 'London to Bristol: Now 92 minutes;
London to Cardiff: Now 113 minutes; London to
Swansea: Now 175 minutes.' stands the glossily-
painted, thrusting snout of locomotive No 253
008. The scene of the third card is beneath the
arched roof of Manchester Piccadilly, and at the
platform waits 'The Manchester Pullman'. A
formally attired attendant stands by the door
inviting the brief-cased executive in a hurry to
board, while another colleague makes notes of
the requirements of another distinguished
passenger who clutches at his newspaper. Unlike
the Pullmans of fifty years ago there is no
mystique about the train, no hint of elegance and
luxury.

Travellers' Rest and Railway Greetings

Parts of the stories of railway stations and hotels are closely linked, and the same is true of the railway hotel postcard and that of the German *Gruss Aus* (greetings from) card. Some of the earliest known *Gruss Aus* cards date from 1883, printed by the famous lithographer, Franz Scheiner, of Würzburg. Most of those early picture cards, with their vignettes around the correspondence space, were only black-printed line illustrations; the chromolithographs did not appear in general use until around 1890.

The *Gruss Aus* cards carried one or more vignettes featuring the prominent and important buildings of a particular town or locality; invariably, one of these buildings was the railway station. The station was a significant social focal point and an obvious meeting place. Its importance in the early days of railways cannot now be fully appreciated, as today's towns have their leisure and community centres as well as the town hall. It gradually became an established practice to buy a greetings card from the station, and to write the important message, 'I am here', then to post it at the station to family and friends back home.

Some of the finer *Gruss Aus* cards are exquisitely coloured examples of the chromolithographer's art, but almost without exception they feature the railway engines and trains in simple outline. Few technical details are shown and the pictures are like illustrations of toy trains.

With more writing being done at railway stations it was not long before the major railways were providing writing rooms. It is here that the story of the railway postcard and the hotels begin to merge. But it is best to go a little further back in railway history to pick up the threads.

The success of the Liverpool & Manchester Railway, which opened on 15 September 1830, heralded the end of the stage-coach era, and with more and more railways being opened, the consequence was that many hostelries on the stage-coach routes had to close down for lack of trade.

The railways were relatively speedy and comfortable in comparison with the stage-coach, enabling journeys the length and breadth of England and Wales to be made in a single day. Their undisputed superiority soon gave rise to a new kind of traveller, the businessman. Steel, coal, textiles and many other industries whose goods were transported by rail, demanded the urgent attention of those in the commercial world. Factories and warehouses sprang up in the large towns and cities alongside the railways; they were prosperous sites.

It was necessary for a firm's executives to visit other establishments and business contacts elsewhere, and first-class railway travel became the status symbol of the day. When required to stop overnight away from home, this new breed of traveller demanded a much higher standard than his stage-coaching forefathers had done. It did not take the railways long to discern that it would be both profitable and expedient for them to provide their own hotels. If conveniently situated near to the station the railway company would be able to retain its clients' patronage, even after they had completed their train journey.

In September 1839, the London & North Western Railway opened the first two railway-owned hotels in Britain. Both hotels were situated at Euston, on either side of the famous, and now demolished Doric Arch. The two hotels, the Victoria on the west side, and the Euston on the east, were both designed by the architect of the arch, Philip Hardwick, and they were eventually formed into a single block in 1881, completely hiding the arch.

Other railways quickly followed the example of the LNWR, and towns like Leeds, Bradford, York and Derby soon had their railway hotels offering varying degrees of comfort and elegance.

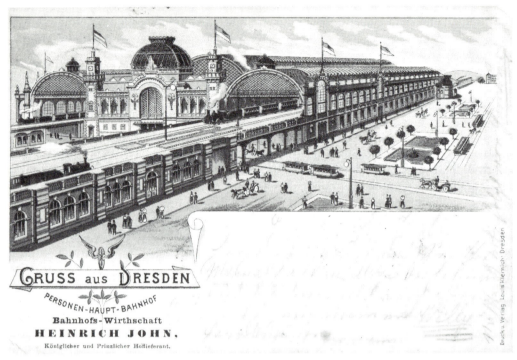

48 This complex at Dresden was typical of many major stations built in Germany during the nineteenth century. Vast glass-roofed 'cathedrals' housed the platforms which were above street level. The tracks ran across the tops of the administration offices, which, to say the least, must have made life difficult for the staff. (Chromolitho by Louis Klernich, Dresden, pu 10 November 1899) *(Frank Staff)*

In their heyday, some of these railway hotels set standards that were far in advance of their time, and some of which are difficult to surpass even today. Electric lifts and lighting, central heating and air-conditioning, and steel-framed buildings with fire protection found, if not their origins, then certainly their development in the railway hotels built around the turn of the century.

At one time there were about ninety hotels which were owned by railway companies, but of these, the nine establishments belonging to the Midland Railway were by far the best appointed and managed. From 1871, William Towle (later Sir) and his sons were responsible for the organisation of the hotels, commencing with the Midland Hotel at Derby. Their standards were carried through well into the days of the London, Midland & Scottish Railway by one of the sons, Arthur Edward Towle.

Several railway hotels have their own niche in history. At the Midland at Manchester in May 1904, The Honourable Stewart Rolls first met Frederick Henry Royce. A sadder occasion was at the Bradford Midland on 13 October 1905,

when Sir Henry Irving (who was playing at the nearby theatre), collapsed and died in its Marble Hall.

Towards the end of the nineteenth century, most hotels provided a writing room for their patrons together with a plentiful supply of attractive pictorial stationery freely available; the hotels' organisation also provided a despatch and receipt facility for patrons' correspondence. Although the pictorial stationery may have included an aspect of the hotel in the general scene, it was not until the advent of the picture postcard that it became general practice to make a feature of the hotel.

Probably the earliest official cards of any sort were the hotel postcards, and among the first of these were those issued by the Midland Grand Hotel, St Pancras, in April 1898, and the Glasgow & South Western Railway for their hotel at St Enoch station, in September 1898; both cards were coloured Court size. Printed in orange-brown, the Midland card shows vignettes of the hotel clock tower and Derwentwater. The Glasgow card shows an external view of the hotel

49 The *café chantant* beneath the glass domed roof overlooked the roof-top garden of the Midland Hotel, Manchester. The hotel combined the most up-to-date features of the Continental hotels with luxurious furnishings; it was described as a 'citadel and a miniature world in one.' (Midland Railway, about 1904, printer unknown) *(Ron Grosvenor)*

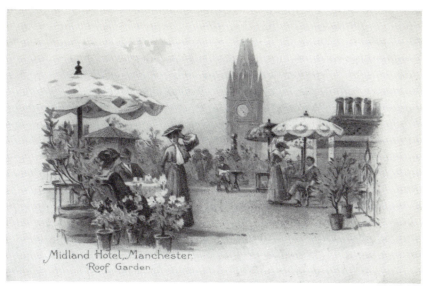

Midland Hotel, Manchester. Roof Garden

and an interior of the restaurant. It was printed by Bertram Cohen & Co, 4 Holborn Place, London, at their works in Germany; the name of the printer is not well known to postcard collectors.

By the time of the introduction of the divided back postcard in 1902 it is probable that full-sized and Court-sized cards were being issued by most of the railway hotels then open. By far the largest number of postcards featuring one hotel were those issued by the MR for their Midland Hotel, Manchester. All the MR hotels were wonderfully adapted to their particular area, but the most exemplary was the Manchester establishment. It revolutionised the concept of hotels throughout Britain, combining with its individual style (at its opening in 1903) all the latest and most effective features of the best continental hotels. Regardless of Manchester's infamous weather, it was ventilated by 'washed' air which was then filtered, and heated to a uniform temperature before being ducted into the halls, corridors and rooms. The saloons were richly panelled in mahogany and tapestries, and its famous Louis Quinze Restaurant opened on to a private terrace, beyond which was the famous glass-covered garden and orchestra. The hotel boasted 400 suites, each fitted with telephones; 100 others were in use by the hotel management. The English, French and German restaurants were each managed by its national cook; other facilities included a Turkish bath, a hairdressing saloon and the most completely equipped sub-post office in any British hotel.

In 1903, the Manchester Midland issued a twelve-card set printed in half-tone from photographs by Warwick Brookes. The pictures include views of the German kitchen, the garden, the coffee room and the 'Royal Suite' dining room. These cards are regarded as probable officials. In 1904-5, a nine-card set of vignetted hotel views printed on buff card was issued. Five of the pictures are of the Manchester hotel, and all cards bear the information 'W. Towle, Manager' together with the MR wyvern crest. In 1906, W.H. Smith & Son, in their Grosvenor Series, produced a series of internal views similar to those published in 1903; the cards were coloured, and are considered as probable officials. In 1907, a twelve-card set, fully coloured, and also considered as probable officials, was issued. Numbered 21816-21827, and similar in style to a 'Nearest Station' series issued about 1904, ten of the cards show interior views of the Manchester Midland, the other two cards being of the exterior.

A much later card featuring the Manchester hotel is from a painting by Charles Flower, and printed by Raphael Tuck & Sons. It is known in two editions by the MR; the LMS also made use of the same picture. Probably the most interesting of all is a little-known card which links with Manchester and St Pancras hotels. It is captioned, 'London and Manchester via The Switzerland of England', and shows line drawings of the two hotels above a timetable for March 1905.

Other Midland hotels featured on postcards were the one at Derby, and the Grand Hotel, St Pancras; both were vignettes printed in a similar colour to the 1898 issue, and carrying the MR

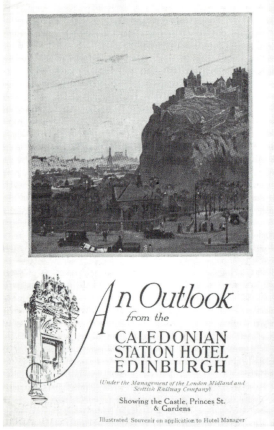

*A*n Outlook
from the
CALEDONIAN
STATION HOTEL
EDINBURGH

(Under the Management of the London Midland and Scottish Railway Company)

Showing the Castle, Princes St. & Gardens

Illustrated Souvenir on application to Hotel Manager

50 One can only compliment the artist upon the accuracy of his picture, the sender of the card observing, 'This is the sight that greets my eyes every time I look out of my bedroom window.' The same picture and format were used on a card issued by the Caledonian Railway. (London, Midland & Scottish Railway, about 1925, printed by McCorquodale) *(Ron Grosvenor)*

'Travel and Entertainment' motif, and issued in 1902. Also featured was the Adelphi Hotel, opened in 1914, and decorated in early Art Deco style. Four cards are known of this hotel which was advertised on one as 'The Most modern Hotel in Europe'. It was renowned for its luxurious furnishings, the public rooms and restaurants being decorated in the style of the staterooms in contemporary Atlantic liners. The story goes that passengers who travelled on the White Star liners would hardly know the difference between their sea passage and dry land when they stayed at the Adelphi.

The Glasgow & South Western Railway issued several cards of its hotels at St Enoch, Station Hotels at Ayr and Dumfries, and the Station Hotel, Turnberry, printed variously by Raphael Tuck & Sons and McCorquodale in chromo, mono, and half-tone versions. Of particular interest is the Turnberry Watercolour set printed by McCorquodale. The six cards show various views of the hotel, the golf course, and the cliff-top lighthouse. The hotel was built by the GSWR specifically to cater for golfing guests, and accordingly a superb golf course was landscaped at the same time; both were opened to the public in May 1906.

Probably the first Scottish railway hotel to offer golfing facilities was the Cruden Bay Hotel, opened by the Great North of Scotland Railway in 1899 at Port Erroll, near Aberdeen. The hotel, which ran its own tramway to the nearby station, was not a great success, and closed in 1939; however, several successful golf tournaments were staged on the Cruden Bay course. The railway company issued a set of cards of the 1909 tournament featuring the semi-finalists and finalists at various stages of their play; it is not known how many cards were issued, but at least twelve have been recorded.

Sometime around 1910, a series of photographic cards in a white frame were issued bearing the title, 'The Great North of Scotland Railway Palace Hotel Series'; there appear to be at least five editions of this series, each bearing this legend. The fifth edition is also known as the Adelphi Series, the cards being numbered. Most of the pictures feature the Palace Hotel, Aberdeen, but other views of the area are included. Four half-tone multi-views, and two green printed cards with pictures on both sides, of the aforementioned hotels are known.

One cannot leave Scotland, golf and hotels, without mention of the renowned Gleneagles Hotel and its world-famous golf course. The management of the Caledonian Railway, canny in business, had noted the success of the GSWR Turnberry Hotel and the Highland Railway's Highland Hotel at Strathpeffer. But their ideas for a prestige hotel with golfing and other sports facilities had to be shelved due to the outbreak of World War I. Landscaping of the golf course was finished and its greens ready for play in 1919. In that same year, the Gleneagles Station, originally known as Crieff Junction, was rebuilt; the old level crossing was replaced by a new approach road, nearly a quarter of a mile in length, making

it one of the finest station approaches in the country, as well as giving easy access to the private road to the hotel and golf course.

The hotel construction started in 1922, and was opened by the LMS on 5 June 1924. It was the subject of a strikingly beautiful poster by Norman Wilkinson. Set in a 600-acre estate, the neo-Georgian façade stands imposingly amid, but blends with, the rugged Scottish glen; the golf course still remains the mecca for the fraternity of the 'Royal and Ancient' game.

The Caledonian Railway's venture into publication of postcards showing its hotels began some time prior to the turn of the century. A Court card, printed by McCorquodale, shows the Central Station Hotel, Glasgow, and bears the dateline, . . .189. . . . The same card was issued with the dateline, . . .190. . . . Presented in poster style, and also printed by McCorquodale, are three cards, two coloured and the third printed in an orange-brown. The first coloured card features both the Glasgow hotel and the Caledonian Station Hotel, Edinburgh; the second is of an outlook from the Edinburgh hotel, the third is an alternative rendering of the second.

The Edinburgh hotel also features in a four-card series in colour, showing the interior, but printed by McCorquodale to a non-standard size of 87mm × 130mm. The title is in black on the picture but with no indication of the year of issue. Similarly, another card showing Princes Street, Edinburgh with the castle and gardens, is titled in black, and known in two editions with variations in the title. The Edinburgh hotel is known in two other issues, one with a white border and a green company crest, and in a vignette with a blue title, issued around 1904. The Glasgow hotel appears in a similar format issued at the same time; also in a vignette with a decorative frame, printed by A. Trur, of Switzerland; on a white-bordered chromolitho published in 1906, and a coloured litho showing its dining room.

The Highland Hotel, mentioned earlier, was featured on a postcard printed by Hills & Co of Sunderland, and bearing the legend, 'Strathpeffer — by the Highland Railway' on the reverse. Eight other hotel cards were issued by the HR between 1905 and 1912.

The London & North Western Railway owned nine hotels, eight of which were illustrated in plain collotype on some early Tuck cards; these cards were issued prior to November 1904. They all have the Britannia motif, but with the wording in the surround changed from 'London & North Western — Railway Company' to 'London & North Western Railway — Company's Hotels'. The exception to this was the card for the Park Hotel, Preston, which had the words 'L. & N.W. and L. & Y. JOINT' around Britannia.

All nine were illustrated on the plain printed McCorquodale issues of May and June, 1905, and the Park Hotel, Preston was issued six times between 1905 and 1909. The Railway Hotel, Bletchley, appeared once on a plain printed issue dated 6/05; no other cards of this hotel were ever issued. The Euston Hotel is featured on several cards produced by both Tuck and McCorquodale; different clock times and telephone numbers can be spotted by eagle-eyed collectors. The Queen's Hotel, Birmingham, is featured on postcards which show it both before and after its rebuilding. It is interesting to note that this LNWR establishment was the only railway-owned hotel in Birmingham; a Great Western project for an hotel at Snow Hill station did not materialise.

The LNWR first issued postcards in April 1904, but it is recorded that cards were being used at the North Western Hotel in Liverpool prior to this date. These cards were printed locally by Hugo Lang & Co, and show internal and external views of the hotels, with a dateline 19... below the titles; these cards are not official railway company issue. Hugo Lang was producing picture postcards of the local area in 1901, and later specialised in artistic portrayals of beautiful girls.

An important Act of Parliament in 1854 dissolved several railway companies and vested their interests in a company to be known as the North Eastern Railway. It became probably the most important railway in the country, with no serious competitor other than the Great Eastern for its compact system of nearly 1,800 miles of line. York was at the centre of this web of rails.

Advertising the Royal Station Hotel, York is a most attractive poster card, No 16 in a set of twenty cards printed by Photochrom and issued in 1908. Very colourful, it also lists the other four hotels in the company's chain, and is surely a must for the serious collector of hotel postcards.

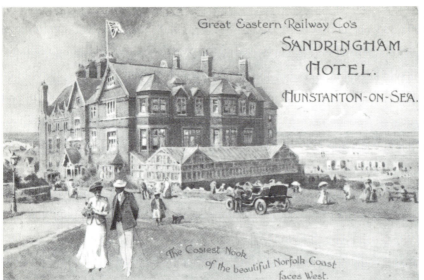

51 This postcard (probably from about 1910) shows the GER Sandringham Hotel. It quotes the company's hotels manager as H.C. Amendt. The caption on the bottom of the picture reads, 'The Cosiest Nook of the beautiful Norfolk Coast faces West.' Although on the east coast shore, and facing out to sea (The Wash), the lie of the land is such that an observer does actually face west. (Great Eastern Railway, printer unknown) *(Ian Wright)*

Another poster-style coloured card was later issued by the LNER of the view from the York hotel's dining room; its presentation was a welcome change from the more usual, rather drab photogravure cards of the 1930s. Probably the earliest hotel card issued by the North Eastern Railway was one in use in 1901, depicting the Zetland Hotel at Saltburn-by-the Sea. This card appears in a set of twelve cards which were issued in five styles. Two of these were printed by Photochrom, two by Ben Johnson & Co, of York and the fifth by that most prolific of all publishers, 'Anonymous'. The full list of Hotel cards issued by the NER is contained in Booklet No 7 of *Railway Official Postcard List*.

Formed of an amalgamation of several companies which received Parliamentary sanction in 1862, the Great Eastern Railway monopolised the counties of Norfolk, Suffolk and Essex and with extensions into Cambridgeshire and Hertfordshire, provided an important link between East Anglia and London. The line also had Royal connections. In 1862, Edward, Prince of Wales, purchased the Sandringham estate, and in 1863 the nearby station of Wolferton welcomed his bride, the future Queen Alexandra. Some thirteen years later a handsome suite of Royal waiting rooms was erected and furnished at the station. Since the rooms were often used for exclusive luncheon parties, it is not too unreasonable to suppose that they eventually came under the watchful eye of Mr H.C. Amendt. He was responsible for the management of all the hotels, refreshment rooms, and dining cars of the GER; his name was discreetly removed from company brochures at the outbreak of World War I.

The Great Eastern Railway issued some rather attractive coloured cards of their hotels at Harwich and Hunstanton, and bearing the company crest; some plain printed cards were later issued, but with date and printer unknown. First opened in 1884, the Great Eastern Hotel at Liverpool Street was featured on several cards, both coloured and photographic. Around the turn of the century the London terminus was rebuilt with eighteen platforms and twenty roads covering sixteen acres; at the same time extensions were made to the hotel which was then reopened in December 1900. In its reconstruction a splendid suite of banqueting halls known as the Abercorn Rooms was included, the most magnificent being the Hamilton Hall. The suite was shown on a coloured four-card set printed by J. Keliher, London, and issued in two editions.

One of the last independent railway companies to acquire a new hotel, the GER added the Felix Hotel, Felixstowe, to its modest chain in 1920. It was featured on a plain card issue of four cards, with the company's name on the picture side; earlier cards of the hotel are known, but of course, they are not GER officials. In the four-card set one of the cards has pictures on both back and front, one showing the 'Seaward Front', and the other a view 'In the Grounds of ...' It is interesting to note that long before the Felix became a railway hotel its management often included train timetables on the picture postcards; this is often confusing to those unaware of the date of the GER's ownership.

Published sometime between 1899 and 1901, the GER issued several *Gruss Aus* type cards as part of its publicity for the Hook of Holland service from Harwich; the vignettes showed the Harwich Hotel. A de luxe train was run from Liverpool Street to Parkeston Quay, covering the 69 miles in 87 minutes. Opened in 1865, the Harwich hotel offered travellers a most welcome refuge after a stormy crossing of the North Sea. The Great Eastern held the mail contract between Harwich and the Hook of Holland, its boats sailing whatever the weather conditions prevailing.

There are still quite a number of gaps in the railway hotel postcard file, some of the most surprising being those which possibly the GWR might have filled. Although it commenced issuing postcards as early as 1898, no early hotel cards have been recorded, despite the company owning at least three such establishments which might have been expected to publicise their services. The earliest GWR hotel postcards date from 1904-5, so one presumes that prior to this the company's hotel patrons were supplied with writing paper and envelopes only.

Picture postcards used by railway hotels, and those picturing the inn and bearing the company's name are most difficult to categorise as officials; many a hostelry was named Railway Hotel even though it had no formal ties with a railway company. Although it had a hand in several hotels, not until 1896 did the GWR commence full ownership of such establishments. Postcards of the company's hotels officially issued by the GWR can readily be identified by their use of the familiar double shield crest prior to 1934, and the newly designed roundel motif thereafter until nationalisation. The majority of GWR hotel cards were not particularly attractive; the exception is perhaps a series of sketches by Charles Mayo (GWR Publicity Department artist) which are of a high standard, and used on GWR cards issued in 1936. Full details of the GWR hotel issues are given in John Silvester's *Official Railway Postcards of the British Isles*.

Between 1902 and 1912, the North British Railway issued quite a surprising number of hotel cards, mostly of the two at Glasgow and Edinburgh, featured in several different styles. One of the North British Station Hotel, Edinburgh and printed by McCorquodale, is almost certainly an LNER issue. A vignette of the North British Station Hotel, Glasgow, printed by McCorquodale, was issued about 1906. Probably the following year, a coloured poster type card was issued which depicted the three NBR hotels at Perth, Glasgow and Edinburgh, and carried the company crest in brown on the back of the card; the printers were W. & A.K. Johnston Ltd of Edinburgh. The same card was also printed for use as a correspondence card. In 1912 a four-view card of the Edinburgh hotel in a decorative frame, and listing the telephone number, was issued in a poster-style presentation; there was no indication of the printer.

As well as the afore-mentioned coloured cards issued by the NBR, during the same time they issued a total of sixteen plain-printed cards, all but one of which were of the Glasgow and Edinburgh hotels. Six of these cards were printed by McCorquodale, the rest anonymously, with several variations in presentation, some of which involved the telephone numbers or different times shown on the Edinburgh hotel clock.

Of the pre-grouping companies which later were constituents of the Southern Railway, only the London & South Western and the South Eastern & Chatham Railways appear to have issued postcards of their hotels. From the LSWR docks at Southampton there was a considerable traffic in foodstuffs, ranging from strawberries and milk to Dorset pork and Dartmoor rabbits. Businessmen trading in these and other commodities needed to stay in the area; the South Western Hotel at Southampton supplied that need. Probably sometime around 1905 the company issued a coloured, vertical format poster card of the hotel.

Three cards were issued by the SECR relating to their South Eastern Hotel, Deal. Printed in half-tone, but with neither printer nor date of issue indicated, the first card shows the front of the hotel, and advertises that there is 'Golf at Deal and Sandwich'. The second card shows the 'Verandah leading from Salle à Manger'; the third card shows 'A Catch of Cod at Deal' with the announcement that there was 'Every Accommodation for Anglers at the South Eastern Hotel, Deal.'

The size of a railway company was no standard by which to gauge its issue of hotel cards. The mighty Great Central Railway, the

last main line in Britain, could only manage one card of its Royal Hotel, Grimsby, while the tiny mountain railway of Snowdon issued five such cards. Two, plain-printed by Valentines, about 1931, were of the Summit Hotels and station; a further three, issued in 1936, were real photograph cards by Photochrom featuring the summit and the Royal Victoria Hotel, Llanberis.

The Great Northern Railway claimed to provide the shortest and fastest journey from London to more towns and cities than any other company. As a partner in the East Coast Route to Scotland the GNR gained its importance, and its operation of the prestigious Flying Scotchman express, which left King's Cross at 10am every weekday, enhanced that state. The company ran a very heavy commercial traffic, its goods vehicles, in number, proportionaly larger than those owned by any other railway company. But in catering for its commercial passengers the GNR did not seem to pay much attention to advertising its hotels' service to them. Three sets of cards in three basic styles with divided and undivided backs, of their hotels at King's Cross Station, Bradford, Peterborough and Leeds, were issued. Presented as a plain oval picture, an oval picture with a decorative frame, or as a standard rectangular picture, the cards were generally printed in brown or blue, but with no indication of date of issue or printer's name.

Once the railways had become established it was not long before they were organising their own well-appointed steamer routes to Ireland. By 1902, it is more than likely that all the railway-owned hotels were issuing standard-sized and Court sized picture postcards of their establishments. Bearing in mind the railways' general lack of advertising awareness, the number of such hotel cards is quite surprisingly high; to that number must also be added the many cards from railway hotels in Ireland.

The Belfast & County Down Railway was incorporated in 1846, and its various sections opened for traffic between 1848 and 1861. Thirty locomotives in dark green livery, and 153 passenger carriages, painted maroon and outlined in gold worked on its 80 miles of track. But the line only managed to publish three cards, two plain and one coloured, with no indication of date or printer, of their Slieve Donard Hotel. Researches have not so far unearthed any other

cards. The coloured card was by 'Jotter'.

In 1876 an amalgamation of some of the oldest railways in Ireland became incorporated as the Great Northern of Ireland Railway. The GNR(I) absorbed other railways over the years until by 1939 it was working 563 miles of line, of which some 319 miles were in Northern Ireland, the rest in Eire. The company's first venture into the postcard world was about 1903 with a 'Cloverleaf' correspondence card. In a cloverleaf design were plain-printed pictures of hotels. The hotel cards were issued three years later, printed in half-tone by Lawrence, Dublin & Welch, of Belfast. Two pictures in a decorative green frame on each of three cards featured Great Northern Hotels in Bundoran, Warrenpoint and Rostrevor.

The same firm of printers also produced a total of seven hotel cards for the Great Southern Railway; it is probably more correct to say that four of them, real photographic, were made specifically for the GSR Hotels Department, according to the legend on the cards. An eighth card, also a photo, and with a white border, was printed by Ashe Studios, Dublin, and showed the Great Southern Hotel, Killarney. As early as 1902, the Great Southern & Western Railway had been referred to on postcards as the 'Great Southern'; understandably, this creates some confusion among collectors. In fact, it was not until 1 January 1925, that the GS&W was absorbed, along with the Midland Great Western Railway, the Dublin & South Eastern Railway, and twenty-four other lines into the Great Southern Railway. The GSR became the largest railway in Ireland, its route mileage nearly three times as much as the other three major lines in Eire, and with a work force of more than 12,000 out of the total of nearly 15,500 railway employees in the Free State.

The Great Southern & Western issued, so far as is known, a total of twenty-four hotel cards, not all of which are specific pictures of an hotel; the titling identifies the categoric origins. Three plain-printed cards of this total, by Lawrence, issued in 1904-5, and featuring three hotels in County Kerry, are presumed to be officials of the GS&W. The artist Walter Hayward Young, more familiarly known as 'Jotter', drew seven pictures of GS&W hotels, the hotel's name and address appearing in the correspondence space.

The same artist also drew two pictures for the

52 Portrush, originally on an extension of the Belfast and Ballymena Railway, was a residential centre for the business executives of Belfast. The 'North Atlantic Express' ran a daily service from Belfast, accomplishing the sixty-five and a quarter miles (with a stop at Ballymena) in eighty minutes. (LMS—Northern Counties Committee, about 1930, printed by James Moore, Belfast) *(Ian Wright)*

INDOOR HEATED SEA WATER SWIMMING POOL LOUIS XIV BALLROOM
LMS-NCC NORTHERN COUNTIES HOTEL • PORTRUSH · CO. ANTRIM

Midland Great Western Railway; of a total of nine MGW Hotel cards only these two are known with certainty to be officials. The remaining seven, in colour, half-tone, and photographic, were issued variously between about 1905 and 1916. The MGW dated from 1845, and although it carried a fair number of passengers, nearly two-thirds of its income was derived from the transport of goods, minerals and livestock. Much of the company's development after the turn of the century was based on the hope that the projected North Channel Tunnel between Larne and Portpatrick would come to fruition.

With the 1923 Grouping, the newly-formed London, Midland & Scottish Railway became the owner of thirty-three hotels in Britain which had formerly belonged to nine independent railway companies and two joint-stock companies. One set of cards, printed by McCorquodale of the Turnberry Hotel, grounds, and golf course, is known with 1922 postmarks; this means that, although issued on behalf of the Glasgow & South Western Railway Hotel Services, they probably appeared *after* that company had officially ceased to exist, and *before* the LMS officially came into being. Altogether, a total of eighty-two hotel postcards, in seventeen different types, and many bearing the name of Arthur Towle, the Hotels Manager, were issued by the LMS. One set of correspondence/hotel cards, plain-printed, were used by the Stock Transfer Department, Euston, with the LMS Hotels logo on some pictures. For the most part, the printers of the LMS Hotel postcards were Raphael Tuck & Sons, and McCorquodale, with Valentines, P.

Cohen & Co (Philco Series for the Gleneagles Hotel), and some anonymous ones.

During the Parliamentary Session of 1860 an Act was passed which allowed the Belfast & Ballymena Railway to change its name to the Belfast & Northern Counties Railway. On 1 July 1903, the line, along with others was amalgamated with the Midland Railway, and became known as the Northern Counties Committee (Midland Railway). The pride of the commissariat of the NCC was the Northern Counties Hotel at Portrush, Co Antrim. Under the aegis of the LMS the hotel was featured on four coloured cards, but with no indication of date or printer's name.

The 1923 grouping brought about changes in the architectural as well as the administrative structure of the railways concerned. In particular, the Midland Hotel, Morecambe, was completely rebuilt in 1933. Its style marked it quite unmistakably as a product of its age, and other hotels were improved to modern standards as a continuing process. As with so many other good works of the time, the outbreak of war in 1939 brought an almost immediate cessation of progress.

Before then, however, the LMS acquired a former private country house at Stratford-upon-Avon, and refurbished it as the Welcome Hotel, which was opened in 1931. From 1939 to 1945, the majority of railway hotels were taken over ('commandeered' was the usual, less formal, expression) for Government or Military use. After the war, those which were fit enough were reopened as hotels, while others were sold as a

means of recovering financial losses.

The London & North Eastern Railway became the owner of twenty-three hotels in 1923, acquired as part of the assets of seven of its constituents. Some fifty-two postcards of these hotels were issued; thirty-seven of these cards, printed in sepia with a white border, appeared in no less than six editions.

Of the Southern Railway's hotels relatively little is known, the company was apparently reluctant to advertise its hotel services, even in its own annual holiday guide, *Hints for Holidays*. Confusion is also somewhat compounded by writers in the 1930s getting their facts wrong; Dendy Marshall quotes only three hotels operated by the Southern Railway, although the company were at least managing to advertise five at the time. The SR owned several properties which it leased to other commercial undertakings, who in turn advertised these hotels on postcards, but such cards are not recognised as SR officials. There would seem to be only four SR hotels for which cards might be found. The South Eastern Hotel at Deal, was splendidly situated on the seafront within easy reach of four famous golf links, and with meals served on the ornate verandahs facing the sea. Regular corridor expresses ran from Charing Cross, and a specially chartered omnibus met every train; the Charing Cross Hotel, London, in the heart of the theatre district, could be entered directly from the station platform; the Craven Hotel was also near to Charing Cross Station; the fourth was the Knowle Hotel at Sidmouth.

Other hotels owned and managed by the Southern, but for which SR cards have yet to be found, were: the South Western Hotel at Southampton, which adjoined the Docks Station with access from the platform, and faced the harbour, was advertised as 'The most modern Hotel in Southern England'; the London and Paris Hotel, Newhaven, adjoined the landing stage for the cross-Channel steamers which the SR operated to Dieppe. Further details of picture postcards issued by the LMS and the LNER are given in List No 17, *Railway Official Postcard List*.

Scarcely had the railways begun their hotel renovation and modernisation programmes, than they were nationalised, and all the hotels came under central management. British Railways hotels were never a great financial success, their managements never truly free to manage. In the early 1980s, under Government direction, they were sold, and another chapter of railway history came to an end.

The immediate post-war period saw many new picture postcards being issued. They are not widely considered very collectable today, but it should be remembered that they will become increasingly hard to find as the years go by. Postcards of 'Golfers at Gleneagles' in the 1970s will be just as elusive as those of 'Business Luncheons at the Midland Grand Hotel, St Pancras', in the 1900s.

Privately Published Railway Postcards

One aspect of postcard history which will never be clear is how many privately published picture postcards were produced; as has been shown, we do not even know the extent to which official ones were produced.

Official records of postcards by the railways themselves were often loosely or incorrectly registered, and the relatively few which have survived both grouping and nationalisation are far from complete. The sorry story continues into the postcard manufacturers' archives; it is only thanks to the diligent researches of the authors mentioned in this book that, in many cases, records of any sort have been unearthed and preserved.

Raphael Tuck & Sons, one of the principal printers of railway officials, had a most erratic system of reference. Whatever its relative merits may have been, on 29 December 1940, during an air raid, Raphael House was destroyed, and the records and originals of much of its stock were lost forever. A similar fate had befallen McCorquodale in 1909, with a disastrous fire at their Cardington Street works, near Euston Station.

It is totally impossible to even hazard a guess at the extent of private publications of railway postcards. Such cards were produced by small, one-man businesses, who on some hitherto unrecorded special occasion produced a small number of prints of one picture; at the other end of the scale were the large firms with international trade producing untold millions of cards. Some idea of the enormity of the manufacturers' production can be gauged from an entry in the 1929 edition of the *London Post Office Directory*. It lists some twenty-five postcard manufacturers, one of whom, the Photochrom Company, advertised 250,000 subjects available! When one considers that picture postcards of these subjects were produced by the million, the total number becomes too large to comprehend.

Before the ordinary postcard came into being,

either in Austria or Britain, an unidentified writer in *The Scotsman* on 17 September 1869, was already drawing parallels between the postcard and the railways in a quite lengthy article, 'Halfpenny Card Postage'. He was a bit previous with his early remarks in noting that 'a system of card postage has been tried, it is believed successfully, in Germany.' His geography was in error and the world's first official postcards were introduced in Austria on 1 October 1869. He observed how the proposed cards in this country could be provided of a standard size by the Post Office, 'having in one corner as an integral part of the card a triangular stamp'. The advantages of such cards as a means of communication were held to be enormous to the public; bulletins, business cards and advertisements could be circulated in half the time as 'the present cumbrous folded sheet of notepaper and gummed-envelope practice.' One advantage considered by the writer was for the businessman, unavoidably detained, and in circumstances where writing a note would be impossible — 'How simple to pencil a card, "Detained; do not wait dinner; expect me home at nine." '

The traveller by the Down train, who just as his train had left the platform remembered that something of consequence had been forgotten at home, had an advantage with the postcard. He 'could pencil a few words, jump out at the first station he came to and post his card, or give it to a porter to be posted in the travelling post-box on the Up train'. But for the facilities offered by card postage he might have had to travel 100 miles before he could do anything.

There were advantages also for the Post Office the writer thought, since the cards would be lighter and less bulky than letters enclosed in envelopes. But where the railways and the Post Office administration really became as one, was in the method of cancellation. 'The cancelling of the card stamp and the stamping in place and date on the card could be done in one operation,

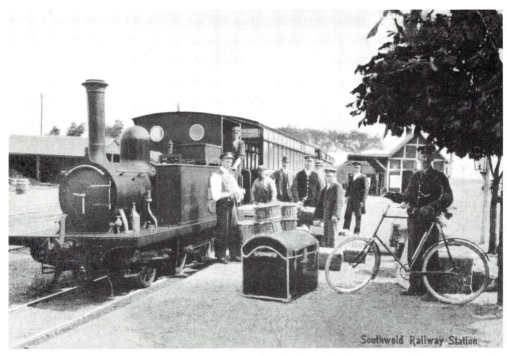

53 The Southwold Railway opened for passengers and freight on 24 September 1879. It had a speed limit of 16 mph and poor trade receipts led to its closure on 12 April 1929. The sender of this local postcard wrote, 'This is a funny little railway. Coming from London you have to change at Halesworth & get into a miniature train running from there & to London.' Halesworth was on the Great Eastern Railway. (Published by F. Jenkins, Southwold; pu Southwold SO August 10 1910) *(Frank Staff)*

in a machine similar to those used for dating railway tickets.'

As the postal historian will know, the postcard was to outstrip by far even the visionary acclaim of the Scottish writer, and around the turn of the century that success became attached to the picture postcard when specialist commercial cards were first produced. In January 1896, the first issue of *Moore's Monthly Magazine* appeared. It was devoted entirely to railways. It is presumed by some that the magazine was produced as a means of answering queries arising from the publication of 'F. Moore's Railway Photographs', a name which started to appear around 1890. In 1897, the title of the magazine was changed to *Locomotive Railway Carriage and Wagon Review*, and after a few years that cumbersome designation was slimmed down to *The Locomotive Magazine*.

The firm responsible for its publication was the Locomotive Publishing Company, and it is thought that the first railway postcards issued by them appeared early in 1900. A superb twelve-card set was issued by the LPC in February 1901, and was sold for 6d. Each card carried three

vignettes in decorative frames, the pictures by half-tone in five coloured inks, one colour to each card. It is noted by Anthony Byatt in his classic work, *Picture Postcards and their Publishers*, that 'at an auction in April, 1977 three of these cards realised £64'.

Some of the earliest coloured railway postcards, other than chromolithographs, were published by the LPC in 1904, featuring thirteen British locomotives and twelve foreign engines. A further eighteen cards bearing the name 'Locomotive Magazine Series' also appeared in 1904. Gilt titling appeared on a 24-card issue between 1904 and 1907, adding distinction to the picture. Over the next seven years all cards had their titles printed on the reverse, together with the Locomotive Magazine trade mark.

Although the LPC specialised in real photographic cards, clearly and sharply printed, they are perhaps equally renowned for the excellent cards, made from photographs painted over in oils, and signed 'F. Moore'. Such cards appear to have first been published by Valentines of Dundee in 1904, and also by Raphael Tuck &

Sons (see Tuck checklist by David Pinfold, in Appendix 1). The technical and chromatic accuracy were excellent, and have been regarded by many railway experts as being the only true colour guide to liveries and rolling stock finishes. Perhaps the stangest thing is that it has bever been satisfactorily explained who, or if, the artist 'F. Moore' was. It is generally supposed that the team of LPC artists worked to a formula laid down by someone, and the finished artwork was given the stereotyped signature; all the signatures are exactly the same, which of course would be impossible if each was an original applied to every new painting — and there are reckoned to be more than 300 of those. Another strange aspect of the F. Moore saga is that during the 1920s and early 1930s many railway books were published containing coloured illustrations signed by the ubiquitous mystery artist, and yet only a relative few seem to have also been published as postcards.

Nowadays postcard collectors can only look at some of the LPC advertisements in the railway magazines with envy. There are lists 'containing all latest photographs and 20 assorted cards sent post free on receipt of 6d.' Along with all the other 'albums of illustrations of British and Foreign Locomotives', scale model sheets, and six-card sets of photographic cards of particular companies' locomotives, it was possible to buy 'POSTCARD ALBUMS to hold 400 cards. Price 6/9 each, Post Free'. Other advertisers in the late 1920s were offering 'burnished sepia photocards of Brighton and S.R. locos, trains, etc.', or 'Postcard Photographs of Locomotives and Expressss Trains', while the railway companies themselves were selling packets of '4 Real Photo Postcards, Different Views' for the modest sum of 8d.

Perhaps for obvious reasons holidays at the seaside have always provided a rich vein of comic cards with a railway theme. For most people the starting point of their week's holiday was the railway station. With the popularity of the seaside for holidays and trips it was not long before enlightened firms were organising works outings for their employees. One such firm was the Bass Brewery at Burton-on-Trent who really went to town on such ventures. Very informative glossy brochures were produced for the occasion giving details of the trip, the railway, and the destination. Photographic postcards were produced for the usual 'family album souvenir' of the occasion, and many of these were taken in and around both railway stations and on the train. The family album often yields up such postcard gems.

In the world of the private postcard Warner Gothard of Barnsley was really in a class by himself. He specialised in the production of 'disaster' cards of a type which were a complete news account in themselves, the principals, the scene of the accident, and all relevant information being presented in montage form. His first such production was for the railway accident at Cudworth in January 1909. Although compared with his later work this was a rather clumsily prepared issue of two cards, they are now difficult to find and are catalogued at anything from £25 to £40 if in mint condition. He is known to have covered forty-six disasters of which he produced seventy-six postcards; of these, nine events were railway accidents, with a tenth, a tram accident at Bournemouth. Their high sales at the time (19 January 1905 to 2 February 1916) are perhaps a little hard for us nowadays to appreciate, but it should be remembered that few photographs appeared in the national newspapers (even of nationally important events and people) until the early 1930s; fewer still appeared in the local press until about the same period. Hence the postcard performed the same function as the television does today.

The importance of the railway station at that time now seems strange to us. In one sense perhaps, the village station was of greater importance to the inhabitants than the main line station in the big town. Out-of-the-way villages depended almost for their existence on the railway and its services; and of course, the station provided secure employment for a number of the local inhabitants. Like the postcard which was an unrivalled, cheap and efficient means of communication, the railways were unrivalled as transporters. Those who could afford one of the newly-invented motor-cars were independent travellers, those who were not so affluent used the trains; this meant that even in the most rural communities the railways were prosperous.

Even within the confines of a small village, the railway station was something of a self-contained community. Apart from the company's directives

bout how and when certain work should be done, and to what standard, it was a matter of local pride that its station should present an attractive face to the rest of the world. It is not therefore surprising that such buildings and their environment should appear on local topographical postcards. Their real value, apart from the prices that some realise in the auction rooms, is that nowadays those picture postcards are sometimes the only pictorial records that such a place existed. Many 'railway' postcards, treasured in collections throughout the country, feature those exquisite pictures of little stations, none of them recorded in a postcard catalogue. For some unknown reason, the local photographer, newsagent, stationer or post office often published a group photograph of men and women on a sunlit platform, while the little suburban locomotive stood patiently simmering, awaiting its passengers. Perhaps it was the first train, or even the last, but the result is a priceless preserved picture postcard.

The original Railway Museum at York opened in the early 1930s, and although it was closed during the war, provided a valuable source of railway postcards. Apart from selling those of the 'Big Four', it also issued its own postcards in colour and black and white. Unfortunately, there is no official record of what those cards were, and of those that are known, relatively few are now preserved in collections. From the former shop manager's private record a list was chronicled in the *Picture Postcard Annual 1984* by Pete Davies. He also listed issues from the new National Railway Museum. But the serious collector of railway picture postcards should be warned — the NRM was opened in September 1975, and by March 1979, several of the cards originally in stock were already out of print! And

to drive home the point, at least one of the firms who were manufacturing and supplying those 'modern' cards is now out of business.

Picture postcards of the railways in the 1980s can be obtained world-wide, but for the most part, even when the train is moving, the effect is static, the picture soulless. Even so, the collector is well-advised to buy these sets of cards, for they will soon be out of print; and almost certainly, there will be no real record of the series other than one's own collection. For an on-going history of the railway postcard in fifty years time, they could be invaluable. The preservation societies have rescued many a locomotive from the scrapyard, and many a first-class saloon from a chicken-farmer's field. Although some of the postcards which they produce lack the life and sparkle of the Edwardian and late Victorian officials, they do present a picture, even if in a sort of 'suspended animation' of a time now gone forever. This has meant that for those too young to remember the days of steam, the picture postcard can now give a new lease of life to it. Modern reproductions of advertisements enhance that life with a sparkle that even the 'old contemporaries' would not have known via the postcard.

There are undoubtedly many more cards, both official and private, just waiting to be discovered and recorded. Apart from the cards, most of which will have only intrinsic value, there are countless stories behind them waiting to be told. It would be much appreciated if, when you do find them, you would advise the researchers mentioned herein of your discoveries; it would help them to fill many gaps in our knowledge of railway picture postcards.

Postcard Selection

LOCOMOTIVES

The locomotive and the railway! Since the very early days of the railways there have been countless ardent admirers, none more so than the young lads who sat on the trackside fences to watch the trains pass. There was no greater joy than a ride on the footplate with the engine driver; right up to the mid-1930s it was truly said, 'Every boy wants to be an engine-driver'.

Much of the attraction of the railways has always been the locomotive. After the Stockton & Darlington Railway the development of the locomotive was quite rapid, and it is perhaps not only sentiment which compels our admiration for those departed locomotives. Long before the advent of the picture postcard and the preservation societies, those magnificent engines, resplendent in appearance, brilliant in brass, and proud in their colourful liveries were cast upon the scrap heap; we shall never look upon their like again.

There are numerous scholarly works on the history of the early locomotives, and it is difficult at times not to be confused, both by the similarity of design and the names of these engines. As the eminent nineteenth-century railway historian, Clement E. Stretton, records in his book (*The Locomotive Engine and its Development*, 1896), 'in 1840 no less than ten engines were running in this country named "Liverpool".' He also records that early engines were built, patented, and then run in trials upon several companies' lines; afterwards, they were broken up, with most of the parts then being used in new engines. This practice extended to the re-use of the number plate, and locomotive historians were recommended to 'always record the makers' numbers'. This was perhaps the origin of the hobby of spotting locomotive numbers.

George Stephenson was one of the first to realise the related importance of locomotive development and that of railway construction. Quite soon after the success of the Stephensons' *Rocket* at the 1829 Rainhill Trials, improvements followed quickly, accelerated by the requirements of the Liverpool & Manchester Railway. Strangely, it was the Continental engineers, particularly of France, who first appreciated the tremendous advantages of the steam locomotive. Marc Sequin established the first steam railway in France in 1829, but if his locomotives were a technical improvement, like subsequent developments, the design was anything but streamlined. French and German locomotives, and to a lesser degree, those of the American railways, were characteristically festooned with pipework around the boiler casing.

Although for the most part, the British locomotives were of cleaner design, they too had their distinctive shapes, and their ardent devotees. The advent of the picture postcard provided them with the perfect outlet for their affection.

54 Great Western Railway *King James* hauls the 10.30am down 'Limited' (the affectionate name for the Cornish Riviera Express) through Kensal Green. After leaving Paddington at the height of the summer season, the train made its first stop at North Road, Plymouth, a distance of 225.5 miles. In 1934 this locomotive held the world's non-stop record with a time of 4hr 5 min, achieving its highest speed, in excess of 80 mph, on the long descent from Savernake to Westbury.

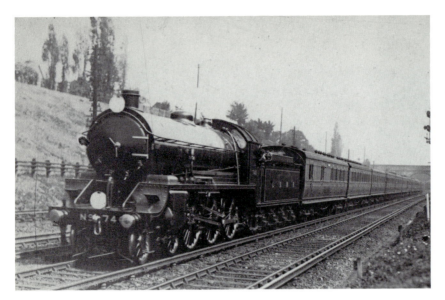

55 London & South Western Railway down North Cornwall Express near Clapham Junction. The 4-6-0 locomotive No 740 of the 760 class, built in 1917 by R.W. Urie, CME, had driving wheels of 6ft 7in diameter, and weighed 77 tons 17 cwt. *(Ron Grosvenor)*

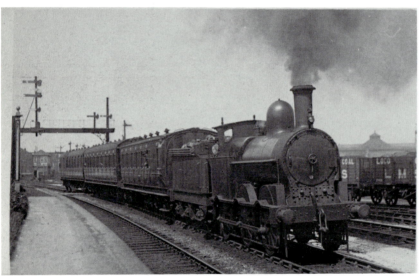

56 Heading a Walsall train out of Derby (Midland), renumbered LMS 8352 (formerly LNWR 'Cauliflower' No 1026) begins to take the strain. These powerful 0-6-0 locomotives were extensively used on suburban services.

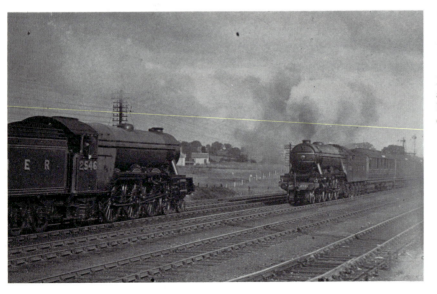

57 A fine study of two high-pressure Pacific 4-6-2 express passenger locomotives of the London & North Eastern Railway about to pass. In 1935, *Papyrus* No 2750 (sister locomotive to No 2751, seen here) achieved 108 mph on a test run between London and Newcastle. *(Ron Grosvenor)*

58 Designed by J.G. Robinson, the 11B Class 4-4-0 locomotives of the Great Central Railway were powerful and elegant. Introduced in 1901, they were rebuilt three times; the class became D9 on the LNER. *(Locomotive Magazine Series No 1809)*

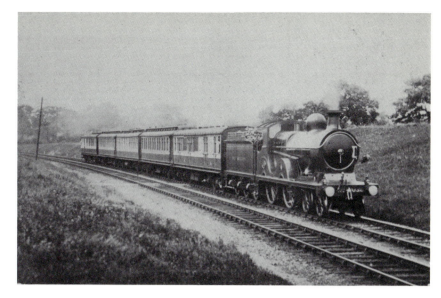

59 Two Great Eastern Railway locomotives stand simmering in Liverpool Street Station. Engine No 1819 was a standard 4–4–0 passenger express of the type used on the Norfolk Coast Express to Cromer; a similar locomotive was used for the Royal train, about 1905. The 2–4–2 Suburban Tank class (in the background) was first built by T.W. Worsdell in 1884.

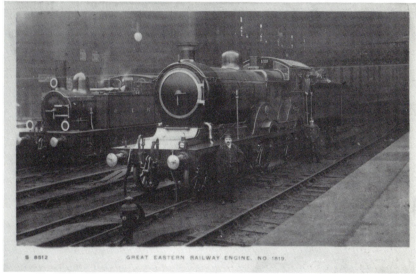

S 8512　　　GREAT EASTERN RAILWAY ENGINE. NO. 1819.

60 A typical scene on the Canadian Pacific Railway, about 1905. The station is probably Gleichen (2,900ft) where the snowy peaks of the Rocky Mountains are in full view. Similar locomotives were used to haul the CPR 'Imperial Limited' between Montreal and Vancouver (2,898 miles) in 96 hours. *(Peter Woolway)*

Climbing the Rockies.

61 A 4-6-2 tank locomotive, Series 354.1, of the Czechoslovakian Railways, is seen leaving its shed, while the 534 class locomotive simmers gently. The 354s, which were superheated, had an automatic recording speed indicator which worked from the rear coupling rod. (Nakladatelstvi, Praha)

62 German State Railways 4-6-2 locomotive No 023.006 heads a three-car rake of typical steel coaches. More than fifty years ago Germany led the world in the use of all-steel coaches, having more than 10,500 in service. This engine was built by Henschel & Son in 1950.

63 A driver on the Festiniog Railway accepts the staff from the station mistress. The staff system allows a train to proceed into the next section of track on a single-line railway; no two drivers could receive this authority at the same time. The Fairlie type locomotive was built at the Boston Lodge Works in 1885.

64 The articulated 0-4-4-0 Fairlie locomotive *Merddin Emrys* together with its crew poses for a photograph, about 1930. Fairlies were first acquired by the Festiniog Railway in 1869. The preservationists of today's FR object to the name, the 'Toy Railway', but the original company was proudly advertising itself as such in the 1920s. *(Peter Woolway)*

65 *Little Wonder* crosses a gulley near Tanygrisiau, date unknown, hauling a very long train. Beyond the two coaches, flat wagons extend right round the curve, and disappear behind the fencing at the far left. The Fairlie Patent locomotive, purchased in 1869, was the seventh engine acquired by the Festiniog Railway.

66 The Coronation-Duchess class Pacifics of the London, Midland and Scottish Railway were designed by Sir William Stanier between 1937 and 1948. Later variants were among the most powerful locomotives in Britain. The first of the class, No 6220 *Coronation*, in a trial run, achieved the record speed of 114mph. (Valentines 38C-2) *(Ron Grosvenor)*

L.M.S. "CORONATION SCOT" THE NEW RECORD-BREAKING LOCO-MOTIVE. TRAVELS BETWEEN GLASGOW AND LONDON IN 6½ HOURS.

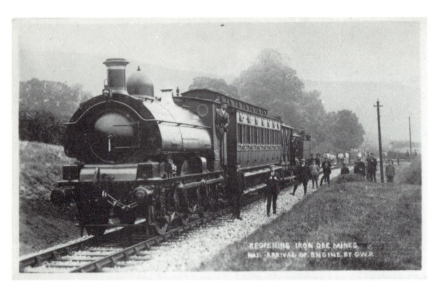

67 A Dean 0–6–0 saddle tank engine arrives to re-open some unspecified iron ore mines, date unknown. This privately published card (No 1) was probably the first in a local series. William Dean became CME in 1877, and was succeeded by his Chief Assistant, George Jackson Churchward, at the Great Western Railway Works, Swindon.

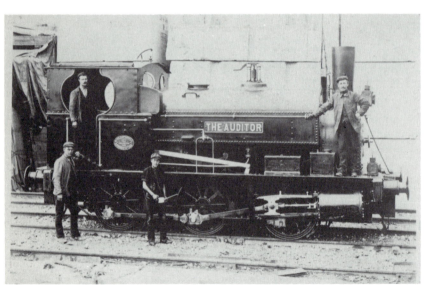

68 Industrial railways and their locomotives have never had the aura of glamour and attention enjoyed by passenger locomotives. The public saw little of them, no passengers travelled on them, and yet they were in existence long before the public railways. And as this fine study shows, the engines were most interesting. This 0–6–0 saddle tank engine was built by Black, Hawthorn & Co, Gateshead-on-Tyne, in 1895, and numbered 1105, for S. Pearson & Son Ltd, Contractors. Date and location unknown. *(Ron Grosvenor)*

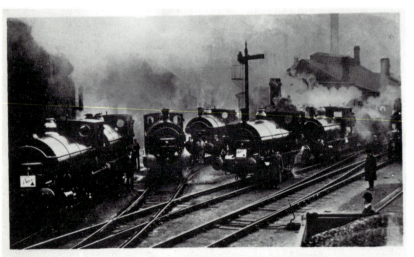

VIEW OF ENGINES BASS'S BREWERY BURTON-ON-TRENT

69 There are several photographic picture postcards of the Bass Brewery and works (the number has never been recorded), many of which feature locomotives. Messrs. Bass, Ratcliff & Gretton operated a most notable railway system at Burton-on-Trent, in conjunction with the LMS. The engines were designed by the chief engineer of the brewery, and built by the North British Locomotive Company at Glasgow; they were painted bright red, with brass domes and copper-capped chimneys.

70 There were two classes of locomotive in use at the Bass Brewery, known as A and B. The former had 3ft 6in wheels, the latter 4ft wheels. The engine pictured here was built in 1901, and is preserved in working order. In the 1930s the brewery ran special express trains several times each day with loads of fifty wagons to all parts of the country. The most important of these trains was the 'Scotch Special', which ran three times weekly from Burton to Carlisle. The railway distribution services were worked in close co-operation with the LMS and the LNER. (Bass Museum)

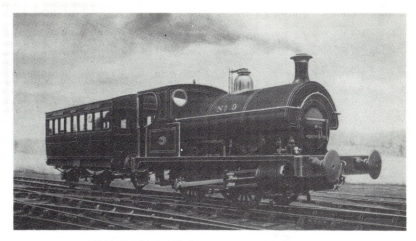

PRIVATE LOCOMOTIVE No 9, and VISITORS' SALOON.
Owned by Messrs. Bass, Ratcliff & Gretton, Limited Burton-on-Trent.
Type 0-4-0 "A" Class, Saddle Tank Engine, designed by the firm's Locomotive Department.

71 Great Western Railway Crane Locomotive *Hercules* No 16, 0-6-4 tank engine. These specialised engines were used mainly for works purposes; the brass notice on the side of the crane gives details of weight and lifting restrictions. The steam-operated crane was mounted over the coal bunker and could be swung to any desired position. When not in use it was slung in line with the boiler. *(Locomotive Magazine* Series, Locomotive Publishing Co) *(Ron Grosvenor)*

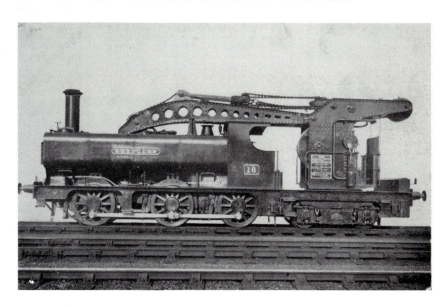

72 This Llanfair locomotive and train crossing Church Street, Welshpool, was typical of many Great Western Railway branch line workings where the town had literally evolved around the railway. The Welshpool and Llanfair Light Railway operated on nine miles of 2ft 6in track (part of which was the old Standard Quarry Tramway of 1818), and was worked by the Cambrian Railway from its opening in April 1903 until absorbed by the GWR in 1922. (Frith's Series)

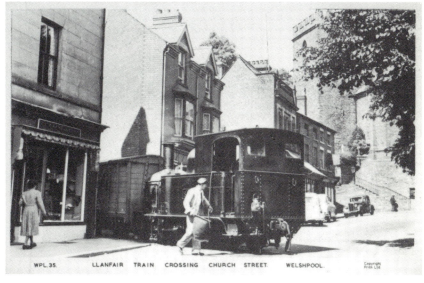

WPL 35. LLANFAIR TRAIN CROSSING CHURCH STREET. WELSHPOOL. Copyright Frith Ltd

73 A perfect example of the rich treasures which can lie in the family album is this wonderful study of a young fireman. The locomotive is a North Eastern Railway 4–4–2 *Atlantic* three-cylinder passenger express, first designed by Sir Vincent Raven, who succeeded Wilson Worsdell as CME in 1910.

74 Postcards of the German State Railway Centenary celebrations in 1935 are not very common. This picture shows *Adler* (Eagle), the first locomotive used on the first public steam railway in Germany. It was a small line, operating in much the same way as a local tramway, and opened between Nuremberg and Fürth, Bavaria, on 7 December 1835. The *Adler*, its boiler painted green, wheels red, and with polished brasswork, was built by R. Stephenson, England. The maker's plate was fixed on the frame alongside the single driving wheel. The locomotive, which hauled carriages painted yellow and red, was a small version of the 'Patentee' class used on the Liverpool & Manchester Railway. (Paul Janke, Nuremberg, No 6302)

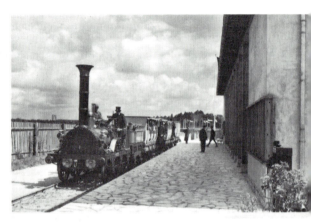

75 A scene inside the Derby workshops of the LMS, 23 October 1932. The 0-6-0 diesel shunter has been brought in for refit, for which parts of Midland Railway No 1831 were used. The locomotive was converted to mobile power unit No 3, and withdrawn from service in September 1939.

76 Locomotive No 423, an obsolescent 4-4-0 suburban passenger engine, stands in the Derby workshops, about 1930.

77 A view inside the Crewe Erecting Shop, about 1935. The locomotive No 6153 (name unknown) undergoing repairs was one of the 'Baby Scots'. These 4-6-0 engines were some of the most successful of the LMS passenger expresses. They were officially rebuilt 'Claughtons', but the reconstruction was so extensive that they became virtually new engines.

78 Great Western Railway 'Atlantic' type, de Glehn compound locomotive No 102, bought in 1903, and scrapped in 1926. Although built in France it was given a Swindon Works No 2025; its 4-4-2 wheel arrangement was not really suited to GWR requirements. de Glehn was the locomotive engineer who established the compound practice on the Northern Railway of France; his cab controls were considerably more complex than the British footplate layout. (Knight Series No 605)

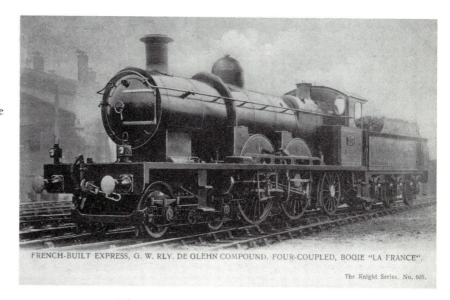

FRENCH-BUILT EXPRESS, G. W. RLY. DE GLEHN COMPOUND, FOUR-COUPLED, BOGIE "LA FRANCE".

The Knight Series. No. 605.

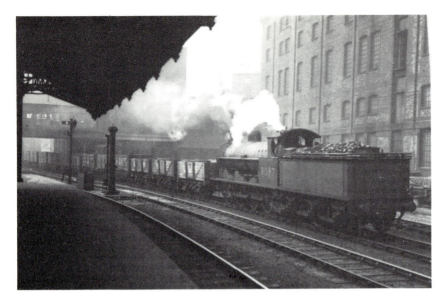

79 An 0-8-0 Freight class locomotive No 9087 takes a rake of empty wagons, tender first, through Huddersfield, about 1933.

80 The original *Doctor Syn* No 9 of the Romney, Hythe & Dymchurch Light Railway Company, the world's smallest public railway. The locomotive, built to an American style design, was completed by the Yorkshire Engine Co in 1931. After exhibition in Canada in 1948, it was renamed *Winston Churchill*, and No 10 was given the name *Doctor Syn*. It was the first of the company's locomotives to be converted (1973) to oil burning. (H & W Hastings, Horseshoe Series *(Rev Teddy Boston)*

81 A curious six-cylinder side-cranked locomotive, the drive being to four-wheel bogies at either end. Despite its unusual design the locomotive, of the Mt Tamalpais & Muir Woods Railway in California, retains the large fire-box which tapered down to a small boiler, characteristic of early American engines. The postcard, with undivided back, would appear to be one of a series by an unspecified publisher.

82 A well-preserved monument to the early railroads of America is this coal-fired Baldwin 4-4-0 of about 1895, photographed in El Paso in 1925. Matthias Baldwin, a skilled mechanic and engineer, first became interested in locomotives when asked to build a model for the Peale Museum, Philadelphia, in 1830. By 1910, the Baldwin Locomotive Works had 13,000 employees turning out six locomotives every day.

83 An ex-Great Eastern 4-6-0, first designed by S.D. Holden in 1911, hauls an express train from Liverpool Street to connect with the Continental steamers at Harwich. The standard rake was eleven bogie coaches, including two Pullman cars. The Parkeston Quay at Harwich was established by the Great Eastern in 1881. (Regent Series No 1152, Regent Publishing Co) *(Ron Grosvenor)*

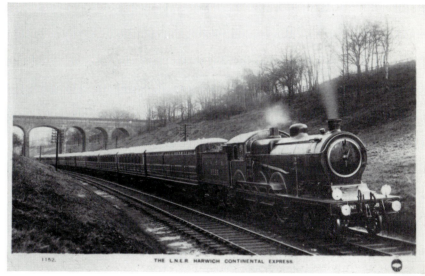

THE L.N.E.R. HARWICH CONTINENTAL EXPRESS

84 The Great Northern Railway claimed to provide the shortest and fastest routes from London to more cities than any other company. After its formal opening in March 1890, the Forth Bridge was used by 'The Flying Scotchman' service, taking just over twelve hours to Aberdeen. This picture is probably incorrectly titled (not unusual with railway postcards) since the 'Flying Scotchman' is not officially recorded as being double-headed. Both of these 'Singles', designed by Patrick Stirling, were used to haul the train. The leading engine was designed between 1886 and 1894; the second was of a class built between 1870 and 1895. Locomotive No 1 of this class is preserved at the Railway Museum, York, and has run in steam at the Great Central Railway, Loughborough. (The Knight Series, No 599) *(Peter Woolway)*

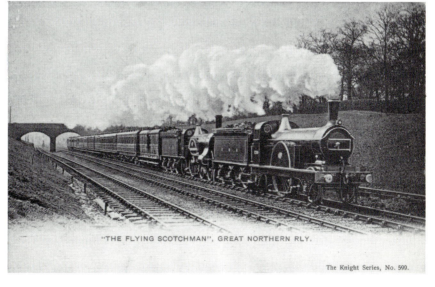

"THE FLYING SCOTCHMAN", GREAT NORTHERN RLY.

The Knight Series, No. 599.

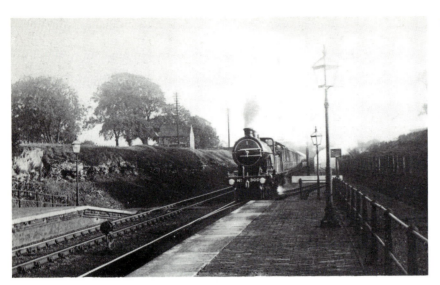

85 The 4-4-2 'Atlantic' class (seen here, station unknown) was first introduced by Ivatt in 1898. The large-boilered version was a turning point in British locomotive design. They were mostly used to haul Pullman expresses between London and Leeds.

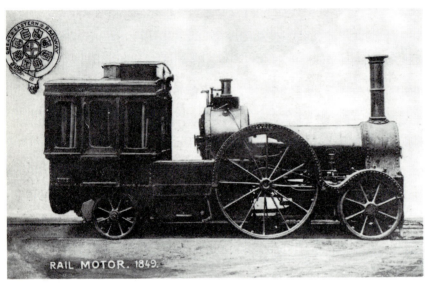

RAIL MOTOR. 1849.

86 It is generally reckoned that the first recorded rail-motor was built by William Pearson in 1848 for the broad gauge Bristol and Exeter Railway. A similar combined coach and engine with a single driving wheel of 4ft 6in diameter was constructed the following year for the Eastern Counties Railway. The ECR was given the Royal Assent in July 1847, and was amalgamated into the Great Eastern Railway in August 1862. (The Great Eastern Railway Series 1905) *(Ian Wright)*

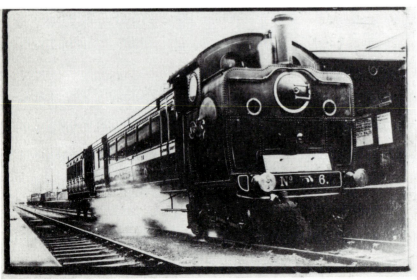

87 Taff Vale Railway, engineer's inspection train, about 1905. The locomotive engineer from 1873 to 1911 was C.T. Hurry Riches, and the company (the crest can be seen on the first coach) was opened in 1840. It had a locomotive works at Cathays, near Cardiff; the livery was changed several times, from green, to Venetian red, and finally black, each with a wide variety of lining; coaches were mainly dark chocolate brown with cream or white upper panels, and goods wagons were dark rich red with white lettering.

88 Seen passing through Stapleton Road Junction, GWR *Trematon Hall* No 5949 heads the 3.32pm Bristol to Cardiff semi-fast train sometime in the mid-1930s. Although the public image of the GWR was one of clean and bright locomotives, as this, and other contemporary pictures show, the engines could be drab and dirty. It was not usual to see inside the tender on railway postcards, but this one clearly shows the fire irons laid on top of the coal; these engines gave their best performances using Welsh 'soft' coal. *(Ron Grosvenor)*

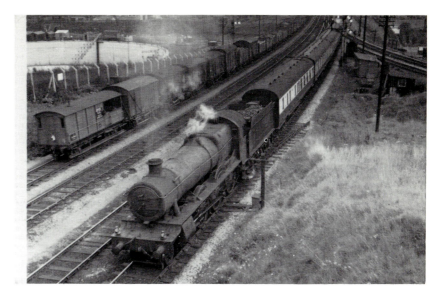

89 Sugar cane is one of the few crops which is burnt before harvesting, and the cane, then free of its 'trash' (the foliage), is cut and loaded into special wagons for transport to the mill. It is quite a picturesque and common sight in Queensland, Australia (one of the world's largest sugar producers), to see these cane trains trundling through the plantations and across the small towns en route to the mill. The track gauge is 3ft 6in and many of the locomotives were originally used on the State Railways in the 1870s. (Peer Productions, No 347)

90 Great Northern Railway Leeds Dining Car Express passing over watertroughs near Peterborough. The GNR was the first to introduce the dining car, in 1879, on its London to Leeds service; this was four years before the North Eastern Railway first used corridor carriages. Although the Midland Railway had introduced Pullman cars in 1874, they were able to serve only light refreshments. Pick-up apparatus for water was introduced by J. Ramsbottom in 1860. (Great Northern Railway, LPC Gilt Title, published 1907) *(Ian Wright)*

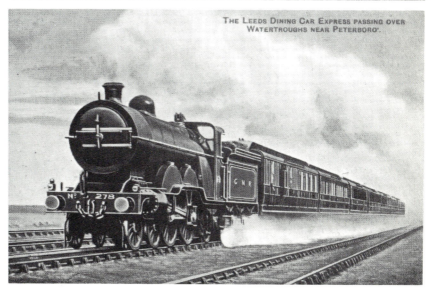

THE LEEDS DINING CAR EXPRESS PASSING OVER WATERTROUGHS NEAR PETERBORO'.

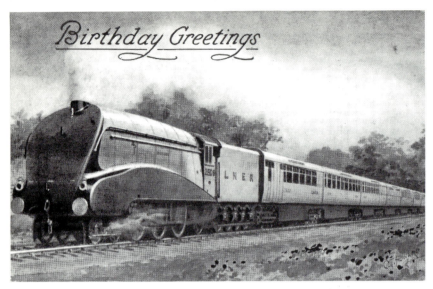

91 The *Silver Jubilee*, the first LNER streamlined express. On a demonstration run on 27 September 1935, between King's Cross and Grantham, the train achieved four world records, and twice reached a speed of 112½ mph. Three days later it went into British railway history as the first ultra-high-speed train in regular service. (J. Salmon Ltd No 4467) *(Peter Woolway)*

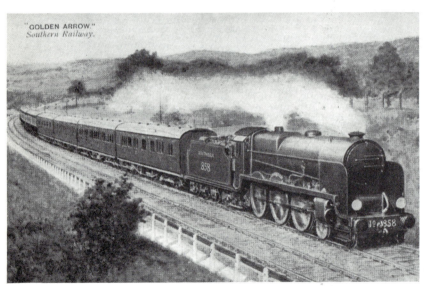

"GOLDEN ARROW."
Southern Railway.

92 The Southern Railway provided a link between London and the Orient by way of its famous 'Golden Arrow' express. Seen here near Hildenborough, on its daily run to Dover, hauled by a locomotive of the 'Lord Nelson' class, the train consisted of four to six Pullman coaches, led by second-class coaches known to the SR as 'non-descripts'. Named after British admirals, the 'Lord Nelson' class, among the most powerful locomotives in use on the SR, were shedded at Battersea specially for working the heavy Continental expresses. This card was a wartime issue, carrying a quotation from Winston Churchill: 'This is a time for everyone to stand together, and hold firm!' (J. Salmon Ltd No 4702) *(Rev Teddy Boston)*

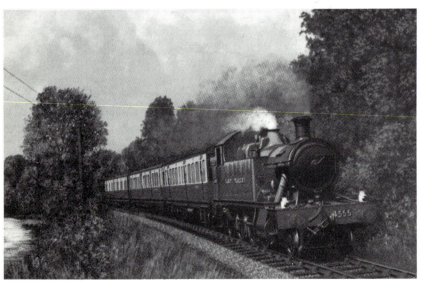

93 An ex-Great Western 2-6-2 tank engine No 4555, heads a local train between Totnes and Ashburton, on the Dart Valley Railway, about 1968. This type of engine was extensively used on London suburban work, and the year before nationalisation No 4555 was shedded at MCH Machynlleth in the Central Wales Division. The GWR had 458 of these locomotives at nationalisation. (Dart Valley Railway Series, Ian Allan)

94 The *Coronation Scot* as pictured here by the artist C.F. Howard is shown in a livery of light blue lined with white. Other liveries of blue and silver, and red and gold were used; the streamlining was eventually removed. Locomotive No 6229 *Duchess of Hamilton*, carrying the *Coronation Scot* nameplates, toured America during the New York World's Fair in 1939. (J. Salmon Ltd No 4700)

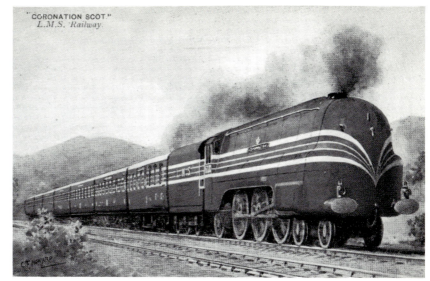

"CORONATION SCOT"
L.M.S. Railway.

95 A delicate line drawing of the LNWR 2–2–2 locomotive *Rowland Hill*, the class being known as 'Dreadnoughts', built in 1884-8. The larger version, known as 'Teutonics', were built in 1889-90. Built at Crewe, No 659 was used on the west coast Euston-Crewe-Carlisle service, hauling 250-ton trains at 50mph. (Midlands Postal Board MPB15)

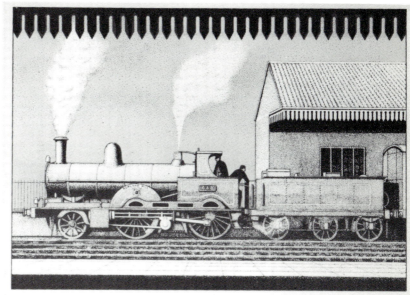

96 One of the more bizarre uses to which locomotives were put during the early months of World War 1. Medium heavy guns were mounted on specially-converted engines with reinforced frames, the idea being to give greater mobility and constantly increasing range to the artillery. But the gun was limited to firing forward only, and with sustained firing the locomotive was liable to be derailed!

CAMP de MAILLY — Pièce de 194, m^le 70-93 sur affût Truc, tout azimut

The St. Petersburg Express,
leaving Ostend.

97 The renowned St Petersburg Express stands alongside a German sleeping car at the Ostend Quay Station, about 1910. The locomotive is a Columbia Type 12 of the series built in 1897. The first of the class was built in 1888, and until 1897 the type had square section chimneys. This view of the front of the engine shows how the enormous trunk of the characteristic chimney dominates the machine. The Express ran an important service from Ostend-Brussels-Berlin, and St Petersburg, connecting with the Trans-Siberian Express, and on to Japan in fourteen days. *(Frank Staff)*

Russian Express Engine,
taking Continental trains through Russian territory.

98 A fine study of a Russian 4-6-0 bogie express locomotive of the Nicholai Railway, about 1910; this type were among the best engines in the country. Weighing 48 tons in working order, a large number of these locomotives were in service on the Trans-Caucasian Railway. More than twenty of this type were built in England; others were built at the Putilov Works in St Petersburg. (Knight Series No 624)

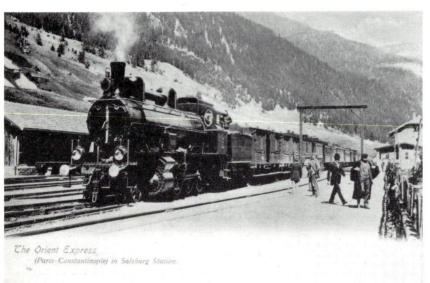

The Orient Express
(Paris-Constantinople) in Salzburg Station.

99 Three times each week the famous 'Orient Express' left Paris on its 1,750 miles journey across Europe to Constanta (Constantinople), and thence across the Black Sea to the Turkish capital of Istanbul. The locomotive shown here was designed and built by J.A. Maffei, of Munich, for the Bavarian State Railways. On its legendary journey the Orient Express changed locomotives no less than nineteen times. (Knight Series No 617)

100 Typical of early French locomotives, No 133 of the Chemin de Fer d'Orléans looks as if it had been designed and assembled by a committee! The design originated in 1854, was transformed with a second set of driving wheels in 1864, and provided with a larger boiler between 1878 and 1888. (Published by HMP, Paris. No 473 'Locomotives de l'Orléans', probably a 500-card set of all French railways, about 1910)

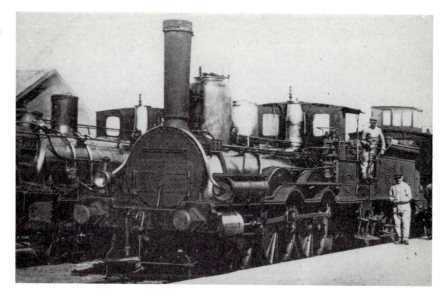

101 Many postcards were produced of *Locomotion No 1* preserved at the Bank Top Station, Darlington. She was shown at many exhibitions, at home and abroad, after being taken out of service in 1857: Philadelphia, 1876; Liverpool, 1886; Newcastle Jubilee, 1887; Paris, 1889; British Empire Exhibition, Wembley, 1924; Stockton and Darlington Centenary, 1925.

102 North Eastern Railway 2-2-4 tank engine No 66 *Aerolite* was originally a six-wheeler built by Kitson in 1851 for display at the Great Exhibition in the Crystal Palace. It was later sold to the Leeds Northern Railway, and in 1854 the company was absorbed into the North Eastern. The NER reconstructed the engine as shown in 1869; it was rebuilt three times, the last in 1902. (Locomotive Publishing Company)

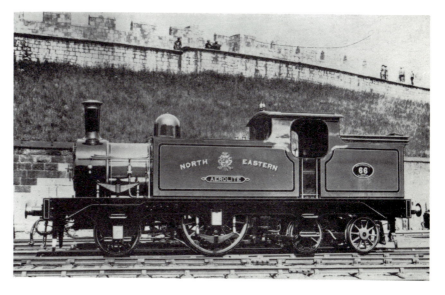

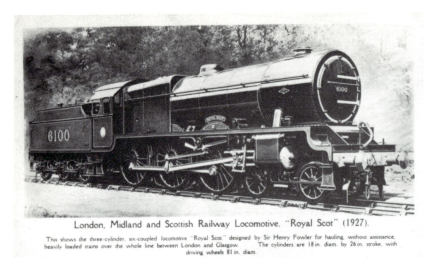

103 London, Midland & Scottish Railway *Royal Scot* No 6100. This class was specially designed to accomplish the run from Euston to Glasgow without change of engine. Complete with her train (the first time this had been done) she toured America in 1933. Because *Royal Scot* was not fitted with the standard American ATC (automatic traffic control), a device which partially applied the brakes when passing a danger signal, she was restricted to 40mph. (Science Museum No 198) *(Peter Woolway)*

London, Midland and Scottish Railway Locomotive. "Royal Scot" (1927).

This shows the three-cylinder, six-coupled locomotive "Royal Scot" designed by Sir Henry Fowler for hauling, without assistance, heavily loaded trains over the whole line between London and Glasgow. The cylinders are 18 in. diam. by 26 in. stroke, with driving wheels 81 in. diam.

The Science Museum. London. No 198 By courtesy of the London, Midland and Scottish Railway Company.

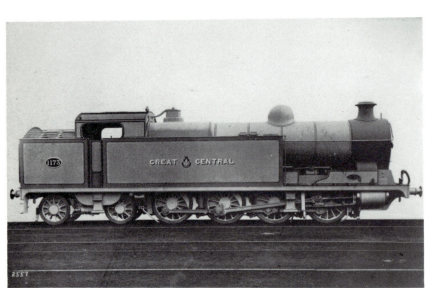

104 Pictured in photographic grey, locomotive No 1173, Great Central Railway, about 1910, shows her clean lines. These 0-8-4 tank engines (later classified by the LNER as S1) were powerful shunting engines which weighed 97 tons each. They were capable of pushing a train of 50 loaded trucks up an incline of 1 in 107. The GCR used them extensively at the Wath marshalling yard, near Doncaster. (F. Moore's Railway Photographs)

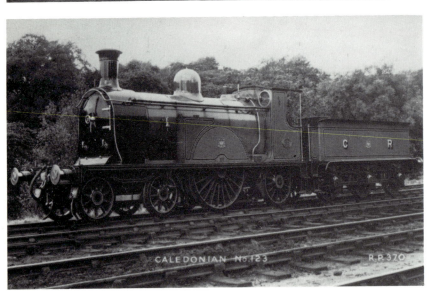

105 Caledonian Railway 4-2-2 No 123 was the last 'Single' in regular passenger service in Britain. She later became LMS Engine No 14010, and was withdrawn from service in 1935. That service lasted 49 years, including the railway race to Edinburgh in 1888. Built in sixty-six days by Neilson & Co of Glasgow, No 123 was designed by the famous Dugald Drummond. (Valentines RP370) *(Rev Teddy Boston)*

106 Kearsley 3872 Electric Locomotive, built in 1936 by Hawthorn, Leslie & Co, Newcastle, for the Lancashire Electric Power Company. The engine was later worked by the Central Electricity Generating Board, operating on a 500v DC overhead wire system. It is interesting to note that the Lancashire & Yorkshire Railway was a pioneer in the use of electric traction on the Liverpool to Crossens section in 1904. (CEGB North Western Region)

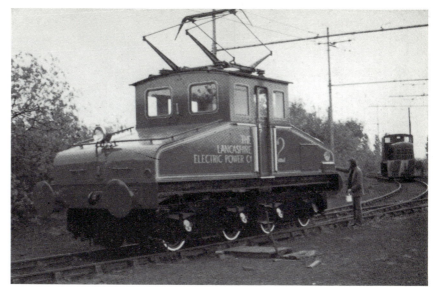

107 London, Midland & Scottish Railway 4-6-0 *Silver Jubilee* locomotive No 5552, built at the Crewe Works. Painted a glossy black finish with chromium-plated fittings, she was named in honour of the Jubilee of King George V. The class of engine was 5XP, designed by Stanier for express passenger work; 5X was its power rating, between classes 5 and 6, and the letter P signified its use as a passenger engine. These engines mainly worked in Scotland, running between Carlisle and Glasgow. *(Peter Woolway)*

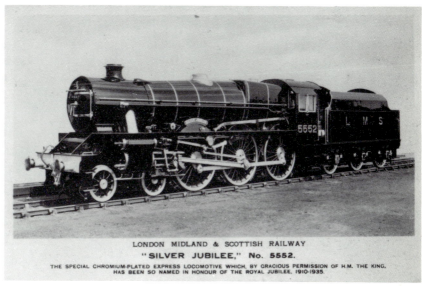

LONDON MIDLAND & SCOTTISH RAILWAY
"SILVER JUBILEE," No. 5552.
THE SPECIAL CHROMIUM-PLATED EXPRESS LOCOMOTIVE WHICH, BY GRACIOUS PERMISSION OF H.M. THE KING, HAS BEEN SO NAMED IN HONOUR OF THE ROYAL JUBILEE, 1910-1935.

108 London & North Eastern Railway 4–6–2 Express Locomotive No 4491, one of five streamlined engines named after countries of the British Empire. Developed from the A4 class designed by Nigel Gresley, and built at Doncaster, these engines were used to haul 'Coronation' trains between London and Edinburgh. (LNER, printed by Locomotive Publishing Co Ltd)

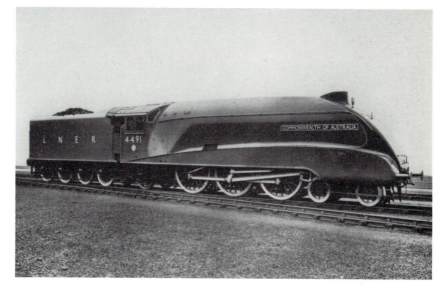

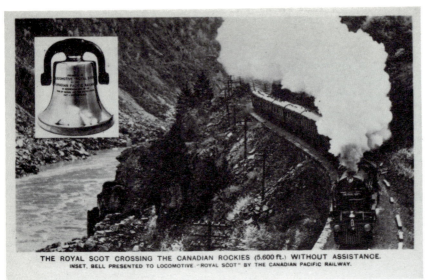

THE ROYAL SCOT CROSSING THE CANADIAN ROCKIES (5,600 ft.) WITHOUT ASSISTANCE.
INSET. BELL PRESENTED TO LOCOMOTIVE "ROYAL SCOT" BY THE CANADIAN PACIFIC RAILWAY.

109 Seen here negotiating an awesome section of single track on the Canadian Pacific Railway, the LMS *Royal Scot* carries a regulation bell and cowcatcher. Much publicity was given to the fact that the locomotive worked its train without assistance from a banking locomotive, from Vancouver to the summit of Kicking Horse Pass (5,329ft above sea-level). No mention was made of the fact that the total weight of the train was only 268 tons against the standard weight of the CPR trains, which were in excess of 1,000 tons. *(Ron Grosvenor)*

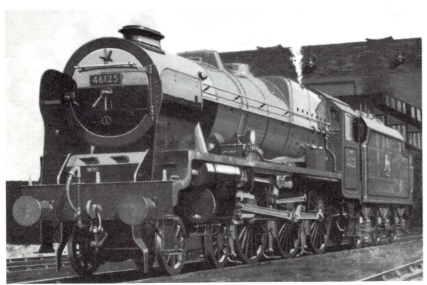

110 A fine painting by V. Welch showing a London Midland Region 'Royal Scot' class 4-6-0 No 46125 *3rd Carabinier* in British Railways green livery. By 1952 'Royal Scot' engines had reduced the Euston-Glasgow time to eight hours each way. (Ian Allan Ltd)

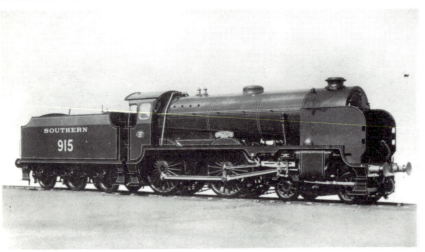

Southern Railway "Schools" Class 4-4-0 Express Passenger Locomotive.

111 The Southern Railway 'Schools' class were the heaviest 4-4-0 express locomotives in Britain in the mid-1930s. They hauled all the main Waterloo to Portsmouth trains, covering the $74\frac{1}{2}$ miles in a little over $1\frac{1}{2}$ hours. *(Ian Wright)*

112 The conventional Fairlie locomotive is a double-ender. The Fairlie 0-4-4 tank engine *Taliesin* No 9 was built at Boston Lodge Works, Festiniog Railway, in 1885. Strangely, it was given the name *Livingston Thompson* despite its brass plate to the contrary. *(Rev Teddy Boston)*

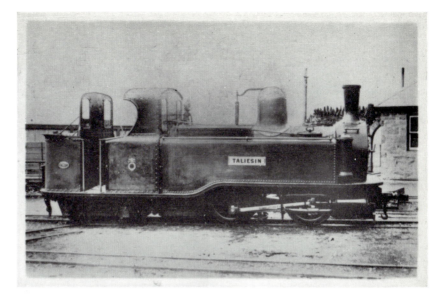

113 Midland Railway 2-4-0 No 86A is seen brightly polished in the Derby Works. The locomotive dates from the 1870s, when similar types were a common sight upon most of the main lines in Britain. The original design was by Matthew Kirtley, and developed by his successor, S.W. Johnson.

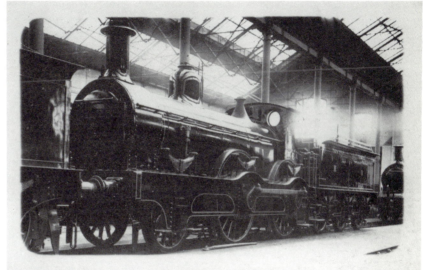

114 London, Midland & Scottish Railway 0-6-0 tank engine No 1815, built at Derby in 1891. This type of tank engine was the most prolific in Britain during the early 1930s, with more than 3,120 in use by the 'Big Four'. They were very aptly known as 'Maids-of-all-Work'. This engine was scrapped in 1932. (F. Moore's Railway Photographs, LPC 10503) *(Stuart Underwood)*

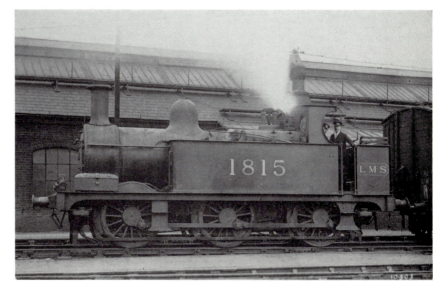

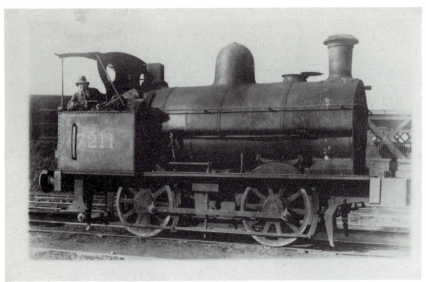

115 Another gem from the family album; the card carries the message, 'Greetings from us 1928', but no other information. Seen here with an LMS number, location unknown, this sturdy shunting engine was one of 235 of similar type in use by all the four main railways in Britain, about 1935.

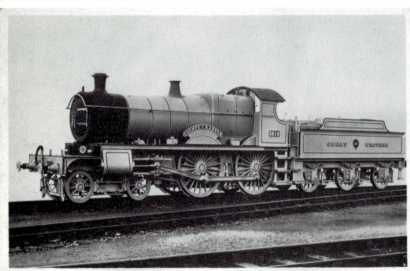

G.W.R.—"COUNTY" CLASS. "COUNTY OF RADNOR."

116 Great Western Railway 4-4-0 'County' class *County of Radnor* No 3818, designed by G.J. Churchward. The first of the class was built in 1904, and weighed, without the tender 58 tons 16cwt. (Great Western Railway Series 6, published July 1908)

117 Czechoslovakian State Railway (CSD) 4-6-2 tank engine heads a rake of eight coaches on a branch line journey. A superheated design, with driving wheels 5ft 3in diameter, the 354 class were used extensively during the mid-1930s. (Nakladatelstvi, Praha C23167-3)

118 A very lucky little boy sits on a superb working model of a North Eastern 4-4-0 locomotive, location unknown. The full-size engine was built to a design by W. Worsdell in 1896, and intended specially for work on steep gradients. Two of the class were built with increased cylinder sizes and driving wheels of 7ft 1in diameter, and were intended for racing purposes.

"Iron Horses are much Superior to Rocking Horses"

119 Inspired by the speed runs of its competitors, the Chicago, Burlington & Quincy Railroad introduced its diesel-electric high-speed three-car train, the 'Burlington Zephyr', in 1934. On its inaugural run, the stainless steel streamlined train covered the 1,015 miles between Omaha and Chicago non-stop, in 13hr 5min. Two more 'Zephyrs' were built, and so popular were the twice-daily runs between Chicago and Minneapolis (at an average speed of 73.3mph) that the CB&Q had to turn passengers away! A similar train, the 'Flying Yankee', was operated by the Boston and Maine Railroad. (E.C. Kropp, Card No 31522, about 1950)

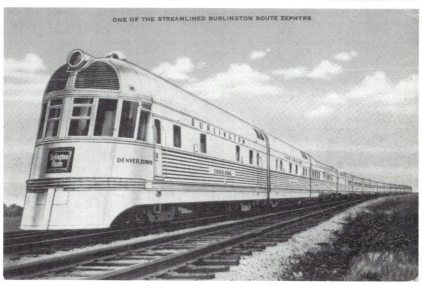

ONE OF THE STREAMLINED BURLINGTON ROUTE ZEPHYRS

120 The famous American A-27, Santa Fe Railway 'Super Chief' is depicted here at Albuquerque, New Mexico. The crack streamlined express is posed in front of the depôt, over-looking the Alvarado Hotel, prior to continuing its journey from Chicago to Los Angeles. The original run was made on Sunday 9 July 1905, with the 2,228 miles being covered in 44 hours. Before it became a regular run (five trains daily from Chicago) hauled by the *Chief*, and taking just over 34 hours for the journey, the train was known as the 'Death Valley Coyote'. (Southwest Post Card Co 'C.T. Art-Colortone' No 9A-H11, about 1950)

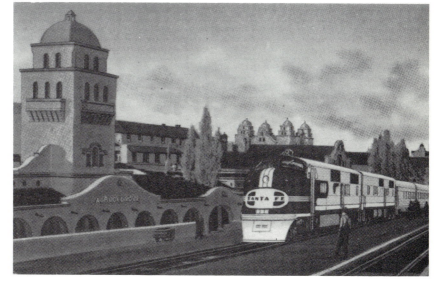

121 The original of this picture was painted by Cyrus Cuneo, father of the renowned railway artist, Terence Cuneo. It was copied, varied, reproduced, and 'pirated' in countless magazines and books, about 1925–35. The locomotive is one of the early engines which used to haul the 'Trans-Canada Limited' across prairie and mountain ranges, on a 2,886-mile journey between Montreal and Vancouver. (Canadian Pacific Railway, advertising card, about 1930)

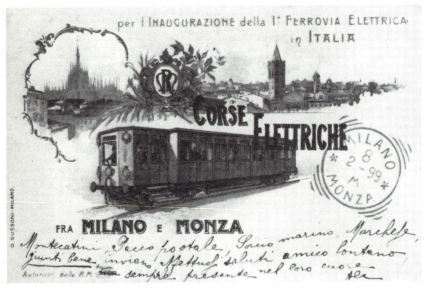

122 Perhaps the first picture postcard to commemorate the inauguration of a railway. The Milan to Monza line was a suburban route which operated on the third rail system (like the London Underground), but its achievements have received scant record in railway history books. The special cancellation cachet was part of the chromolithographed design. Note the very unusual driving compartment of the coach.

ROLLING STOCK

To many people the term rolling stock refers to passenger carriages, but it should never be forgotten that passengers were among the last considerations in the introduction and development of the railways. In a book published in 1649 (*Chorographia, or a Survey of Newcastle-upon-Tyne*) it was said that 'Railways are an Invention of the Coal Carriers of Northumberland'. In the now scarce reprint of the rare original, published in 1818, the historian Nicholas Wood observed, 'A South Country man named BEAUMONT introduced WAGGONS there [Newcastle] which ran on tramways, as well as many wonderful engines'.

The first railways were in business to haul coal and other industrial products, and anyone wishing to travel by train had to accept whatever accommodation was available, or provide their own carriage, in return for payment of the fare. Such conditions of course excluded all but the rich who were quite content, and able, to have their private carriage loaded onto a low wagon. When more and more other people demanded transport by train they travelled in what were nothing more than open-ended wagons. Some of these early carriages had their access, not from the station platform, but from between the track rails!

A fortnight after the formal opening of the Stockton & Darlington Railway on 10 October 1825, the first coach specifically designed for the railway made its initial run. *Experiment*, as it was named, was little more than a stagecoach body on an iron frame, with springless cast-iron wheels. It was not until nearly thirteen years later that anyone gave any serious thought to the design of a railway carriage, rather than a stagecoach running on railway tracks. Isambard Brunel, of the Great Western Railway, constructed a grand saloon 'being most gorgeously fitted up'.

For some considerable time after the Regulation of Railways Act (1844), which provided rail travel for third class passengers, it was generally true that first class carriages were roofed and had glazed windows, second class unglazed windows, and third class open wagons, not always with seats. An alternative, as described in a House of Commons Report in 1845 which surveyed twenty-six railways, was of horse-box shape, and 'on some lines only one door was available for each 50 passengers'. By this time the design of railway carriages had begun to move away from the influence of the stagecoach, but not until the advent of the Pullman car on the Midland Railway in 1875 did that change become really significant.

As with all innovations, once the standards had been set, improvements and developments quickly followed. Bogies for a smoother ride round curves, dining cars, toilets, electric lights, corridors, and steel coaches for safety, all appeared before the turn of the century. By the mid-1930s there were nearly 50,000 carriages running on the 'Big Four' railways, of which more than 500 were restaurant cars, 300 sleepers, and 230 Pullmans. The railways of Britain had become supreme in the field of comfort and convenience. But all these improvements increased the weight of the trains, necessitating more powerful locomotives, and standardisation of design components which embodied many of the best features of all rolling stock.

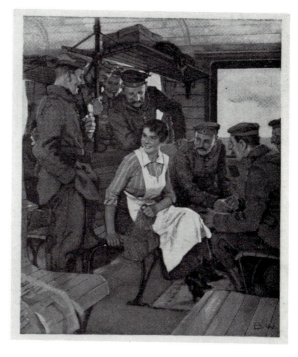

123 The German soldiers are going on leave, travelling by what appears to be a local 'stopping' train, the young country girl relishing the attention from so many admirers. It was a feature of German railways that the third class compartments were not upholstered, the plain wooden seats being painted yellow, grained, and varnished. They were quite well-shaped, and more comfortable than might have been imagined. (Kriegspostkarten by B. Wennerberg, No 13 *Urlaubsfahrt* [Going on Leave], printed by Albert Langen, Munich, about 1915)

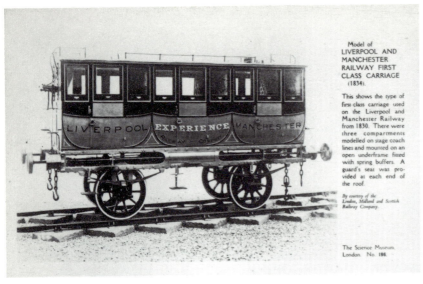

Model of
LIVERPOOL AND
MANCHESTER
RAILWAY FIRST
CLASS CARRIAGE
(1834).

This shows the type of first-class carriage used on the Liverpool and Manchester Railway from 1830. There were three compartments modelled on stage coach lines and mounted on an open underframe fitted with spring buffers. A guard's seat was provided at each end of the roof.

By courtesy of the London, Midland and Scottish Railway Company.

The Science Museum, London. No. 196.

124 This photograph shows a model of the Liverpool & Manchester Railway carriage *Experience*, presumably made from original drawings. There are a few minor discrepancies between this and the LNWR artist's impression (see colour plates) (The Science Museum No 196, about 1930)

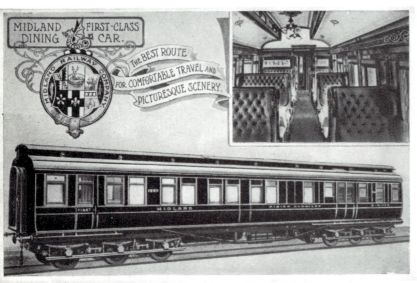

125 A definite improvement on the Liverpool & Manchester Railway coaches of seventy years earlier, in part justifying the claim for the 'Best... for Comfortable Travel'. The general introduction of the clerestory roof with its partial glazing to admit more daylight probably first occurred on the Great Western in the early 1870s, and lasted for about sixty years. (Midland Railway, Set 2, published mid-1905)

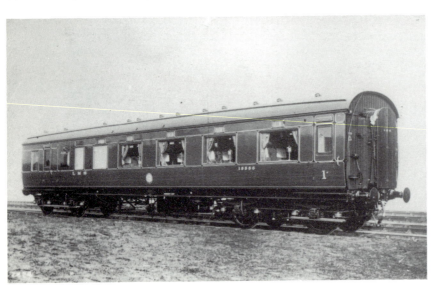

126 London, Midland & Scottish Railway first class corridor brake, about 1935, of the type used extensively on the 'Royal Scot' express and other prestigious trains. Its four compartments were each upholstered and decorated in a different style, with reservations for non-smokers. The large windows gave an uninterrupted view, with the ventilation window above, complete with its own little curtains. (F. Moore's Railway Photographs, LPC) *(Peter Woolway)*

127 Pictured with a group of un-named dignitaries, the first Great Central passenger train through Tickhill Station stands at the platform, 16 September 1908. The vestibule carriage is very similar to Chairman Watkin's (1864-1894) saloon, and was almost certainly an influence upon the design of the GCR Immingham tramcars.

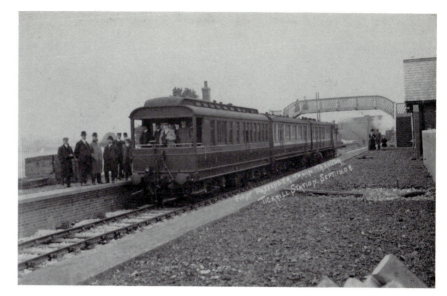

128 The 'Beaver Tail Observation Car' of the streamlined *Coronation* was the continuation of the LNWR's attempt in 1911 to bring American practice to railways in Britain. Although these special saloons offered better viewing facilities they were never very popular. In 1937 the LNER *Coronation* took the speed record from the GWR with an overall average of 71.9mph between London and York. On this all-streamlined train the coaches were linked with aluminium-coated rubber sheeting. (London & North Eastern Railway, published 1935, printed by the Locomotive Publishing Co Ltd)

L.N.E.R. "THE CORONATION" — TAIL END.

129 Grand Junction Railway travelling post office carriage. Built in 1938 by Nathaniel Worsdell, this special coach enabled Post Office employees to sort mails en route. The first TPO was run on the Grand Junction on 1 July 1837, between Liverpool and Birmingham. The coach was 16ft long, 7ft6in wide, and weighed 4 tons. (Richard Blake Mail Coach Cards No 6RB, published 1984)

1838. Grand Junction Railway T.P.O. Carriage

1838. London and Birmingham Railway Mail Bed-Carriage

130 London & Birmingham Railway mail bed-carriage, 1838. These curious composite coaches allowed for two passengers to sleep lengthwise with their feet in the boot section beneath the guard's foot-rest. The mails were carried in the roof boxes, the larger one for letters and small parcels, the small one for passengers' personal valuables. (Richard Blake Mail Coach Cards No 5RB, published 1984)

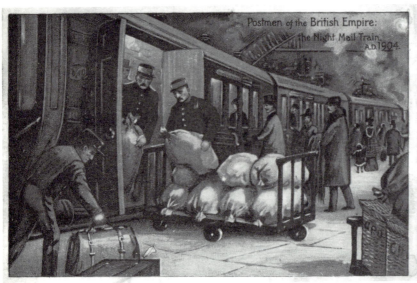

131 One of a very popular series on the world's postal services, this scene was enacted every night at the major stations throughout Britain. The true mail trains did not carry passengers. The 'North Western TPO Night Down', known as the 'West Coast Postal' left Euston at 8.30pm with thirteen coaches of mail, arriving at Aberdeen with two coaches, some eleven hours later. (Pictorial Post Card, 'Postmen of the British Empire, the Night Mail Train, A.D.1904')

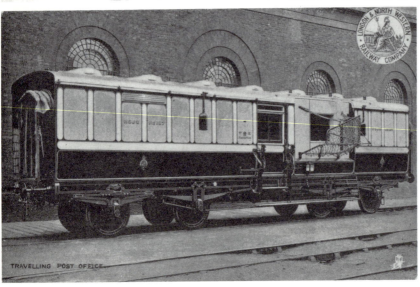

132 That necessity is the mother of invention is clearly shown in this exterior of a LNWR travelling post office. With more and more mail being carried by the railways it became necessary to pick up and deliver sorted mail while the train was travelling at speed. The result was the invention of the special catcher apparatus by John Ramsey, who was attached to the missing letter branch of the Post Office; he was soon afterwards appointed Post Office Inspector-General. (London & North Western Railway, Set 11, published August 1904, printed by Raphael Tuck & Sons Ltd) *(Peter Woolway)*

133 In this LNWR picture the mail pouch is seen suspended from the special trackside iron post ready to be picked up at speed. The rope net on the side of the carriage swept the pouch into the sorting van; sorted mail left the train by a converse method. Electric alarm bells warned the postmen in the van that a pickup was due, because the mailbag was literally hurled into the compartment. (London & North Western Railway Set No 6 'Express Trains' Revised Series, published November 1904, printed by McCorquodale) *(Peter Woolway)*

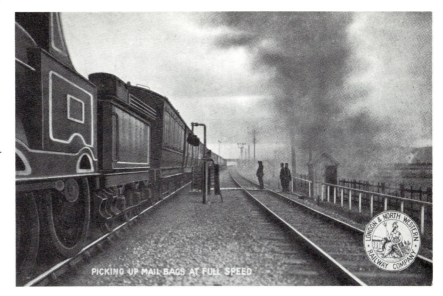

PICKING UP MAIL BAGS AT FULL SPEED

134 The interior of a mail van, showing on the left the pigeonholed racks for the letters. At the far end, on the right, beyond the dark leather curtain, was the lever which operated the collapsible net which caught the mailbags from the trackside standards. This card was a reissue of an earlier set, all of the cards being changed. The picture was updated and carries the Royal coat of arms. (London & North Western Railway Set 22, reissued 1906-7, printed by McCorquodale)

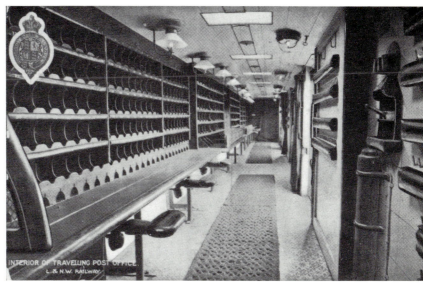

INTERIOR OF TRAVELLING POST OFFICE
L. & N.W. RAILWAY

135 What must surely rate as the most unusual 'rolling stock' of any railway! It was known to the slate quarry workers as *car gwyllt*, or 'wild car'. Made by the blacksmith at Manod, it provided a speedy, if somewhat perilous method of descending the mountain. *(Peter Woolway)*

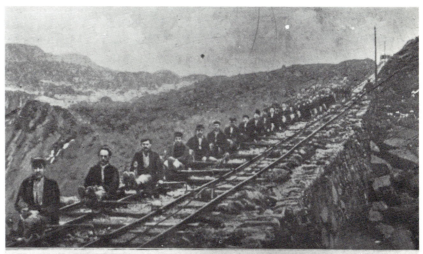

BLAENAU FESTINIOG. Leaving Work at Graigddu Quarry

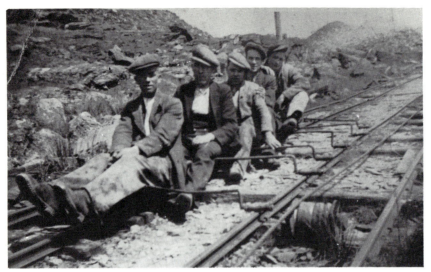

136 A closer view of the 'wild car' at Craig Ddu Quarry, Blaenau Festiniog. The seat was a short length of old planking to the underside of which was fastened a small wheel, with a simple lever handbrake. It was balanced catamaran-style by a cranked bar and a roller travelling on the inside rail of the adjacent track. The quarrymen sat, their backs unsupported, their legs uncomfortably raised, and their hands clasping the brake, pulling in unison and hoping to stop safely! *(Peter Woolway)*

137 A corner of Stapleford's Wagon Works, Coalville, Leicestershire, late September 1908. The sender of the postcard, 'Dad', wrote, 'I thought you would like to see one of our latest productions. You will know the two standing near'. The 'latest production' was a 20-ton oil tank wagon for the Great Indian Peninsular Railway, which crossed the mountain range of the Western Ghats. GIPR trains were hauled by powerful 2–8–4 tank engines. The corner occupied by the tanker wagon now houses the offices of the Springboard Centre, sponsored by the Leicestershire County Council, which accommodates small business workshops.

138 London, Midland & Scottish Railway 'Crocodile' well bogie wagon, bright in its new paintwork, location unknown. The manufacturers plates show it to have been made by Cammell-Laird, probably assembled at their Nottingham works, about 1925. The bogies were made at the Leeds Forge Company, and the wheels by the Newlay Wheel Company, also at Leeds. Wagons of this type were used for the transport of very heavy loads (up to 40 tons) of non-standard dimensions. (F. Moore's Railway Photographs, LPC No 7965) *(Peter Woolway)*

139 A scarce picture of a Kearney high-speed railway car which was never put into service. Cars of this design, which were planned to seat forty-six persons, were equipped with two 50hp motors, and carried small balancing bogies on the roof. The carriages were to have been built by the Brush Electrical Engineering Company, of Loughborough. It was also proposed that the KHSR monorail system should work an underground railway on Tyneside, the Kearney cars weighing only half as much as conventional high power electric cars. (Kearney High-Speed Railway Co Ltd) *(Ron Grosvenor)*

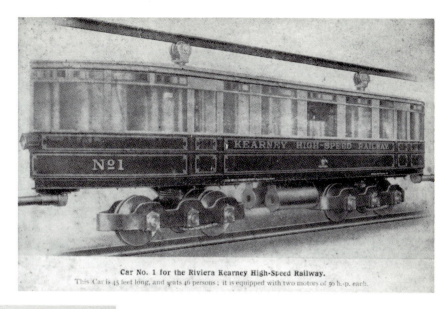

Car No. 1 for the Riviera Kearney High-Speed Railway.
This Car is 45 feet long, and seats 46 persons; it is equipped with two motors of 50 h.-p. each.

141 Quite a contrast to the cushioned comfort of the named expresses is the primitive construction of this early GWR third class coach, location unknown, about 1930. There is very little basic difference between this coach and those of the 1850s. The coat of arms of the GWR combined the crests of the City of London and Bristol. It is interesting to note that none of the railways who so proudly displayed their heraldic crests had permission from the College of Heralds.

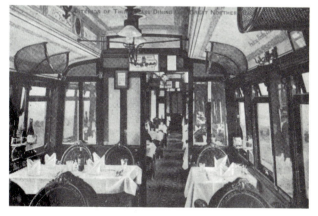

140 Interior of third class dining car, Great Northern Railway, about 1910. The company were the first to introduce the dining car into Britain in 1879; the service was mainly used on the London to Leeds expresses. With buttoned velvet upholstered gilded Regency-style chairs, the degree of opulence was quite amazing. Between the hand-luggage nets on the enamelled panels above the windows was painted the notice, 'Smoking Strictly Prohibited'. (Picture by F. Moore, probable LPC publication)

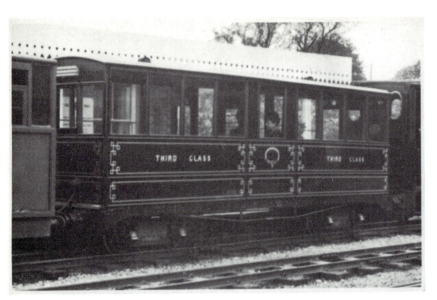

142 Rather grand styling in the livery of this Talyllyn Railway coach, date unknown. It is rather reminiscent of the much more elaborate decoration to be found on Pullman coaches. In 1908 the livery of the passenger rolling stock was standardised as bright red. The track gauge is 2ft 3in, and the line was closed in 1949, the company dating back to 1865. It was reopened in 1951, and is the oldest steam-hauled narrow gauge railway in the world.

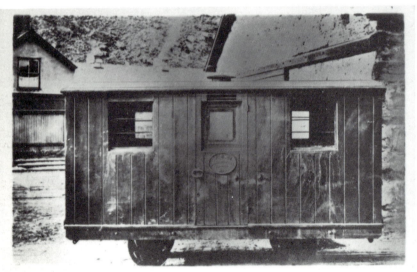

143 Festiniog Railway carriage No 9, date unknown. The FR began to carry passengers in 1864; they travelled at their own risk, but paid no fare. The following year a limited regular service was introduced.

144 Philadelphia & Western Railroad 'Bullet', about 1935. Diesel rail coaches of semi-streamlined construction in three-car units appeared on the American railways in the late 1920s for use on suburban services. In these early 1930s cars the streamlining was more for styling than high-speed efficiency, although they were noted for their rapid acceleration. (A-V Designs, NY, No TP34) *(Ron Grosvenor)*

145 Great Western Railway steam rail-car at Swindon, 1931. The GWR were among the pioneers of rail-car development and design, and soon discarded the steam coach with its numerous disadvantages in favour of the diesel rail-car. The three-car set introduced on the Birmingham-Cardiff inter-urban service in 1934 proved an immediate success. (Connoisseur Series A No 4)

146 Vestibule bogie coach, American style, built by the Lancaster Carriage Works, 1898, for the Weston, Clevedon & Portishead Railway. This was a retrograde design, both in coachwork and bogie units; together with the very elementary suspension units the spoked wheels must have provided a most uncomfortable ride. (Ron Grosvenor)

147 'Pullman' coaches on a Romney, Hythe & Dymchurch Railway train. The carriages were fully enclosed mainline compartment coaches in miniature; eight of them were built in 1928 for winter use. The engine is No 7 *Typhoon*, built in 1927 by Davey Paxman & Co of Colchester. (S & E 'Norman' Series No 43) (Rev Teddy Boston)

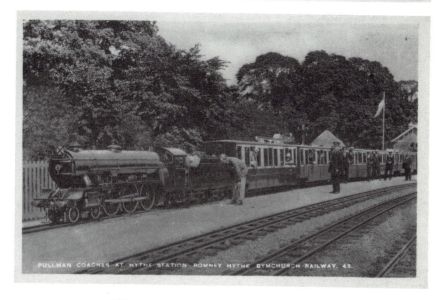

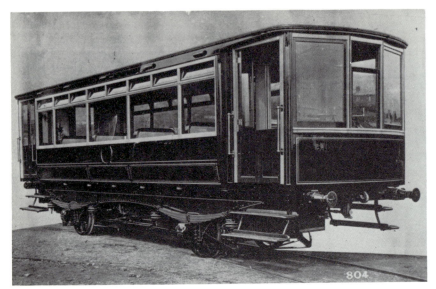

148 London, Brighton & South Coast Railway petrol railcar, about 1930. This was the prototype intended for suburban use, and after branch line trials was tested on the Brighton Down line. Its further development was halted by the LBSC electrification schemes.

149 First class composite and lavatory stock for use on the London, Brighton & South Coast Railway, about 1890. A painted instruction on the main beam at the end of the coach indicates that it is 'To be returned to Brighton'. It was probably one of the last such carriages built by the LBSC since the new 12-wheeled bogie coaches appeared at this time. Note the splendid coat of arms on the centre door panel.

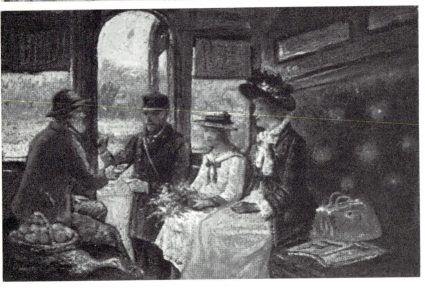

150 Travel by train was the subject of many paintings, both private and commercial, and today's specialist artists like Cuneo, Weston, Shepherd, and Heiron carry on the traditions and skills of other great painters. The realism (and great social value) of those early pictures is quite remarkable. The painting, 'Third Class-the Departure', by Abraham Solomon, exhibited at the Royal Academy in 1854, is an history lesson in itself, telling of emigration to Australia by the posters in the carriage. (Raphael Tuck & Sons, 'By Train' Oilette Postcard 9186, from the original by J.A. Heyerman, about 1905)

THE UNDERGROUND

The underground railway system, more familiarly known as the 'Tube' or the 'Metro', evolved from the development of railway tunnelling. Legend has it that the son of the famous Isambard Kingdom Brunel, Marc Isambard Brunel, gained inspiration for his building of the Thames Tunnel by watching shipworms burrowing their way through ships' timbers; he was on contract to the British government while working in Chatham Dockyard. The Thames Tunnel was built between 1825 and 1843, and the technique of using a boring shield and lining the tunnel behind it was successful.

Authority was given for the construction of a subway between Tower Hill and Bermondsey, which James Henry Greathead built in 1869. Strictly, a cable tramway, this was the first 'tube'. Greathead eventually managed to revive interest in the City and Southwark Subway, which was later built as the City and South London Railway, and became the world's first underground electric railway. Because of the manner of its construction, excavation by means of a cylindrical 'mole' or shield, with iron linings bolted together behind it as the work progressed, the resultant tunnel was nicknamed the 'Tube'. Some people confuse the term 'Underground' with the 'Tube', but in technical terms it was not until many years later that the two words became truly synonymous. The original Metropolitan Railway, which gave the name 'Metro' to several later underground railway systems, was built on the 'cut and cover'

principle. A shallow rectangular cutting was excavated beneath the streets, and covered with a reinforced 'roof'.

The problem of suburban traffic on the railways in big towns and cities had long been a serious one, for which many novel ideas were formulated. The solution was to take the railways below ground, an idea which gave rise to much opposition. The Metropolitan Railway, running on mixed gauge and operated by the Great Western Railway with their locomotives and rolling stock, opened on 10 January 1863. Not until 22 September 1905 did the last steam train run on the line, having been replaced earlier that year by electric trains.

Some idea of the scale of the problem of providing adequate suburban services can be gauged from the fact that by 1914 the London underground electric railway system was carrying $1\frac{1}{2}$ million passengers every day. Even more staggering are the figures quoted by the Great Eastern Railway who, by 1909, were operating 990 trains every 24 hours from their Liverpool Street terminus!

Rolling stock on the underground was at first the same ordinary compartment carriages that were used on the conventional railways. Different needs required new designs, and the open plan car, with all the seats placed along the sides, was evolved. Steel coaches, flexibly linked in multiple units, controlled by a motorman at the front, became the standard which is now taken so much for granted.

151 The Central London Railway was opened in 1900 between Shepherds Bush and the Bank. Although it is not stated, perhaps this picture commemorates the first train, one of a type with a Siemens motor of about 50hp. Similar locomotives were extensively used on Central European railways into the late 1930s. (Wrench Series No 2956, possible official, published December 1903 to November 1904) *(Ron Grosvenor)*

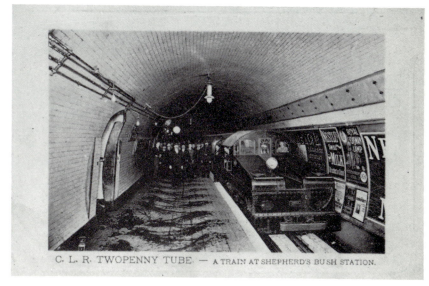

C. L. R. TWOPENNY TUBE. — A TRAIN AT SHEPHERD'S BUSH STATION.

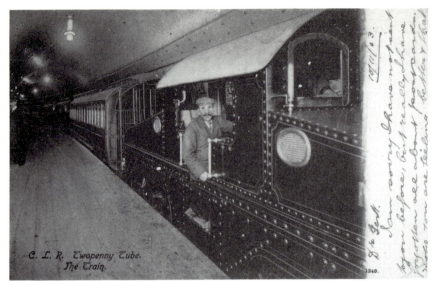

C. L. R. Twopenny Tube.
The Train.

152 The idea of the open driving cab was a legacy from the days of steam on the underground railways, which persisted until about 1910. The clerestory-roofed coaches, which first appeared in the 1880s, remained until the early 1930s. (Hartmann No 1340, possible official, pu 10 November 1903)

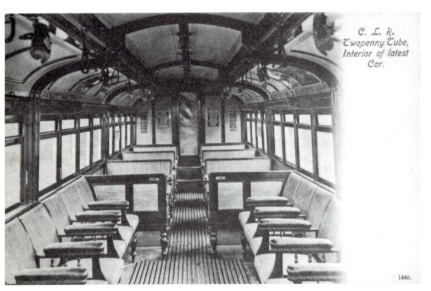

C. L. R.
Twopenny Tube,
Interior of latest
Car.

153 In this interior view of the latest CLR car a good idea can be obtained of the spacious and comfortable seating. Extra passengers were catered for by the use of the looped leather straps. On either side of the door at the end of the coach can be seen the route boards of the train, in this case, between Shepherds Bush and Bank, both ways. (Hartmann No 144c, possibly official, published October 1910) *(Ron Grosvenor)*

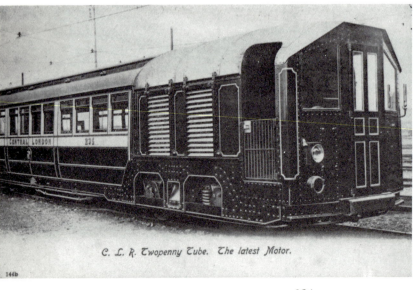

C. L. R. Twopenny Tube. The latest Motor.

154 The latest motor on the Central London Railway was classified as 'open' stock, entrance to the driving position by way of the 'garden-gate' metal wicket. Although the livery colours were not standardised until about 1914, this collotype picture shows the style which was later adopted. Electric locomotives were coloured chocolate; passenger stock was the same, with white upper panels. The louvres behind the driving compartment were picked out in vermilion. The company crest was just below the name 'Central London'. (Possible official published by Central London Railway about October 1902, printed by Hartmann, No 144b) *(Ron Grosvenor)*

155 This picture is an artist's impression of a typical tube station, but not specified. The board above the platform indicates that it is on the City & South London Railway, but the title to the picture, 'Central Tube Station' is a little confusing. The locomotive and carriages are drawn in CLR livery. Part of the caption on the reverse of the card declares, 'These railways are comfortable and pleasant travelling'. (Tuck Oilette, London Railway Stations Series 11, Postcard 9383, published 1907)

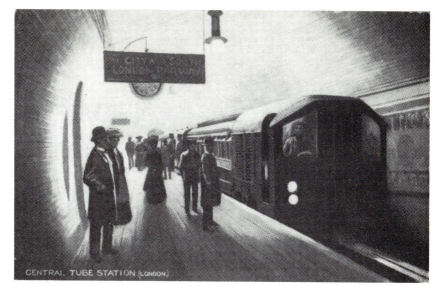

156 This Central London Railway whitewashing train was a standard tunnel maintenance train converted for spraying. The arc of Y-shaped nozzles can be seen in front of the screen at the end of the coach. The use of the whitewash was to lighten the track between stations for the benefit of the driver. The picture is a sepia half tone. (CLR official about 1902, printer unknown) *(Patrick B. Whitehouse)*

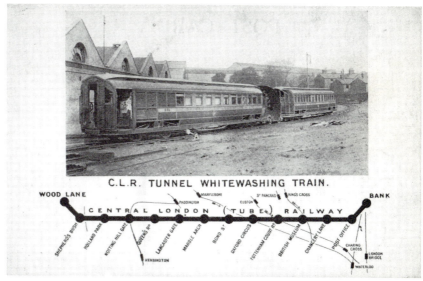

157 Although not specified, the boiler house shown in the picture was at the Shepherd's Bush power station. This was Central London Railway property; the only other company owned power station being that at Neasden (Metropolitan). The Lot's Road, Chelsea power station, with its distinctive four tall chimneys, generated electricity for the rest of the underground system; it was opened in 1905. (Possible official, a twelve-card set printed in four editions, 1903-4, Wrench Series No 2962) *(Ron Grosvenor)*

158 One of the world's most unusual underground railways is the Post Office 'Tube', running between Paddington and Whitechapel. Evolved from the Pneumatic Railway of 1862, construction was commenced in 1914, and the line opened for traffic in December 1927. Eighty feet below London's streets, its headquarters are at the Mount Pleasant Post Office, and it connects six sorting offices and two main line stations. (House of Questa, No 2 of a six-card set, published October 1981 for the Post Office)

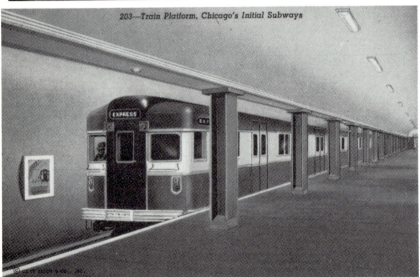

203—Train Platform, Chicago's Initial Subways

159 Chicago's remarkable urban underground transport system was originally constructed in 1900 by the Illinois Telephone and Telegraph Company for carrying its wires and cables. Apart from carrying passengers, the system was developed for the transport of freight and animals. In the downtown area, continuous platforms, more than eight miles long, accommodated the passengers. The sleek, all-metal cars, with automatic train control, ran on rubber insulated tracks. (J.O. Stoll, 'C.T. Art-Colortone No 203, about 1950)

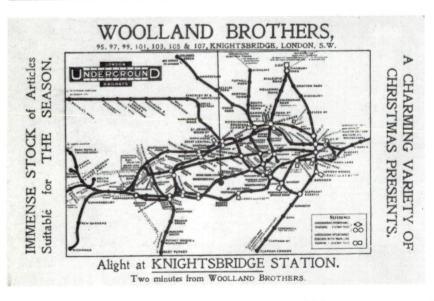

WOOLLAND BROTHERS,
95, 97, 99, 101, 103, 105 & 107, KNIGHTSBRIDGE, LONDON, S.W.

IMMENSE STOCK of Articles Suitable for THE SEASON.

A CHARMING VARIETY OF CHRISTMAS PRESENTS.

Alight at KNIGHTSBRIDGE STATION.
Two minutes from WOOLLAND BROTHERS.

160 A trade card issued about 1915 by the London Underground to one of its 'customers'. In exchange for promoting the Underground various firms were allowed to overprint their own advertisements on these cards, the face of which was a poster-type picture. The geographic map of the system with all its congestion demonstrates why the diagrammatic map was introduced in 1933.

STATIONS

Every station, large and small, is a clearing house of passengers and freight, with trains to almost every part of the country, day and night. Like the small country halt, the working of the terminal stations is of tremendous interest, a part of an intricate organisation dealing with several thousand trains and millions of passengers daily.

Some of these stations have gone down in history, and many have been deemed worthy of detailed examination in several books. The Victorians with their newly acquired process of making cast-iron in vast quantities turned the railway station into a functional artform. Indeed, so much was made of the practice of turning ordinary functional objects into ornaments that at times acanthus-bound pediments, fern-fronded fluted columns, and enfoliated capitals seem to run, undisciplined, through many major stations. Victorian railway companies contended with each other in station architecture. These companies were distinguished by their colourful liveries; so too were they characterised by their architecture. Midland Gothic, South Coast Classical, and London & North Western Palladian are now part of our rich railway heritage; or were, until British Rail architects modernised and standardised the stations.

Although those which do manage to survive continue to be studied as closely as cathedrals (some of these historic stations are often regarded as cathedrals of industrial architecture), some are more modest in their demands for attention. The tiny station of Blackwell Mill in Derbyshire was one of the smallest in Britain, its tiny platforms only long enough to accommodate a six-wheel coach; the station at Cambridge had only one platform, but that could take several trains standing at it at the same time.

Some of even the smaller stations, while not of the highest architectural merit, were such self-contained hives of industry, almost a community in themselves, that they deserve wider attention by historians before the vital information about them is lost. Where now are the colourful posters and metal plaques which once seemed to be an almost integral part of the structure of the railway station? Sadly, it is not only the trains which have departed.

161 A picture which probably symbolises, as much as any, the function of the Victorian railway station. Waterloo Station, the terminus of the London & South Western Railway, was, at the time of the grouping, the largest and best-equipped in Britain. The culmination of its rebuilding (which took twenty-two years) was the opening of the Memorial Arch in 1922 by Queen Mary. The arch commemorated the railway staff killed during World War 1. (See also illustration 361)

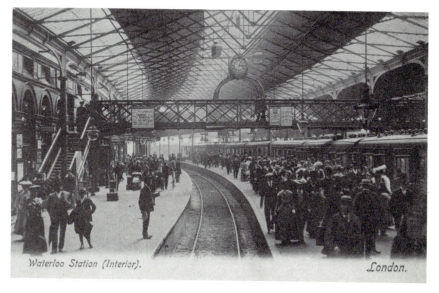

Waterloo Station (Interior). *London.*

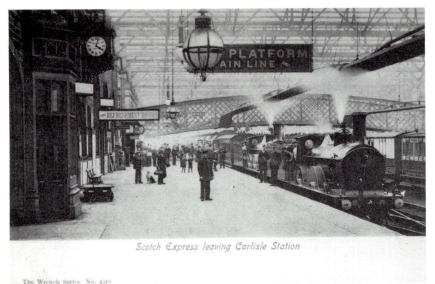

Scotch Express leaving Carlisle Station

The Wrench Series No. 4510

162 Carlisle Station was once known as the 'Gateway to Scotland'. In the days before grouping, the Citadel Station jointly owned by the Caledonian and the LNWR, was the junction of seven railways. Just over a mile away from the station were the Kingmoor and Durran Hill marshalling yards. The first railway to reach Carlisle was the North Eastern in 1838; the Midland Railway, as in the picture, did not arrive until 1875. (Wrench Series No 4510)

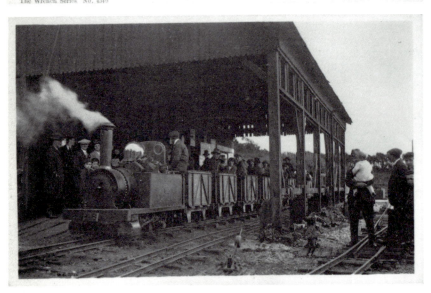

163 Certainly not the most glamorous of railway stations, to judge by this view of Old Ravenglass Station, about 1923. The engine, an 0–6–0 tank engine, was built in 1881 by Sir Arthur Heywood (who built the locomotives for the Duke of Westminster's railway at Eaton Hall in Cheshire), and was scrapped in 1926. The R&E was opened for passenger traffic on 20 November 1876. (Ravenglass & Eskdale Railway Co 'Historical Series' No 2) *(Ron Grosvenor)*

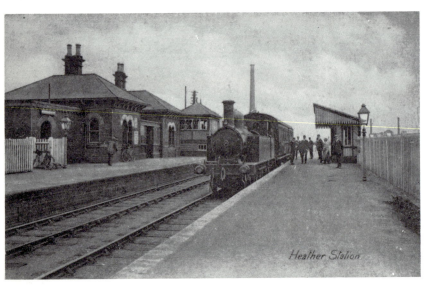

Heather Station

164 Heather Station was on a stretch of line from Charnwood Forest Junction to Shackerstone operated by the London & North Western and Midland Joint Railway. The line was opened southwards to Nuneaton and north to Coalville on 1 September 1873. The station retained its name until 1894 when it was changed to Heather and Ibstock; it was closed in 1931. The picture was taken about 1910. (R.J. Fowkes, Post Office, Heather, 'Rexatone Series')

165 Oban Station was on the
Caledonian Railway (later absorbed
into the LMS), forming an important
link between Glasgow and
Edinburgh. The Caledonian expresses
were regarded as equal in comfort to
the finest English trains, and were
very popular. (Caledonian Railway
official, Series 27 'Oban', issued 1907;
type 'Glosso', an eight-card set which
sold at 6d) *(Ian Wright)*

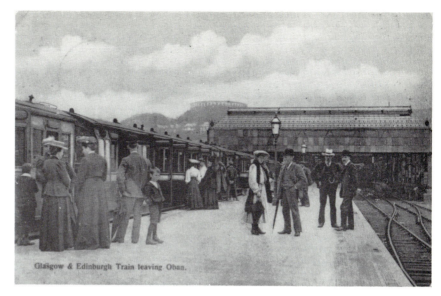

Glasgow & Edinburgh Train leaving Oban.

166 This picture of Andover Station
in 1908 typifies the summers of
Edwardian elegance. In 1847, the
London & South Western Railway
received authorisation to construct a
line to be known as the Andover &
Southampton Junction Railway.
Although only a small country
station, it was an important junction
providing links between London,
Southampton, Cheltenham, and
Devon and Cornwall. The picture was
taken by pioneer photographer and
postcard publisher, Francis Frith,
who photographed more than 2,000
towns and villages in Britain. (Francis
Frith Collection No 60096)

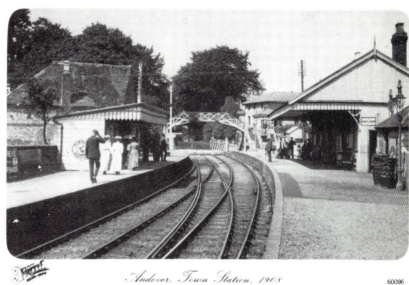

Andover. Town Station. 1908. 60096

167 A fine study of Millhouses and
Ecclesall Station, south of Sheffield,
on the Midland Railway. What at
first sight appears to be a signal-box is
in fact the Stationmaster's office; the
oriel window gave him a commanding
view of the station and its approaches.
The stationmaster at a small station
not only had to be an administrator,
with a watchful eye on local traffic
developments, but also a salesman,
canvassing for extra business in freight
as well as passengers.

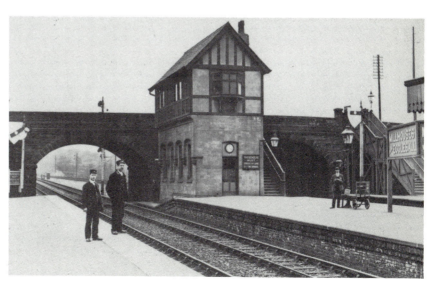

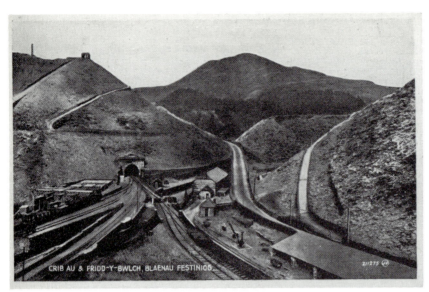

CRIB AU & FRIDD-Y-BWLCH, BLAENAU FESTINIOG.

168 This picture is thought to have been taken about 1885. It shows the Llechwedd Slate Quarry exchange sidings at the south end of the Blaenau Festiniog tunnel (*Twnel Mawr* — Big Tunnel). Although its exact length is disputed, the tunnel is generally reckoned to be 2 miles 333 yd. A temporary station was built on the site in 1879 to establish the LNWR links beyond Ffestiniog, and in compliance with the provisions of the 1872 Act. (Valentines 'Phototype' No 211275) *(Brian Render)*

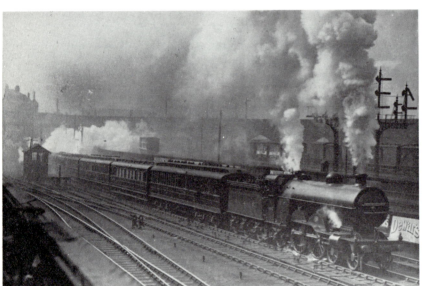

169 A powerful, if smoke-laden study of the Down Leeds Express leaving the Great Northern Railway's London terminus, King's Cross. The GNR was the second main line to enter London, and King's Cross was opened in 1852. In its ultimate form the station was one of Britain's largest, with seventeen platforms totalling more than two miles in length. The locomotive is a GNR 'Atlantic' 4–4–2 No 1441. *(Ron Grosvenor)*

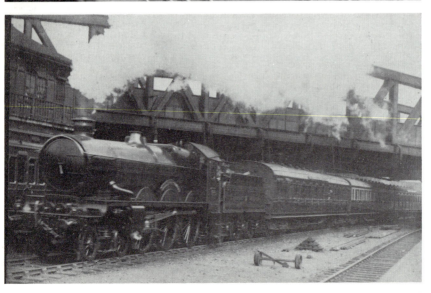

170 Pulling away from Paddington the Great Western *Caerphilly Castle* No 4073 heads the down Cheltenham express. Like the other early railways into London, the GWR soon found it necessary to expand. The original station, built in 1838, was altered several times by 1845. Brunel sanctioned extensions which were completed in 1854, to designs by Matthew Digby Wyatt, at a cost of £650,000. At the end of the rebuilding programme in 1935 the station had been extended to sixteen platforms. *(Ron Grosvenor)*

171 Wigan Central Station, a branch line terminus, was the northernmost station on the Lancashire section of the Great Central Railway. Construction of the line reached there in 1884, and the station moved from its temporary location at Darlington Street to these buildings on 3 September 1892. The line connected with the Cheshire Lines Committee route to Manchester and Liverpool Central Stations. (Locomotive Publishing Company, No L1218)

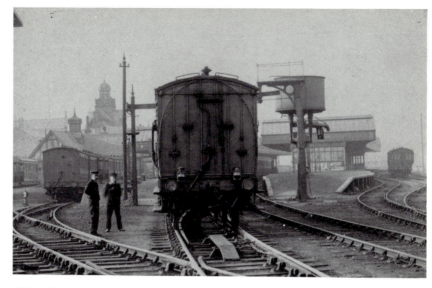

172 The maritime station at Cherbourg provided a connection between the French State Railway and the cross-Channel ferries to Southampton and the London & South Western Railway. Most of this traffic was by the L&SWR triple-screw turbine steam-ships. (French publication, ELD, No 23, about 1910)

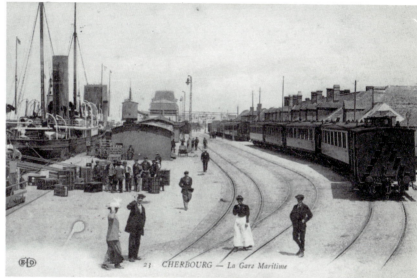

23 CHERBOURG — La Gare Maritime

173 A delightful interior view of Anvers Central Station. The inspiration of the Crystal Palace is clearly to be seen. With so much decorated glass it is small wonder that such stations were regarded as 'cathedrals'. The station in this form was built about 1864 as part of the Grand Central Railway of Belgium; there was also a link with the Anvers to Gand Railway. The locomotive standing at the left is a 2-4-0 Type 1 of about 1898, developed from a design by Chief Engineer Belpaire in 1867; the type continued until 1922.

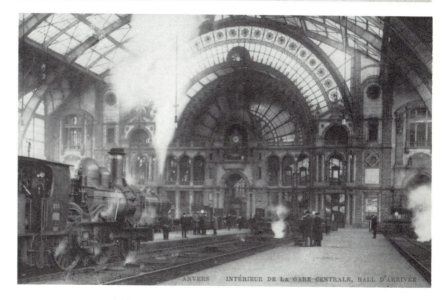

ANVERS INTÉRIEUR DE LA GARE CENTRALE, HALL D'ARRIVÉE

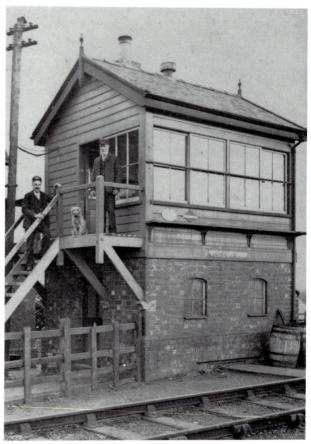

174 Looking like a set from a Hollywood Western is Geuda Springs, Kansas, the Wells Fargo stage waiting for any passengers. Seemingly in the middle of nowhere, the station had a Western Union Telegraph office and a post office. The card was posted on the morning of 19 August 1910, the writer observing, 'This is the road side station at Geuda Springs, Kan. "Arrived on Time" they say that because this train beats the LC & Dover railway for speed'.

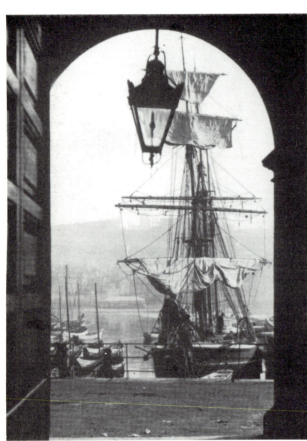

175 Not the most usual view of a railway station! This view was taken by Frank Sutcliffe on 19 September 1895, and is of the Whitby Dock End seen through the entrance to the North Eastern Railway's town station. The NER, which had a tremendous trade in coal, timber, and grain, owned docks at Hull, Tyne, Sunderland and Hartlepool, but did not make use of the Whitby facilities. (Sutcliffe Gallery, Whitby, No 28–12C, published 1980)

176 The signal-box was, and still is, a necessary complement to a large station complex. This one, in a privately-taken photograph, is believed to be on the North Eastern Railway. Signalmen, who were in the department of the superintendent of the line, started their careers as porters. Having gained practical experience of railway work in general, they then proceeded to the telegraph office. Some of the work here was a preparation for their duties in the signal-box.

177 This interior view of Faenza station appears to be more exterior. The station was on a *direttissima* (through) line to Bologna Junction, giving access between Milan, Rome, and the Adriatic coast. The locomotives are of a local design of about 1890; for the more mountainous sections of the line, powerful compound locomotives were used. (Albonetti, Faenza, No 64803, about 1910)

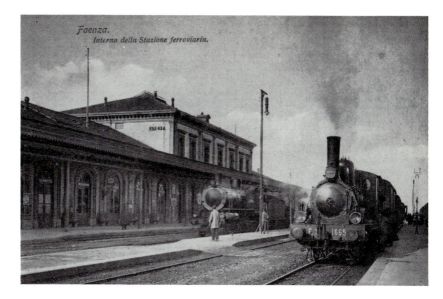

178 Considering that Blaby Station, its platform and supports, were all made of wood, the fire seems to have been quickly brought under control. All seems to be safe, as a trolley bearing luggage can just been seen inside the doorway. An enamelled sign just beyond the way out announces 'Sketchley Dyeing and Cleaning'. *(Stuart Underwood)*

179 A Great Western Railway auto-trailer unit stands in Treharris Station. The station was originally part of the Newport, Abergavenny & Hereford Railway which joined the Taff Vale Railway at Quaker's Yard, the next station. This gave access to Merthyr (on the destination board of the coach). *(Peter Woolway)*

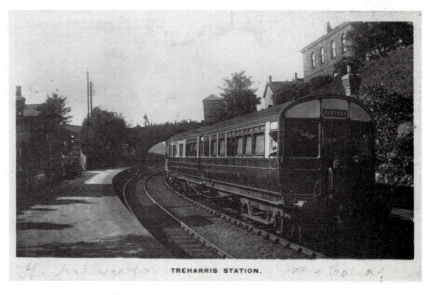

TREHARRIS STATION.

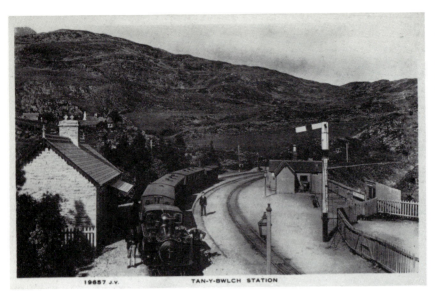

180 One of the many views of Tan-y-Bwlch Station on the Festiniog Railway, which can be found on countless postcards, both old and modern. The building on the left of the picture is shown in earlier photographs as being an open 'barn'. Trains passed through the station section by operating the 'staff and block' system. The locomotive seen here is one of the Fairlie engines, probably *Merddin Emrys*. (Valentine's picture, on a non-Valentine's card, No 19657) *(Peter Woolway)*

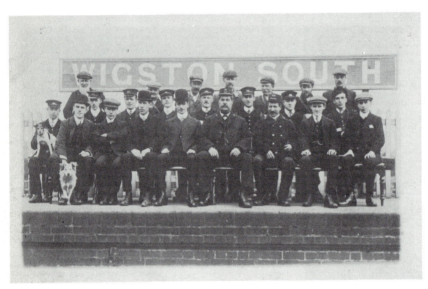

181 The only two things which can be said with any certainty about this photograph are that the men are Midland Railway staff at Wigston South Station. Probably taken about 1910, it is another example of what can be discovered in family photograph albums. If only someone had thought to write some details on the reverse. *(Stuart Underwood)*

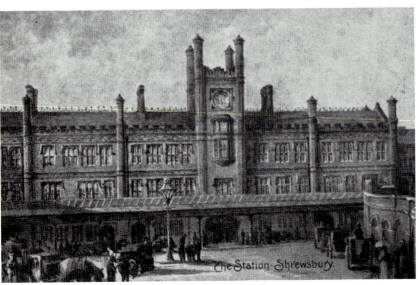

182 Taking a leaf out of the books of the larger picture postcard publishers, many provincial publishers issued artist-drawn views of local stations. This picture, about 1902, is believed to have been drawn by Edwin Cole. Shrewsbury was an important station providing cross-country links through to Wales via the Cambrian Railway, and via the Shrewsbury and Hereford line to Liverpool and Manchester. After grouping it was jointly owned and worked by the Great Western Railway and the LMSR. (L. Wilding, Salop Art Press)

183 Carrying on the traditions of earlier railway picture postcard artists is this modern study of Kidderminster Station, about 1900. It is generally acknowledged that the original design was intended for construction at Stratford-upon-Avon. The first station buildings at Kidderminster were destroyed by fire in 1863, and so the Great Western Railway erected this lovely building as a replacement. Unfortunately, it was demolished in 1968. (Severn Valley Railway, Series 1 No 2)

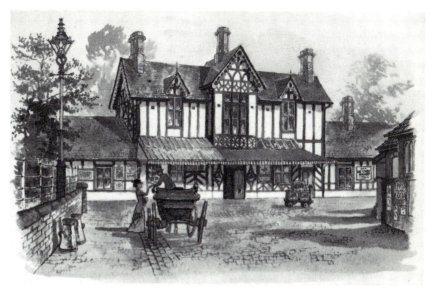

184 Charing Cross Station, 1907, as seen by an artist. The station was built in 1864 by the South Eastern & Chatham Railway, who had to acquire the Hungerford suspension bridge in order that pedestrian rights could be preserved. The Continental expresses departed from here carrying the Continental, Indian, and Australian mail between London and Dover and Calais. (Richard Tilling, SE&CR Series, No TC7) *(Rev Teddy Boston)*

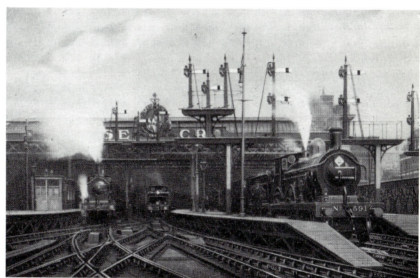

185 Birkenhead Central Station, not a very busy place to judge by this picture. After the 1923 grouping it developed very important cross-country services with both Bournemouth and Dover. At Reading West a GWR locomotive took trains on to Bournemouth, and from Reading (GWR) Southern Railway engines hauled the expresses to Dover, Deal, Folkestone and Margate. (Wrench Series No 7576)

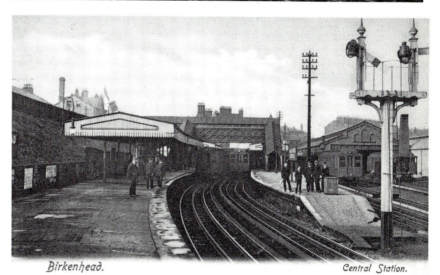

Birkenhead. *Central Station.*

The Wrench Series, No. 7576

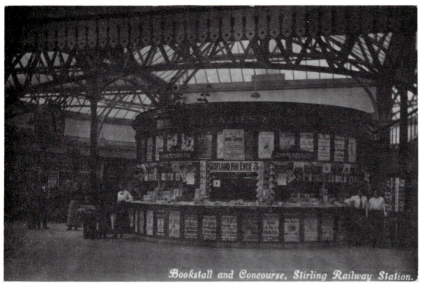

Bookstall and Concourse, Stirling Railway Station.

186 In this picture of the bookstall and concourse, Stirling Station, are several slices of history. Originally a station on the Scottish Central Railway (1845), later absorbed into Caledonian Railway, Stirling was an important distribution point for the western mail. The railway bookstall is an inseparable part of railway travelling and history; W.H. Smith put his first well-equipped bookstalls on the LNWR in 1851. J. Menzies & Co, the large publishers, were the Scottish counterpart of W.H. Smith. Here, the staff (manageress, three lady assistants, and one lad) pose beside an array of postcards, books, and magazines. Note the newspaper headline about the Zeppelin raids ('106 Victims'). (J. Menzies, 'Caledonia Series')

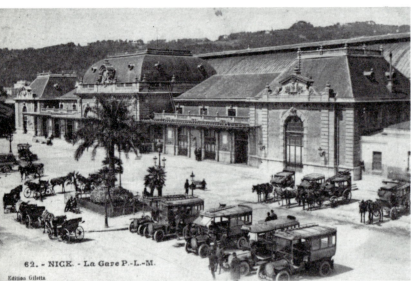

62. - NICE. - La Gare P.-L.-M.

Edition Giletta

187 The station at Nice, on the Paris-Lyon-Mediterranean Railway, was built to the distinctive design for PLM main stations. Just beyond Nice, a popular resort, was the loveliest stretch of line on the entire route, winding a sinuous course beneath the Maritime Alps, through orange groves and gardens. Note the quaint and elegant recently introduced motor taxis with their uniformed drivers, waiting among the landaus and carriages. (Giletta Series, Nice, No 62, about 1910)

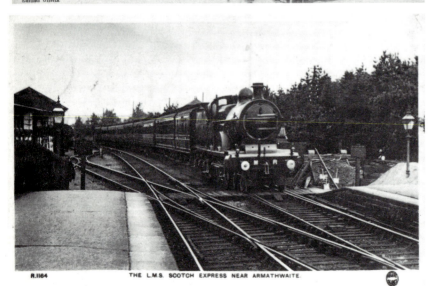

R.1164 THE L.M.S. SCOTCH EXPRESS NEAR ARMATHWAITE.

188 The LMS Scotch Express about to enter Armathwaite Station, passing an old Midland Railway notice warning about trespass. The Scotch Express ran on two routes: the old LNWR section from Euston, Crewe and Carlisle; and the Midland section from St Pancras, Leeds and on to Carlisle. The journey to Glasgow and Edinburgh took between 8hr 15min and 9hr 20min (Regent Series No R1164) *(Stuart Underwood)*

189 The Victoria Station, Nottingham, with its Renaissance-style architecture, was one of the Great Central Railway showpieces. It had twelve platforms and was originally operated as 'open', with no tickets being examined or collected there. There was no ceremony for its official public opening on 24 May 1900 (Queen Victoria's birthday): instead, a special commemorative medallion was struck which acknowledged both events. The vault of the all-glass main roof was more than 40ft above the platforms, and extended through to the glass awnings over the bay platforms; the end of the main roof was closed off with a glass wind screen. It is interesting to note that all parts of the station complex were lit by electricity generated at the power house at the northern end. (W.H. Smith 'Kingsway' Series No 2540)

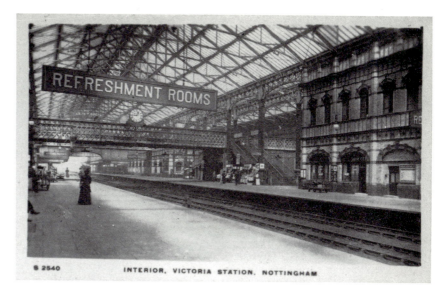

INTERIOR, VICTORIA STATION, NOTTINGHAM

190 A typical view of Leicester Midland Station, about 1910. To the left, immediately beneath where the parcels bridge entered the platform buildings was a W.H. Smith bookstall. The glass roof was bombed out during World War II, and was not repaired until the early 1970s. In the late 1970s, after considerable outcry from railway enthusiasts and civic trust conservationists, the beautiful exterior was saved from demolition by BR. The platform buildings were demolished, and from this picture, only the platforms remain as original.

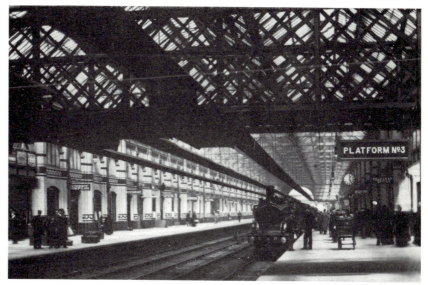

191 A view which perfectly shows why the railways took certain routes and became so important. It is taken from the foot-bridge at the end of the Loughborough Midland Station and shows the Falcon Works, of the Brush Electrical Engineering Company. The tracks from the works yard lead directly onto the main goods lines which pass behind the station; an industrial locomotive can be seen just behind the lookout hut from which the points were changed. Brush tramcars, locomotives and engines have been part of railway history for nearly 130 years. The station is that to which Thomas Cook brought the world's first public railway excursion.

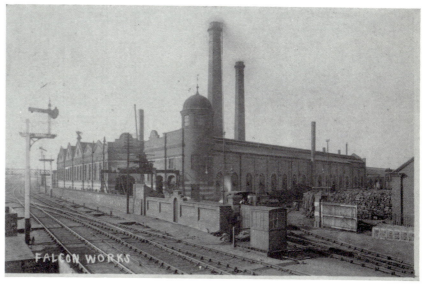

FALCON WORKS

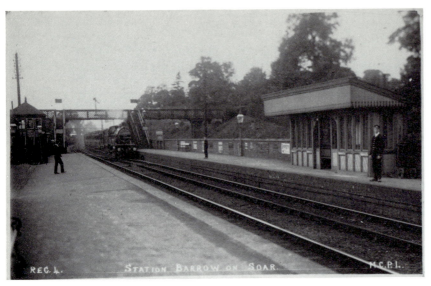

192 A view across a typical Midland country station at Barrow-on-Soar just as a Deeley 4-4-0, heading the down Manchester express, passes through. The goods lines were behind the wall. To the left was the attractive station building with its cosy booking hall. The station was closed in mid-1968, and within two months everything in the picture, with the exception of the footbridge (a right of way), had been demolished. Only a double bow in the tracks indicated that once an island platform had existed; the platform on the left of the picture was cut back to a position in line with what had been the rear of the signal-box. (Moore, Leicester, Reg 4)

STATION BARROW ON SOAR.

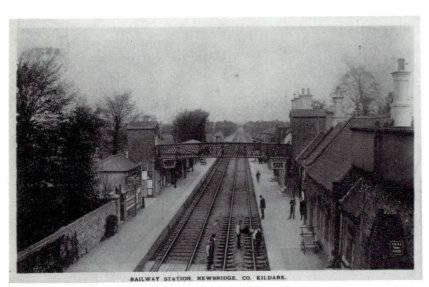

193 A view not often seen on station picture postcards, as the line gang repair a section of track under the watchful eye of the bowler-hatted foreman. The station was on the line of the Great Southern and Western Railway, which was opened 4 August 1846; the line was amalgamated into the Great Southern Railways (Ireland) on 1 January 1924. *(Peter Woolway)*

RAILWAY STATION, NEWBRIDGE, CO. KILDARE.

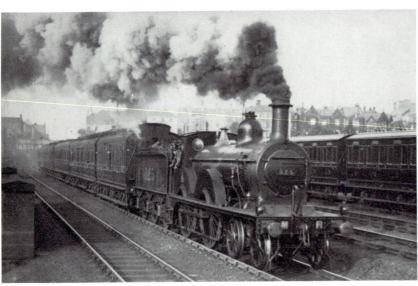

194 The Leicester to Birmingham train, headed by a Johnson 4-4-0, No 325 (which seems to be making hard work of the job), leaves Leicester (London Road) Station, on the Midland Railway. The clerestoried coaches were standard MR suburban stock, the original design for which appeared in the mid-1870s. In addition to the passenger facilities, Leicester Midland had an extensive marshalling yard complex. (Henry Salmon, No 761) *(Ron Grosvenor)*

195 By the time the northern extension of the last main line railway built in Britain had reached Leicester, funds were getting low. Although they put on a good show, the Great Central Railway could never match the architectural eminence of some of the other established main line railway companies. (W.H. Smith 'Kingsway' Series No S 2400, about 1904)

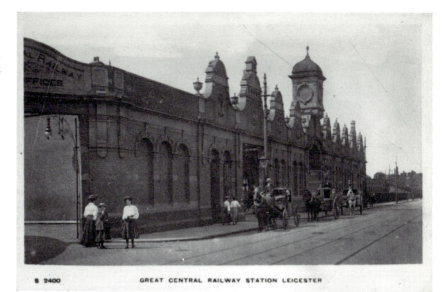

S 2400 GREAT CENTRAL RAILWAY STATION LEICESTER

196 Another station view with a repair gang at work, date unknown. The station is Clapham Junction on the London & South Western Railway. It was originally named Battersea Junction, but for reasons which have puzzled historians since it was opened on 2 March 1863, the name was changed. The usual explanation is that 'it sounded more important'. More than a mile away from Clapham, it was by 1910 the busiest railway junction in the world, handling more than 1,400 trains per day, or slightly more than one train every minute! Note the rolling stock with the extended guards' compartment and prominent observation windows.

197 Like many other main stations in Germany, the *Hauptbahnhof* at Frankfurt-am-Main was a vast concourse taking the tracks above street level. The huge arches of glass housed the ticket offices and waiting rooms along with the railway administration complex. The little vignette shows a scene at the ticket barrier, with Porter No 8 carrying the lady's bags. (Hosenblatt, Frankfurt,

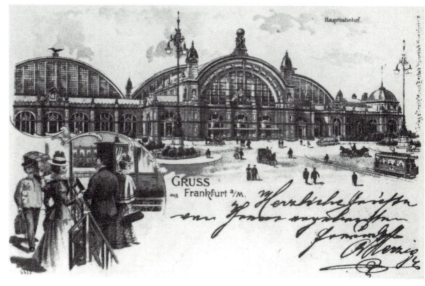

ADVERTISEMENTS

'Advertising Sells' is a maxim almost as old as the market place itself. But strangely, the railways, even the two most publicity-conscious of them all, the Great Western Railway and the London & North Western Railway, paid little heed to the general principle. Although at first sight, it would seem that they made extensive efforts to promote their services, in fact they only dipped an exploratory toe in the deep waters of advertising. Perhaps even stranger still, they allowed and encouraged outside companies to exploit the railways' resources in promoting their own products and services: witness for example the proliferation of artistic and colourful enamelled signs which were once an almost integral part of railway station decoration.

With the tremendous boom in the popularity of the picture postcard the railways came to realise that they could exploit them to their own benefit. That realisation, however, stopped short of real practical effort; their endeavours were neither co-ordinated nor integrated. Indeed, most of the British railway companies did not have an advertising department at all.

Early advertising on the railways was purely typographical; public notices which reeled off a list of times, places, and services like entries in a ledger. In keeping with the practice of the mid-Victorian era, even guide books had such exhaustingly long-winded titles that the prospective traveller must have been too weary to do other than skim through the first few pages. Some attempt at pictorial decoration was made by some of the railways who included their coats of arms on various publications.

The French developed the art of lithography to such an extent that the coloured, pictorial billboard poster became a work of art. English railways began to take a leaf out of their book, raising the standards of art and advertising even higher. Suddenly, the most distinguished artists, many Royal Academicians, were commissioned to produce advertising artwork, but little of that artwork ever found its way onto the picture postcard. Having received a beautiful picture to promote their services, the railway companies frequently reverted to previous practices, cluttering it with huge areas of type containing detailed references to trains, times, hotels, and reduced rates for families.

Such was the encouragement given, by the first decade of this century, to top rank artists such as Frank Brangwyn, John Hassall, Edward Johnston (who designed the typeface still used by London Transport on the Underground), and many others, to produce fine art work that their influence still remains in the art and printing world.

Great strides were made in advertising techniques, but World War I intervened, putting an effective halt to those hard-won steps. Then in 1918 followed the uneasy years of peace, and the trauma of grouping in 1923. Suddenly, railway advertising seemed revitalised, and the late 1920s and early 1930s saw the heyday of the colourful railway poster. Sir Felix J.C. Pole, general manager of the Great Western Railway, wrote in 1927 of 'The need for good work'. He also mentioned that the new advertising departments 'must be able to plan and prepare advertising... with a knowledge of illustrating processes and printing'. But sadly his words were to fall on gradually deafening ears. The golden ages of both the railways and the picture postcard were coming to a close, with less than fifteen years left to run.

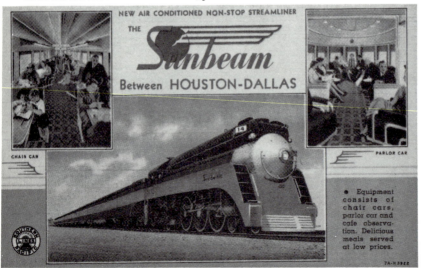

198 American railroads were able to build their locomotives on the grand scale (up to 16ft high from track level) thanks to the farsightedness of the pioneer builders. The 'Sunbeam' 4-6-4, painted in orange, red and black livery, was a high-speed, streamlined passenger train on the Southern Pacific Lines between Houston and Dallas, Texas. With its random seating in chair cars and parlor cars, the 'Sunbeam' was reckoned to be one of the most smooth-running, luxuriously-furnished trains in the south-west during the mid-1930s. (Possible Southern Pacific Lines official, Art-Colortone No 7A-H3922, printed by Curt Teich & Co, Chicago, about 1935)

199 This artist-drawn picture shows the 'Liberty Limited', the premier daily Pullman express of the Pennsylvania Railroad in 1926. No extra fare was charged for the Pullman service, and the train ran between Washington, Baltimore, Chicago, and all points west. Its sister train was the 'Broadway Limited', known as the 'Aristocrat of the Rails', which ran between New York and the Union Station, Chicago, in twenty hours. The same advertising card was used for both trains, seen here crossing Rockville Bridge, over the Susquehanna River, near Harrisburg, Philadelphia. (Possible Pennsylvania Railroad official, printer unknown, about 1926)

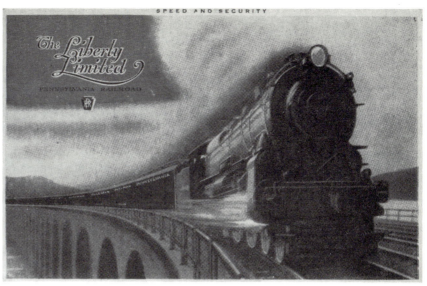

200 The Union Pacific Railroad were very confident when they published this advertisement card for the 1949 Chicago Railroad Fair. The caption on the reverse reads, 'Travelers think of the Union Pacific when they plan trips to or from the Scenic West'. The Union Pacific was renowned for its streamlined expresses. Although nicknamed 'Big Boy', this huge 4-8-8-4 Mallet was not the largest of its kind by a long way. That honour was held by a Belgian 'Franco' articulated engine with a 0-6-2+2-4-2-4-2+2-6-0 wheel arrangement. (Union Pacific Railroad Company, official, 1949) *(Ron Grosvenor)*

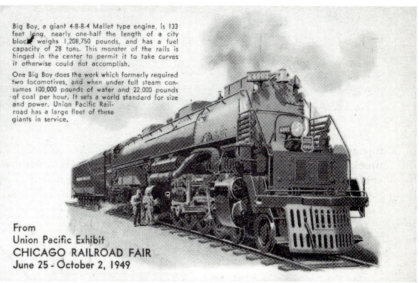

201 These attractive and informative Panoram plate-sunk picture postcards issued by the North Eastern Railway were probably offered in sets of four. A total of forty cards has been recorded, offering twelve circular tours to twenty-six different places on the NER network. (North Eastern Railway Panoram View card, No 16, issued 1903) *(Ian Wright)*

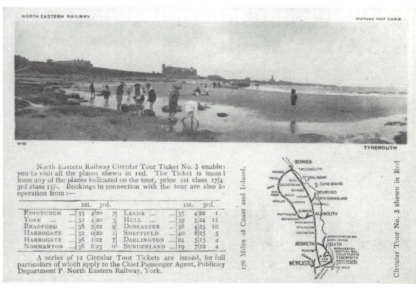

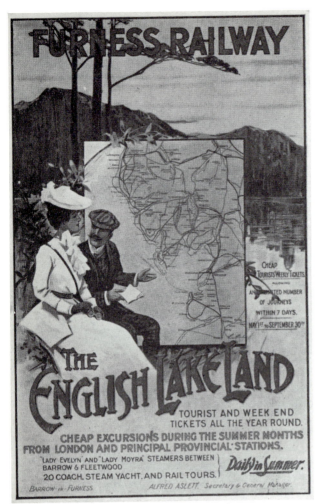

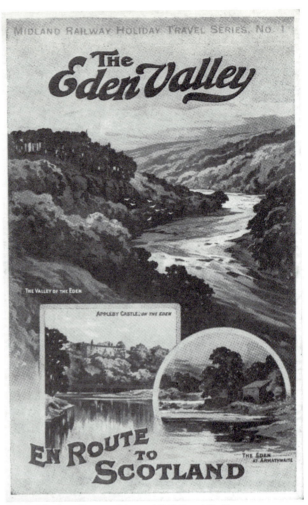

202 This poster card, although quite colourful, did not do the Furness Railway credit, and demonstrates quite clearly how an otherwise pleasant picture could be destroyed by the indiscriminate use of typography. The names and features on the map are quite indistinct. (Furness Railway official, Raphael Tuck & Sons 'Poster Post Cards', Series No 21, published 1914) *(Ian Wright)*

203 The heading on this card 'Midland Railway Holiday Travel Series No 1' is a little confusing, since the six-card set was the ninth to be issued. The simple colourful style told its own story, although it did not have the dramatic impact which characterised the picture posters twenty years later. (Midland Railway Poster Reproduction, Set No 9, issued about 1906) *(Ian Wright)*

204 This early American card may have been a joint promotional venture between the Washington, Alexandria & Mount Vernon Railway and the trustees of the Washington Mansion. It is on an undivided back 'Private Mailing Card'; these were not authorised by an Act of Congress until 19 May 1898. Although suburban electric systems were in use by 1904, it was not untill 1928 that the Pennsylvania Railroad decided to electrify the entire route between Washington and New York. *(Ron Grosvenor)*

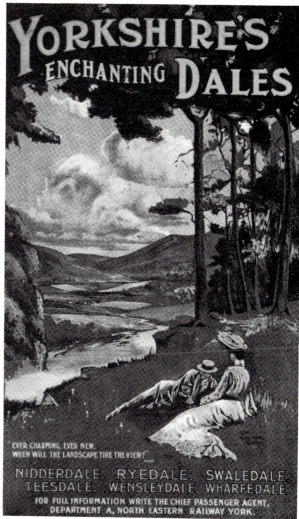

205 With its invitation to travellers to visit the Roman Wall (Hadrian's Wall), this advertisement was one of a twenty-card set of poster cards issued by the North Eastern Railway. They were available at the 1908 Franco-British Exhibition. The caption on the reverse also referred the traveller to Tyneside's 'natural charms and invigorating air'. (North Eastern Railway Poster Post Cards Series, No 18, issued about 1908, printed by Photochrom) *(Ian Wright)*

206 In the same series is this enchanting picture of Yorkshire's Dales. As the caption on the reverse said, 'No single picture, no half-dozen words, can possibly give expression to the innumerable charms of the Yorkshire Dales'. (North Eastern Railway Poster Post Cards Series, No 19, printed by Photochrom) *(Ian Wright)*

207 The railway builders considered these steam-driven cranes and pile-drivers to be the 'heavy artillery' in their armoury. During the construction of some stretches of line it was often possible to excavate, unload, and build, all in one operation. The British firms of Ruston-Bucyrus and Ransomes & Rapier were among the leading manufacturers of such equipment. This locomotive crane, working on the Pittsburgh & Lake Erie section of the New York Central Lines, was built by the Ohio Locomotive Crane Co, who claimed that the P&LE reckoned 'this to be their very best construction gang'. Issued about 1920.

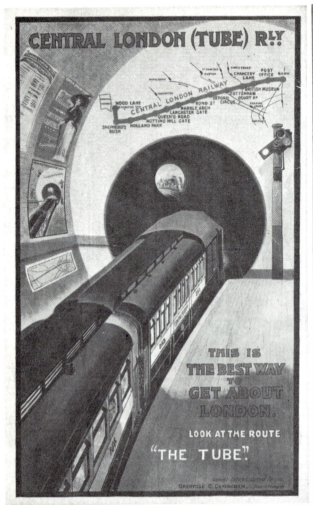

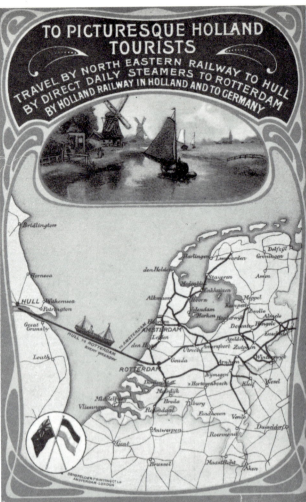

208 Printed in a rather dull sepia, this Central London Railway poster card deserved better treatment. The picture gives an accurate record of rolling stock livery and motor design, and the route of the line opened in 1900. Beside the Tube mouth is a poster with the same picture, on which is a poster, and so on *ad infinitum*. A postcard featuring the lady and the slogan 'For the Shopping Centres' on the topmost poster has not yet been recorded. (Central London Railway official poster card, issued about 1902) *(Ian Wright)*

209 Although geographically incorrect — the North Sea is shown very little wider than a Dutch canal — this North Eastern Railway Poster card is a good example of how to represent a map on a postcard. It is clear and distinct. Probably issued more for use as a correspondence card than for sale to the public, it bears an overprint 'The Hull & Netherlands S.S.Compy. Ltd., Hull, The Holland S.S.Compy., Amsterdam'. It was preaddressed with a rubber stamp 'Continental Enquiry Tourist & Travel Office, Central Station, Newcastle-on-Tyne'. The use of chromolithography and its art nouveau-esque style date it at about 1903. (North Eastern Railway Poster, printed by Senefelder Printing Co Ltd, Amsterdam, London) *(Ian Wright)*

210 Canadian Pacific Pavilion, British Empire Exhibition, Wembley, 1915. The Canadian Pacific Railway was the parent company of the Steamship Co and the Dominion Express Co of Canada, claiming to be 'The World's Greatest Transportation Company'. The two central panels on either side of the pavilion entrance represented the prow of an Empress steamer, and the head of a CPR locomotive, complete with flashing headlight. (Canadian Pacific official, probably printed by Raphael Tuck, issued 1925)

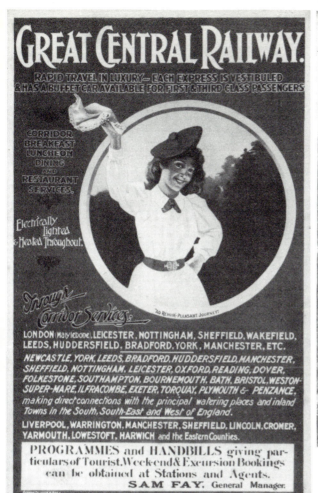

Royal British Mail Harwich-Hook of Holland Route to
the Continent Daily (Sundays included).
To Antwerp every week day.

211 Printed in very sombre grey is this cheerful picture, appropriately entitled, 'Au revoir, Pleasant Journey'. If only the GCR had merely added the words 'Great Central Railway' and the title alone to the picture instead of this rigmarole. The card was either given free in restaurant cars or used for official correspondence. (Great Central Railway correspondence poster card, about 1902) *(Ian Wright)*

212 A charming little picture which deserved a better rendering than dull green, grey, and brown. The Hook of Holland express was a train de luxe, with passenger cars panelled in varnished teak, all twelve coaches being vestibuled corridor stock. The journey from Liverpool Street to Parkeston Quay took only 85 minutes during which time forty-seven first-class and sixty-four second-class diners were served from one kitchen coach. (Great Eastern Railway poster reproduction/correspondence card, published 1906) *(Ian Wright)*

213 A typical Bagnall advertisement trade card, about 1925. Unfortunately the firm rarely gave other than technical information on these cards. The original photograph was of an engine built to a particular firm's requirements; thereafter, the photograph would be used to show the type to other potential customers. This 0-6-2 loco was designed to operate on a 2ft 6in gauge track, and weighed $16\frac{3}{4}$ tons. *(Rev Teddy Boston)*

METROPOLITAN RAILWAY. Northwood, Green Lane.

214 This quiet pastoral scene is part of what the Metropolitan Railway described as 'Metro-land, the rural Arcardia'. The Metropolitan Railway Surplus Lands Committee, part of the MR Country Estates Ltd, built several houses in Northwood, during 1925, for a deposit of £5, with no house costing less than £1,000. Thirty-six trains daily ran to London, the minimum time being 28 minutes. This card advertised weekend trips at cheap fares to Chesham, Stoke Mandeville, and London. (Metropolitan Railway correspondence advertising view card, issued about 1904, possibly earlier)

215 This card, one of a series of twelve, like the others, showed the industrial uses of equipment manufactured by Bleichert's Aerial Transporters Ltd, Egypt House, London. Using the simple apparatus shown, wagon shunting with an endless rope became an easy manual variation of the transporters used on some Alpine railways. Using this mono-cable system high tonnage loads could be moved easily by one man. (Bleichert, about 1905)

216 Railway picture postcards are to be found in all places and guises. This postal stationery card was issued for the Central American Exposition of 1897. The reverse was overprinted by Errington and Martin, 'Stamp Importers and Philatelic Publishers', London. The railway system of Guatemala was part of the Pan-American Railway, opened in 1908, and connected through to the Tehuantepec Railway of Mexico at Suchiate on the border.

156

217 The Union Pacific Railroad believed in comfort and privacy as standard for its passengers. In the luxury of the secluded 'Gold Room' diner on its Domeliner 'City of Los Angeles', passengers could enjoy excellent food and then watch the scenery from the luxurious Astra Dome. The modern Pullman coaches provided day and night comfort, with private sleeping car rooms, each with convenient room service. Compare the gold-plated tableware and layout with the earlier Midland Railway card. (Picture No. 8) (Union Pacific Railroad advertising card, twelve-card set, about 1955)

218 A dramatic two-tone poster by Fred Taylor, reproduced as a postcard; on the poster, the artist's signature was just above the rails in front of the leading wheels. The picture is of *Locomotion No 1* which, on Tuesday 27 September 1825, drew the world's first passenger train on the Stockton & Darlington Railway. A handbill issued earlier, proudly describes *Locomotion* as 'The Company's Locomotive Engine and the Engine's Tender'. (London & North Eastern Railway, 'Railway Centenary 1825–1925', printed by Photochrom Co Ltd) *(John Silvester)*

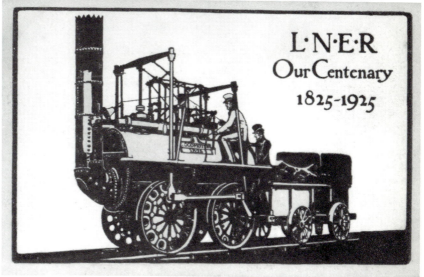

219 More than a thousand miles of canals were owned by the railways. Canal company share prices plummeted with the development of the railways, who bought them out to overcome opposition to railway construction. For many years they served as feeder routes for the transport of freight. Dredgers such as the one shown here, built by Priestman Brothers, Ltd, of Hull were floating versions of the earlier 'steam navvies' used in railway construction. (Priestman Brothers, about 1906, printer unknown) *(John Silvester)*

220 Every town had its ticket and travel agent, their windows a treasure house of railway and shipping ephemera. But few can have gone to the lengths of Robert Jones to attract customers, by putting a stuffed Canadian bison on display! Emigration was being well promoted to judge by the posters and shipping postcards in the window. The Allan Line poster offered 'Happy Homes for All. Free Farms. Millions of Acres of Fertile Wheatland Awaiting Owners'. The GWR could only advertise excursion tickets against a background of a contour map of Cornwall. *(John Silvester)*

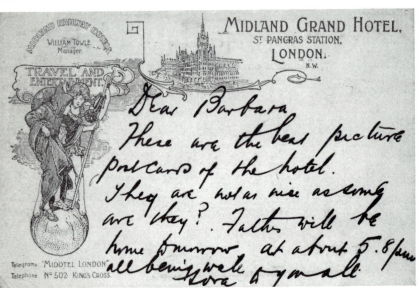

221 If the writer of this card had stayed at the Midland Grand Hotel she would not have been so uncomplimentary. It was the MR policy to provide for the comfortable travel of its passengers, and also their pleasurable lodging and entertainment at their destination. The St Pancras hotel was regarded as one of the finest such establishments, and the Towle family ensured that it maintained its good reputation. (Midland Railway, brown printed UB, issued about September 1902) *(John Silvester)*

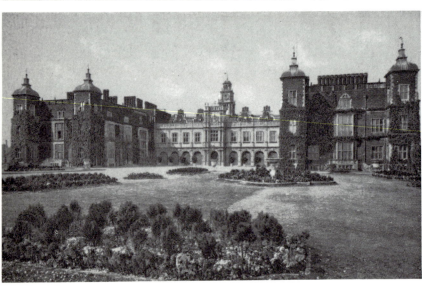

222 Many railway companies promoted their lines by extolling the virtues of the towns and countryside accessible by train, as the following postcards show. Hatfield House, the ancestral home of the Cecil family. The original palace was built in 1497, and Elizabeth, later Queen of England, was kept prisoner there. The present building was erected in 1607-12, a fine example of Elizabethan-style architecture. It contains the celebrated Rainbow portrait of Elizabeth I by Zucchero. (Great Northern Railway 'Stately Homes of England' Series, Edition de Luxe Bevelled Gilt Edge issued 1908, printed by Photochrom)

223 Wasdale Head, where British rock climbing began in the 1880s, is at the NE end of Wastwater Lake. The village church is one of the smallest in the land, and its cemetery contains the graves of many rock climbers. (Furness Railway, issued July 1902, Edition 3, printed by McCorquodale) *(Ian Wright)*

224 At least seven lithographic stones were used to build up this splendid colour picture of the west front of Peterborough Cathedral. The reverse of the card was overprinted for use as a correspondence card in the 'Office of the Superintendent of the Line, Liverpool Street Station'. (Great Eastern Railway Correspondence card, issued about 1902, 'View' Post Card No 515 by Raphael Tuck & Sons) *(Ian Wright)*

225 Chromolithographic postcards from Russia are uncommon, especially featuring railways. This picture by the artist V. Ovsyainkova gives a good impression of the beauty of the Urals in the late spring. Halfway between Moscow and Sverdlovsk on the Trans-Siberian Railway, the leafy forests of the western slopes, with herds of deer and bears, were regarded by the Russians as a 'green and gold paradise'. ('Siberia in the Ural' Series 4 No 2, lithographed by E.I. Marcus, St Petersburg)

226 St Michael's Mount featured quite prominently in GWR publicity, and the artist Leonard Richmond produced many pictures of 'The Western Land' in the 1930s. Eight cards in this series of his work are known; a free booklet was available on application to the superintendent of the line at Paddington. (Great Western Railway, issued about 1938, printed by W.G. Briggs & Co, London) *(Ian Wright)*

227 The GNR took a leaf out of the German postcard industry's book with their panorama cards. Cromer and Sheringham are situated on a part of the Norfolk coast known as 'Poppyland', and were very popular resorts. The GNR ran through corridor expresses from 'London and all parts of England'. The overprint on the reverse invited applications for 'gratis illustrated booklets and excursion programme respecting holiday resorts' on the East Coast, and in Scotland. (Great Northern Railway, poster card, about 1907, printer unknown) *(Ian Wright)*

228 A slightly different style gives the panoramic view but allows a closer view. Skegness was renowned for its grand expanses of safe bathing beaches, and by the time this card was issued had become one of the most popular resorts of Britain. 'This salubrious district' was within easy reach of passengers 'from the South, the Midlands, and the North of England alike'. (Great Northern Railway, Poster card, about 1907, printer unknown)

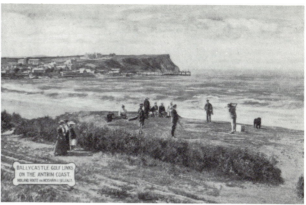

230 A bit disastrous for the golfer inclined to 'slice' his strokes, and the Northern Channel of the Irish Sea can be very rough! Ballycastle was a small but popular resort on the Antrim coast, with a good nine-hole golf course on the Warren, on the sea-shore near to town. (Midland Railway, Set 17 'Antrim Coast', issued about 1905–10, printed by Photochrom) *(Ian Wright)*

229 Fritton Lake, acknowledged as one of the most beautiful of the Norfolk Broads, can only be reached by road, and the nearest station was St Olave's. At one time, the nearby Fritton Hall was a tourist attraction and boats could be hired there. (Great Eastern Railway, 'Norfolk Broads' Set 2, Tuck Oilette, issued July 1905, specially produced by Raphael Tuck & Sons)

231 The early railway picture postcards have left us with the treasures of the chromolithographer's art as well as the names of companies long since gone. The original picture was by R. Joust, 1898, whose artistic licence with a sunset scene complements the tranquillity of the subject. (District Railway, issued 1898, Card No 7677, by Pictorial Post-Card Syndicate Ltd, pu 4 September 1899) *(John Silvester)*

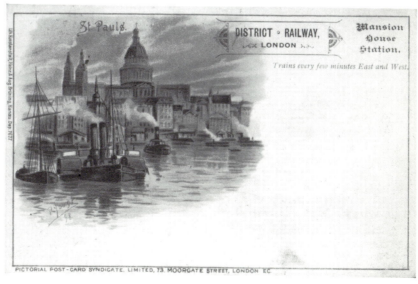

232 One of a six-card set of cards featuring London views, and used by several railway companies, is this picture of the Tower of London. As with the others, the picture title is printed in gold, the company's name being overprinted in black. Even if the craftsmen and machinery were still available today, it would cost a small fortune to produce such a card. Yet it could be obtained before 1900, already with a halfpenny stamp, from a station vending machine, for only one penny. (South Eastern & Chatham and Dover Railway, Court card No 7679, issued about 1898, printed by Pictorial Post-Card Syndicate Ltd) *(John Silvester)*

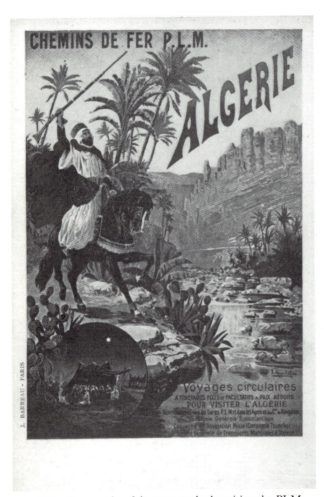

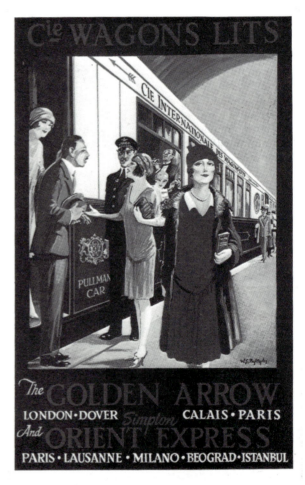

233 A very colourful poster card advertising the PLM round trip to Algeria, the original chromolithograph drawn by Hugo d'Alési. The Paris, Lyons, Mediterranean Railway was the largest system in France, operating several popular trains de luxe to Mediterranean countries, and catering only for first-class passengers. (Chemins de Fer PLM, issued about 1910, printed by J. Barreau, Paris)

234 The first 'Orient Express' departed from the Gare de Strasbourg on 4 October 1883, headed for Romania. Its last run, between Paris and Istanbul, was on 19 May 1977. Contrary to popular belief, Agatha Christie's *Murder on the Orient Express* could never have taken place, since there never was a day Pullman attached to the train. The famous express was 'revived' on 25 May 1982, and many of the sleeping cars from the late 1920s were refurbished and included in the modern great train. (Dalkeith Classic Poster Card No P63)

RAILWAY SHIPS AND DOCKS

It was under Smeaton, the builder of the Eddystone lighthouse, that the first railway engineer, William Jessop, was trained. Smeaton also suggested the first public railway at Loughborough, Leicestershire. The type of rail now used on railways throughout the world was, in its first form, patented by Jessop in 1779. Ten years later he laid down a line between Nanpantan and Loughborough, the intention being to connect with the Ashby coalfields by both rail and the Loughborough Canal and the Leicester Navigation Canal. The rails were of a double-girder section afterwards known as 'fish-belly'. As long ago as 1649, railways, or wooden tramways, were invented by the coal carriers of Northumberland who discharged their chaldrons of coal into the waiting ships. So with their origins connected to canals and sea-going shipping it is perhaps not surprising that the railways became ship-owners as well.

Canal companies had no difficulty at first in maintaining their trade against the opposition of the early railways. Then speed of transport and the ability to collect and deliver goods within the factory yards soon made the railways supreme. Without through connections between different railways in various parts of the country, the railways themselves found it imperative to take to the water, and fleets were acquired to ply between ports.

In 1846 the Sheffield, Ashton-under-Lyne, & Manchester Railway became amalgamated with several others, becoming the Manchester, Sheffield & Lincolnshire Railway. In the process it acquired the New Holland ferry, and thereby became the first railway company in the world to own a steamship.

The railway companies began to acquire their own fleets, trading between harbours and docks in which they had a commercial interest; some of these installations were constructed by the railways themselves. By 1910, fourteen of the chief British railway companies between them owned more than 200 vessels; even those who were not ship-owners had commercial and financial interests in various shipping companies.

While the early trading freight of the railway ships had been principally concerned with coal, iron ore, and timber, with the growth in industry the railway companies quickly began to extend their commercial interests. Admiralty packets carried the Royal Mail from Holyhead to Dublin until 1849, when the Government invited tenders from private companies. Although the Chester & Holyhead Railway had a financial interest in the mail it did not tender, thinking its claim was enough. They failed to secure the contract, other railway companies learned from their mistake, and by the turn of the century, most of the overseas mails, to the Continent, South Africa, India, and Australia, were being carried by ships owned by railway companies.

The building of docks and associated installations were a tremendous advantage when negotiating mail and freight contracts. In 1835 the Southampton Dock Company, part of the London & Southampton Railway (later the London & South Western Railway) began to construct the outer dock. By 1845, although incomplete, it was in use by the Royal Mail Steam Packet Company, and as early as 1853, the Union Steam Collier Company was supplying coal to all the ships using Southampton Docks.

235 One of the rarest of railway postcards, although known in three versions, is this Campbeltown & Machrihanish Light Railway issue, date unknown. The line was opened for passengers in August 1906, and closed in 1932, the company being wound up and the track lifted in 1933. The only difference on the three versions of this card is the return train time. (Campbeltown & Machrihanish Official) *(Ian Wright)*

New Midland Turbine S.S. Manxman leaving Heysham Harbour

236 The Heysham harbour was constructed by the Midland Railway in 1896, with Parliamentary sanction. In 1910 the MR had six steamers, of which, the *Manxman*, one of the two turbine-powered ships in the fleet, was the largest (2,173 tons). The accommodation was of the highest class, being notably luxurious and artistically decorated. There are three versions of the same picture, with alterations in the titling. (Midland Railway official, about 1907) *(Val Sitch)*

237 There are several postcards of this well-known LMS turbine steamer *Duke of Lancaster*, the most notable being the artist-drawn picture by M. Secretan on the official card. The steamer had berth accommodation for 412 passengers, which she carried at 21 knots on the Heysham to Belfast route. This was one of five routes between Britain and Ireland operated by the company. (Photocard by W. Robertson & Co, Gourock)

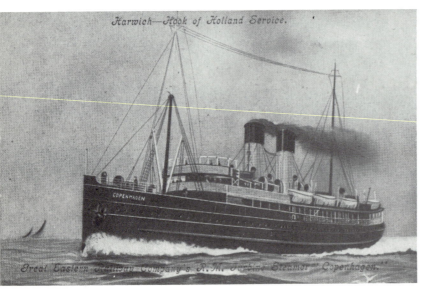

Harwich—Hook of Holland Service.

Great Eastern Railway Company's R.M. Turbine Steamer "Copenhagen".

238 The Great Eastern Railway Company's Royal Mail turbine steamer *Copenhagen* was one of three premier vessels employed on the Harwich to Hook of Holland service. Like her sister ships, the *St Petersburg* and the *Munich*, she was a triple screw turbine capable of 21 knots. They were fitted for wireless telegraphy and submarine signalling. Among the largest railway steamships sailing under the 'red duster', they had many of the passenger comforts of the latest Atlantic liners. (Great Eastern Railway official, published in three editions, about 1910) *(Ian Wright)*

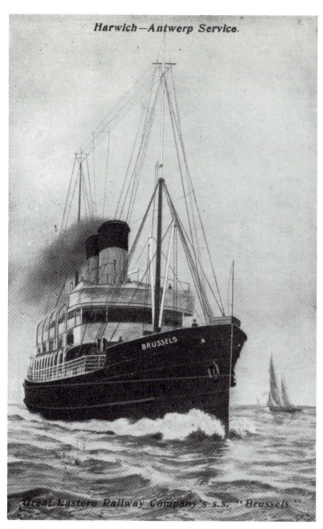

Great Eastern Railway Company's s.s. "Brussels."

ON STEAM YACHT 'SWIFT'
WINDERMERE

FURNESS RAILWAY
VIA
LAKE SIDE STATION
(WINDERMERE)

239 An artist-drawn picture of the Great Eastern Railway's SS *Brussels*. The steamship commerce of the GER was confined to the important services between Harwich and the Hook of Holland and Antwerp. A GER wireless telegraphy station was situated at Parkeston Quay, Harwich. Three small paddle steamers plied along the coast to Ipswich and Felixstowe. (Great Eastern Railway official, published in three editions, about 1910) *(Ian Wright)*

240 A charming and colourful chromolithograph advertising the Furness Railway's steam yacht excursion trips across Lake Windermere. Through bookings could be made from principal stations on the Lancashire & Yorkshire Railway. Four variations of this card are known, each with alterations in the style of titling. (Furness Railway official, published 1902, printed by McCorquodale & Co) *(Ian Wright)*

241 What the real SY *Swift* looked like — or at least, part of her. To judge by this photograph, the FR trips around Lake Windermere were very popular. The Furness Railway steamers sailed on Coniston and Windermere Lakes, the heart of the English Lake District. (Furness Railway official, Series No 10, English Lakes Steamers, published 1909, printed by Raphael Tuck & Sons Ltd) *(Ian Wright)*

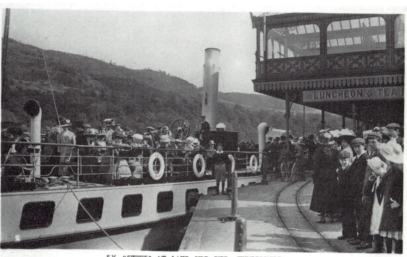

S.Y. "SWIFT" AT LAKE SIDE PIER, (WINDERMERE) COPYRIGHT

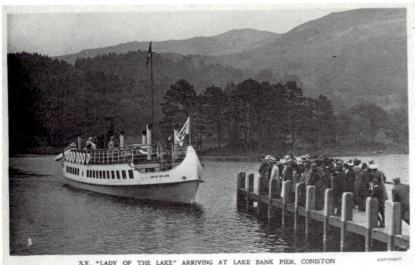

S.Y. "LADY OF THE LAKE" ARRIVING AT LAKE BANK PIER, CONISTON

242 The SY *Lady of the Lake* was the sister ship to the *Swift*. Holiday makers from Blackpool caught the FR steamer *Lady Evelyn* from Fleetwood to Barrow across Morecambe Bay for excursions on the company's lake steamers. (Furness Railway official, Series No 9, 'English Lakes Steamers', published 1909, printed by Raphael Tuck & Sons Ltd) *(Ian Wright)*

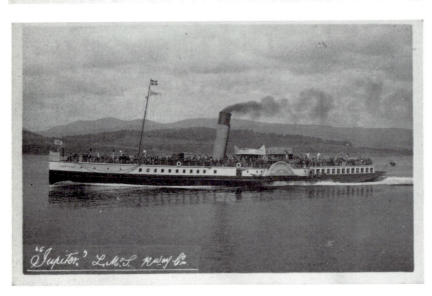

243 Built in 1896 for the Glasgow & South Western Railway, SP (steel paddle) *Jupiter* was constructed on Clydebank and operated between Greenock, Gourock, and Rothesay. On this latter section she was a very popular ship, being both comfortable and fast ($18\frac{1}{2}$ knots). She was reconditioned after World War I and resumed her sailings in 1920. (Photocard by W. Robertson & Co, Gourock)

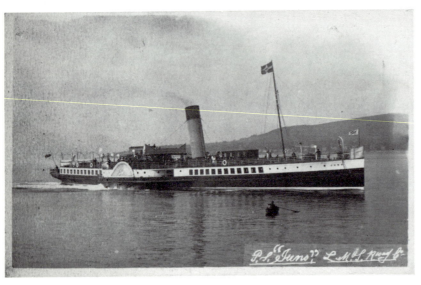

244 Built on the same general lines as the *Jupiter*, the SP *Juno* was 15ft longer. Clydebank-built in 1898 for the Glasgow & South Western Railway, *Juno* was a powerful boat capable of around 19 knots. Most of her work was excursion trips out of Ayr. Like many others of the Clyde fleet, she served as a minesweeper during World War I, and was reconditioned in 1919. (Photocard by W. Robertson & Co, Gourock)

245 Work on the Immingham Dock commenced in July 1906, and it took six years to complete the 71-acre complex. Capable of taking the largest vessels whatever the tide, it had special facilities for dealing with the coal traffic from Yorkshire and the Midlands. (FCC Series No 5)

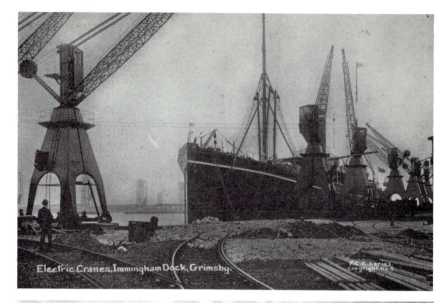

Electric Cranes, Immingham Dock, Grimsby.

246 The Immingham Deep Water Docks covered more than seventy acres, capable of taking the largest vessels at any tide. There were special facilities for dealing with the coal traffic from the South Yorkshire, Derbyshire, and Nottinghamshire collieries. The view here includes the heavy cargo crane which dealt with products from the Midlands steelworks, and the timber wharf. Illustrated booklets about the docks were available free from the GCR publicity department. (Great Central Railway, issued 1912, printed by Photochrom)

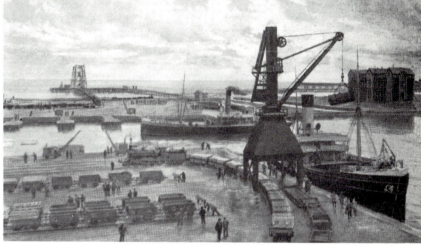

247 More than 3,000 people were invited to witness the official opening of the Great Central Railway Immingham Dock by King George V. This gold-embossed card admitted the bearer to position no 2413.

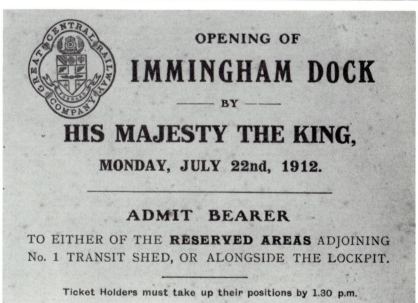

OPENING OF

IMMINGHAM DOCK

—— BY ——

HIS MAJESTY THE KING,

MONDAY, JULY 22nd, 1912.

ADMIT BEARER

TO EITHER OF THE **RESERVED AREAS** ADJOINING No. 1 TRANSIT SHED, OR ALONGSIDE THE LOCKPIT.

Ticket Holders must take up their positions by 1.30 p.m.

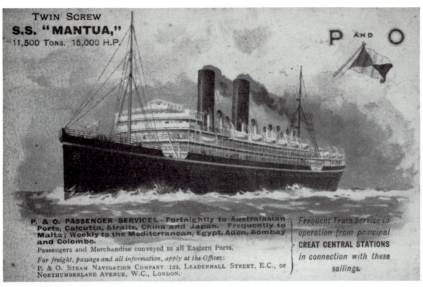

TWIN SCREW
S.S. "MANTUA,"
11,500 TONS. 15,000 H.P.

P AND O

P. & O. PASSENGER SERVICES.—Fortnightly to Australasian Ports, Calcutta, Straits, China and Japan. Frequently to Malta; Weekly to the Mediterranean, Egypt, Aden, Bombay and Colombo.
Passengers and Merchandise conveyed to all Eastern Ports.
For freight, passage and all information, apply at the Offices:
P. & O. STEAM NAVIGATION COMPANY. 122, LEADENHALL STREET, E.C., or NORTHUMBERLAND AVENUE, W.C., LONDON.

Frequent Train Service in operation from principal CREAT CENTRAL STATIONS in connection with these sailings.

248 Like the other main line companies, the Great Central Railway ran frequent 'Boat Specials' to connect with the major shipping lines. The Peninsular & Orient traffic was accorded exceptional facilities, with three trains of normal make-up standing at one platform. In the mid-1930s it was not unusual for more than 1,000 passengers and their luggage to be dealt with in less than half an hour. (Peninsular & Orient official chromolithograph overprinted with GCR information, about 1910) *(Ian Wright)*

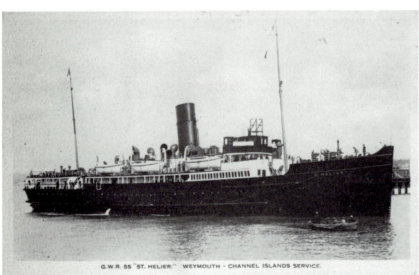

G.W.R. SS "ST. HELIER." WEYMOUTH - CHANNEL ISLANDS SERVICE.

249 Along with its sister ship, the SS *St Patrick*, the Great Western Railway steamer *St Helier* operated on the cross-Channel services out of Weymouth. These were run in conjunction with the Southern Railway. Passengers holding return tickets could travel out by the SR route, via Southampton, and return by the GWR route, via Weymouth, or vice-versa. The ships were advertised as 'among the most comfortable and luxurious of any crossing the English Channel'. Both ships gave valiant service during the Dunkirk evacuation in 1940. *(Ron Grosvenor)*

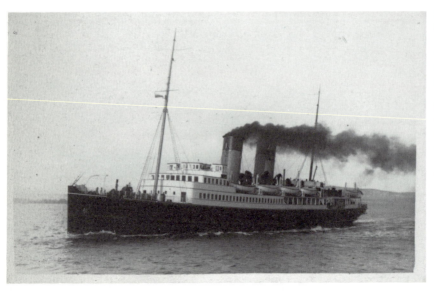

250 The London & North Western Railway's express steamer, SS *Scotia* was one of four similar ships, the *Cambria*, *Anglia*, and *Hibernia* being the others, which headed the LNWR fleet. They operated the quickest and shortest route between Holyhead and Dublin, with an open sea passage of 2 hours 45 minutes. Travelling at 22 knots, passengers were able to dine in well-appointed luxurious saloons. (Photocard by W. Robertson & Co, Gourock)

251 The original *Cambria* was built for the LNWR in 1897. This British Railways MV *Cambria* was built in 1949 by Harland & Wolff, Belfast, to operate on the same service as her predecessor. She accommodates 2,000 passengers in 436 cabins, at a speed of 21 knots. (British Railways about 1955, printed by Photochrom Co Ltd)

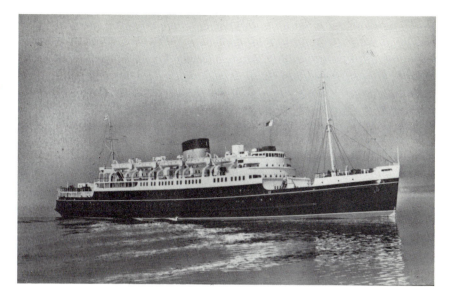

252 An early correspondence/vignette card of the Glasgow & South Western Railway. The line ran through the heart of Burns country, and the pride of its fleet berthed at Ardrossan was the PS *Glen Sannox*. This 19-knot paddle steamer was reputed to carry its passengers across to Arran so smoothly and quickly that they had hardly time to realise the beauty of the vessel. (Glasgow & South Western official, published 1902, printed by Andrew Reid & Co Ltd, Newcastle) *(Ian Wright)*

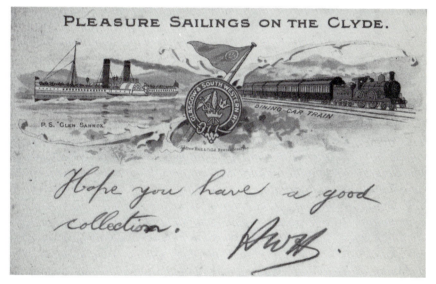

253 In this picture, the PS *Glen Sannox* can be compared with the chromolithograph of the correspondence card. A steel paddle steamer, she was built in 1892, her 260ft length being furnished in a lavish manner. Although powerful and fast, she was considered unsuitable for war service as a minesweeper, and was returned to her normal peacetime service. By agreement with the two companies, she maintained her Arran sailings for both the GSWR and the Caledonian Railway. (Glasgow & South Western Railway official, date unknown, printed by McCorquodale)

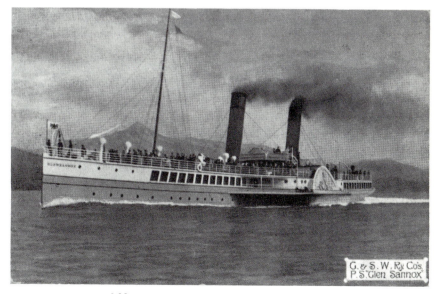

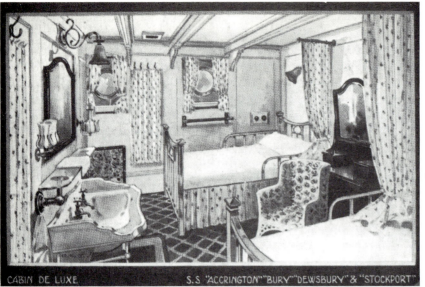

CABIN DE LUXE S.S "ACCRINGTON" "BURY" "DEWSBURY" & "STOCKPORT"

254 This painting by C.E. Turner gives an impression of the sumptuously appointed cabins on the GCR steamers. They were proudly advertised as being 'provided with every modern improvement for the convenience of passengers. For comfort and speed they are unsurpassed by any sailing from the East Coast'. (Great Central Railway official, published 1911, printed by Taylor Garnett Evans & Co Ltd) *(Ian Wright)*

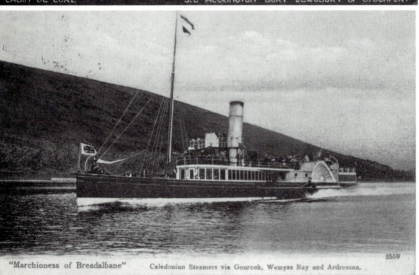

"Marchioness of Breadalbane" Caledonian Steamers via Gourock, Wemyss Bay and Ardrossan.

255 The *Marchioness of Breadalbane* was a steel paddle steamer, 200ft long, and built in 1890 for the Caledonian Railway to operate on the extended Wemyss Bay service. Around the turn of the century, the Clyde passenger traffic was practically controlled by the Caledonian, North British, and Glasgow & South Western railways. It was acknowledged that nowhere in the world was the same comfort in sailing to be had, with the frequency of services, and moderate fares. (Caledonian Railway official, Reliable Series No 85377, Card No 2559, about 1910)

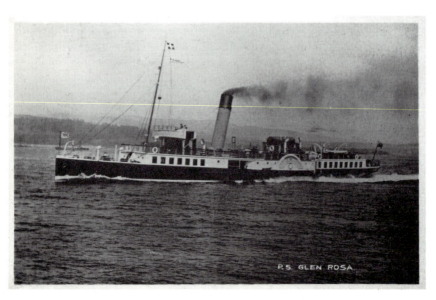

P.S. GLEN ROSA

256 The steel paddle steamer *Glen Rosa* was the second ship to bear that name, and with her sister ship, the SP *Minerva*, was added to the Glasgow & South Western Railway's fleet in 1893. Being intended for all-year-round work, they were of slightly greater draught than the usual Clyde steamers. During the summer *Glen Rosa* plied on the Firth of Clyde, and in winter sailed only between Ardrossan and Arran. She was eventually acquired by the LMS.

257 The Canadian Pacific's liner, *Empress of Britain*, seen here on Clydebank in 1931, was commissioned for war service in 1914. She carried troops to all theatres of war, and on one of her transatlantic crossings during World War I, narrowly missed being torpedoed. In October 1940, she was bombed and set on fire by a German aeroplane, and then torpedoed by a U-Boat in mid-Atlantic. (W.H. Smith 'Kingsway Real Photo Series' No S 19126, about 1931)

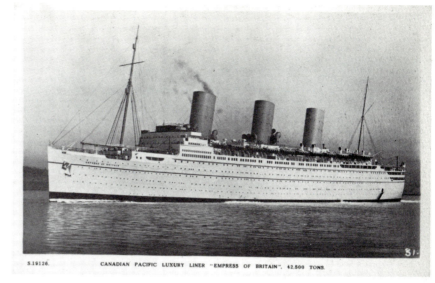

S.19126. CANADIAN PACIFIC LUXURY LINER "EMPRESS OF BRITAIN", 42,500 TONS.

258 The Southern Railway SS *St Briac* was one of several new steamers acquired by the company in the early 1930s to sail on the Channel Islands service from Southampton. Special supper-car expresses made up of the latest corridor stock and Pullman cars left London (Waterloo) every night to connect with the steamers. The first port of call was Guernsey after a 6½ hours' journey. (Ocean Trading Co Photocard, about 1935)

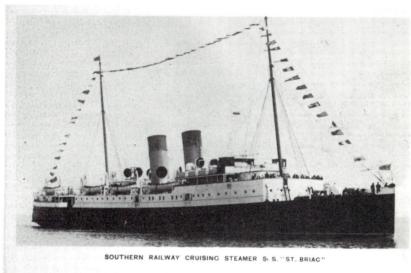

SOUTHERN RAILWAY CRUISING STEAMER S. S. "ST. BRIAC"

259 The Southern Railway operated several cross-Channel services which connected with the French railway network. From Honfleur passengers entrained at Le Havre on the CF L'Etat line, and thence to Paris via the important Mantes junction. On the return journey tomatoes and strawberries were shipped in such quantities that holds and half the deck space were occupied. French onion-sellers would often travel to and fro on the SR steamers. (French litho card, about 1925)

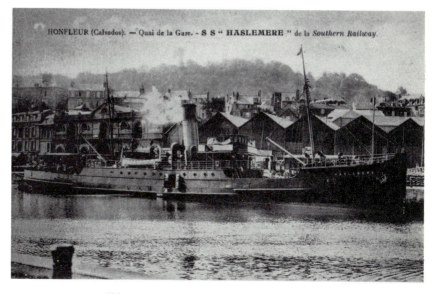

HONFLEUR (Calvados). — Quai de la Gare. - S S " HASLEMERE ." de la *Southern Railway*.

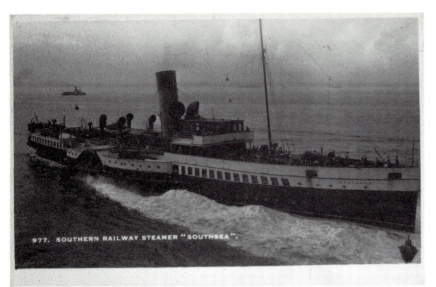

977. SOUTHERN RAILWAY STEAMER "SOUTHSEA".

260 Some of the SR paddle steamers originally belonged to the Isle of Wight Marine Transit Company who operated a train ferry service. The town of Southsea held a pre-eminent position for excursions, and the Southern Railway operated an hourly service to the Isle of Wight. The IOW railway system became part of the SR at the 1923 grouping. (Sweetman & Son 'Sologlaze' Series No 977, about 1930)

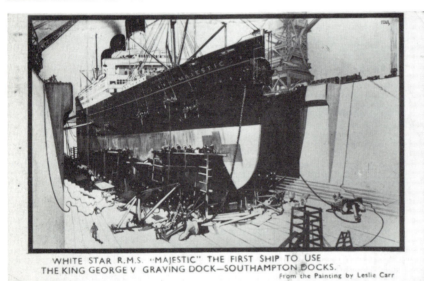

WHITE STAR R.M.S. "MAJESTIC" THE FIRST SHIP TO USE
THE KING GEORGE V GRAVING DOCK—SOUTHAMPTON DOCKS.
From the Painting by Leslie Carr

261 The docks at Southampton, England's premier passenger port, were owned and managed by the Southern Railway. Covering more than 250 acres, the Docks Extension scheme, begun in 1932, enabled twenty of the world's largest liners to be accommodated at the same time. The floating dock was the largest in the world, as was the King George V Graving Dock, specially built to accommodate the RMS *Queen Mary*. Writing on 24 January 1934, when the RMS *Majestic* was in dry dock, the sender of the card asked, 'How would you like a tour round this liner?' *(Ian Wright)*

2158. F. G. O. Stuart. THE OCEAN DOCK, SOUTHAMPTON.

262 An impressive view of part of the Southampton Docks and the Southern Railway goods yards in the forefront. The four-funnel ship on the right is the RMS *Aquitania*, and behind her is berthed the SS *Berengaria*, both of the Cunard White Star Line. The dockside sheds to the left are of the White Star and American Lines, and in front of them a shunting engine gets ready to deal with a short rake of coaches. (F.G.O. Stuart, No 2158, about 1930)

263 The LNER ferry, RMS *Antwerp*, was originally built for the Great Eastern Railway, and she worked under the flag of the Great Eastern Train Ferries Ltd. Operating between Harwich and Antwerp every night, she carried special wagons, longer than the British standard, and painted white, ready to transfer to the Continental rail network. The picture is artist-drawn, and produced in the WHS 'Kingsway' style. The number '33' in the bottom right-hand corner was previously thought to be a year code, but this card was acquired in 1927.

L.N.E.R. R.M.S. "ANTWERP"

264 Another LNER steamship, the RMS *Vienna*, which operated on the nightly Harwich to Hook of Holland service. Fast and comfortable, these ships provided connections to and from Holland, Northern and Central Europe, as well as the Middle East.

L.N.E.R. R.M.S. "VIENNA"

265 Built in 1896 for the North British Railway, the steel paddle steamer *Talisman*, later acquired by the LNER, operated on the Rothesay route as consort to the SP *Redgauntlet*. She was a very smart boat with a good turn of speed. After minesweeping service during World War I she was rebuilt, her fore-saloon being extended to the full width of the vessel, and her bridge brought for'ard of the funnel. (Valentines photocard, about 1932)

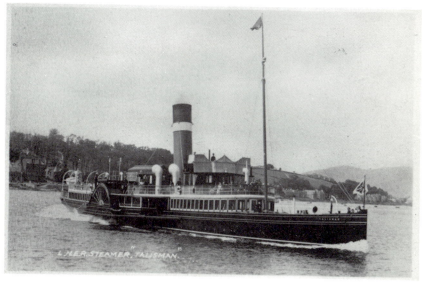

L.N.E.R. STEAMER "TALISMAN"

173

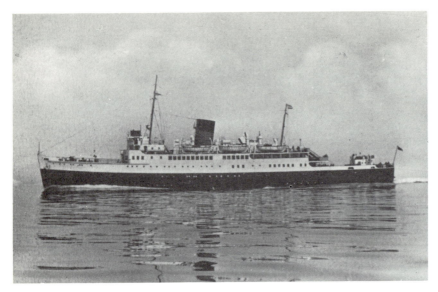

266 The SS *St Patrick*, bearer of a name famous in GWR steamship history, was built in 1948 for the Fishguard and Rosslare Railways & Harbours Company by Cammell-Laird, Birkenhead. She had accommodation for 1,300 passengers. (British Railways official, about 1955, printed by Photochrom Co)

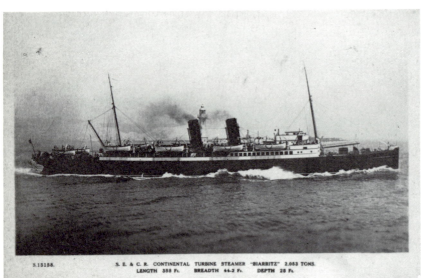

S.15158. S. E. & C. R. CONTINENTAL TURBINE STEAMER "BIARRITZ" 2.083 TONS.
LENGTH 355 Ft. BREADTH 44.2 Ft. DEPTH 28 Ft.

267 The South Eastern and the London, Chatham & Dover Railways, before amalgamation, had good steamship services. They first received Parliamentary sanction to work steamers in 1852. Always in competition with the London, Brighton & South Coast Railway, by 1911 the SE&CR was operating five turbine Channel steamers. (W.H. Smith 'Kingsway Series' No 15158, about 1923) *(Ron Grosvenor)*

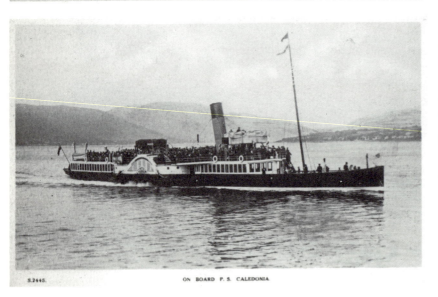

S.2445. ON BOARD P.S. CALEDONIA.

268 The steel paddle steamer *Caledonia*, came from the yard of J. Reid at Port Glasgow in 1889, ready for the opening of the Gourock route. The Caledonian Railway steamers were among the finest boats built at the time. Of moderate size, the PS *Caledonia* had full deck-saloons fore and aft. During war service in 1914–18, she was seriously damaged in a collision on a French river. (Caledonia Series No S 2445, printed by J. Menzies & Co, about 1932)

269 The original *Caledonia* was broken up in the late 1930s and replaced by another vessel of the same name, seen in this picture by J. Nicholson. The sender of this card, 'On board this boat somewhere near the Isle of Arran', wrote, 'We are especially enjoying this trip. Br. Rlys are really giving us our moneysworth today'. (J. Salmon Ltd, Card No 5057, pu 6 July 1953)

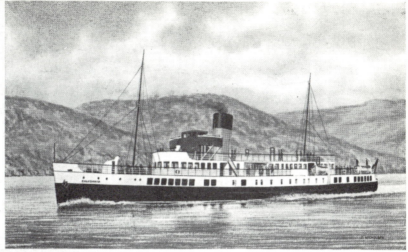

P.S. CALEDONIA River Clyde Steamers

270 The Royal Mail Steam Packet Company's SS *Lorna Doone* was originally owned by Edwards, Robertson & Co who sailed her from Ilfracombe, Devon; she was built in 1891. The British Post Office first used steamers for the conveyance of mails in 1821. With the advent of the railways, frequent connections were made to and from London with special boat trains. As well as the individual company house flag, RMSP vessels carried a Union Jack across the centre of which was a mounted postman blowing his horn. (Royal Mail Steam Packet Company, possible official correspondence card, about 1902)

271 This artist-drawn picture was available in both French and English versions. Although the NER did not own any steamships directly, it did claim to be the largest owner of docks of any railway company in the world. From the company's docks at Hull, Middlesborough, Hartlepool, and Newcastle, there were frequent sailings to all parts of the world. The facilities at Hull enabled fruit and other traffic to be loaded direct into trucks. (North Eastern Railway official, about 1910, printed by Photochrom Co)

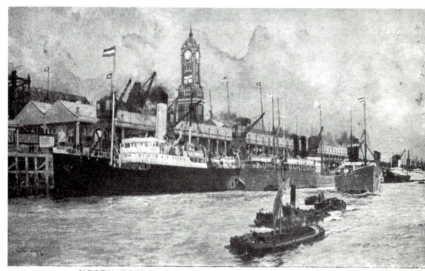

NORTH EASTERN RAILWAY RIVERSIDE QUAY. HULL.

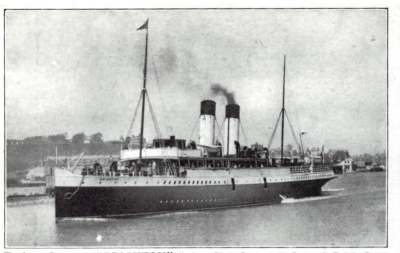

Turbine Steamer "BRIGHTON" (Newhaven-Dieppe Service to the Continent). Built by Denny Brothers. Length 276 feet, breadth 34 feet, gross tonnage 1,129 Parson's turbines, estimated 6,000 h.p. Speed 21 knots per hour.

272 In 1852 the LBSC obtained parliamentary powers to operate steamships, and the service which began in 1824 with the General Steam Navigation Company was worked jointly with the Chemins de Fer de l'Ouest et l'Etat. The TS *Brighton* was put into service in 1903, the first twin-screw turbine steamer in the company. Its sister ship *Dieppe* was introduced in 1905. A picture postcard of the *Brighton* was first issued in 1907. (Southern Railway, probable official, about 1924, printer unknown) *(John Silvester)*

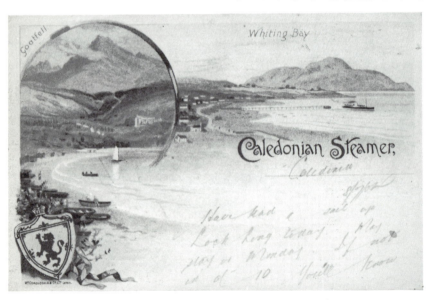

273 On the reverse of this delicately-tinted chromolithograph of Whiting Bay is a plain-printed picture of a paddle steamer at Gourock Pier, and an advertisement for 'Caledonian Routes to the Coast via Gourock, Wemyss Bay, and Ardrossan. Speed and Comfort'. The Clyde passenger traffic was controlled by the Caledonian, North British, and Glasgow & South Western Railways. Nowhere in the world at the time (1860 to 1900) was the same accommodation and comfort, frequency of service, and moderate fares to be had. The CR operated twenty sailings daily to and from Gourock alone. (Caledonian Railway, 'Caledonian Steamer' Series, about 1902, printed by McCorquodale) *(Ian Wright)*

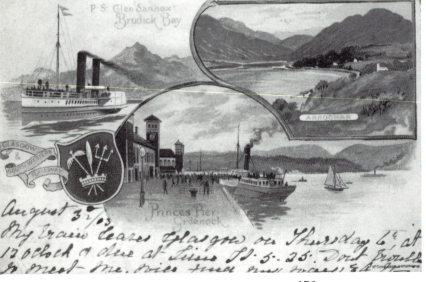

274 There was fierce rivalry between the G&SWR and the Caledonian, and when the Glasgow line opened its railway connections to the Princes Pier in December 1869, passengers from the boats made a rush for the South Western train. The travelling public were glad to be rid of the inconveniences at the Caledonian's Custom House Quay. James Gilchrist deliberately delayed traffic, forcing the steamers to wait, and hoping that G&SWR passengers would transfer their affections. The result was that both the steamboat owners and the Post Office, with their mail contract, transferred their business to the more reliable company. (Glasgow & South Western Railway, issued July 1902, printed by McCorquodale) *(Ian Wright)*

275 The Canadian Pacific Railway operated a large fleet of liners, and its company flag first appeared on the Atlantic in 1903 when the CPR bought the fifteen vessel fleet of the Elder Dempster Beaver Line. The SS *Empress of Scotland* held pride of place as the largest ship in the CPR service. With a gross tonnage of 25,160, she had accommodation for 1800 passengers. (Raphael Tuck & Sons 'Celebrated Liners', Oilette Postcard No 3592, about 1930)

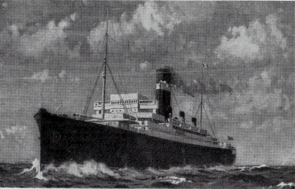

ANCHOR-DONALDSON LINE—Turbine Twin-Screw Steamship "ATHENIA."

276 The *Athenia* was built in the Govan shipyards in 1923; of 13,465 tons, she served on the trans-Atlantic routes to Quebec and Montreal in the summer, and St John's, Halifax, and Portland in the winter. The Anchor-Donaldson Line and the Canadian National Railways ran special connecting services. The CNR had offices in Glasgow, which was the departure port for the steamships.

277 By 1910, the Great Central Railway owned sixteen ships and operated regular Continental services by these well-appointed steamers. Boat expresses ran alongside the steamers at Grimsby Docks for passengers to embark to Hamburg (daily), and Antwerp and Rotterdam (three times per week). Grimsby, which at one time was the largest fishing port in the world, owed its success to the old Manchester, Sheffield & Lincolnshire Railway; with the advent of the GCR it received additional attention. (Great Central Railway, issued 1911, printed by Taylor Garnett Evans & Co, Manchester)

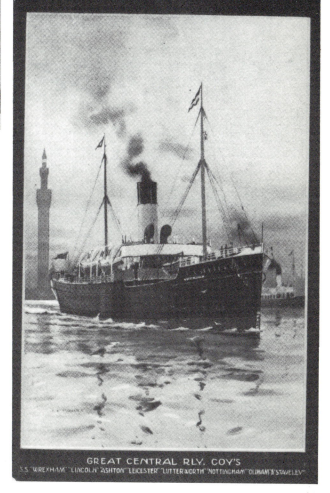

GREAT CENTRAL RLY. COY'S
S.S. "WREXHAM" "LINCOLN" "ASHTON" "LEICESTER" "LUTTERWORTH" "NOTTINGHAM" "OLDHAM" "STAVELEY"

ROYAL TRAINS

Costing in excess of £7.5m, a new Royal train is being built for service in 1989. The new train will be secure in the extreme. In a distinctive livery of claret and grey, the new coaches will be armour-plated, and with special armoured glass, able to withstand an attack from high-velocity rifles. This protection means that each 32-tonne coach will be carrying an extra 12 tonnes of armoured steel, all on specially strengthened bogies. Included in the rake of fourteen coaches of the Royal train will be a special security coach at the front of the train, next to the Royal sleeping coach. Its equipment will include some of the most up-to-date and sophisticated electronic alarms and surveillance systems. It is therefore with a great sense of change that one reads in *Railways for All* by J.F. Gairns, (about 1923), in the chapter 'When Royalty Travels': 'In Great Britain however, little danger is to be apprehended from fanatics or representatives of revolutionary agencies'.

The first 'Queens Carriage' was probably used only by Queen Adelaide and Prince Albert. The prince was the first Royal person to travel by train, doing so on 14 November 1839, accompanied by his elder brother, between Slough and Paddington. As a suitor to Queen Victoria he had visited her at Windsor Castle, travelling by ordinary train. On 15 August 1840 the Dowager Queen Adelaide, widow of William IV, travelled from Wallington Road to Slough in a coach specially built by the Great Western Railway.

It was certainly a coach fit for a queen, very handsome, 21ft long, 9ft wide, and carried on four wooden wheels with wooden tyres to reduce noise. The external livery was the standard GWR chocolate and cream. The interior design and upholstery was 'handsomely arranged with hanging sofas of carved wood in the rich style of Louis XIV'. Silks and satins, painted panels representing the four elements, rosewood tables, and the floor of the entire carriage covered with India matting.

Learning that it was to be used for a journey by the King of Prussia, the General Traffic Committee of the GWR considered that it was not so safe on its four wheels as the standard first-class coaches. Accordingly chief engineer Brunel recommended that a new frame with eight wheels and improved suspension was necessary. The necessary alterations were carried out prior to Queen Victoria's first trial of the new means of locomotion on 13 June 1842. In the year of the Great Exhibition, 1851, the historic carriage was taken out of service, and modified to the standards of an ordinary saloon. It was broken up in 1879.

The story of the Royal Trains is quite a long and literally colourful one. Several of the companies had special engines painted in distinctive colours, mostly red, white, and blue motifs, with frequent use of the Royal Arms. The London, Brighton & South Coast Railway, justly proud of its immaculate coaches, and wanting to present the same 'glossy' image throughout, actually painted the entire top layer of coal in the tender white!

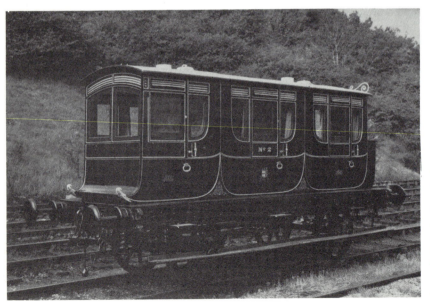

278 Constructed in 1842 for the use of the Dowager Queen Adelaide by the London & Birmingham Railway, this Royal saloon clearly shows its stagecoach ancestry. Indeed, the bodywork was made by a London coach builder onto a L&B underframe. Apart from its furnishings, it was very little different from the company's standard first-class carriages. (J. Arthur Dixon photogravure card, about 1960)

279 A coloured view of the sleeping compartment in Queen Adelaide's coach. The pictures were taken from original LNWR photographs, then coloured by 'F. Moore'; discrepancies can often be found in the arrangement of the furniture. Stretchers were laid across the facing seats with an over-mattress, the Queen's feet extending into the mail boot at the end of the coach. (London & North Western Railway official, issued about October 1906, printed by McCorquodale)

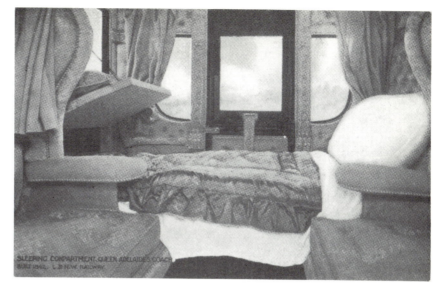

280 Prior to the turn of the century when this Royal saloon was in use, considerable progress had been made in coach construction. The LNWR had wished to build an entirely new vehicle, but Queen Victoria preferred to keep the old, which had so many memories for her. This picture was originally produced by Raphael Tuck. The reverse of the card was overprinted by a Leicester firm and used as a correspondence card. (Originally London & North Western Railway official, issued August 1904 and November 1904, additional printing by McCorquodale)

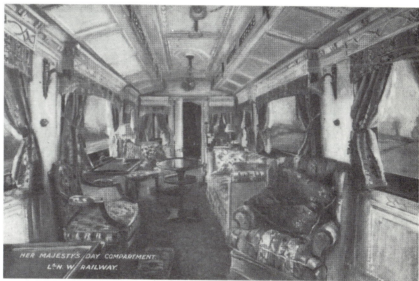

281 The saloon pictured here was furnished to the requirements of the Prince of Wales, who later became King George V. The two coaches in the Royal Train were in 'balanced pairs'. Queen Alexandra was always accompanied by Princess Victoria on her travels, so provision was made for the Prince of Wales to accompany King Edward VII. (London & North Western Railway official, Set 45, issued October/December 1906, printed by McCorquodale & Co)

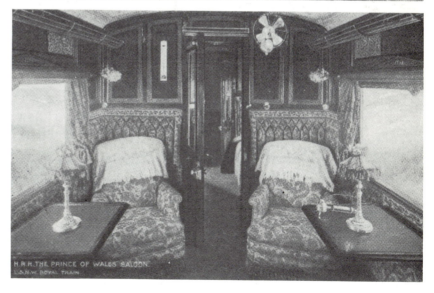

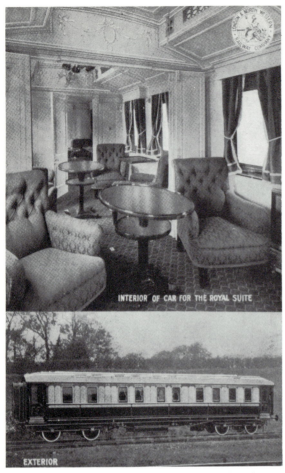

INTERIOR OF CAR FOR THE ROYAL SUITE

EXTERIOR

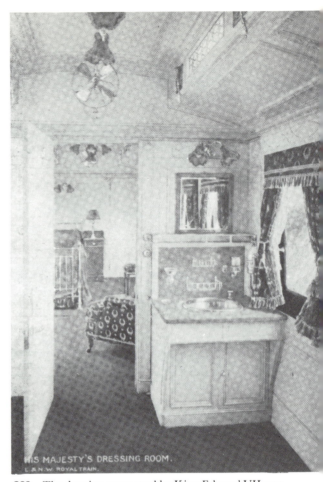

HIS MAJESTY'S DRESSING ROOM.
L & N.W. ROYAL TRAIN.

282 In this picture part of the lounge for the Royal attendants is seen. It contrasts in relative simplicity with the luxurious furnishings of King Edward VII's sitting room; this was fitted up in order that affairs of state could be attended to while travelling. (London & North Western Railway official, Set 4 'Royal Saloons', issued four times May 1905 to January 1906, printed by McCorquodale & Co)

283 The dressing room used by King Edward VII was apparently changed very little for King George V who succeeded him. A bath was installed during World War I, it not being unusual for their Majesties to live for as long as a week at a time on the Royal Train. LMS photographs of 1935 show exactly the same picture. (London & North Western Railway official, Set 45, issued October 1906, printed by McCorquodale & Co)

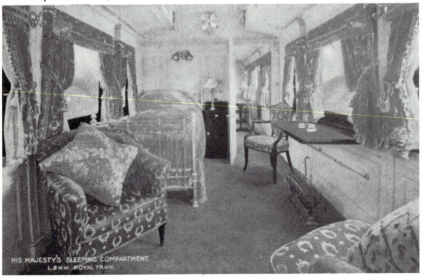

HIS MAJESTY'S SLEEPING COMPARTMENT.
L & N.W. ROYAL TRAIN.

284 Several variations of this picture are known, few of which give a date or information other than the fact that it was part of the Royal suite. In its colouring of light green silk and damask furnishings and white-enamelled panels, it was virtually copied by the Great Northern Railway for their Royal coach built in 1909. When used for day journeys the bed was removed and the compartment converted into a dining room. (London & North Western Railway official, Set 4, issued 1906, printed by McCorquodale & Co)

RAILWAY SERVICES

Primarily the railways were, and are, in business to carry passengers and freight, manage the trains, and maintain the lines upon which they run. But for 150 years they have offered much more; what a writer in 1925 called 'Railway Side-shows'.

In the early days a railway company merely operated a line upon which firms ran their own traffic, the customers owning the vehicles. But demand soon outstripped these practices, and the railway companies soon launched out with their own wagons, to which were eventually added fleets of vans, drays, lorries and buses. Goods were collected, transported, and delivered, all in one commercial operation. Such all-embracing services were available to the private individual as well as large firms. Passengers not wanting to carry all their luggage with them, had part of it dealt with on the 'fetch and carry' basis. They themselves could be transported in this manner, with omnibuses in rural and outlying areas conveying people to and from the railway stations.

At those stations passengers could obtain refreshments; either a cup of tea and a sandwich, or even sitting down to a full-course meal in the dining-room. In many cases these facilities were leased through outside caterers, but then the railway companies began to do the work for themselves. It was but a short step from catering to full board and lodgings, and so the railway hotel came into being.

The complete range of services offered by the railway companies has yet to claim the wider attentions of the historian. Several companies had special businesses such as quarries, laundries, bakeries, power stations, printing works, orphanages and hospitals. The miscellaneous works of the railways are incredible. Crewe was at one time supplied with its water by the London, Midland & Scottish Railway. Schools and churches were often largely sponsored by the railway companies who served the towns and villages in which they were situated, those in Doncaster and Swindon being cases in point. And of course, for the members of staff and their families and friends, there were the clubs and entertainment halls. It was not unknown for one large company to build locomotives and carriages for another smaller railway.

Perhaps the one service about which most is known is 'the Works'. Great legends have been built around Crewe, Doncaster, Derby, Swindon, Willesden, and Wolverton, to name but a few. Working in close liaison with the administrative offices was the premier department — the stores. All materials required, or to be distributed by the railway, were ordered or despatched from here. The foundry and the pattern shop, the forge and the boiler shop, and a variety of miscellaneous departments, all came under the general umbrella of 'the Works'.

In them, and throughout the railway companies' network, thousands of people were employed, many of whom would have scarcely known one end of a locomotive from the other. But in these great establishments, men and boys, women and girls, handed in their time-checks (a legacy from the metal 'tickets' or tallies of the Leicester & Swannington Railway) to receive payment in return for almost every known trade and profession. All of which was dispensed under the name 'Service'.

285 This East Coast Joint Stock correspondence card is somewhat reminiscent of the earlier German *Gruss Aus* cards. Printed in chromolithography, it gives a reasonably accurate picture of the locomotives and trains of the day operated by the companies named beneath the shields — note that there are wheels shown on one side only! The locomotive is similar to the North Eastern 4-4-0 express engines designed by W. Worsdell around 1896. (East Coast Companies vignette correspondence card, issued about 1900, printed by Andrew Reid & Co, Newcastle-on-Tyne, pu Newcastle 4 February 1904) *(Ron Grosvenor)*

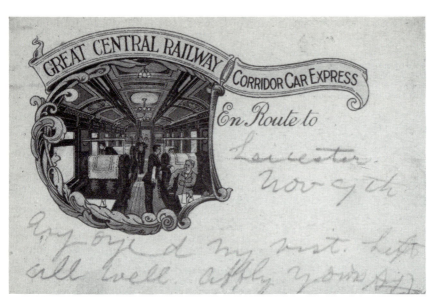

286 Some idea of the elegance of corridor cars can be gauged from this correspondence card which was issued free in the restaurant cars. The London Extension of the Manchester, Sheffield & Lincolnshire Railway (it became the Great Central Railway on 1 August 1897) led to the introduction of restaurant car services from London (Marylebone) to the North. (Great Central Railway correspondence card, about 1900)

MOTOR CARS PRESENTED TO RED CROSS SOCIETY (SCOTTISH BRANCH) BY THE DIRECTORS, OFFICERS, AND EMPLOYEES OF THE GLASGOW & SOUTH WESTERN RAILWAY.

287 Ambulance work took a very prominent place in the general organisation of all railways. In 1897 the St John's Ambulance Association offered a challenge trophy for competition among the teams of the various railways. The motor cars seen here are Fords; contemporary dealers' service manuals show how they could, literally, be taken completely apart and reassembled. (Glasgow & South Western Railway official, issued about 1920, printed by McCorquodale) *(Ian Wright)*

288 The aeroplane which inaugurated the first British railway—air service between Plymouth and Cardiff, in April 1933, was this Westland 'Wessex' G–ABVB, seen here just after take-off from Shanklin Airport. Its three engines gave it a cruising speed of about 105mph, and its spacious cabin could seat eight. With the formation of the Railway Air Services in 1934, G–ABVB operated between Portsmouth and the Isle of Wight carrying thousands of passengers.

289 The Railway Air Services fleet, mostly of de Havilland aircraft, was based at Croydon, flying services to the Channel Islands and the Orkney and Shetland Isles, Northern Ireland and the Hebrides. Twin-engined DH89 Dragon-Six planes, better known as the Dragon Rapide, were used on extensive inland routes. Carrying between four and ten passengers, its 200hp Gypsy Six engines gave the airliner a top speed of 165mph. RAS machines were painted in silver with green and red stripes.

290 A mail train on the LNWR thunders past the watchful station man just as the mails have been exchanged. The mail to be delivered was secured in a leather case, hung from the side of the carriage at floor level, to be caught in the lower set. At the same time, mail was collected from the top of the trackside standard. Although the railways ran special mail trains, the post office vans could be attached to ordinary trains.

291 A very practical example of railway service under tragic circumstances. A motor car plunged down an embankment into the river at Great Haywood, Staffordshire, and its occupants were drowned. Divers located the bodies, and fire-engines pumped out the area. The North Staffordshire Railway Company manual fire-engine is second from the left; the steam-powered pumps took about 7 minutes to raise the required pressure. This card is one of an extremely scarce twelve-card set produced locally, about 1905.

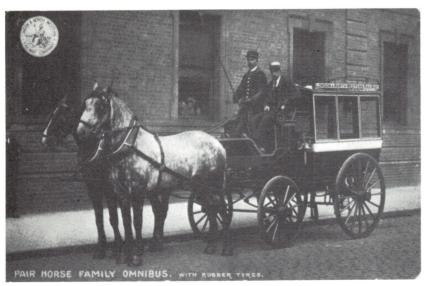

PAIR HORSE FAMILY OMNIBUS. WITH RUBBER TYRES.

292 Although the British railways pioneered the introduction of mechanical traction on the roads, by the mid-1930s less than half of the railways' road vehicles were motor driven. When this picture was taken the average cost of a railway horse was about £50, and its welfare received special consideration. Parcel vans and omnibuses used light horses; dray horses were heavier, while Shires were used for shunting operations. (London & North Western Railway, Set No 27, 'Road Vehicles', issued January 1905, printed by McCorquodale. This set was issued in four versions.)

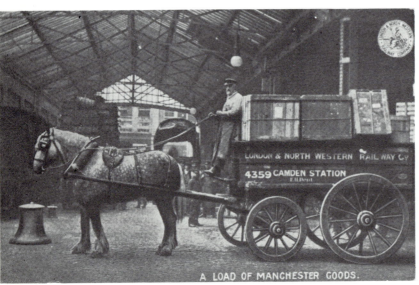

A LOAD OF MANCHESTER GOODS.

293 The title, 'A Load of Manchester Goods', is not as vague as it might seem. All of the London termini had busy goods yards serving all the cities of the Midlands and the North. Manchester was a big distribution centre, and every day the drays and vans handled consignments of every description. (London & North Western Railway Set No 25 'Miscellaneous', issued January 1905,

PACKING WAREHOUSES

Cadbury, Bournville, Eng.

294 Some idea of the railways' involvement in British commerce can be gauged from this picture of one of Cadbury's Bourneville warehouses. This one building was like a large railway station with several platforms. Postcards like this were given away in magazines for promotional purposes. Not only is there no record of numbers of sets and cards, but the number of firms who produced these advertising-type cards is not known. (Cadbury Lid, Bourneville Series Postcard, about 1910)

295 London & North Western Railway, Erecting Shop, Willesden Junction, 1917. The two men in the foreground were Belgian refugees, the one on the right having been a Wagon Shop foreman with the Belgian State Railways. Willesden was an important exchange point for several lines, and with its engine and carriage sheds was a complete and self-contained railway centre. It was from the erecting shop that completed engines emerged after overhaul, ready for steam trials, before going to the paint shop to receive service livery.

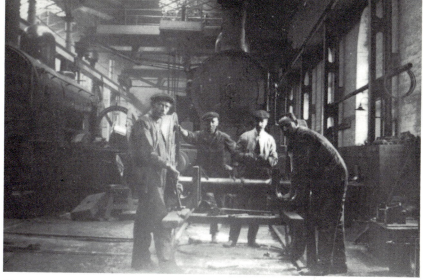

296 In this view of Doncaster Works, sometime in 1935, the 2-6-2T was being newly built, the LNER maker's plate on the smokebox casing quoting the date. The LNER made extensive use of this type of locomotive in the 1930s for suburban passenger services. The Doncaster Works was organised on the 'belt' or progressive system, so that component assemblies were brought together at various stages, and the locomotive completed as it moved through the different shops.

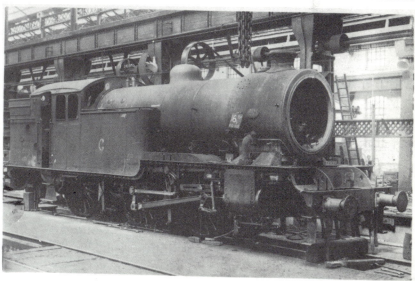

297 It was said that Crewe locomotive works were 'probably the largest and most celebrated railway establishment in the world'. To judge by this picture, probably taken on an open day in July 1933, at least two members of the public are showing an interest. The almost completed locomotive on display is one of the 'Royal Scot' Class, which between 1928 and 1935 bore the brunt of the hardest work on the LMS. *(Ron Grosvenor)*

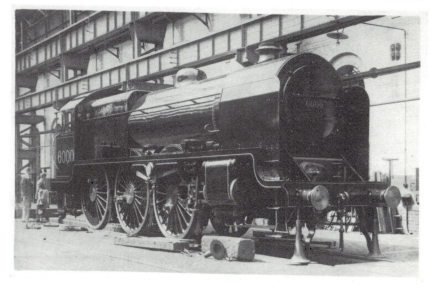

BRIDGES, TUNNELS, AND VIADUCTS

The great problem facing the railway builders was how to keep their lines straight and level. They never did entirely solve the problem, but in the process they achieved some heroic work. Not since the Romans had built some of their aqueducts had engineers been required to construct such miraculous architecture.

In most cases the Victorian engineers and their contemporaries had no examples to follow, no textbooks to read, and they had to set their own examples and evolve their own techniques. That they did so with outstanding success can be seen in their bridges, tunnels, and viaducts which have survived.

Building a railway across flat and open country presented relatively few problems, but laying tracks across rivers and gorges, and even the ocean, or tunnelling through mountain ranges, taxed the engineers' ingenuity to the full. On the Kalka-Simla Railway, principally used by the Indian Government, and connecting with the Great Indian Peninsular Railway, galleries resembling the Roman aqueducts were cut into a mountain face. These tiers of arches were carved out of solid rock until the desired track level was reached; they were then faced and reinforced with additional masonry.

In North America many a railway was taken across a gorge or plain by means of trestle bridges, but not directly so. The trestles carried dumping trucks loaded with rocks and earth, their contents being tipped over the side. Eventually the trestles were buried, forming the reinforcement of an embankment across which the final track of the railway was laid. One famous trestle bridge, over the Dale Creek, near Cheyenne, actually carried trains across its 130ft high timber and steel spans while a tunnel was excavated behind it. Then, when the new line was ready, this magnificent bridge was destroyed.

Until the early 1920s many of Brunel's famous timber trestle bridges could be seen throughout Devon and Cornwall, along with a few in South Wales. They were regarded as miracles of engineering in their day. Some were more than 1,000ft long, and only because of the need to lay double track for heavier trains were they replaced by masonry viaducts.

In Britain the Victorian bridge architects and builders always seemed to be aware of their surroundings, and made their structures complement the environment as much as possible. The fact that they succeeded is evidenced by successive generations of railway travellers who took their journey so much a matter of course that they gave little, if any, heed to the enormous labour and incredible skill involved. A train could hurtle across a bridge or speed through a tunnel in minutes, but before then years of toil had been required to make the passage possible.

The cost, in most cases, hardly bears contemplation, but perhaps in the wonderful legacy which those engineers gave to travellers and bystanders, their efforts were worth every penny.

BRITANNIA TUBULAR BRIDGE. LOOKING N.W.

ROBERT STEPHENSON, ENGINEER.

298 The Britannia Tubular Bridge, 1,510ft long, which stands as a monument to the genius of its designer, Robert Stephenson, ran into difficulties before it was built. The Admiralty refused to allow the Menai Straits to be blocked for even one day, and no scaffolding was to be used. The bridge was built in sections on the bank, and the giant box-girder 'tubes' floated on pontoons at high tide, and raised into position by hydraulic lifts. Begun in 1845, the bridge was opened for single line traffic on 18 March 1850. (London & North Western Railway, 'Additional Series' Set 19 'Signal Boxes, Etc', issued January 1905, printed by McCorquodale)

299 The Great Western Railway was famed for its trestle bridges throughout Wales, among the best being the Crumlin Viaduct. It crossed the Ebbw Vale at a height of 200ft over a length of 1,658ft, and was situated between Pontypool Road and Pontllanfraith. Built by engineer Kennard at a cost of £62,000, when it was opened for traffic on 1 June 1857, it was the largest railway viaduct in the world.

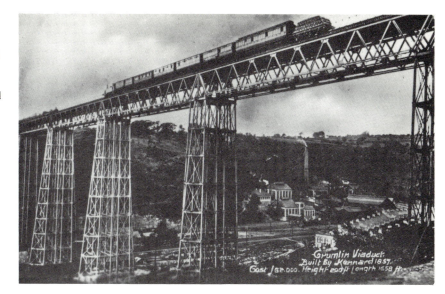

300 One of the few projects initiated by George Stephenson which he did not live to see completed was the High Level bridge in Newcastle-on-Tyne. A prospectus of the High Level Bridge Company was issued in 1843, with Robert Stephenson as the consulting engineer and designer. The project was taken up by the Newcastle and Darlington Railway Company, and the bridge was regarded as more picturesque than the Menai Bridge, and was styled as 'the King of Railway Structures'. (Old Reliable Series, possibly printed by William Ritchie & Sons, about 1900)

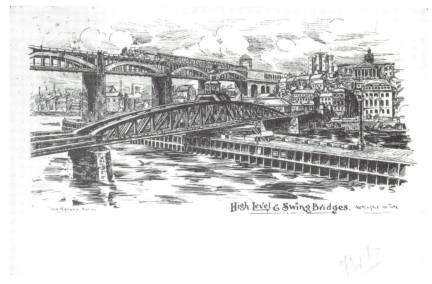

301 The Kaiser Wilhelm Bridge at Solingen crossed the River Wupper carrying a double track railway on the loftiest trussed bridge in the world. With a clear span of 525ft, and at a height of 350ft, it was opened for traffic on 15 July 1897, just four years after work on it commenced. (*Gruss Aus* No 4818, printed by Rosenblatt, Frankfurt)

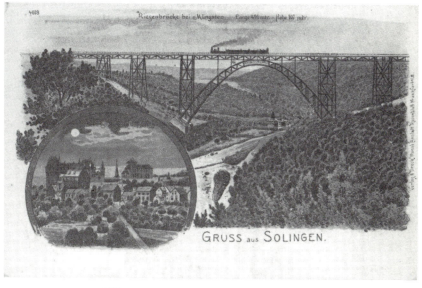

187

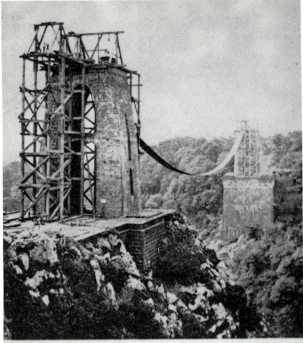

Clifton Suspension Bridge in course of Construction.
H. B. & Son.

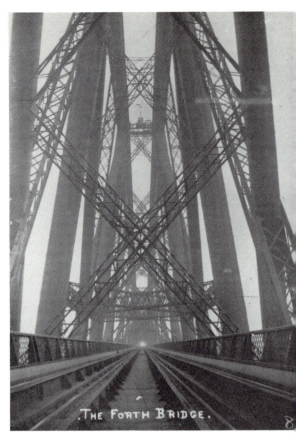

.THE FORTH BRIDGE.

302 The design of Isambard Kingdom Brunel for the Clifton Suspension Bridge was chosen by the great engineer Telford as surpassing all other designs submitted by the world's leading engineers. His success with this design, at the age of twenty-three, set Brunel firmly on his career with the GWR. Addressing a Parliamentary Committee, Brunel declared that the GWR 'should eclipse all that had preceded them.' Brunel's original and delicate drawings for the bridge, construction of which took thirty-two years to complete, are now in the GWR Museum, Swindon.

303 Probably the most famous and photographed railway bridge of all, with its three diamond spans stretching across the Firth of Forth. Some idea of the complexity of its structure can be seen in this picture. A tremendously advanced design, it took more than 5,000 men seven years to build, and in the process they used more than 5 million rivets in 51,000 tons of steel. It was opened by Edward, Prince of Wales, on 4 March 1890.

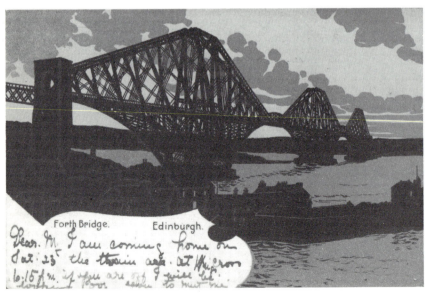

Forth Bridge. Edinburgh.

304 A silhouette picture of the same bridge, printed in black, silver and green. The art of silhouetting, or producing pictures from shadowgraphs, was revived in the mid–1890s, after being extremely popular fifty years earlier. With the advent of the picture postcard its popularity was extended, particularly on the Continent, and some very artistic productions were made. (Stewart and Woolf, Series No 328, about 1900)

188

305 A rather dramatic and colourful picture of the Hudson River Tunnel, New York. Known as the 'Hudson Tubes', they were built because it was impossible to bridge the Hudson. Purely for railways (the Holland Tubes were for motor traffic), they belonged to an independent company unconnected with the New York subway, and ran to Newark, New Jersey. In the mid-1930s, with no controls, fares were very high, even for short stages. (Success Postal Card Co, No 1010) *(Ron Grosvenor)*

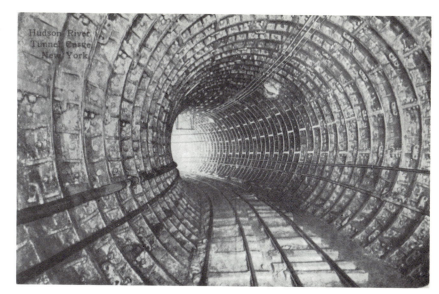

306 The south portal of the Simplon Tunnel near Iselle. This famous tunnel, bored through the Alps, was begun in 1898 by the Jura-Simplon Railway Company. The tunnel was established in February 1905, by boring from both Brig and Iselle and the official opening was on 25 January 1906. Work on the second tunnel was commenced shortly afterwards, interrupted by World War I, and finally completed in December 1919. Both tunnels were opened for full traffic on 4 December 1921.

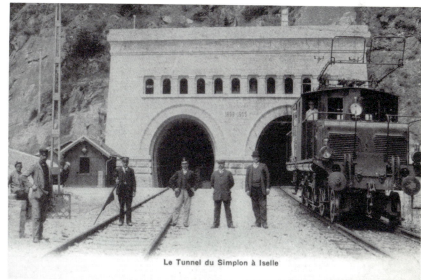

Le Tunnel du Simplon à Iselle

307 This view of the north portal of the Simplon Tunnel was taken shortly after the official opening. The excavation of the tunnel, nearly $12\frac{1}{2}$ miles long, was a gigantic enterprise; nothing similar had been attempted before. It should be remembered that petrol, diesel, and electric motors, used during construction, were still in their infancy. (Decorative embossed chromolithograph No 5982 by Guggenheim, Zurich; half-tone picture No 4138a, by Ruggeri, Brig)

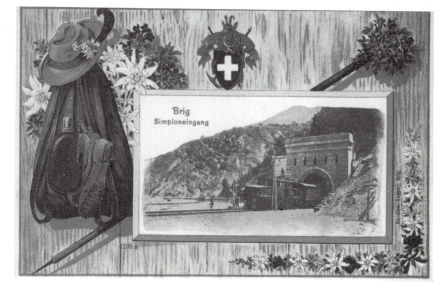

Brig
Simploneingang

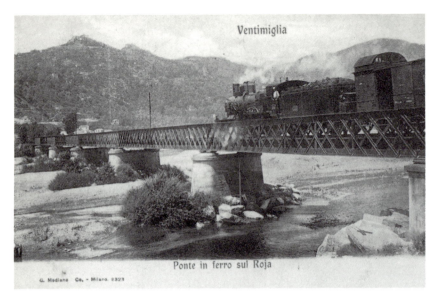

Ventimiglia

Ponte in ferro sul Roja

G. Modiano Co. - Milano. 2323

308 This lattice girder bridge on the Italian State Railways near Ventimiglia is of typical construction seen throughout southern Europe. The ISR ran a special rail-car service from Ventimiglia to Oulx for residents on the French and Italian Riviera.

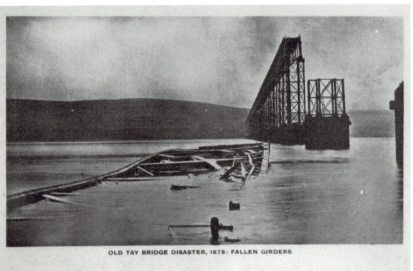

OLD TAY BRIDGE DISASTER, 1879: FALLEN GIRDERS

309 During the stormy night of 28 December 1879, the central part of the Tay Bridge, designed by Sir Thomas Bouch, fell into the Tay while a passenger train was crossing, killing all seventy-two passengers and crew. The disaster brought attention to Bouch's inadequate specification for the proposed Forth Bridge, which was eventually designed by Sir John Fowler. (Valentines XL Series)

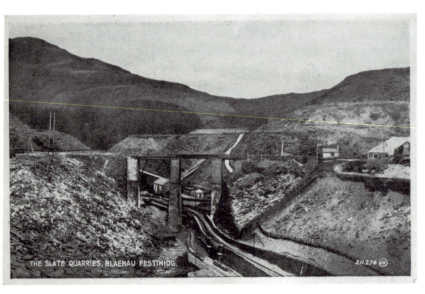

THE SLATE QUARRIES, BLAENAU FESTINIOG. 211.274

310 Really quite an historic picture of the Pen-y-Bont (High Level Bridge), Oakley Quarries, about 1920. The original wooden beams which carried the slate quarry railway were replaced by steel joists in 1957; the bridge was demolished in 1970. Beyond the left-hand arch, 80ft high, can be seen the small building which housed the Greaves power station, in use up to 1981. Of the two tracks between the right-hand arch the one enclosed by slate walls was that of the LNWR, the other being that of the Festiniog Railway. (Valentines 'Phototype' No JV2ll.274) *(Brian Render)*

311 Probably the most common type of railway bridge seen in Britain. Built around 100 years ago, bridges like this have survived as a monument to the craftsmanship and skills of their builders. In many cases, both the brickwork and the ironwork were eventually demolished only because the line had been closed or the heavier traffic required a stronger bridge. Note the solid tyres of the Bristol motor bus en route to Durdham Downs; also the newly-made embankment, about 1910.

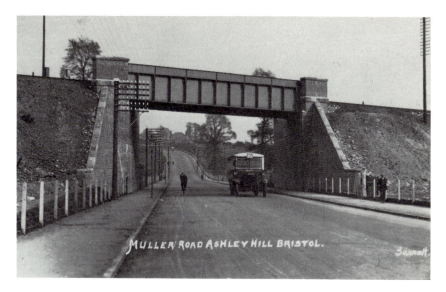

312 A scene on the Duke of York's Bridge, near the holiday camp, on the Romney, Hythe & Dymchurch Railway. The Duke of York, later King George VI, visiting what was then his boys' camp at nearby Jesson, drove the first train across the 56ft span girder bridge. The photograph for this card was taken by H. Greenly, and a similar picture appears in *Railway Wonders of the World*, p231, Vol I. (Card No 23, produced for the R H & D R by F. Moore, about 1934)

313 Bewdley Tunnel, about 1920, on the GWR line between Bewdley and Kidderminster, is delightfully captured in this colourful picture by an unnamed artist. This modern picture is in the best traditions of the golden age, and features a 2021-class 0-6-0 pannier tank engine emerging from the 480yd long red sandstone tunnel. (Severn Valley Railway, Series 1 No 4) *(Ron Grosvenor)*

1275. Maypool Viaduct, Nr. Dartmouth.

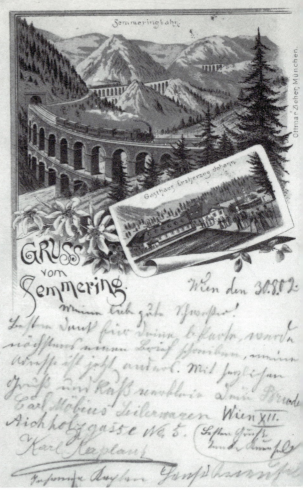

314 As the sender of this postcard so truly wrote in June 1962, 'This scene is unfortunately becoming too rare'. Even the glorious weather which he and his wife were enjoying could not entirely lighten his sadness. A GWR 'Hall' class locomotive heads a mixed rake from Kingswear over the Maypool Viaduct, and is about to enter the Greenway Tunnel to Brimm Hill, en route to Churston station.

315 On one of the oldest mountain railways in Europe, the Semmeringbahn, built between 1848 and 1854, is the famous curved Gamperi Viaduct. The railway climbs over several viaducts and numerous galleries which cling to the side of the mountain. It ascends to just over 3,000ft before entering the final tunnel, 1,530yd long, of the Semmering Pass. (Ottmar Zieher, München, pu 1902)

PENMAENMAWR VIADUCT. VIEW FROM THE SEA.

316 The rocky headland of Penmaenmawr is conspicuous for miles, shelving abruptly to the sea, and squeezed in between is the viaduct. The line was originally part of the Chester & Holyhead Railway, this section through the Bangor being opened on 1 May 1848. The C&HR was operated by the London & North Western in 1856, eventually being taken over in 1859. The LMS helped to develop the area as a resort, referring to Penmaenmawr as 'The Prettiest Place in the Principality'. (London & North Western Railway, Set 25 'Miscellaneous', issued January 1905, printed by McCorquodale) *(Peter Woolway)*

ACCIDENTS

Considering the bad start by which they were first presented to the world (William Huskisson, President of the Board of Trade, received fatal injuries on the opening day of the Liverpool to Manchester Railway, 15 September 1830), the railways of the world do not have a bad safety record. Perversely, bad accidents are good news, safety is bad news.

Accidents will happen, and when they do, they frequently (apart from causing suffering and anguish) ruin good records and reputations.

In the Victorian and Edwardian period, the railways increased their passenger traffic to a phenomenal degree. As they did so, they became more aware of safety and reliability. Most of the accidents occurred because of faulty equipment, and so improved systems and techniques, along with more sophisticated designs, were introduced. These measures helped to reduce, but not eliminate, a further cause of accidents, human error. A third cause, that of malicious or negligent damage to railway equipment, was also difficult to eliminate altogether.

In the early days, accidents were frequent rather than serious, with the breakdown of engines and equipment being the chief cause. It was not unknown for a locomotive to come to grief, only for the engines sent to the rescue also to become disabled. Nowadays, breakdowns are less frequent, but the speed and weight of trains is a far greater hazard.

The Victorians were very fond of statistics concerning the railways, and in 1895, a prominent member of the newly formed Royal Statistical Society produced some very impressive figures. During the previous year more than 912½ million passengers had been conveyed, out of which only one passenger in every 57 millions was killed. That is as if the railways carried the then population of the United States, and only killed one person'

By the time that the Great Western Railway had carried three million passengers, the casualty list was only one broken leg. But on Christmas Eve, 1841, a mixed goods and passenger train ran into a landslip near Reading, killing eight persons and injuring at least sixteen.

Addressing the House of Commons in 1869, John Bright solemnly declared that in 1868, of nearly 300 million passengers carried on the railways of Britain, forty were killed and 519 injured. 'This loss of life does not include servants of the companies nor trespassers. But the House will see that notwithstanding the enormous increase in the number of passengers, the number of persons who have lost their lives has somewhat fallen off . . . and therefore there is nothing to excite alarm.'

In 1899, a group of wealthy American political agitators near Denver deliberately staged a railway collision as a public spectacle; their audience numbered 40,000. The idea was to draw attention to Nevada silver prices. After the two locomotives had crashed together (not at the planned spot, and nearly causing an horrific disaster), spectators scrambled over the wreckage in an orgy of souvenir hunting. The promoters made a profit of $10,000, but their 'free silver' agitations came to naught.

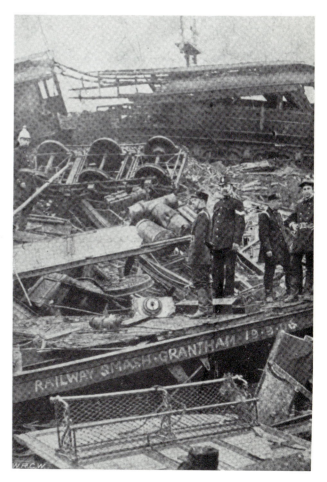

317 The year 1906 was a black one, in which there were three notable accidents, at Grantham, Salisbury, and Elliott Junction. A total of fifty-eight passengers were killed and 631 injured. With the wooden coaches being splintered to matchwood, it is a miracle that the disaster here at Grantham, on 19 September 1906, did not cause more casualties. (W.R.C. Wheeler, Grantham, 1906; number of cards in series unknown) *(Ron Grosvenor)*

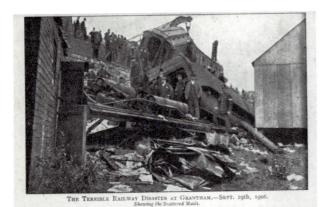

THE TERRIBLE RAILWAY DISASTER AT GRANTHAM.—SEPT. 19th, 1906.
Showing the Scattered Mails.

318 Another view of the same accident, purporting to show the scattered mails; the police sergeant seems determined to appear on as many pictures as possible! Britain was very slow in introducing all-steel coaches for safety. In 1935 there were only 700 such coaches, while Germany, who led the way in their use, had 10,500 in service.

320 The Germans also had their own railway disasters to claim the attention of the photographers, as this derailment on a section of the Berlin Elevated Railway shows. The Hoch und Untergrundbahn was opened in 1892, and its fifty miles of track, actually running through houses and across roads, was designed with feeder lines to the main State Railway. The accident occurred on 26 September 1908, and this card was posted from Berlin on the 30th. Little has been recorded about the Rotophot Company, which was producing postcards well before 1902. (Rotophot, Berlin, 1908)

319 A German postcard manufacturer's view of the Salisbury disaster, which shows very pointedly how a calamity brings out the ghoul in us. Elegant Edwardian ladies in their summer dresses listen eagerly as a young man explains all the details. (H. Hiliger, Berlin No 112)

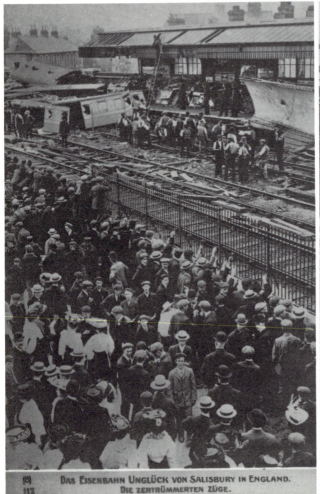

DAS EISENBAHN UNGLÜCK VON SALISBURY IN ENGLAND.
DIE ZERTRÜMMERTEN ZÜGE.

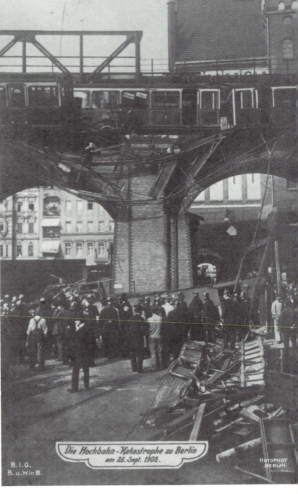

Die Hochbahn-Katastrophe zu Berlin am 26. Sept. 1908.

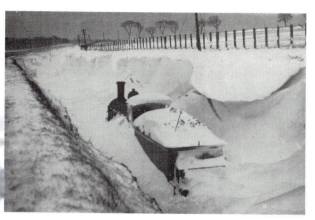

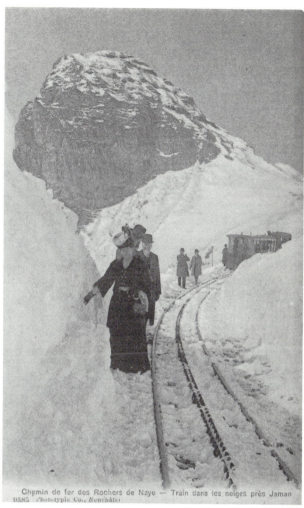

321 'The 8.15 is running late this morning'. Sometime in December 1908, the driver and fireman decided that the track ahead was impassable; it obviously got worse after they left! Even so, the boiler remained hot enough to prevent the snow settling on it. The scene was taken by an enterprising local photographer, on the North British line, near Montrose. *(Ron Grosvenor)*

322 Probably the driver on this mountain railway had similar thoughts. The Glion — Rochers de Naye Railway used the Abt rack and pinion system, although it is doubtful whether the passengers seen here would have appreciated its finer technical points; the lady seems most unsuitably dressed for climbing down a mountain in the snow. (Phototypie Co Neuchâtel, No 9385)

Chemin de fer des Rochers de Naye — Train dans les neiges près Jaman
9385 Phototypie Co., Neuchâtel

323 Sometime in 1907, a troop train was involved in an accident at Traws, but little record, other than this snapshot taken after the major wreckage had been removed, appears to have been made. The postcard was postally used 2 October 1907. (*Peter Woolway*)

324 The famous engine in the ruins of Dixmude. The small Belgian town was an important junction conecting through to the French railway system. It was the scene of many bloody battles for its possession in October 1914. On 28 October Belgian engineers opened the gates of the Furnes lock at Nieuport, letting in the sea between the River Yser and the high railway embankment. The locomotive and some rolling stock were then deliberately derailed into the flood waters. The following day at dawn began the first battle of Ypres. (Nels, Brussels, 'Ruins of Dixmude' series)

325 Some idea of how little protection was given by wooden carriages can be gauged from this picture of the wreck of the Cromer Express, at Witham, 1 September 1905. Less than two years later, the Great Eastern Railway had replaced most of its non-corridor stock, and wa running the Norfolk Coast Express with twelve vestibuled corridor coaches. The publisher of this card advertised on the back that photographs could also be obtained. (Fred Spalding, Chelmsford, No 640)

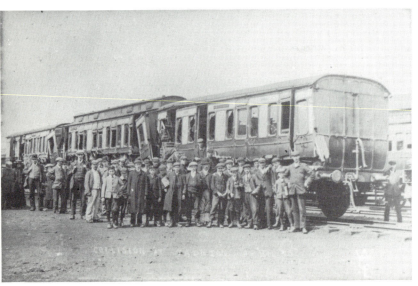

326 Were the proud posers surviving passengers or curious bystanders, at the scene of this collision at Taunton, 30 April 1907? The station area at Taunton was a bottleneck, with no speed restrictions, and no through lines allowing passing. Scissored tracks from both the east and the west brought Up and Down trains to the same platform. This situation was not altered until the mid–1930s.

TRAINS OR TRAMS?

To define the origins of, and differences between, railways and tramways would appear to be simple and clear-cut. But to the historian the issue is not quite so distinct. Many of the early 'railways' started out in life being incorporated as either 'tramroads' or 'tramways'.

The date of the invention of tramways is uncertain, but it is probably between 1602 and 1649, although rutways of probable Phoenician origin are known to have existed about 2,000 BC. The Diolkos 'cradle-way' was unearthed by the Greek Archaeological Service in 1957; a wooden mining wagon, alleged to date from the sixteenth century, is exhibited in a Berlin museum. German mining historians claim that as long ago as the twelth century, wooden tracks were in use in the Tyrolese mines.

Colliery trams of cast-iron plates ('plated way') were laid at Whitehaven in 1738. The first sizeable iron railroad was laid down at the Coalbrookdale Iron Company in November, 1767; according to the historian Nicholas Wood, the credit was due to a Mr Reynolds, one of the proprietors of the firm. The company's books confirm this. In a book *The Coal-viewer and Engine-builder*, published in 1797, John Carr, as manager of the Duke of Norfolk's Nunnery Colliery near Sheffield, claimed to have invented and laid such rails in November 1776.

Early tramway history is a little more confused by the fact that those cast-iron 'plate' rails were cast by James Outram at his foundry at Ripley in 1775. The plates were of 'L' section, cast in 5ft lengths, and known as 'Outram-ways'. Many people, even today, erroneously state that the word 'tramways' was derived from 'Outram'. But the word was in use long before the advent of the Ripley iron founder. Considering medieval mining history, the word is probably derived from the Scandinavian word *tram*, meaning a wooden beam or doorstep.

Tramline construction took another important step in 1788, when William Jessop was credited with the development of the narrow rail to guide flanged wheels. Writing in 1824, Alexander Scott said, 'The first Public Railway Company seems to have been established at Loughborough in the year 1789 under the direction of William Jessop.' This was a line for the Loughborough Canal at Nanpantan to connect with the Leicester Navigation Canal.

Richard Trevithick constructed a high-pressure tram-engine (so designated in the original plan) in October 1803, and won a 1,000 guineas bet for the proprietor of the Pen-y-darran Iron Works. Writing to a friend in February of the following year, he said, 'The tram-waggon has been at work several times. It works exceedingly well, and is much more manageable than horses.'

The date of the earliest operational steam tramcar used for public service was probably 1872, when a Mr Grantham built his engine. It was tested in 1873 at West Brompton, and eventually put into service in 1876 on the Wantage Tramway. The first steam tramway locomotive to ply for hire on the public streets was Hughes' Patent Tramway Engine. It was constructed by Henry Hughes at the Falcon Engine and Car Works Ltd, Loughborough (later Brush Electrical Engineering). Transported to Leicester by the Midland Railways, it made its appearance on 27 March 1876, on the Belgrave Line of the Leicester Tramways Company.

327 In 1901 the Leicester Tramways Company was bought out by the Corporation, and early in 1903 they began the task of extending the system. This was known as the 'Siege of Leicester', and the trackwork around the Clock Tower (seen at the left) was the most complex in Britain, around which were operated forty different routes. Removal of the old granite sets, replacing with hardwood blocks (some still remain in Belgrave), and infilling to raise the new road by nearly two feet, took only ten days (without nightwork).

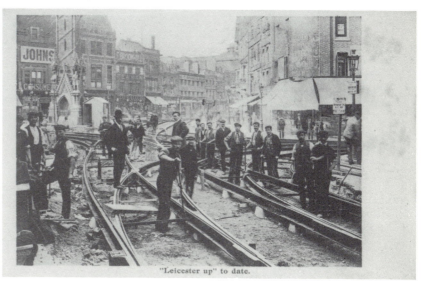
"Leicester up" to date.

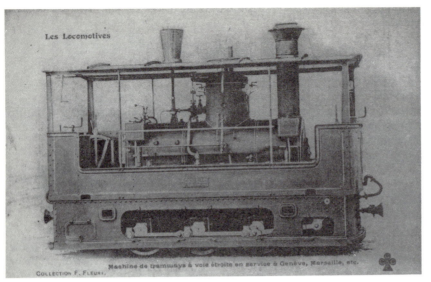

328 Built by the Société Suisse Locomotive Works at Winterthur, about 1890, this steam tramway engine operated services in the narrow streets of Geneva. Most of the cars were open-tops, and passengers complained that they were showered with hot cinders and sparks. (Collection F. Fleury, published by C&C, France, about 1905) *(Rev Teddy Boston)*

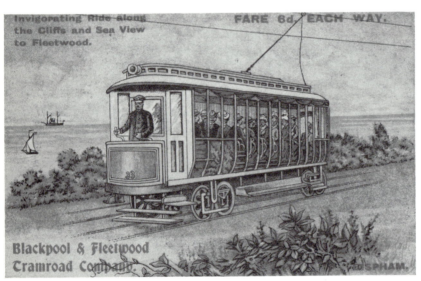

329 The crossbench open-sided car of the Blackpool & Fleetwood Tramroad Company seen on this advertisement card was one of more than twenty-five of varied design in the fleet. The company was bought by the Blackpool Corporation in 1920. A similar car is now preserved at the National Tramway Museum, Crich. The card was issued at Bispham, the site of the depot and power station. (Blackpool & Fleetwood Tramroad Company, about 1904)

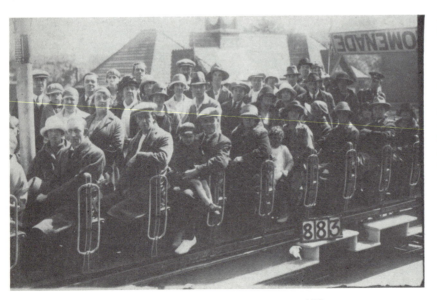

330 The start of the circular tour, Blackpool, came with the purchase in 1911 of twenty-four 'toast-rack' trams. The ride was very popular with charabanc day-trippers. In 1927 the ritual stop for photographs was discouraged; the number on the running board was for picture identification if passengers wished to buy a copy of the photograph. One of these 'toast-racks' is now preserved in the National Tramway Museum.

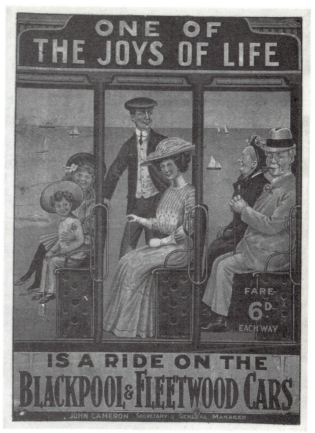

331 Presumably not all passengers travelled merely for
the ride, but more for the view! Unfortunately the make
of car cannot be verified from this picture. (Bamforth &
Co, 'Witty Comic' Series No 2665, about 1925)

332 Promoting the idea of family involvement when
advertising a product or service was an almost certain
success. Where better than in Blackpool where the whole
family was on holiday? The Blackpool & Fleetwood line
opened in 1898, using Milnes 'toast-rack' trams, one of
which is preserved in the Tramway Museum at Crich.
Blackpool Corporation acquired the company in 1920.
(Mumbles Railway Publishing, No MRP/23)

333 Pictured here is Toby the tram
engine. Short and sturdy, with a cow-
catcher, his friend is the coach
Henrietta, and together they take
trucks to the main line for the Big
Trains. They are both friends of
Thomas, the Tank Engine. The
characters were first created in 1943,
and published in 1945. The present
series of cards is based on 'The
Railway Series' by Rev W. Awdry.
(Judges Postcards Ltd, 'Thomas The
Tank Engine & Friends' No c8007)
(by permission of Rev W. Awdry)

MIXED TRAFFIC

Much of the traffic on the railways is still very mixed, both on the rails and behind the scenes, from driving the passenger expresses to issuing tickets, marshalling the goods trains to working the signals. True to form, railway picture postcards have always mirrored the many facets of the industry, its origins and services, its humour and its hard work, its sadness and its grandeur. The railways provided yet another outlet, of almost limitless horizons, in which the postcard publishers could exercise their ingenuity in portraying the scene, real and imagined.

For the railways themselves, their matter-of-fact concern was how to transport efficiently both freight and passengers. These considerations soon led to the development of specialist locomotives. The LNER built two 2-8-2 'Mikado' engines for heavy freight service, hauling 100-wagon rakes weighing around 1,600 tons. A far cry indeed from Robert Stephenson's *Lancashire Witch*, built in 1828, and which was capable of hauling 50 tons at 8mph.

When the freight was carried to its destination, more than a wide variety of specialist rolling stock was required. To ensure that the goods carried in a 'Python' or a 'Lafish' (covered carriage trucks on the GWR and LNER) travelled and arrived safely the signalmen had to 'watch' the train every yard of its journey. Distant, outer home, home, starter, and advanced starter signals controlled the passage of the trains on the Up and Down lines. What had once been a largely manual job became one of pushing buttons, but none the less responsible for that. The signalman controlled the trains by means of a complex electro-mechanical system, flexible in operation, but which could be solidly locked for security.

Track laying and maintenance is now more of a science than manual labour, with British and German machines capable of lifting old track and replacing it with new, and electronically checking levels, as standard equipment. All a far cry from the famous LMS poster by Stanhope Forbes in 1924 showing 'The Permanent Way — Relaying Track'. What a splendid picture postcard that would have made, even if the 'Look Out' was paying more attention to the artist than the oncoming passenger train!

Railway humour is a field waiting to be explored by today's historians. In the pre-Grouping period especially, postcard publishers opened the gate wide on the subject. Every conceivable kind of comic situation was portrayed on the cards from the basely vulgar to the charmingly genteel. Martin Anderson, a Scottish artist otherwise known as 'Cynicus', produced some unconventional satirical pictures of Edwardian railway life. The railway traveller from 1904 onwards would have been familiar with the comic postcards of Donald McGill, probably Britain's most prolific picture postcard artist. His cards are very valuable historically because his fat ladies, timid spinsters, daring young things, parsons and drunks are all set against authentic backgrounds.

As early as 1842 the British railways found it necessary to establish a means of checking various companies' shares in 'through' traffic for both passengers and goods. Accordingly, the Railway Clearing House was formed with a staff of six clerks who dealt with all the problems of mixed traffic.

The picture postcards had to wait until around the turn of the century before they could give their record of the railways.

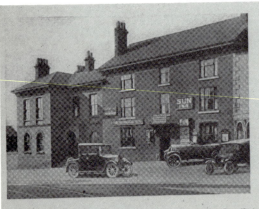

A LITTLE group of plain, practical men were, on the morning of the 16th of August, 1832, sitting round the parlour table of a village inn, in Nottinghamshire. They were coal masters—deep in mines, in council, and in pocket. Once a week they were wont to meet at the "Sun," at Eastwood, to ponder their dark designs, and when business was over they solaced themselves with the best fare the landlord could provide.

A better means of transit for their coal being necessary, "after anxious deliberation upon all the facts before them, they proceeded to enter on their minutes the declaration that — there remains no other plan for their adoption than to attempt to lay a railway from these collieries to the town of Leicester."

"On the 4th of October, at a special meeting at the Sun Inn, Eastwood, it was unanimously decided, that a railway be forthwith formed from Pinxton to Leicester, as essential to the interest of the coal trade of this district," and thus the "Sun Inn," at Eastwood, became the birth-place of the great Midland system of railways, of which the country is justly proud. Commenced April, 1838. Opened May 30th, 1839.

"THE SUN," Birthplace of the Midland Railway. Proprietor: SAM WOOD.

334 For more than twelve years before the colliery owners of Eastwood, meeting at The Sun inn, made their historic decision, a tramway had been carrying coals and cotton from the Pinxton wharf of the Cromford Canal to Mansfield. George Stephenson, in 1832, was delivering coals to Leicester from his new pits at Snibston at less than ten shillings a ton. From the 'anxious deliberation' of the Eastwood colliers was born the Pinxton to Leicester Railway which became united into the Midland Railway.

335 An example of postal stationery specially for the 1933 WIPA (Viennese International Philatelic Exhibition) Congress, and cacheted at the Art Gallery. With the design of the stamp matching the picture on the card some enhancement of value is given. A pity that the artist was not familiar with his subject. *(Mike Clarke)*

336 'Not least among the peculiarities of Wales is the length of the names of many of the villages, an example of which is illustrated in the picture. Easy, no doubt, to the native Welshman, the pronunciation to the visitor presents insuperable difficulties, and many weird and amusing tales are told of the results of these attempts.' So runs the caption on the reverse of this card, postally used at Cardiff, 2 July 1917. (Raphael Tuck & Sons 'Welsh Rarebits' Oilette, Postcard No 9340)

"*A Welsh Rarebit*"

337 One can sympathise with the poor fellow in this Donald McGill comic picture. What railway traveller at some time has not frantically searched through pockets, bags, and purse for that elusive piece of card or paper, the precious ticket? (Inter-Art Co, 'Comique' Series, No 3243)

" LOST YER TICKET SIR ? WELL IT DON'T MATTER ABOUT THAT NOW——"
" OH, DON' IT ? THASH ALL YOU KNOW. I WANT IT TO SEE WHERE I'M GOIN' ! "

PUSH-STARTING THE SNOWDON MOUNTAIN RAILWAY ON A COLD MORNING.

338 This comic picture postcard tells its own story, and also fills the gap, as the artist hopes, 'Between the blue skies and the one you wouldn't dare send your maiden aunt.' Rupert Besley is one of the prominent artists of modern cards; a former teacher of French and history, he has been working full-time as an artist since 1983. (J. Arthur Dixon, No PHU/24608)

339 Humour, especially when directed against authority, is universal. This scene on the Czechoslovakian State Railway is one of a series by the artist E. Schrabal, which pokes fun at the fat and pompous station officer and the long-suffering guard. On other cards, watches have been checked against the timetable, and now the departure log is signed. (Minerva Series, Prague, about 1930) *(Mike Clarke)*

340 The Swansea and Mumbles Railway of 1879 began life as the Oystermouth Railway or Tramroad in 1804, and was originally worked by horses. The track was laid to fulfil the requirements of steam traction although it was not until 1887 that steam traction displaced the horses. Saddle tank locomotives eventually replaced the enclosed condensing tank engine seen in the picture. The train was usually up to eighteen cars carrying nearly 1,800 passengers. (F. Frith & Co, Postcard No 43670A)

202

341 Some of the guests at the Prince of Wales Lake Hotel seem to be making a perilous, if stately, start to their trip in the Lake District. Strangely, the notice board for the Furness Railway, on the side wall, is devoid of posters.

342 According to the caption on the reverse of this card, Bognor was a quiet family resort occupying a sheltered position on the South Coast. It was one of the select watering places, with a promenade a mile long on the sea wall, theatre and assembly rooms, and was noted for its 'sands, boating, fishing, &c.' Note the bathing huts on the segregated part of the beach where only females were allowed. (London, Brighton & South Coast Railway, Series 2, issued 1907, printed in collotype by Waterlow & Sons Ltd) *(Ron Grosvenor)*

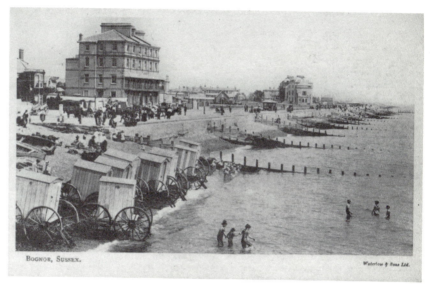

343 The railway station was a social focal point, as can be gauged from the notice behind this charabanc of trippers on a Choir Outing to Whitby, 25 June 1925. According to the regulations, this 'chara' could only carry twenty-three passengers; it seems to be 'one over the odds', although no-one bothered very much in those days.

Gruss vom Rhein. Zahnradbahn n. d. Drachenfels.

344 The manufacturers of novelty cards were not slow to see the possibilities offered by the popularity of railway travel. In this example the window opens to reveal a 'concertina' of miniature pictures of Leicester scenes. The overprint and the strip of pictures could be made for any location. (Pocket Novelty Card, 'Dainty' Series, about 1920)

345 In this view of the Drachenfels Zahnradbahn (Dragon Rock Rack Railway) near the Rhine in Germany, the Abt rack system can be clearly seen. The system was patented in 1882, and the axle pinions, gearing with the ladder rack, transmit the power. The outer wheels on the conventional type rails are for carrying purposes only. *(Peter Woolway)*

346 Operated by a variation on the Abt rack system this cliff railway was in the Old Town quarter of Kiev, on the right bank of the Dnieper river. As if to make history more confused the caption on this Russian postcard, produced in Moscow, describes the picture as 'Mechanical Locomotive Tramway'. The centre of the city, seen here about 1905, was ruthlessly destroyed 1941–3. *(Peter Woolway)*

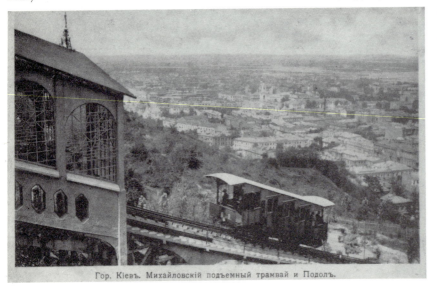

Гор. Кіевъ. Михайловскій подъемный трамвай и Подолъ.

347 In the early 1930s the Floating Dry Dock at Southampton was the largest in the world, capable of accommodating the biggest liners then afloat, up to 60,000 tons. The docking of 50,000 ton vessels was a common occurrence. Owned and managed entirely by the Southern Railway Company, the Southampton Docks complex, with high water four times daily, allowed the largest ocean liners to berth any time, day or night. The liner in the background appears to be the Cunard White Star RMS *Aquitania*.

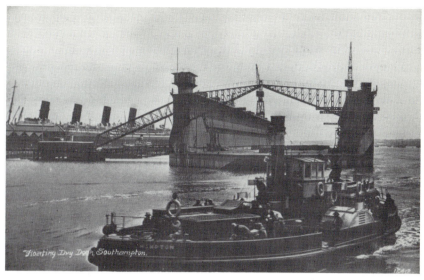

348 One of the more tragic reminders of what was meant by 'Railway Service'. The LNWR Memorial, unveiled by Earl Haig, 21 October 1921, commemorates 3,719 employees who fell in World War I. (Wildt & Kray, No 89, 1921)

349 Less obvious as a memorial is this grand portal at the northern entrance to the L&SWR Waterloo Station. The arch was incorporated into the rebuilding of the station which had been delayed by World War I. (W.H. Smith, Kingsway Series) *(Ron Grosvenor)*

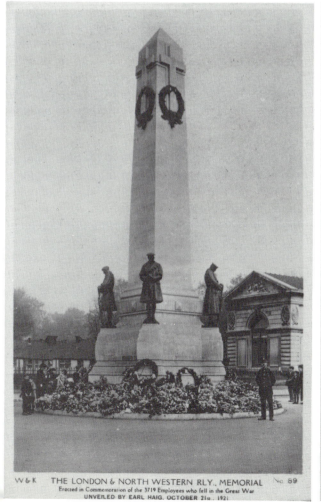

W & K THE LONDON & NORTH WESTERN RLY., MEMORIAL No 89
Erected in Commemoration of the 3719 Employees who fell in the Great War
UNVEILED BY EARL HAIG, OCTOBER 21st, 1921

View of the Northern Entrance to the Station and Memorial Arch dedicated to the employees of the London & South Western Railway Company who gave their lives for King and Country in the Great War, 1914-1918. Unveiled by Queen Mary, 21 st. March, 1922.

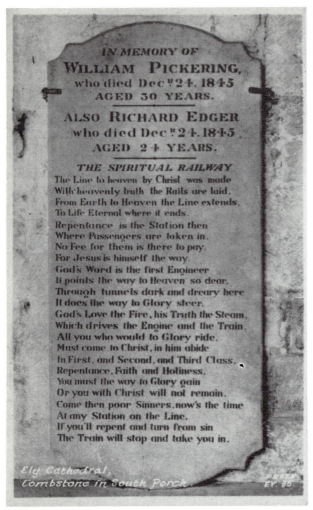

IN MEMORY OF
WILLIAM PICKERING,
who died Dec. 24, 1845
AGED 30 YEARS.

ALSO RICHARD EDGER
who died Dec. 24, 1845
AGED 24 YEARS.

THE SPIRITUAL RAILWAY

The Line to heaven by Christ was made
With heavenly truth the Rails are laid.
From Earth to Heaven the Line extends,
To Life Eternal where it ends.
Repentance is the Station then
Where Passengers are taken in.
No Fee for them is there to pay.
For Jesus is himself the way.
God's Word is the first Engineer
It points the way to Heaven so dear,
Through tunnels dark and dreary here
It does the way to Glory steer.
God's Love the Fire, his Truth the Steam,
Which drives the Engine and the Train,
All you who would to Glory ride,
Must come to Christ, in him abide
In First, and Second, and Third Class.
Repentance, Faith and Holiness,
You must the way to Glory gain
Or you with Christ will not remain.
Come then poor Sinners, now's the time
At any Station on the Line.
If you'll repent and turn from sin
The Train will stop and take you in.

Ely Cathedral
Tombstone in South Porch

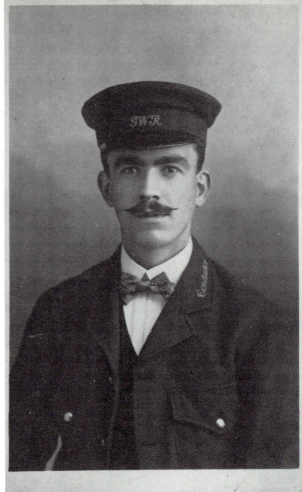

MIDLAND

350 A memorial tombstone preserved in Ely Cathedral, to two railway employees. (Friends of Ely Cathedral, about 1935, printed by F. Frith & Co)

351 The family portrait album often yields gems like this one of a GWR conductor, about 1910. Unfortunately, very rarely do they have any identification, date, place, on them; sometimes even the photographer is not mentioned. (Photograph by A. & G. Taylor, Newport, Pontypool, Ebbw Vale & Brynmawr)

352 It is uncommon to find railway armorial bearings specifically featured on postcards. Although most companies used an heraldic device, none had been granted the right to bear them by the College of Heralds. The arms of the Midland varied slightly from the company seal which carried the arms of Nottingham instead of those of Bristol (top right). the other arms are (left to right): Birmingham, Derby (represented by a deer in a park); (below) Leicester, Lincoln, and Leeds. The supporters are a dolphin on the left, and a salamander on the right, with the wyvern above the shield. The wyvern was the crest of the Mercian king and Leicester was the capital of Mercia.

353 'Der Krieg im Osten.' In the final stages of the war in the East, the Germans became quite adept at disarranging tracks to delay the Allied advance. Here at Eydtkuhnen station the Allies obviously got there first with their bombardment. It would have needed a good set of bogies to negotiate the track behind the two officers. (Fritz Krauskopf, Konigsberg, No 149, postally used Eydtkuhnen, 25 February 1918)

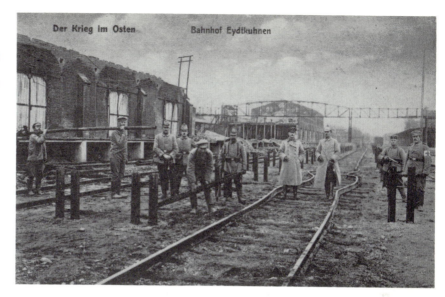

354 This artist drawn scene translated as 'Distribution of Charity gifts at a Station in Austro-Hungary' was typical of many others throughout Europe during World War I. After many hours of travel in closed wagons the troops were glad to see a friendly face with the offer of food, drink, and a chat. (Artist E. Gatterburg, 'Gloria-Viktoria' Album, Series 47/2 No 42, published by Kriegshilfe (War Relief) Munich, 1914–18)

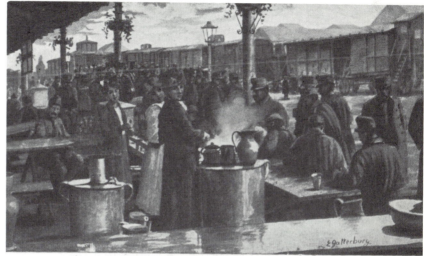

355 Perhaps the troops on this train, about 1939, enjoyed 'kisses that tasted like wine' far better than champagne or soup. ('Farewell' No PC158, Camden Graphics [BBC Hulton Picture Library])

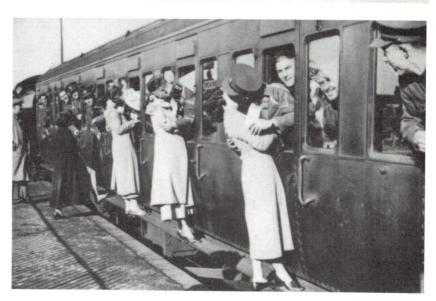

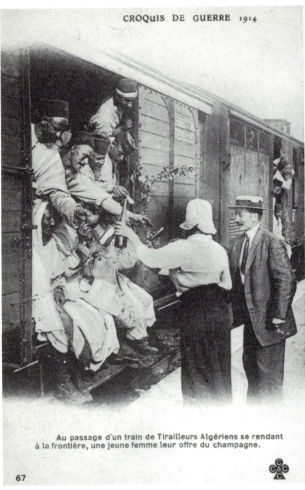

CROQUIS DE GUERRE 1914

Au passage d'un train de Tirailleurs Algériens se rendant à la frontière, une jeune femme leur offre du champagne.

67

Fare well

356 Algerian Riflemen on their way to the front in 1914, being offered champagne by a young woman. The men seem eager to quench their thirst. The sender of the card wrote of British troops travelling in the same kind of carriages, 'Only they are not so fortunate as to have refreshments.' The accommodation was for forty men or eight horses. ('Sketches of War 1914', No 67, published by C&C, Paris)

357 The girl on the train and the fond farewell were popular themes on postcards, ranging from the saucy to the romantic, the comic to the novelty. Compare this peacetime scene with that shown in postcard 355. (Leo Stainer, Innsbruck, No 1198, about 1910)

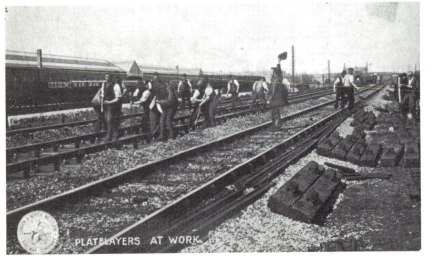

PLATELAYERS AT WORK.

358 Platelayers at Work on the LNWR. Such gangs of workmen had a 'look-out' employed solely to keep watch for approaching trains. On this picture he was probably behind the photographer. The man at the left foreground and the man holding the surveyor's rods on the right, seem more interested in the camera. Note the foreman (distinguished by his bowler hat) posing as he directs the labours of the gangers. (London & North Western Railway, Set 25 'Miscellaneous', issued January 1905, printed by McCorquodale)

359 At least these Russian gangers working on the Trans-Siberian do not have any worries about oncoming trains. They are still in the process of cutting the channels in the baulks to accommodate the rails. The card was sent from Omsk, as a Christmas greeting, 1905. (Card No 34, published Russia, 1904)

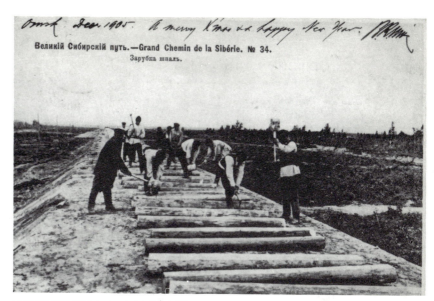

360 A good example of the almost instant news appeal of the postcard by a local photographer. Obviously feelings ran high during the strike of Great Northern Railway moulders in Peterborough, 1913, according to the writer of the card. He and his friend Walter (far left next to houses) were on their way home to dinner as the strikers escorted the foreman home; he lived in this street.

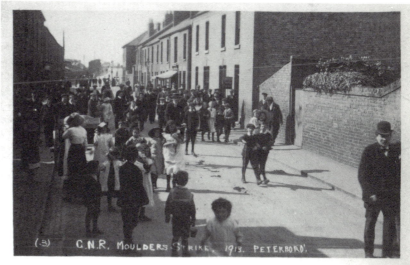

361 The Shire Highlands Railway was first opened to traffic in 1908, as part of the Nyasaland Railways. The entire project, including the Central Africa Railway and the Trans-Zambesi Railway, was completed in 1935. Small boats like the one seen here brought workers and materials along the Luchenza River. The line used quite a wide variety of locomotives, including two Sentinel-Cammell steam rail-cars; these were run with cheap fares to induce the natives to travel more frequently. (Card of small series, published about 1910, A.J. Storey, BCA)

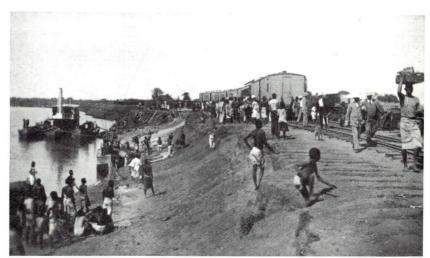

A. J. Storey, Photo., Blantyre, B.C.A.
NJANJE. FIRST TRAIN ON THE SHIRE HIGHLANDS RAILWAY, NYASALAND.

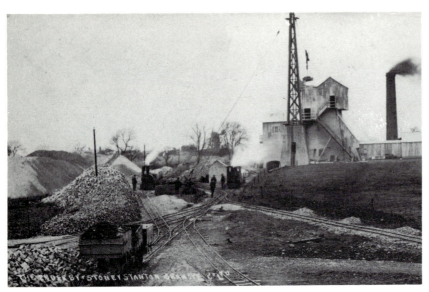

362 Industrial light railways, used in mines and quarries, were first on the scene, and yet their contribution to transport history has received relatively little acclaim. In many cases small communities were born, lived, and died depending upon them for their prosperity. Saddle-tanks built by Bagnall and Hudswell were used extensively on these non-public railways. The Stoney Stanton, Leicestershire, quarries seen here, supplied granite for both road and railway construction.

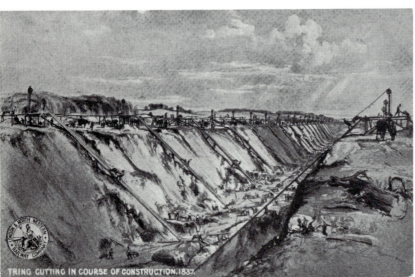

363 The sheer scale of human effort, as portrayed in this picture of the construction of the Tring Cutting, cannot really be grasped. Even with the assistance of horse power on the winches each barrow-load of spoil must have felt like tons by the time the navvy had guided it up the precarious incline. The development of the highly successful Ruston-Hornsby 'steam navvy' in 1875 came too late for Tring, excavated in 1837. (London & North Western Railway, Set 21 'Railway Cuttings', issued January, 1905, printed by McCorquodale)

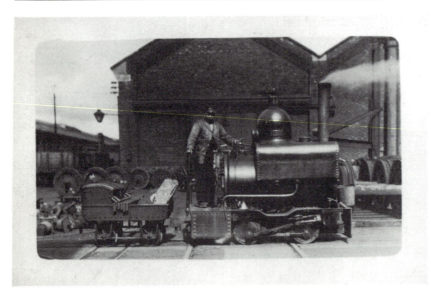

364 This card was rescued from an old family album. Other than the fact that the 0-4-0 locomotive was named *Fly* (the plate is fixed to the dome), and that the works were somewhere on the Midland Railway, nothing else is known.

365 Made of the stoutest timber, well bolted and plated, this wagon was typical of the more than three-quarters of a million which trundled the tracks in 1910. It could carry twelve tons of coal or coke; steel hoppers contained fifty or sixty tons but were much more expensive for the private owner, such as a local corporation. This new wagon was built to a Railway Clearing House specification 1923.

366 In this splendid view of the Erecting Shop at Derby there is not a workman to be seen! They would have given life and normality to a very formal picture. The engine halfway down the shop is a 2-6-4 taper boiler, 3-cylinder tank engine, specially built by the LMS in 1934, for service on the Tilbury and Southend lines. (London, Midland & Scottish Railway, about 1934, Anon) *(Ron Grosvenor)*

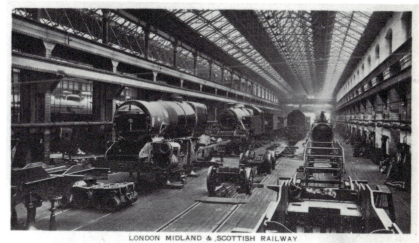

LONDON MIDLAND & SCOTTISH RAILWAY
BUILDING LOCOMOTIVES AT DERBY WORKS. THE ERECTING SHOP.
OVER 7,000 ENGINES ARE OWNED BY THE L M S RAILWAY
THE MAJORITY OF THEM BEING CONSTRUCTED AT LMS WORKS.

367 Locomotives and trains appeared in abundance on greetings cards of all descriptions. Cards of the type shown here were overprinted with the appropriate legend, or had a plain back overprinted with details of the engine, and then issued by the London County Council as 'Reward Cards' for good attendance and punctuality at school. Not so very much sought are the deckle-edged real photographic birthday cards, where locomotives like the *Flying Scotsman* are wreathed in roses and sentimental verse. The locomotive here is a Dean-Churchward 4-4-0 'Bulldog' Class. (J. Salmon, No 1741)

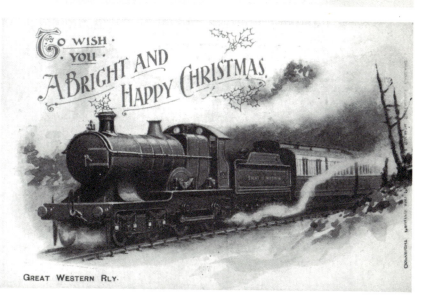

GREAT WESTERN RLY.

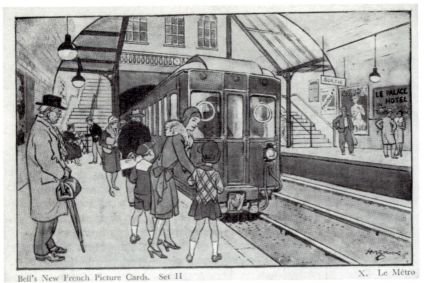

Bell's New French Picture Cards. Set II X. Le Métro

368 One of a series of French language cards illustrated by H.M. Brock, showing scenes on the Metro and other railways. The Paris Metropolitan Railway was an amalgamation of the Metropolitan and the Nord-Sud, a total of twelve lines, in 1930. The original system was opened in 1900, running between Porte Vincennes and Porte Maillot. The Metro networked under Paris so closely that no place above ground was more than a quarter of a mile from a station. (G. Bell & Sons, Set II No X, about 1930)

A DANGEROUS FINISH

369 The most unexpected picture postcards yield a railway theme. This one is from a series of cards on fox hunting, about 1908. (Raphael Tuck & Sons, Oilette, 'Fox Hunting' No. 9450)

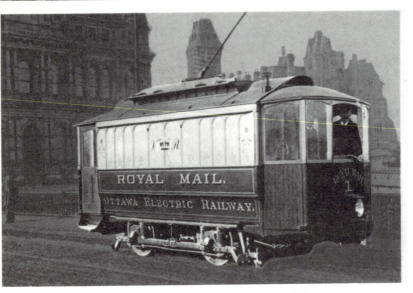

370 Car No 1 on the Ottawa Electric Railway was the first in a small fleet of specially built Royal Mail trolleys. Seen here about 1894, crossing the city, its function was similar to the Post Office underground railway cars in London. The card, similar to British PHQ, was issued to accompany a commemorative 8 cent Canadian postage stamp. (National Postal Museum, Ontario, No 3PM-2S)

371 A very scarce card, presumed to be one of a small series featuring interesting places on the South Eastern Railway. Postally used, South Norwood, 19 August 1915, there is no indication of the printer. Note the reference to the trains dividing. When a connection was required, but it was not desirable to stop the whole train, special 'slip coaches' could be detached from the main train. Under their own impetus they ran to a stopping-place controlled by their own guard. (*Ian Wright*)

Nearest Railway Station— **Woodside, S.E.R.**

TRAINS.	Charing Cross.	Cannon Street.	Woodside.
	—	10.25	11 8
	2 52	3⅓.	3 47

Passengers should enquire for a Woodside carriage; the trains divide at New Beckenham, the front part only comes to Woodside.

372 It is unusual to find real photograph postcards of carriage interiors, the pictures being solely of the furnishings and fittings. In this LNWR first class carriage, the pictures above the Nottingham lace antimacassars are of Lake District scenes, with the nearest station indicated. The very plush woven moquette, upholstered and buttoned for the seats, continues around the windows, and is trimmed with real leather. (*John Silvester*)

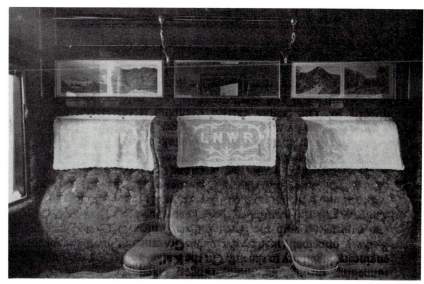

373 This photograph, one of several privately-produced picture postcards, shows a bridge near Saltash being demolished. The approaches to the station, just beyond the bridge, were being widened, and an explosive charge was the simplest and most effective way of removing the bridge. (*John Silvester*)

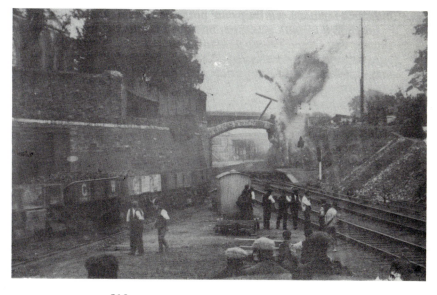

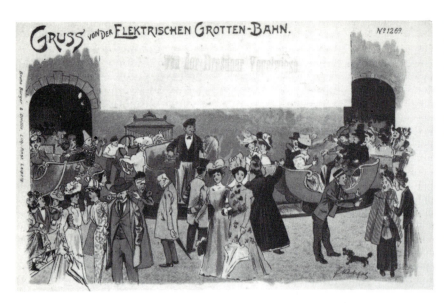

374 An unusual railway postcard, a greetings card from what was, presumably, an important fair. The card was sent from Dresden, 6 August 1902, a rubber stamp in the message space signifying that it was 'from the Dresden Bird-park'. But why should a fun-fair type train be running in such a place? And what was so important about the fair which would make folks wish to send a card from there? It is very strange, because the previous large fair to be held in Dresden was at the 1897 Exhibition. (Electric Cave Railway, card No 1269, printed by Burger & Ottillie, Leipzig) *(Mike Clarke)*

375 This poster of the Liverpool Overhead Railway was the basis of many company promotions, the only alterations being in the information contained in the panel at the bottom. During the centenary celebrations in 1930 of the Liverpool & Manchester Railway passengers on the LOR were given free passes to inspect the Atlantic liners berthed in the docks below.

376 The use of railway stations as posting places was convenient for both the writer and the Post Office. The post-box took several forms, this one is known as a 'bracket box'. Originally made of wood, they were issued by the Post Office about 1883; similar types were also used on paquet boats. This box, the only one complete, is one of three known to be in regular use, and is installed at Machynlleth Station, North Wales. (Bath Postal Museum, No 11, issued March 1985)

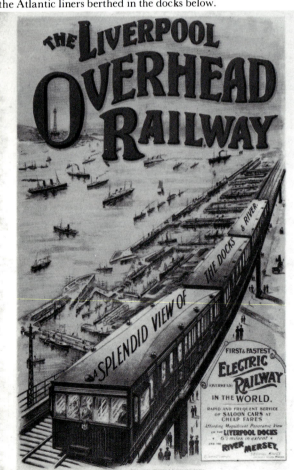

HOTELS, THE TRAVELLERS' REST

The story of the railway hotel, a much over-looked aspect of railway history, has yet to be told in all its fascinating fullness. Beyond London they were establised principally for the convenience of passengers who needed to break their journey for a night or two. As the railways grew in popularity so too did the hotels, and quite prominent architects were commissioned to design them for the major lines. So grand were some, that if certain stations are to be regarded as 'cathedrals' then these must surely rank as 'palaces'.

The original hotel adjoining the York terminal station was designed by G.T. Andrews; the station was rebuilt in 1877, and Thomas Prosser designed an impressive Italian Gothic hotel to stand beside it. Although some outstanding buildings of their kind were built, and still survive, the Gothic Revival movement among architects for station hotels was not very popular. Perhaps one of the most supreme examples of Victorian architecture is the St Pancras Station and Hotel, designed by Gilbert Scott.

Railway hotels became great caravanserais accommodating hundreds of guests, with palatial staircases, dining and banqueting halls, special saloons for their cosmopolitan patrons. Some developed more as commercial hotels for business people, while others flourished as tourist and holiday havens. Others, known only by personal recommendation, were quiet little retreats away from all the rush and turmoil, which gave first-class accommodation even if they were close to the station.

As might be expected, the need to provide an hotel service brought into being many specialist branches of work. Huge bakeries and laundries, and large depots for the storage and supply of groceries, crockery, and linen, which the commissariat department could despatch to all parts of its company's system came into operation. With the later addition of refreshment rooms and restaurant cars the department became tremendously important. Farm and agricultural lands were acquired by the railways to meet the needs of their hotels, with the commissariat concerned with such details as the keeping of pigs to eat the waste food and provide the morning bacon, the new-laid eggs which the dining-room patrons ate with it, coming from another part of the farm.

The railways gave some publicity to their hotels via the picture postcard, one example being the Royal Station Hotel at York, which advertised the hotel garage on one card. This was 'One of the finest in England', with full service facilities, and is interesting as a social document in that it reflects the growing change in people's travelling habits, a change which was to take away much of the hotels' former business.

With the 1923 grouping the Big Four became the owners of the largest chain of hotels, railway or otherwise, in the world. Situated throughout the country, many of them were the most prestigious of their kind, from the Gleneagles in Scotland to the Lord Warden at Dover. These 'travellers' rests' were among the finest establishments in the country, and were a great boon to the many thousands of passengers.

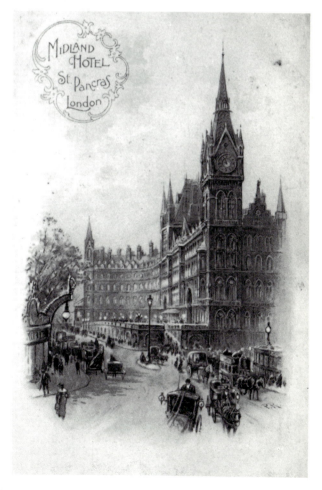

377 In the dignity and grace of its architecture, the Midland Grand Hotel at St Pancras was one of the most beautiful hotels in London. Built as an integral part of the London terminus in October 1868, it remains as one of the finest examples of Gothic Revival architecture. It was designed by Gilbert Scott, and was considered one of the finest modern buildings of its day. (Midland Railway, about 1904, chromolithograph, printer unknown) *(Ron Grosvenor)*

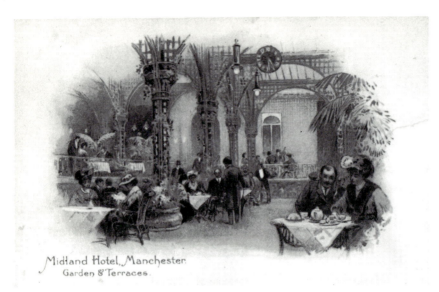

Midland Hotel, Manchester.
Garden & Terraces.

378 Contemporary photographs show this chromolithographed picture of the gardens and terraces of the Midland Hotel, to be inaccurate in one thing — there are no sun-umbrellas over some of the tables! The Manchester hotel was regarded as the most prominent of all the Midland Railway hotels; the *café chantant*, seen here, on the private terrace, was renowned. (Midland Railway, about 1904, printer unknown) *(Ian Wright)*

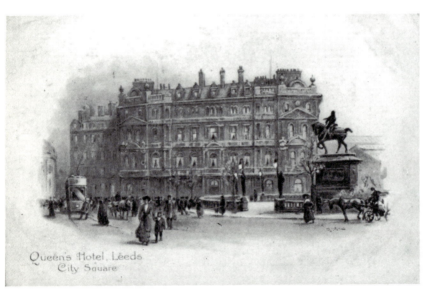

Queen's Hotel, Leeds
City Square

379 The Queen's Hotel, Leeds, situated close to the Midland Railway station, was advertised as 'The Premier Hotel of Yorkshire', and was luxuriously furnished. A comfortable hostelry, conducted under the ubiquitous management of 'Messrs Towle', it afforded a convenient break for travellers between England and Scotland, as well as for Yorkshire tourists. (Midland Railway, about 1904, printer unknown) *(Ron Grosvenor)*

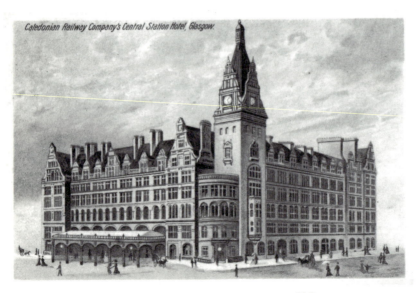

Caledonian Railway Company's Central Station Hotel, Glasgow.

380 The first portrayal of the Caledonian Railway Company's Central Station Hotel, Glasgow, was on a Court card in 1899. On this chromolithograph, dramatic effect is given to the splendid building by excluding all neighbouring buildings. A touch of artistic licence with red and gold tinted clouds gives the commercial edifice a romantic air. (Caledonian Railway, about 1906, printer unknown) *(Ian Wright)*

381 The same building, identical view, later period. An extension appears to have been built onto the far right end of the hotel, and a name-board added to the station canopy. Open landau cars (their drivers ignoring any rules of the road) and a tram have joined the hansom cabs on the street. The card was sent from Belfast to Birkenhead (24 October 1907), the writer arranging to meet his friend on Liverpool Central Station between 4.15p.m. and 4.20pm. on the morrow.

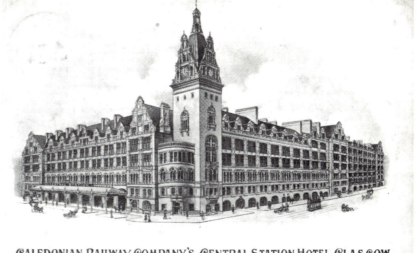

CALEDONIAN RAILWAY COMPANY'S CENTRAL STATION HOTEL, GLASGOW.

382 By the time that this postcard was sent (28 March 1933) the Great Central Railway had become the LNER. Close examination of the picture shows it to be a half-tone lithograph with artist's additions of people and motor-cars. The people are elegant Edwardians, about 1900 (the GCR reached London in 1899), but the cars are about 1910. An official GCR brochure of 1899 features a line drawing of the Hotel Great Central on the back cover, perhaps suggesting that it was company owned and managed.

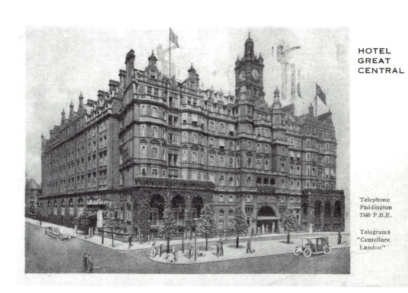

HOTEL GREAT CENTRAL

Telephone
Paddington
7340 P.B.E.

Telegrams
"Centellare
London"

383 An interesting slice of history is preserved on this artist-drawn picture. Adjoining the hotel, the station is shown to be 'Great Central & Great Northern Railway'. The GNR had a financial interest in the construction of part of the Sheffield & Lincolnshire Extension Railway in 1846, although it was not until 1853 that Nottingham came into the GNR system. The Consolidation Act (1849) brought the GNR and the Manchester, Sheffield & Lincolnshire Railway into joint operation and ownership; the 1897 Act changed the name of the MSLR to Great Central Railway. Although the line has closed and the station replaced by a shopping centre, the hotel survives. *(Stuart Underwood)*

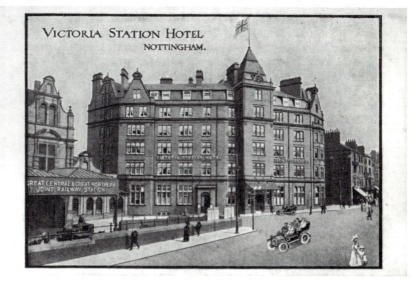

VICTORIA STATION HOTEL
NOTTINGHAM.

GREAT CENTRAL & GREAT NORTHERN
JOINT RAILWAY STATION

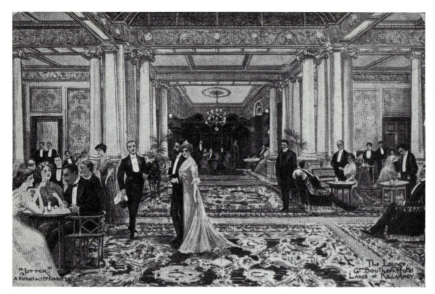

384 An artist-drawn picture of 'The Lounge, Gt. Southern Hotel, Lakes of Killarney' by one who was more renowned for his outdoor scenes, children, and comic cards. Otherwise known as Walter Hayward Young, 'Jotter' was a prolific artist, and to date, more than 800 of his designs have been identified. (Great Southern & Western Railway, about 1905, printed by A. Burkart & Co) *(Ian Wright)*

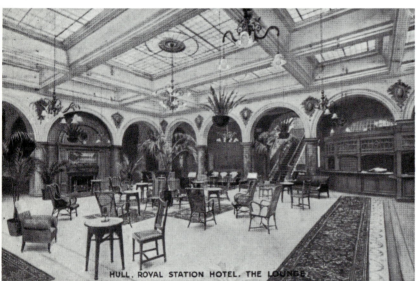

385 This view of The Lounge, Royal Station Hotel, Hull, is one of two in a five-card set, about 1910. The hotel had recently been enlarged and improved, with the addition of electric light and a lift. It was advertised as being 'Most convenient and comfortable for Families and Gentlemen'. Information was also given about the 'New Grill Room, and up-to-date Tea Room on the Station Platform.' (North Eastern Railway, Hotels (five cards), printed by Photochrom) *(Ian Wright)*

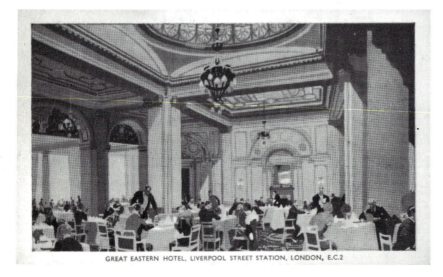

386 The Great Eastern Hotel, which adjoined Liverpool Street Station, was originally owned by the Great Eastern Railway, and reopened in 1900. This view of the dining room, about 1930, is by an unknown artist. After the 1923 grouping the hotel was owned and managed by the LNER, who advertised that it had the 'Largest Luncheon and Banqueting Rooms in the City.' (London & North Eastern Railway, printer unknown) *(Ian Wright)*

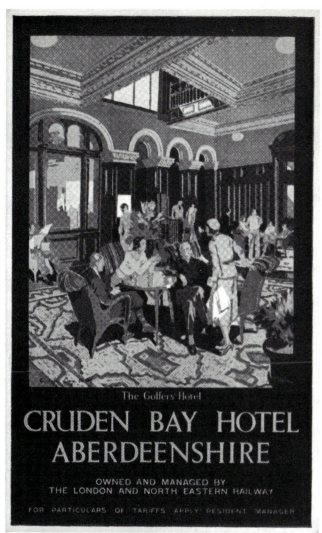

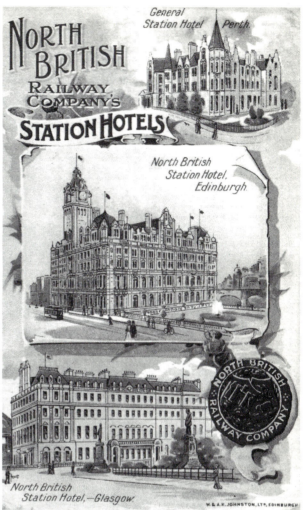

387 An artist drawn picture of 'The Golfers Hotel', otherwise known as the Cruden Bay Hotel, Aberdeenshire. It was owned and managed by the LNER, and overlooked two golf courses. Other sporting facilities offered by this famous establishment (from the days of the Great North of Scotland Railway's ownership) included croquet, tennis, bowls, sea bathing, and fishing. (London & North Eastern Railway, about 1930, printer unknown) *(Ian Wright)*

388 The change in people's travelling habits can be gauged from the comments of the sender of this card, pu 9 June 1908, 'We are here come by Motor Car with our friends'. Although not journeying to Edinburgh by train, they obviously wanted the best of both worlds by staying at the railway's hotel. (North British Railway, issued about 1907, printed by W. & A.K. Johnston, Edinburgh) *(Ian Wright)*

389 During the summer season the GNR(I) carried considerable excursion traffic to Bundoran at specially low fares. Nearby Ballyshannon had quite a large trade in grain and minerals to rival its salmon fishing industry. At the waterfall in the Erne special mounting ladders facilitated the capture of the salmon. Ballyshannon was on the old Donegal Railway which was sold to the GNR(I) in 1906. (Great Northern Railway [Ireland], issued 1905, printer unknown)

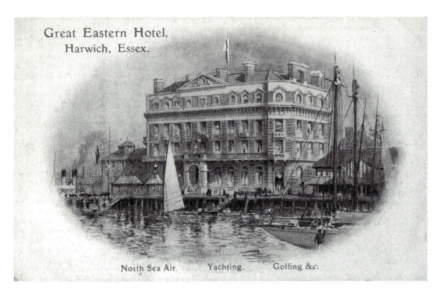

North Sea Air. Yachting. Golfing &c.

390 The Great Eastern Hotel featured on several of the GER hotel postcards, but none so attractively as this artist-drawn coloured picture. A similar view, but showing more of the harbour, was featured on a plain-printed issue of 1901. (Great Eastern Railway, date and printer unknown) *(Ian Wright)*

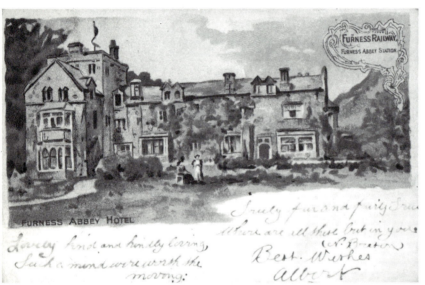

391 It is not surprising perhaps, that the Furness Railway should issue such colourful and artistic picture postcards. The artist George Romney, famous for his paintings of Lady Hamilton, was born at Dalton-in-Furness, and his house at High Cocken was restored by the FR. They installed a small museum containing his coloured engravings and most prominent works. (Furness Railway, first series of officials, July 1902, printed by Raphael Tuck & Sons) *(Ian Wright)*

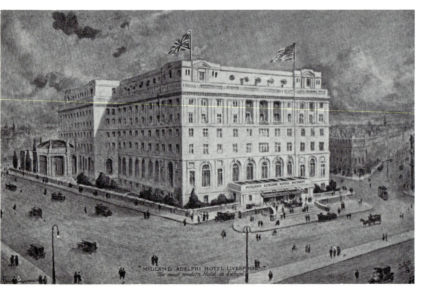

392 The Midland Adelphi Hotel, Liverpool, was acquired by Arthur Towle, the Midland Railway Hotels manager, in 1892. At the time, it was somewhat run-down, and was extensively rebuilt in 1912. It was internally decorated in an early Art Deco style, and opened in 1914 just prior to the outbreak of World War I. Although advertised as 'The most modern Hotel in Europe', it is doubtful if it ever reached the prominence of trade for which it was built. (Midland Railway, about 1919, Oilette printed by Raphael Tuck & Sons)

393 This three-quarter rear view of the Midland Hotel, Morecambe does not do justice to its architectural style. The sweeping curve of its front gives the impression of being the bridge of a trans-Atlantic liner. Opened in 1933, it was built around an existing hotel, which was then demolished to make way for the promenade improvements. (Printed and published by J. Salmon Ltd, card No 3986, from a water colour painting by W. Carruthers, about 1933) *(John Silvester)*

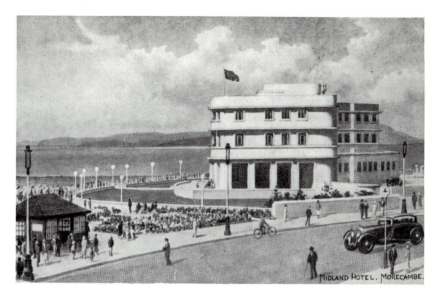

394 The Hotel Terminus Nord received its main influx of guests every evening soon after 5.40pm. That was the time of arrival of the 'Golden Arrow' (*Flèche d'Or*) express into the Gare du Nord six hours and forty minutes after leaving Victoria Station, London. Since this picture was taken, about 1910, the buildings and streets around the station have been altered and re-named.

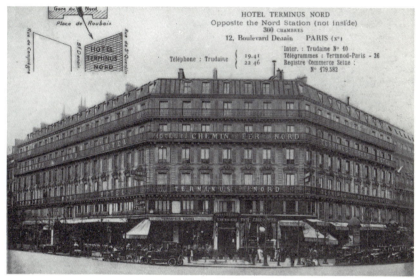

395 The Great Central Hotel, Loughborough, was never owned by the GCR, but was always closely associated with it. Built in 1898 to coincide with the opening of the railway, it was constructed of red-brick and terra-cotta locally made. Just out of the picture to the right was the large goods depot of the GCR, with the station entrance on top of the road-bridge over the main line just 100yd behind the photographer. (Pictorial Post Card Co, about 1905)

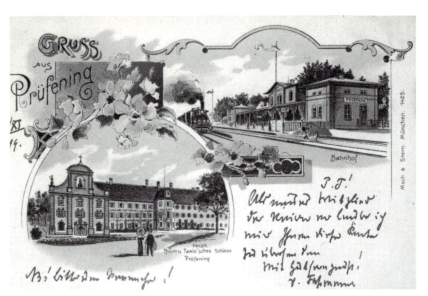

396 On this greetings card from Prufening, pu 1 November 1899, a typical Royal Bavarian State Railway suburban train pulls into the station; all such trains carried a destination board on the buffer beam. One of the reasons that the German railway station was of such civic importance was that the small railway towns obtained clauses in the Railway Acts, making it compulsory for all trains to stop at their respective stations. (Moch & Stern, Munich) *(Mike Clarke)*

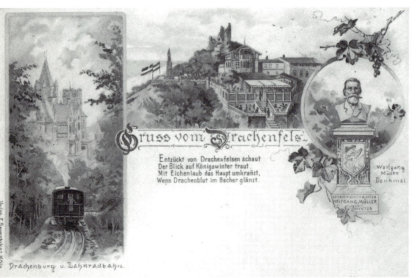

397 The Drachenburg Rack Railway operated in an area alive with legend. Drachenfels, a 1,055ft peak in the Rhineland (10 miles from Bonn) is the steepest in the Siebengebirge mountain range, and contains the Drachenshöle (Dragon's cave), by tradition the lair of the dragon slain by Siegfried. The ruined castle behind the summit station dates from the Thirty Years' War (1618–48). *(Mike Clarke)*

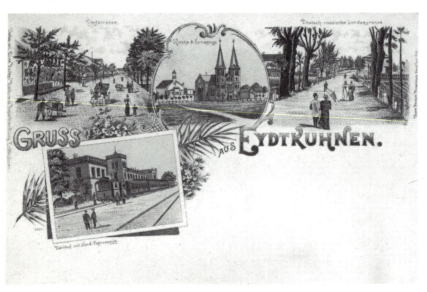

398 Unusual for most *Gruss Aus* cards which include the station buildings in a vignette, this card from Eydtkuhnen also shows the prestigious Nord Express. Introduced in 1894, the Nord ran on four routes: Ostend-Brussels-Berlin-Bucharest; Berlin-Warsaw; Paris-Berlin-Warsaw-Riga; Hanover-Hamburg-Copenhagen. Daily runs were made to Berlin, Riga, and Bucharest, with thrice weekly journeys to Warsaw from Paris. The rolling stock was owned by the famous *Compagnie Internationale des Wagons-Lits.* *(Mike Clarke)*

399 The Holborn Viaduct, 80ft wide, crossed Holborn Valley, from the western end of Newgate Street to Farringdon Street, and curved through to Hatton Garden. It was part of a large slum-clearance scheme begun in 1868, costing in excess of £1½m, of which the Corporation of London recouped about half from the sale of building land around the cleared area. The Holborn Viaduct Hotel, built near to the ornamental cast-iron bridge, was owned by the South Eastern & Chatham Railway. ('Celesque Series', Photochrom Co Ltd) *(John Silvester)*

400 An unusual view for an hotel card, most pictures being shown from street level. The North Western Hotel, Liverpool, was connected with both the arrival and departure platforms of the LNWR Lime Street Station (seen on the right of the picture). Built principally for the convenience of American and Canadian travellers, the hotel had upwards of 200 bedrooms, and had a 'spacious coffee room available for ladies and gentlemen.' (The 'Bird's Eye Series', about 1910, published by W.C.G.) *(John Silvester)*

Appendix 1

RAILWAY POSTCARD CHECKLISTS

TUCK COLLECTOR'S CIRCLE

The object of the Tuck Collector's Circle is to collect and collate information on the picture postcards published by Raphael Tuck & Sons Limited. The firm was commenced sometime around 1866, and in 1893 were awarded the Royal Warrant, as Fine Art Publishers, by Queen Victoria. They were probably the world's largest publishers of picture postcards, the first series being issued in 1899. In their range were many different kinds of cards using a variety of processes in their presentation. Probably the most popular was the 'Oilette', on which railways were featured in great diversity through twenty-nine series, and more than thirty-five individual cards of railway interest, being parts of other series.

For more than ten years the members of the Tuck Collectors' Circle have laid emphasis upon the production of lists of cards in numerical order. This task is almost complete, and the Circle is currently engaged upon the compiling of thematic lists. The railway list which follows is one such compilation, but which is still incomplete. Any corrections or additions should be sent to David Pinfold, 7 Glenville, Northampton NN3 1LZ.

The list is divided into three parts, each in numerical order. This does highlight the illogicality of Tuck's numbering system. Part 3 does not include the many views of the Forth Bridge; there seems to be one in every 'Edinburgh Series', and there are about twenty of those. It is very probable that there are many additions to be made to Part 3, information being very sparse.

Part 1 Series depicting Locomotives and Trains

Oilette 2548 Re-issue of Oilette 9316 'Famous American Expresses'.

Oilette 3541 'Famous Expresses'. Issued 1926.
LNER Harrogate Pullman Express; LNER Flying Scotsman; LNER Leeds-Bradford Express; LMS Express; SR Continental Boat Express; SR Bournemouth Express.

(The next three sets are accredited to the artist Barnard Way, and are generally thought to be rare, having been issued in smaller quantities than the pre-1914 sets.)
Oilette 3547 'Famous Expresses'. Issued 1926.
LNER Continental Boat Train; LNER Flying Scotsman; LMS Scotch Express; LMS Glasgow-London Express on the Midland; GWR Cornish Riviera Limited; SR and L&SWR Southampton Boat Express.

Oilette 3569 'Famous Expresses'. Issued 1926.
LNER Newcastle-Liverpool Express; LNER Perth Express; LMS A West Coast Express with L & Y ENGINE; LMS Caledonian Express; SR The Southern Belle LB&SCR; Great Southern (Ireland) Dublin-Queenstown.

Oilette 3570 'Famous Expresses'. Issued 1926.
LMS Perth-Inverness Express on the Highland Division; GWR Bristol 2-hour Express; LNER Harrogate-Edinburgh Express; SR Kent Coast Express on S.E. Section; SR The Atlantic Coast Express; LMS Birmingham 2-hours Express on the N.W. Division.

Oilette 3593 'The World's Fliers'.
LNER The Flying Scotsman; SR Continental Express — Lord Nelson; CPR Trans-Canada Limited; CNR Continental Limited; The New York Central 'Twentieth Century Limited'; North of France Paris-Calais Pullman 'Golden Arrow'.

Series 4984 (Sepia) 'Famous Tender Engines' and 'Famous Tank Engines'.
(Tenders) 4-2-2- Shanghai — Nanking Railway; 4-4-0 Che Kiang Railway; 4-4-0 Buenos Ayres Central Railway; 4-4-0 Tao Ching Railway; 4-6-0 Buenos Ayres Central Railway; 4-6-0 Buenos Midland Railway.
(Tanks) Argentine Government Railway; Londonderry & Lough Swilly Railway; British War Office 'Victory'; Shanghai-Nanking Railway; 106 Metropolitan Railway.

Oilette 5303 'Famous Expresses'. Issued 1936.
GWR Cornish Riviera Express; LMS Royal Scot; LMS Glasgow-Manchester Express; GWR Paddington-Birmingham Express; SR Bournemouth Belle; GWR Cheltenham Flyer.

Oilette 5304 'Famous Expresses'. Issued 1936.
LNER West Riding Pullman; LMS Royal Scot; SR Atlantic Coast Express; LNER Flying Scotsman; LNER Leeds-Bradford-Hull Express; SR Golden Arrow.

(The pictures in this series bear the name 'F. Moore', a fictitious name for several artists who produced pictures for the Locomotive Publishing Co.)
Oilette 6493 'Famous Expresses'. Issued 1904.
Manchester Express GCR; Flying Dutchman, near Slough GWR; Wild Irishman LNWR taking water at Bushey; Leeds Express MR near Hendon; Continental Express GER near Brentwood; Flying Scotchman GNR near Hatfield.

Oilette 8619 'Scotch Expresses'. Issued 1913.
HR Passenger Train Inverness & Perth; NBR Edinburgh Express; Glasgow Express CR [2 different pictures, same title]; Corridor Express GSWR; NBR Lothian Coast Express.

Oilette 9040 'Famous Expresses' Series II. Issued 1904.
Scotch Express NER; Bournemouth Express L&SWR; Dover Boat Express SE&CR; Highland Express CR; Brighton Pullman Limited LB&SCR; Liverpool-Manchester Express L&YR;

Oilette 9150 'Famous Expresses' Series III. Artist, F. Moore. Issued 1905.
Southend Express LT&SR; GNR Kings Cross-Leeds, taking water near Doncaster; Plymouth Express GWR; Glasgow Express GSWR; Lake District Express FR; Leeds and Bradford Express MR.

Oilette 9161 'Famous Expresses' Series VIII. Issued 1907.
The American Boat Express L&SWR; The Fishguard Boat Express to Ireland GWR; Sheffield and Manchester Express GCR; Scotch Express MR; Great Eastern Express; Corridor Express GSWR.

Oilette 9226 'Famous Expresses' Series IV. Issued 1906.
(This series contains nine cards — most series were of six cards — with the first five being of a different style of presentation to the others which also have an unboxed title.)
Manchester Express MR; Bournemouth Express L&SWR; GS&WR American Mail; Liverpool Express LNWR; Brighton Express LB&SCR; Yarmouth Express GER; The 'Cornishman' near Bath GWR; Birmingham Express L&NWR; Scotch Express on Shap summit L&NWR:

Oilette 9274 'Railways of the World'.
Italian Southern Railway; The 'Katy Flyer' Missouri, Kansas & Texas Rly.; Rigi Rack Railway, Switzerland; The Twentieth Century Limited, New York Central; Russia: The St. Petersburg-Moscow Express; The Khedive's Special, Egyptian State Railways.

Oilette 9316 'Famous American Expresses'.

(Oilette 2548 is a reprint of 9316, but includes a card captioned 'The North Western Limited'. This is identical to 'The Overland Limited'; thus the same design is used twice, but with different captions. It is not certain whether this is also true of 9316.) The Empire State Express; The Overland Limited; The Bay State Limited; The Twentieth Century Limited; The Pennsylvania Special.

Oilette 9329 'Famous Expresses'.
Ostend-Brussels Express, Belgian State Railways; Paris-Calais Express, Northern Railway of France; Johannesburg-Cape Express, Central South African Rlys.; Bombay-Poona Mail, Great Indian Peninsular Rly.; Alexandria-Cairo Express, Egyptian State Railways; Orient Express, near Constantinople.

Oilette 9662 'Famous Expresses' Series IX. Issued 1909.
Edinburgh Express NER; CR Glasgow Express; L&SWR London and Plymouth Express; GNR Flying Scotsman; L&NWR Irish Boat Express, Britannia Bridge, Menai Straits; GWR Cornish Riviera Express.

Oilette 9687 'Famous Expresses' Series XI. Issued 1912.
Up Hull Nottingham Express GNR Fastest Train on GNR; L&SWR Bournemouth Express; L&NWR City-City Express, Birmingham-Broad Street; GWR Birmingham to London 2 hour Express—New Route; SE&CR American Car Express; NER Newcastle-Liverpool Express picking up water.

Oilette 9760 (Platemarked) 'Famous Expresses Series II.
(It is assumed that this specially authenticated series would have the usual complement of six cards, but to date only one has been recorded). Lake District Express FR.

Oilette 9972 'Famous Expresses' Series X. Issued 1917.
Leeds and Bradford Express GNR; Glasgow Express CR; Southern Belle LB&SCR; Cornish Riviera Express GWR; Great Eastern Express GER; Scotch Express L&NWR.

Oilette 123 (French) 'Chemin de Fer d'Orleans'
Oilette 124 (French) 'Chemin de Fer d'Orleans'
(Although the cards have been nominally divided into two series, each has a sequential number, unusual in itself, which in reality makes the two series into one twelve-card series.)
1 Rapide de Paris à Bordeaux
2 Sud Express Paris-Madrid
3 Rapide de Paris à Bordeaux
4 Express de Paris au Mont Doré.

5 Express de Bordeaux a Clermont Ferrand
6 Étude de Vapeur a Clermont Ferrand
7 Express de Paris
8 Rapide de Bordeaux-Paris
9 Rapide de Paris à Bordeaux
10 Rapide de Paris à Nantes
11 Automotrice Electrique
12 Express de Clermont-Ferrand à Bordeaux

Part 2 Series depicting associated railway subjects

Oilette 3404 'Model Railway Engines'.
London, Midland & Scottish Railway (Caledonian Section); London, Midland & Scottish Railway (Midland Section); London, Midland & Scottish Railway (London & North Western Section); Great Western Railway; Southern Railway; London & North Eastern Railway (Great Northern Section).

Oilette 8570 'London Railway Stations'. Issued 1909 (Reprint of 9279).
Paddington Station GWR; Euston Station L&NWR; Waterloo Station L&SWR; St. Pancras Station MR; Charing Cross-Folkestone Express; Kings Cross Station GNR.

Oilette 9186 'By Train'. Artist: J.A. Heyerman.
Six untitled cards.

Oilette 9279 'London Railway Stations'. Issued 1906. (See Oilette 8570)

Oilette 9383 'London Railway Stations' Series II. Issued 1907.
Great Central Station, Marylebone; Broad Street Station; Liverpool Street Station; London Bridge Station; Moorgate Street Station; Central Tube Station.

Part 3 Individual cards of railway interest, being part of other series

No 777 Enamelled Sepia. 'Bombay'.
View of Victoria Terminus & Municipal Building.

No 1259 Framed Aquagraph. 'Leicester'.
Midland Station.

No 1543 'Firelight Effects'
The Fog Signalman.

No 1808 Silverette. 'London'.
Charing Cross Station.

No 1932 Silverette. 'Liverpool'
Overhead Railway.

No 2000 'Town & City—London'.
Charing Cross Station.

No 2206 (USA) 'Chicago'.
La Salle Street Station.

No 2211 (USA) 'Columbus, Ohio'.
Union Station.

No 2267 (USA) 'Atlanta, Ga.'
Atlanta Terminal Station.

No 2497 (USA) 'Houston, Tex.'
Grand Central Depot and Train Shed.

No 2546 (USA) 'New Orleans'.
Union Station.

No 4757 Charmette/View. 'Liverpool'.
Central Station.

No 5002 Raphotype. (USA) 'Pittsburg, Pa.'
Union Station, Penn R R

No 5566 Raphotype. (USA) 'Newport, R.I.'
NY, NH, & HRR Station.

No 5680 Raphotype. (USA) 'Plymouth, Mass.'
Park Avenue and RR Station.

Oilette 7022 'Bombay'.
Victoria Terminus.

Oilette 7045 'California'—Giant Trees'.
Log Section of Cars.

Oilette 7066 'Madras'.
Central Station.
(NB This card is also recorded with the number 7065A.)

Oilette 7140 'Buxton'.
The Railway and Roadway, Ashwood Dale.

Oilette 7218 'Nottingham'.
Midland Station. Victoria Station and Hotel.

Oilette 7268 'Capetown'.
Railway Station and Lower end of Adderley Street.

Oilette 7269 'Croydon'.
West Croydon Station.

Oilette 7290 'Carlisle'.
Carlisle Station.

Oilette 7371 'Teignmouth'.
The Flying Dutchman.

Oilette 7413 'Newcastle-on-Tyne'.
Central Station.

Oilette 7436 'Philadelphia Series I'.
Philadelphia and Reading Terminal

Oilette 7437 'Philadelphia Series II'
Pennsylvania Railroad Depot
(NB The two cards listed above [7436/7437] are the same pictures as USA No 2258)

Oilette 7578 'Glasgow'.
Subway Station, St Enoch Square.

Oilette 7618 'Paris Series I'.
Gare Saint Lazare.

Oilette 7664 'Interlaken'.
Station of the Mountain Railway.

Oilette 7757 'Siberia'.
Manchurian Express.

Oilette 7951 'Mexico Series II'.
San Diego, now the Railway Station, Cuatla.

Oilette 7607 'Amsterdam'.
Central Station

Oilette 8925 'Bombay'.
Victoria Terminus Station.

Oilette 8969 'Bombay'.
View of Victoria Terminus and Municipal Building.

Oilette 934 (French) 'Paris'.
Gare Saint Lazare.

Oilette 952 (French) 'Paris'.
Gare du Nord.

RAILWAY 'OFFICIAL' POSTCARD LISTS

Few integrated records about postcards were ever kept by the old railway companies, who seemed to think that an entry in an accounts book was sufficient documentary evidence that a business transaction had taken place. In several cases this has meant that researchers, with no official information being found, have had to base some dates on the earliest noted postal use of the cards.

Before the completed lists could be published other distracting problems needed to be resolved; most, if not all, of these problems came to light during research, and some can never be categorically determined. Many postcards bear a code number, some of which can be obviously identified as printers' references, and the cards dated accordingly.

Confusion is often compounded by the railway companies themselves; eg it is not always possible to differentiate between the Irish Great Southern Railway and Great Southern and Western Railway cards because a number of the latter, from as early as 1902, use the title 'Great Southern'.

Other anomalies arise because so very little is known about the printer, photographer, and other associated companies mentioned on some postcards. In the absence of positive evidence the status of some cards is uncertain, although they are generally regarded as probable officials. Trade cards are for most practical purposes outside the scope of these lists, although most of those issued were of postcard size. Many postcards jointly issued with French railway companies are most confusing since they often carry more than one picture, with English and French versions for the appropriate direction of travel. French poster cards owe their inclusion in the lists to the existence of the joint issues with English railways.

The researches of John Alsop, Brian Hilton and Ian Wright have resulted in the publication of *Railway Official Postcard Lists* as a series of twenty booklets (listed below). The authors have listed all the known official cards, but accept that there may be some odd cards not known to them. Details (and preferably photocopies) of such cards would be gratefully received. Information should be sent to, and the lists obtained from Ian Wright, 43 Little Norton Lane, Sheffield S8 8GA.

1 North Staffordshire Railway.
2 Midland Railway.
3 Lancashire and Yorkshire Railway.
4 Furness Railway.
5 Welsh Railway Companies.
6 Great Central & Great Northern Railway Companies.
7 Hull & Barnsley, North Eastern & East Coast Route Companies.
8 Great Eastern Railway Company.
9 Great Western Railway Company.
10 Irish & Isle of Man Railway Companies.
11 Pre-Grouping Southern Railway Companies.
12 Minor Scottish Railway Companies.
13 North British & West Highland Railway Companies
14 Highland, Invergarry & Fort Augustus, Wick & Lybster Railway Companies.
15 Caledonian, Callander & Oban Railway Companies.
16 The London Underground Railways.
17 Post Grouping LMS, LNER, SR.
18 Minor English Railway Companies.
19 London & North Western Railway Company.
20 French Poster Cards.

REFERENCE HANDBOOKS

Official Railway Postcards of the British Isles by Reginald Silvester has been published in two volumes (two others are in the course of preparation). They are informative and make interesting reading. Also with many black and white illustrations of the postcards described, they are the first books to list and describe such cards in detail. The postcards documented in these, and subsequent parts, are those issued by the railway companies prior to the 1923 grouping. They give due recognition to this form of railway publicity used by the companies as an additional aid to their revenue and advertising promotions.

The author acknowledges that his efforts could not have come to fruition without the helpful advice of several fellow collectors. Among these he names John Alsop, Trevor Cook, Norman Hansford, and Eric Watson who confirmed his findings. Special mention is made of the contributions of Derek Brough, and the well known postal history collector, the late Harold Waterton. Help from dealers also made the books possible, notable being Ken Lawson (Specialised Postcard Auctions and Chairman, Postcard Traders Association), Ron Mead (RF Postcards), John H.D. Smith (International Postcard Market), and Desmond Chamberlain. Anne Mobbs assembled the original manuscripts, which were checked by Thelma Duke (Ducal); additional help was rendered by Rosina Stevens, Ron Grosvenor, and Ken Stubbs.

In preparing these works (the four volumes will document the postcards issued by some 120 railways) the author has endeavoured to list all the sets and series cards issued, and to document the variations and alterations made to these cards for special services or events. New cards are still being discovered by collectors, and the details are worthy of the attention of collectors for they often give clues to further cards yet to be found. Most importantly, they add to our knowledge of the railway business during the era of the picture postcard before World War 1.

The extent of the information in these books amply upholds the author's hope that each book will help collectors in their quests and make the task of documentation of their finds somewhat easier.

Part One

After an Introduction briefly describing the inter-relation of postcard and railway history, the book commences with a short history of the London & North Western Railway. This is followed by a similar history of the company and its postcards, and a chronological table of postcard issues, and catalogue information.

Set out in chronological order, with details and descriptions together with titles and historical information are listed the Series 1-12, with two additional sets, Hotel and odd cards printed by Raphael Tuck & Sons. These are followed in similar style by references for Series 1-4 (revised), and Series 15-60, printed by McCorquodale. Also included are the reprints of Series 1-36 and the many non-set McCorquodale postcards. The centre pages of the book illustrate in black-and-white 144 postcards from the Series described.

The book concludes with very informative and interesting sections on advertising overprints, postcard values, and LNWR postcard values.

Part Two

This volume is in similar format to the first, dealing with the railway history, postcard events and lists of the Great Central, Great Western, Barry, Cambrian, Corris and Vale of Rheiddol Railways. There are seventy-three black and white illustrations representing all of the companies, but mostly of Great Central and Great Western postcards.

Appendix 2

GLOSSARY

Art Nouveau
An artistic style which came into vogue towards the end of the nineteenth century. It was an expression of the new decorative forms, symbolic of nature, characterised by floral forms enclosed in undulating asymmetrical lines. Its capricious flourishing style depended almost entirely on imagination. Although this meant that it was doomed to early decline, the style dominated graphic art, decorative ornament, and architectural design between 1895 and 1905.

Art Deco
A formalised art style largely initiated by Parisian fashion designers. Its characteristics of geometric symmetry and simplicity allied to boldness of colour extended into all forms of decor from 1909 to 1935. It upheld the doctrine of the Art Nouveau movement that unity of design was paramount, and that decor and style should be complementary.

Back
The side of a picture postcard bearing the stamp and address, and most often carrying the word(s) POST-CARD. Although on the opposite side of the card to that which bears a vignette, or is fully pictorial, small pictures are sometimes used on the address side.

Bas-Relief
A moulded form giving a three-dimensional aspect to a picture; it is similar to embossing. The reverse of a bas-relief picture was filled with a china-clay plaster before attachment to a conventional flat card backing.

Bromide
A silver salt of hydrobromic acid used as a coating on a photographic paper. The term also refers to an early photographic process using bromine, a red non-metallic chemical. Combined with other chemicals it produced a dark brown tone, usually referred to as sepia.

Chromolithography
A colour printing process using several lithographic stones (one for each basic colour) to reproduce a facsimile of an original colour drawing. The term is usually colloquially shortened to 'chromo.' Early picture postcards were produced by chromolithography, using a specially fine limestone quarried at Solnhofen in central Bavaria. This was the reason that such cards carry the legend 'Printed in Bavaria' (or 'Saxony' or 'Germany'). When held at an angle against the light, the layers of coloured inks can be clearly distinguished. The method produces some superb fine colour printing. See also 'Lithography'

Collotype
A method of printing from photographs or other pictures. Although resembling lithography the process results in a 'flat' reproduction, lacking in depth. Thick plate–glass was coated with a gelatin–biochromate emulsion, and the image of the original was printed on to the plate by exposure to light. The emulsion not affected by the light and not hardened, absorbs moisture. The printing ink is accepted by the hardened emulsion, but rejected by the moistened parts (a principle of lithography). The picture thus produced has a smooth granular tone.

Condition Ratings
A standard method of defining criteria by which picture postcards are judged for value.
Mint (M): A card which has not been postally used; is in pristine condition, with no marks or blemishes of any kind; printing in perfect register; original guillotine edges still detectable.
Excellent (X): As above, but card postally used.
Very Good (VG): Either unused or postally used. No major blemishes, and only slight trace(s) of album marks. Edge of card still fine, but bearing only minute evidence of handling.
Good (G): Either unused or postally used. Evidence of handling and wear in slight traces, but not detrimental to the picture and/or general aspect of the card. Blemishes of a minor nature. *Fair* (F): Either unused or postally used. Obvious traces of handling and wear; damage at edges and corners, and possible major blemishes.

Court Card
A correspondence card with vignette decoration, used as postal stationery, and posted inside an envelope. Its British Post Office regulation size was $4\frac{1}{2}$ x $3\frac{1}{2}$in (115 x 89mm). It was officially in use from 21 January 1895 until 1 November 1899.

Divided Back
A reference to the address or non-picture side of a postcard, which in January 1902, received sanction

for the printing of a vertical line down the centre of the card. The left–hand section contained the message, while the right–hand side was for the address. German authorities followed suit in 1905, and USA in 1907. Prior to this, without the vertical line, where only the address was allowed on this part of the card, the style is known as 'Undivided.'

Embossed

A card with the picture or design raised in relief from the general surface, creating a three-dimensional representation of the subject. Finely sculpted moulds, male and female, were positioned in perfect register above and beneath the card which was then subjected to pressure and heat. The result was an image which enhanced the visual reality of the original.

Front

The pictorial side of a postcard, opposite to that which is for the stamp and/or address. The philatelist regards the normal stamp side of a card as the front.

Gruss Aus

A special type of greetings card which originated in Germany, about 1883. The words *Gruss Aus* (greetings from) were incorporated with the name of a town, together with several vignetted views. The ornamental words and the pictures were surrounded with floral type decorations. Produced by the chromolithographic process, such cards are keenly collected.

Half-Tone

A printing method which arranges the continuous tone of the original into a regular series of dots, and produces the visual impression of a graduated tone. A screen of fine lines (up to 160 per inch) is interposed between the camera and the original picture. The resultant image is broken up into dots of varying sizes, which, when printed on to a smoothly coated paper or card can hardly be detected with the naked eye.

Heliograph

An early mechanical process not using a half-tone screen. By means of a diapositive, instead of a negative, the tonal range is reversed (dark becomes light). The process produces fine facsimiles, but with the print slightly raised, in a similar manner to intaglio.

Intaglio

The reverse of relief printing, a form of etching, which produces a soft, rich quality to the degrees of light and shade in the original. A three-colour process is possible by this method, but before the days of photography, analysis of the original to resolve the design into the primary colours was done by eye. Early picture postcards were produced by the intaglio process, but the time and expense involved

soon made it commercially impractical.

Lithography

A printing process invented in 1796 by Aloys Senefelder, by means of which an image on a flat surface becomes a printing plate. Originally made on fine limestone, and later developed with the use of zinc and aluminium foils, the lithographic printing surface was made by the action of suitable chemicals. With the advent of photography its chief use was in the production of half-tone pictures, the majority of picture postcards being made by this method.

Mezzotint

An engraving process producing a tone effect. A rocker, a steel chisel whose edge is set with fine teeth, is drawn horizontally and vertically across a copper plate, thus producing a burred surface. Into this surface the lines of the design are engraved. Its time-consuming preparation, although used for many early postcards, made it unsuitable for large commercial production.

Officials

Postcards, pictorial or plain, issued by a company to promote or advertise a product or service. Railways, shipping lines, and hotels were among the principal publishers of such cards. These were issued free to patrons, used for internal correspondence, or sold to the general public.

Oilette

A trade-name used by fine art and postcard publishers Raphael Tuck and Sons to describe superb reproductions of original oil paintings. Countless thousands of sets in all categories were produced by the company. They were so good that many other firms imitated the style, and some pirated versions were issued.

Oilfacsim

A type of picture postcard in which the surface of the card was lightly moulded to represent the brush strokes of an oil painting.

Plate Sunk

Set within the outer edges of the card a 'plate', or section to carry the picture is 'sunk', or impressed. The process is the reverse of embossing, and creates a 'frame' around the picture.

Postal Stationery

A term usually applied to cards and other stationery which have been printed to show prepayment of the postage rate. Originally, such items, especially postcards, were issued by the postal authorities or their agents; for this reason they are sometimes known as officials. The monopoly of such cards came to an end on 1 September 1894, when privately-printed post-

cards bearing adhesive stamps were authorised for postal transmission.

Postcard Sizes

At least nine different sizes were authorised by the British postal authorities between 1 October 1870 ($4\frac{3}{4} \times 3\frac{1}{2}$in or 122×88mm), and 1 November 1899 ($5\frac{1}{2} \times 3\frac{1}{2}$in or 140×89mm). Giant cards, disliked both by collectors and postal authorities, have been known to exceed $12 \times 6\frac{1}{2}$in. Intermediate cards — approximately $5\frac{1}{8} \times 3\frac{1}{8}$in (130 x 80mm) first appeared in 1892 and were phased out after 1 November 1899, lasting until about 1902. Midget cards were $2\frac{3}{4} \times 3\frac{1}{2}$in; $3\frac{1}{4}$in square, or diamond-shaped with 3in sides. Bookmark cards were approximately $1\frac{3}{4} \times 5\frac{1}{2}$in. All these non-standard size picture postcards are usually categorised as 'Novelty'.

Poster

Advertising postcards reproducing actual posters or resembling the style. Usually, the large lettering style can be seen to be an integral part of the original picture; some of the finer pictorial details, due to reduction to postcard size, will be a little indistinct. A poster-style card does not usually feature the lettering so prominently, but the design is bold and colourful.

Private Mailing Card

A term which is hardly ever found on postcards other than those made and used in the USA. An Act of Congress, 19 May 1898, allowed private postcards to be printed bearing this title on the back. Private postcards issued before this date, and therefore without official sanction, are known as 'Pioneers'. In December 1901, the regulation was withdrawn, and the words 'Post Card' allowed instead.

Rare

A comparative term, frequently misused, mostly by people who know of no other recorded examples. It should only be used to describe picture postcards which are positively known and recorded, since there is always the possibility that another similar card will be discovered. Just as something which is 'unique' cannot be said to be 'nearly', so, 'rare' cannot be quantified. The term should be used with discretion, and never, if more than about twenty are known.

Real Photographic Used to describe a postcard, usually a topographical view, where the picture has been produced by a photographic process. Such a card can be from the mass-production of a large firm, such as 'Rotary Photographic', or a one-off issue by a local photographer.

Rotogravure

A process in which the printing plate is a copper-plated cylinder carrying a photo-sensitive emulsion. A half-tone screen between the camera and the original picture produces a grid of fine crossed lines, light in tone, visible under magnification.

Scarce

A term sometimes confused with 'rare'. It really means that such postcards are not readily available in large numbers, or are difficult to find, although there could be many thousands extant. The term should always relate to availability, and not numbers of cards which have survived.

Sepia

A colour of fine brown. It is used to refer to pictures produced by photographic, lithographic, collotype and gravure processes. The tone varies through several shades from light golden brown to dark brown.

Set

A number of picture postcards arranged together by a publisher to form a series, which can be either a combination of letters and figures, or a title. It is not unknown for a set to contain as many as 500 cards, but most issues are to be commonly found in numbers of four, five, six, ten, or twelve.

Vignette A small pictorial embellishment not contained within a formal border, and occupying less than the full size of the postcard. Several vignettes can thus be arranged on the front of a card, still leaving space for the writing of a message. The style is most frequently seen on *Gruss Aus* cards. With the advent of photography and the lifting of postal restrictions, the vignette was developed into the 'Multi-view', where several pictures fill the front of the card.

Wheel Arrangement

A system of notation which generally decides the class of service for a locomotive. The notation starts from the front of the engine, and accounts for its wheels, either in fact or in theory; thus no wheels of a particular type are classified as 'O'. The leading wheels, perhaps on a bogie, are noted, followed by reference to the coupled, or driving wheels, the notation finishing with reference to any trailing or 'idler' wheels. Thus, a Pacific-type locomotive is known as a 4-6-2; the French system, which classifies by axles, would refer to a 2-3-1 type. 'Double-ended' locomotives continue the notation in reverse, ie, 2-4-0-0-4-2; when the engine is articulated the notation reads, 2-4-0+0-4-2. For tank engines the classification is followed by the letter 'T'.

Appendix 3

PUBLISHERS OF RAILWAY POSTCARDS

Full details of these and other publishers can be obtained from *Picture Postcards and their Publishers* by Anthony Byatt. The list below includes the principal publishers, but excludes railway companies.

Abraham, George Perry Ltd, Keswick.
Photographer and publisher who established his business in Lake Road, Keswick, Cumberland, in 1865. He was joined in the business by his two sons in 1907. It was about this time that they first produced picture postcards. The firm ceased trading in 1967.

Allen, David & Sons Ltd, London, Harrow, and Belfast.
The firm specialised in pictorial advertising posters, chiefly for the theatre. Such posters were often reproduced as trade cards, and the company's first picture postcards appeared about 1903.

Alpha (Alphalsa) Publishing Co. Ltd, London.
The firm was established about 1910, then trading under the name Alfred Stiebel & Co, Fine Art Publishers. It published a considerable number of railway cards but is chiefly remembered for its silk postcards woven in Coventry.

Cynicus Art Publishing Co, Tayport, Scotland.
'Cynicus' was a pseudonym used by Martin Anderson. He established his business in 1902, producing comic cards. Most of these were designed for the seaside tourist trade, showing 'Our Local Express'... or 'The Last Train to. . .' which allowed the name of the resort to be overprinted. The business failed in 1911.

Frith, Francis & Co, Reigate, Surrey.
Photographer and publisher who established his business in 1859. His first picture postcards were published as Court cards, about 1898. In its early years, the firm was the largest photographic distributor in the world. It went into liquidation in 1971.

Giesen Bros & Co, London.
The firm was publishing picture postcards by 1902, and was associated with the Berlin firm, Rotophot. It is known chiefly for its production of fine embossed cards.

Gothard, Warner, Barnsley.
A publisher and photographer who specialised in 'disaster' type cards, especially multi-views. High quality cards were produced of several railway accidents between 1905 and 1916. His whole range of picture postcards is much in demand.

Hartmann, Frederick, London.
His business was established in 1902, the year in which he persuaded the British Post Office to introduce the 'divided back' postcard. Although the firm had a very good reputation for Fine Art reproduction, it ceased trading about 1909.

Hildesheimer, Siegmund & Co, London.
The firm commenced as art publishers about 1876, and their earliest postcards appeared around the turn of the century; by 1902 they advertised a considerable range of subjects. The firm is mostly renowned for its extensive production of chromolithographic view cards.

Hoffman, C.R., Southampton.
Little is known about the firm of 'Shipping Photocard Publishers' which flourished between the two wars. Most of the Southern Railway Channel steamers were covered by the firm. The photographic excellence of Hoffman's cards makes them very collectable.

Jarrold & Sons Ltd, Norwich.
The firm began as printers in the early 1800s; Court cards were probably produced in 1895, although this is not certain. They produced a fine and extensive series of heraldic cards and many East Anglian view cards.

Knight Bros Ltd, London.
Established in 1904 by Watson and George Knight who had previously worked with Evelyn Wrench (qv) in the production of picture postcards. Their ten-colour photo-reproduction railway series, 'Flyers of the Iron Road', is highly collectable.

Locomotive Publishing Co Ltd, London.
The firm's first picture postcards were published around the turn of the century. They specialised in the production of very high quality cards in several different photographic processes. Their colour cards are generally acknowledged to be superior to most other publishers. The company produced its greatest

range of cards in association with *The Locomotive Magazine*, which it also published. The only reference number on their cards is written in pencil, and it has never been established whether these are series numbers or sales figures. As Anthony Byatt says, the LPC 'has left us a major contribution to the pre-1923 railway pattern in this country.'

McCorquodale & Co, Glasgow and London.
Fine art and book publishers who specialised in printing all forms of railway company literature. They were established prior to the turn of the century, and their picture postcards were used as officials by several railway companies. They ceased trading about 1930.

Photochrom Company Ltd. Tunbridge Wells.
One of the most prolific postcard publishers, the firm originated in Switzerland, and was established in Britain in 1896. Its earliest postcards appear to have been published about 1903, and with special commissions from several railway companies, it produced many fine series.

Picture Postcard Co Ltd, London.
The company was in business for only two years, but it made its mark on postcard history. Its Great Western Railway officials, and those printed for other companies, are highly prized by collectors. The GWR cards are among the earliest postcards available from railway station vending machines.

Pouteau, Ernest, London.
Best known for his real photograph cards, which although of high quality, are somewhat lacking in information of the subject. His cards carry the initials 'E.P.' within an art nouveauesque frame.

Reid, Andrew & Co Ltd, Newcastle-upon-Tyne.
Founded early in the Victorian era, this firm produced its first picture postcards in 1902. Advert-

ising cards for shipping lines and railway companies, in high quality chromolithography, are very collectable.

Salmon, Joseph, Ltd, Sevenoaks, Kent.
Founded about 1815, the company's first picture postcards were issued in 1903 as facsimiles of watercolour paintings. Soon after world war 1 the firm produced an impressive series of aviation and railway postcards.

Smith, E. Gordon, London.
Commencing in 1903, publishing view cards of London, the firm soon began to expand. By 1905 he was publishing sets of cards of eight major railway companies

Smith, W.H. & Son, London.
Well-known as booksellers and newsagents, who set up the first railway bookstall in 1851. Were producing picture postcards about 1905. Its 'Kingsway' series features many real photograph cards of railway interest.

Tuck, Raphael & Sons Ltd, London.
The name of Raphael Tuck is paramount in both fine art publishing and picture postcard history. Its first postcard series on railways was published in 1906 (see Appendix 1) The detailed history in Anthony Byatt's book is most interesting.

Valentine & Sons Ltd, Dundee.
This well-known Scottish firm began specialising in picture postcards from as early as 1896. It produced a wide variety of subjects on many types of postcard, and published several popular series of railway interest.

Wrench, Evelyn, Ltd, London.
His first postcards were published in November 1900, finely printed by collotype. The firm expanded too quickly and was forced to close in 1906.

Appendix 4

POSTCARD MAGAZINES and CATALOGUES

Great Britain

Picture Postcard Monthly
Edited by Brian Lund, and published by Reflections Of A Bygone Age, 15 Debdale Lane, Keyworth, Nottingham NG12 5HT. Articles, news items, illustrations, of interest to postcard collectors world-wide.

British Postcard Collector's Magazine
Published ,and edited by Ron Griffiths, 47 Long Arrotts, Hemel Hempstead, Hertfordshire HP1 3EX. Irregular publication dates. Articles mainly of interest to collectors of modern picture postcards.

Collector's Fayre
Edited by Angie Smith, published by Quartet Publications, 149 North Street, Romford, Essex RM1 1ED. News, views, information and illustrations of the collecting world, plus large specialist section on picture postcards, philately, and ephemera.

IPM Catalogue of Picture Postcards and Year Book
Compiled by John H.D. Smith, and published annually by IPM Publications, 2 Frederick Gardens, Brighton BN1 4TB. A comprehensive catalogue with detailed information and price guide on all postcard collecting themes, together with specialist articles, surveys, advertisements, and directory. Profusely illustrated.

RF Picture Postcard Catalogue
Compiled by Joan Venman and Ron Mead, and published by RF Postcards, 17 Hilary Crescent, Rayleigh, Essex. Thematic price guide, and specialist sections, market trends, directory. Colour and black & white illustrations.

Stanley Gibbons Postcard Catalogue
Compiled by Tonie and Valmai Holt, and published by Stanley Gibbons Publications Ltd, 399 Strand, London WC2R 0LX. Thematic listing of postcards, with three-band pricing system and guide. Detailed section on artists, directory, and illustrations.

In addition to these magazines, articles of interest to picture postcard collectors can be found in several of the major stamp collecting magazines. Information concerning *International Collectors Guide* can be obtained from M. Clarke, PO Box 7, Sheringham, Norfolk NR26 8JL.

France

Cartes Postales et Collections BP No 15, 95220 Herblay.
L'Officiel International des Cartes Postales
Compiled and published by Joëlle & Gerard Neudin.

United States of America

Postcard Collector 700 East State Street, Iola, Wl 54990.
Deltiology Box 13 Avalon, New Jersey NJ08202.
Standard Postcard Catalog
Compiled and published by James Lowe, 10 Felton Avenue, Ridley Park, PA 19078.

Appendix 5

PRESS NOTICES

The London & North Western Railway was obviously very proud of its commercial success with the production and sale of picture postcards. Some time after June 1905, when the company issued Set 33 'LNWR Steamships', it also published an eight-page booklet of press notices. At the bottom of the front cover was quoted the number of cards sold in the first twelve months — not some approximate figure, ie 'more than 2½ million', but an exact number, '2,693,618'.

The back cover of the booklet announced 'The L&NWR PICTORIAL POST CARDS (33 Sets Published) are now being used in many COLLEGES and SCHOOLS throughout the Country.' The advertisement went on to say that the cards could be obtained at 'Stations, Town Offices, Hotels, in the Dining Cars, and on board the Steamers: also from the Company's Agents in the principal Towns of Great Britain and Ireland, or post free from Mr. F.H. Dent, Broad Street Station, London E.C.'

The price per set of six different cards was 2d to the public, but to stationers and the trade the price was 15s per gross (144) sets. There was obviously quite a large profit margin in the sale of picture postcards.

The epigrams of praise are quite revealing in themselves, and quite obviously some of the newspapers and magazines were out of their depth, almost to the point of being taciturn, in their reviews of a novel publishing venture. Considering that the LNWR had issued more than 350 different cards in several editions, the comment by the *Gentleman's Journal*, 'The designing and printing are done in England' hardly represents an in-depth study of the subject; the *Penrith Observer*, 'Exclusively printed in England' was equally vague. Probably the palm should go to the *Halifax Guardian* whose review included 'Excellently got up'.

However, some of the reviews quoted were more informative. The first quotation was taken from a source which the LNWR obviously regarded as being authoritative, *The Picture Post Card and Collectors' Chronicle*. Copies of this magazine are now collectors' items in themselves. The editor observed that the cards 'Form a veritable pictorial encyclopaedia of railway travelling. No railway company has made better use of the pictorial postcard than the L.&N.W.

The Company have rendered themselves pre-eminent in the sphere of advertising by postcards.'

The *Railway Magazine* had similar thoughts: 'When the L.&N.W. Railway undertakes anything it is sure to be well done, and this truism applies to the premier issue of L.&N.W. pictorial post cards. Their success has been remarkable.' Considering the somewhat sober style of *The Times*, their exuberant comments were praise indeed, 'The whole series is full of interest, showing as it does the marvellous development of a great trunk railway, from the time of its inception down to the present day.' Their sentiments were echoed by the *Shrewsbury Chronicle*, who were clearly aware of the power of publicity, 'A valuable medium for drawing attention to the developments and possibilities of railway travelling, and to the places of interest to be reached by their wonderful system. Their superior finish is a triumph for home craftsmen.'

Apart from the company's own sales and financial records, the remarks made by these publications country-wide showed just how perfectly the LNWR had judged its market. The public was interested in postcard collecting, railway travel, and in particular, the origins of 'The Premier Line'. The LNWR did not disappoint them. The following is an amalgam of several more opinions from the nation's press.

'In a series of beautifully coloured post cards, interesting alike from an artistic and educational point of view, for the tale they tell of quaint beginnings and continuous advance. The cards give a pictorial version of the Company's progress, and include views of some of the earliest railways and rolling stock. Artistically photographed and printed, the post cards issued by the premier railway company completely outrival all others, and form a comprehensive illustrated history of railways, showing every phase of railway working past and present.

Collectors will be after them with great avidity, from the trains of 1837, with luggage on the roofs of coaches and second class passengers outside, to the very interesting pictures of old-time goods trains, with their open cars, with men and animals mixed, and piles of hay. In striking contrast are the up-to-date flyers, such as the 'Hardwicke' engine, doing its 67 miles an hour in the race from Euston to Aberdeen,

and the smart new boats on the Irish service; also, the photos of the latest train de luxe — their Majesties Royal Saloons — form an interesting section.'

A writer in the *Inverness Courier* was obviously of a like mind with his compatriot penman in *The Scotsman* some thirty-six years earlier, stating, 'The idea commends itself as a means of communication between passengers and their friends.' Several of the reviewers mentioned the beauty of the printing, the low cost, and the quality of the production which was agreed by many to be 'above the average of publications of the kind', reflecting great credit on the enterprise of the company. The *Joint Stock Companies Journal* considered that 'The collection amounts to a pictorial history of the line from the "thirties".'

But probably best summing up the opinions of them all was the *Halifax Evening Courier* which said, 'The best set of cards that has been issued by a railway company.' And with hindsight, we can agree whole-heartedly with *The Globe:* 'Lovers of pictorial post cards owe a debt of gratitude to the L.&N.W.R Company.'

Bibliography

Despite a formal history going back to at least 1869, the picture postcard has received relatively little literary coverage. Most books documenting its origins and specific histories have been written within the past thirty years; some of them have become classic works of reference. Books covering the subject of railways on postcards are few in number; along with general works on railways or postcards they are listed here as both interesting reading and a guide for the postcard collector and railway enthusiast.

Postcards (general)

Pictures in the Post, Richard Carline (Gordon Fraser 1959; revised 1971)

The Picture Postcard and its Origins, Frank Staff (Lutterworth Press, 1966; revised 1979)

Picture Postcards of the Golden Age, Tonie & Valmai Holt (Postcard Publishing Co, 1971; revised 1978)

Picture Postcards and Their Publishers, Anthony Byatt (Golden Age Postcard Books, 1978)

Collecting Postcards 1894-1914, William Duvâl & Valerie Monahan (Blandford Press, 1978)

Collecting Postcards 1914-1930, Valerie Monahan (Blandford Press, 1980)

Railway Postcards

Gruss von der Bahn, Werner Sonntag (Motorbuch Verlag, Stuttgart, 1978)

Official Railway Postcards of the British Isles
 Part 1 – London & North Western Railway, Reginald Silvester (BPH Publications, 1978)

Official Railway Postcards of the British Isles
 Part 2 – Great Western Railway & Others, Reginald Silvester (BPH Publications, 1981)

Railway Official Postcard Lists 1-20 (77 railways pre-grouping to post-grouping) John Alsop, Brian Hilton, Ian Wright (privately published, 1981; available from 43 Little Norton Lane, Sheffield S8 8GA

Railways in Britain On Old Picture Postcards, Brian Lund (Reflections of a Bygone Age, 1983)

Postcard Reference

Picture Postcards and Travel, Frank Staff (Lutterworth Press, 1979)

Picture Postcard Annual, 1980-1986, Edited by Brian Lund (Reflections of a Bygone Age)

The Dictionary of Picture Postcards in Britain 1894–1939, A.W. Coysh (Antique Collectors Club, 1984)

Posters and Postcards

The Romantic Journey, Edmund Swinglehurst (Pica Editions, 1974)

Masters of the Poster 1896-1900, Edited by Alain Weill (Academy Editions, 1977)

Ephemera of Travel & Transport, Janice Anderson & Edmund Swinglehurst (New Cavendish Books, 1981)

Cook's Tours, Edmund Swinglehurst (Blandford Press 1982)

Railway Reference

Go Great Western, Roger Burdett Wilson (David & Charles, 1970)

Railway Relics & Regalia, Edited by Patrick B. Whitehouse (Country Life, 1975)

The Railways of the World, Ernest Protheroe (George Routledge & Sons, c1910)

Our Home Railways, Vols 1 & 11, W.J. Gordon (Frederick Warne & Co, 1910)

Britain's Railway Liveries 1825-1948, Ernest F. Carter (Burke, 1952)

An Historical Geography of the Railways of the British Isles, Ernest F. Carter (Cassell, 1959)

LMS Coaches, An Illustrated History, D. Jenkinson & R.J. Essery (Ian Allan, 1969); revised, Oxford Publishing Co, 1977)

Railway Wonders of the World, Vols 1 & 2, Edited by Clarence Winchester (The Amalgamated Press, 1935)

The Clyde Passenger Steamer, Captain James Williamson (James MacLehose & Sons, 1904)

Clyde River Steamers of the Last Fifty Years, Andrew McQueen (Gowans & Gray Ltd, 1923)

Echoes of Old Clyde Paddle Wheels, Andrew McQueen (Gowans & Gray Ltd, 1924)

Index

Figures in **bold** type refer to illustration numbers